MW00398549

Underground
Buildings
More than Meets the Eye

Loretta Hall

Quill Driver Books

Sanger, California

Copyright © 2004 by Loretta Hall. All Rights Reserved. No part of this book may be reproduced in any form or by any electonic or mechanical means including information storage and retrieval systems without permission in writing from the publisher, except by a reviewer, who may quote brief passages in a review.

Published by Quill Driver Books/Word Dancer Press, Inc.

1831 Industrial Way #101

Sanger, California 93657

559-876-2170 • 1-800-497-4904 • FAX 559-876-2180

QuillDriverBooks.com

Info@QuillDriverBooks.com

Quill Driver Books titles may be purchased in quantity at special discounts for educational, fund-raising, business, or promotional use. Please contact Special Markets, Quill Driver Books/Word Dancer Press, Inc. at the above address or at 1-800-497-4909.

Printed in China

First Printing

To order another copy of this book, please call
1-800-497-4909

ISBN 1-884956-27-0

Library of Congress Cataloging-in-Publication Data

Hall, Loretta.
 Underground buildings : more than meets the eye / by Loretta Hall.
 p. cm.
Includes index.
 ISBN 1-884956-27-0
 1. Underground architecture--United States. 2. Architecture--United States--20th century. I. Title.
NA2542.7.H35 2003
720'.473'0973--dc21

2002155434

Contents

FOREWORD

This book caused me to reminisce about my father's boyhood Alabama home. It had two underground features that were common to all of the houses in his community–a potato cellar and a storm shelter. The cool and dry cellar preserved potatoes, onions, and other vegetables through the winter. The storm shelter was usually separated from the house, but near enough to provide refuge against the fierce winds and tornadoes that appeared suddenly throughout the southeast. They were both vital to quality of life, but improvements in technology supplanted them and caused them to slip from memory.

Another childhood memory was seeing the sides and roofs of southern barns painted with giant messages like "See Ruby Falls," or "Visit Rock City." Promoters learned more than 60 years ago that travelers on primary routes were fair game, and that such messages could induce them to visit the famous cave complex near Chattanooga. I remember enjoying a measure of pride as I told my friends about visiting this famous site. The caves and the messages became icons, and many of the barn signs are now being restored to preserve this important part of southern culture.

I remember a recent visit to the Civil Engineering Department at the University of Minnesota. It is housed in an underground building, constructed in 1983 for the twin purposes of demonstrating energy conservation and showing Americans how good an underground building could be. It received a handful of awards, including the "Outstanding Civil Engineering Achievement Award" of the American Society of Civil Engineers. It was relatively easy to build. The first three floors were dug out of glacial soil on top of a limestone formation. Shafts were drilled through the stone (about three stories deep), and earthmoving equipment gouged out two more floors from the sandstone beneath the limestone. During my visit, it was fascinating to see the building's energy saving features, and its unique design that seemed light, open, and airy. It was obvious that the students and faculty members were extremely proud of it.

Why am I relating these personal stories? *Because this book reminds all of us that "invisible" underground structures are part of the fabric of American life.* They have long been with us, and there are more of them around than most of us realize. The more than one hundred examples in this book illustrate this.

Loretta Hall provides an even-handed review of underground structures starting with the reasons they are built and venturing into the benefits and disadvantages of such structures. Separate chapters are devoted to topics like underground homes, businesses, public buildings, defense structures, and recreational facilities.

The book is chock full of fascinating facts and descriptions. It was easy for me to accept that there are at least 5,000 to 7,000 underground American homes, and that 40 U.S. schools are partially or totally underground. But, until I read this book, I had no idea that Kansas City was a hotbed of underground business activity. Former mines make up more than 10 percent of the local business/industrial space, where 4,000 people work underground for 400 businesses in 30 underground industrial parks.

You will also enjoy the examples, reading about topics like the secret Congressional hideaway buried beneath a wing of the famous Greenbrier Resort in West Virginia. This Cold War structure was built to allow Congress to function in case of a nuclear attack. The multi-story, 153-room complex was top secret for 30 years, completely unknown to the public. Portions of it were designed to blend into existing hotel activities, and were unrecognized in spite of the fact that millions of guests enjoyed the rich amenities of the "conference rooms" that were built to the dimensions needed for the Senate and House of Representatives.

This book is so thorough that at one point I decided to test it by searching for something about my golfing hobby. To my surprise, it was there! One case involved 16,000 square feet of underground living space 25 feet below ground near Las Vegas. It housed two residences and a simulated outdoor area with a personalized putting green. The author located a second example, a glow-in-the-dark miniature golf course in a 10,000 sq. ft. manmade cave at Laurel Caverns in western Pennsylvania. Yes, this book seems to cover everything.

One final item, you are going to love the chapter titles and paragraph headings. The author has a gift for causing chuckles while using them to capture the essence of a topic. It was easy for me to see that "Bookin' it Below" had something to do with underground libraries. And, the heading "Correct me if I'm Wrong, Mr. Wright" was so intriguing that I kept reading to learn how an underground jail was retrofitted into Frank Lloyd Wright's marvelous Marin County Civic Center complex.

The author is to be congratulated for the range and completeness of her research, and the enormous number of good examples. She has poured light onto the dark (ouch! sorry about that pun) by reminding us that invisible buildings are all around us.

Enjoy your tour of underground structures in this well written, interesting, and fun book.

DANIEL S. TURNER
PAST PRESIDENT, AMERICAN SOCIETY OF CIVIL ENGINEERS

INTRODUCTION

I first started thinking about underground buildings when I walked into the Centennial Science and Engineering Library at the University of New Mexico several years ago. This was a new experience. Above the building, only an array of skylights and a small, mostly glass room enclosing an elevator and a stairway obstructed the campus. This was interesting, I thought. I wondered if this was very unusual. Not really, I found out. Right next door is an underground physics laboratory and classroom building. Downtown, I discovered, a cluster of upscale shops takes up no visible space, snuggling under a large patio where office workers can enjoy an outdoor lunch. All of this in Albuquerque, New Mexico—not exactly the avant-garde capitol of the country. There must be more examples, I thought. But where? Why? How can we be sure they are safe? I embarked on a fascinating journey of research, which I invite you to share as you read this book.

After I read everything I could find about buildings constructed within the earth, I worked up the nerve to contact several pioneers of modern underground construction. Without exception, they were gracious and cooperative, happy to share their experience. "I used to say to people, twenty years ago, that when you stop hearing about these things [earth-covered buildings], it will mean they are no longer novel," Frank Moreland, one of the pioneers, told me. "Nationwide, these things are being built all over the place. They are no longer unusual enough to report on," he said. I decided to report on them.

It reminds me of a Bertrand Russell paradox. The fact that underground buildings are no longer noteworthy, is noteworthy.

Unusual as they are, underground buildings are surprisingly common. They can be found all over the world. Significant developments exist in Japan, China, Australia, Russia, and throughout Europe. In the United States, they represent a small percentage of the nearly 80 million public and private structures. Still, there are thousands of them. I'd be willing to bet that most people have experienced at least one, perhaps without even thinking about it.

Thinking about it, however, is part of the problem. The *idea* of entering an underground building is (usually) much more intimidating than the reality of doing it. In fact, many of these buildings are so skillfully designed that most people do not even realize that they are descending below the surface of the earth when they enter them. Yet, somehow, there is often a moment of panic when people think about going underground or suddenly realize that they're already there.

I invite you, in the following chapters, to experience more than 100 underground buildings in the United States and Canada. As you read about these examples, you will notice that pragmatic and aesthetic considerations vie for prominence. You will find impressive success stories and discouraging tales of failure. Some underground buildings are incredibly energy-efficient, for example, and others leaked so badly they were abandoned. You will see a vast style spectrum, ranging from stunning examples of hidden opulence to humble subterranean cubbyholes where unassuming people immerse themselves in nature's simplicity.

I am not a zealot proclaiming that I have found the answer to mankind's shelter problems. Overall, I am convinced that these buildings can be safe, practical, and attractive—despite the fact that I tend to be claustrophobic. But, I do not think underground buildings are always superior to aboveground structures. They may be more suitable in some places, for some purposes, for some reasons. The underground option should simply be given equal consideration in the planning process for any new building.

There are too many subterranean structures, even in this limited part of the world, to describe or even to identify. That is why this book is an introduction, not an encyclopedia. You may know of a great example that is not mentioned here. I hope this book will arouse your awareness enough to notice it. Perhaps you will even develop an attitude like that of a devoted bird watcher, ever alert for an unexpected encounter with a new manifestation. Drop by my web site at www.SubsurfaceBuildings.com, where I am building a database of the underground buildings of North America. If you find one that is not on my list, tell me about it by e-mail. While you're there, check the site for additional information and new developments.

In trying to answer the *how* and *why* questions about underground buildings, I have tried to explain design concepts and construction techniques in ways that are informative without being intimidating. This book is designed as a tour, not a treatise. I hope you find it interesting, informative, and fun.

PART I

UNDERGROUND ARCHITECTURE GROWS UP

1

OVERVIEW

LAYING THE GROUNDWORK

What is an *underground building*? The answer seems trivially obvious. In reality, however, defining the term is as tricky as explaining what a *skyscraper* is. Clearly, very tall buildings like the Empire State Building qualify as skyscrapers, but no definitive criterion, such as a height measurement or a number of floors, is universally accepted. T.J. Gottesdiener, a partner in Skidmore, Owings & Merrill, an architectural firm that has designed many skyscrapers including the Sears Tower, once quipped, "I don't think it is how many floors you have. I think it is attitude."

Similarly, the difficulty with defining *underground buildings* is not a quantitative one, but a qualitative one. What matters is not how much ground the building is under, but whether it is under any ground at all. Basements represent one aspect of the problem, for example. Is it fair to call a building's basement an underground structure? A simple basement, which is certainly *in ground*, has some characteristics in common with truly underground, earth-covered structures, but it also has a noticeably different character.

A complicating fact is that some basements are more underground than others. An interesting example is the Civil and Mineral Engineering Building constructed at the University of Minnesota in 1982. Like a tail wagging the dog, this building is a mega-basement with a subordinate surface structure. In fact, five basement levels contain 95 percent of its 150,000 square feet of floor space. Besides containing laboratories, classrooms, and offices, the building itself is an experiment in underground construction and use.

Confusion also arises with regard to *earth-sheltered* structures, which are typically built with their main floors at ground level or only slightly below. They achieve some of the benefits of underground construction by having dirt piled up against their walls in sloping embankments called *berms*. Sometimes, but not always, a layer of soil and vegetation covers their roofs. The varieties and degrees of earth sheltering include such extremes as buildings with soil on their roofs but no berming on their walls, and conventionally roofed buildings with berming only a few feet deep on a wall or two. Fully earth-covered, above-grade structures should probably be included in the category of underground buildings, but where along the progression to the minimal limits of earth sheltering should the line be drawn?

In seeking to resolve the definition dilemma, it may be instructive to look for examples of wise people who have grappled with similar difficulties. U.S. Supreme Court Justice Potter Stewart, writing a 1964 opinion relating to obscenity, faced the task of what he called "trying to define what may be indefinable." Rather than offering a clear, comprehensive definition, he simply asserted, "I know it when I see it."

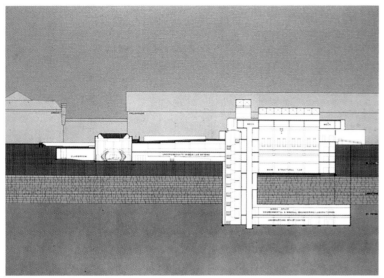

Compared to nearby buildings (shown in gold), the Civil and Mineral Engineering building is relatively inconspicuous above ground. Below ground, its basements extend 112 feet deep and sprawl out beneath a terraced lawn. Courtesy of David J. Bennett, FAIA

Perhaps that is the best that can be said of underground buildings as well. Some of the examples explored in this book are more, or less, underground than others, but they have an underground *attitude*. All of them enjoy at least some of the benefits of underground construction. There is, after all, no point in constructing underground buildings unless they offer advantages over more conventional aboveground structures.

As explained in this chapter, the advantages are numerous and diverse. We begin by looking at the interiors of buildings and the benefits that affect their occupants. Then we look at the surrounding environment and benefits that affect individual passersby and society at large. Finally, we consider how underground placement affects the structure itself.

INTERIOR MOTIVES

DUCK AND COVER

Aside from a few isolated experiments with underground construction, the first groundswell of interest in subterranean structures came as a result of the Cold War. The world spent one-third of its time between 1914 and 1945 embroiled in widespread, devastating wars. The culmination of that period of conflict was the horrific destruction of two Japanese cities by atomic bombs. Following World War II, a clear demarcation developed. The United States and the Soviet Union, each backed by numerous allies, faced each other across an irreconcilable barrier of competing political philosophies. In an escalating arms race, each superpower amassed more numerous and more powerful nuclear weapons.

To ensure the survival of military and civilian leaders, governments built underground shelters that were hardened to withstand powerful explosions and the intrusion of radioactive fallout. Companies, inspired by their own

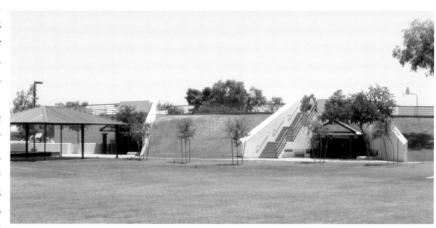

Ann Ott Elementary School in Phoenix, Arizona, sits half a story below ground. Earth berms protect its walls, and a thick concrete roof shields the interior from summer heat and aircraft noise from nearby Sky Harbor Airport.

survival instincts and the need to perpetuate the economic viability of their society, constructed underground refuges for essential documents and key personnel. Individual citizens, driven by a desire to protect their families from the quick death of an atomic explosion or the slow death

of lingering nuclear radiation fallout, built bomb shelters in their back yards. Some, seeking comfortable living conditions while anticipating or enduring the potential disaster, embellished their shelters into actual homes. Thus, the first wave of modern underground construction in North America began, spurred by the need for military and civil defense.

PROTECTION RACKET

Even in peacetime, underground facilities are used to protect important information, essential equipment, and valuables. Their extraordinarily thick shells and limited number of access points deter theft, sabotage, and accidental damage. Many businesses, for example, store paper documents and electronic data files in secure warehouses located in former mines or recycled Cold War shelters. Companies that rely on the continuous operation of valuable, sensitive computers enclose them in state-of-the-art underground buildings. Irreplaceable film archives are secured in climate-controlled, underground vaults. Elementary schools in neighborhoods near busy airports escape aircraft noise by moving underground. Manufacturers of high-precision products eliminate wind- or traffic-induced vibration of their equipment by placing their factories inside bedrock.

Some underground facilities are built to protect people and spaces on the outside from what is contained inside. At Yucca Mountain, Nevada, a cavern created within a stone mountain will shield the environment from the radioactive waste stored inside it. Underground jails and prisons enjoy excellent escape records. No stray bullets escape a subterranean firing range, and neither does the noise.

Like many of the other direct benefits of underground structures, enhanced security often produces an economic bonus. For example, at Sandia National Laboratories in Albuquerque, New Mexico, a small nuclear reactor used for research was housed in a surface building. Even within a highly secure section of Kirtland Air Force Base, the cost of guarding the reactor and its uranium supplies proved excessive. The $10 million annual security expense dwarfed the $2 million cost of operating the reactor. In 2000, the reactor was shut down and its fuel moved to a secure storage vault while plans were finalized for construction of a 10,000-square-foot underground building to house the reactor. Security costs at the subsurface facility were projected to decrease by half, producing enough savings to recover the cost of the new building within six years.

LOW ON ENERGY

Underground buildings are cool. They are also warm. Their advantage over aboveground buildings is that they are cool in the summer and warm in the winter. The explanation is less intuitive and more technical than you might expect. The advantage comes, not from the earth's effectiveness as insula-

Space Center Executive Park leases office, warehouse, and manufacturing space in a former limestone mine near Kansas City. This attractive atrium serves as one of nine ventilation shafts. Fans circulate 1 million cubic feet of air per minute through the 5-million-square-foot industrial park. Courtesy of Space Center Kansas City, Inc.

GOING UNDERGROUND THE WRIGHT WAY

Feet crunching across the gravelly desert on a sunny July afternoon sounds almost like the sizzle of a frying pan. There is a spot of shade ahead, where a patio between two buildings is covered by a roof that links one structure to the other. Anticipating a little relief from the heat, you step into the shade, where you are pleasantly surprised by an unexpected cool breeze. Here in the midst of Taliesin West, the Arizona campus of Frank Lloyd Wright's architectural school, there is comfort as well as beauty.

Skillfully funneling air through passageways and windows to increase its speed was one way Wright produced a natural cooling effect in this arid environment. Decorative pools and modest fountains cool the air through evaporation. One building, the Cabaret Theater, is recessed halfway into the ground to take advantage of cooler subsurface temperatures.

Wright manipulated air flow and shielded buildings with earth in other climate zones, too. One example, built in Madison, Wisconsin, in 1948, is known as the Solar Hemicycle. Because it was the second house Wright designed for Herbert Jacobs, it is sometimes called Jacobs II. The stone house is shaped like one-third of a circle. The inner arc-shaped wall is a 48-foot-long, 14-foot-high bank of windows flanked by stone wall sections at the ends. It faces south for passive solar heating. The curvature of the wall defines a circular garden area in front of the house. The garden is recessed 4 feet below the building's floor level, which itself is 1½ feet below the surrounding land.

The rear, outer arc-shaped wall of the house is bermed to the bottom of a 1-foot-high row of windows just under the roof. Bill Taylor, a subsequent owner who meticulously rebuilt the neglected house during the 1980s, estimates that the berm saves only about 20 percent of the structure's energy loss. It does serve another purpose, however. Wright designed it to act as an airfoil. In his book *Building with Frank Lloyd Wright*, Herbert Jacobs retold the architect's explanation: "The sunken garden in front of the hemicycle acts to form a ball of dead air, and the long slope of dirt against the back wall is necessary so that the wind will blow over the house instead of against it. When it is finished, you can stand on your front terrace in a strong wind and light your pipe without any trouble. With little wind blowing against [the house] . . . your heating costs will be very low."

tion, but from something called the *thermal flywheel effect*. The earth's atmosphere reacts quickly to temperature fluctuations, whether they are caused by the daily solar cycle or the movement of a cold front. The solid matter of the earth—the soil and rock masses—react much more slowly. In fact, by the time the temperature effect of winter or summer weather works its way several feet down through the ground, the seasons are changing. Winter's coolness reaches an underground building during the summer, and summer warmth arrives in the winter.

At roughly the depth of a one-story underground building, the surrounding soil temperature hovers near the local yearly average air temperature. As a result, summer temperatures inside the structure are cool enough to reduce or eliminate the need for air conditioning. Depending on the local climate, indoor winter temperatures in underground buildings tend to stabilize between 60°F and 70°F. Warmth generated by electrical appliances such as lights and computers, by activities such as cooking and bathing, and even by the occupants' body heat are often sufficient to compensate for the natural coolness. The amount of heating and cooling energy saved in underground buildings varies depending on several factors, including climate, structural design, and use (e.g., manufacturing or office work). Generally, building below the surface produces energy savings ranging from 50 to 80 percent. Considering that buildings consume about one-third of all the energy used in the United States, including nearly two-thirds of the nation's electricity production, subsurface structures offer enormous potential for energy conservation.

Reducing energy consumption creates several important ramifications. Monthly energy bills are lower. Reduced heating and cooling demands mean lower-capacity (i.e., less-expensive) equipment can be installed initially. Using less energy conserves essential natural resources. The consequences of power outages are buffered, regardless of whether they are caused

by storms, malicious intervention, or simple mechanical failure. For instance, some wholesale distributors store frozen foods in enormous underground warehouses located inside former limestone mines. After initially being cooled for two years, these environments can withstand months-long power or equipment failures without significant warming.

All of those ramifications are important. However, the one that gave the greatest impetus to underground building development in the United States was the nation's reliance on foreign sources of oil. Beginning in October 1973, Arab oil-producing nations refused to sell crude oil to the United States because of its support of Israel. The embargo lasted only five months, but it generated a sense of vulnerability that lasted much longer. Fears of energy shortages and escalating prices triggered a new surge of interest in underground housing.

COMFORT AND SAFETY

Protection from the elements can do more than preserve natural resources and reduce monthly bills. It can also keep people comfortable. The Canadian metropolises of Toronto and Montreal are notorious for their bitterly cold winters. In both cities, each day, hundreds of thousands of people work, shop, dine, and commute without worrying about wind, temperature, or precipitation. Miles of underground shopping malls and pedestrian walkways provide protected access between downtown buildings and subway stations. Occasionally, news media report human-interest stories about people who have not ventured outdoors for a month or more. Similar, though smaller, subterranean systems can be found in major cities throughout the United States.

Underground buildings protect people and their possessions from natural disasters. A 1979 survey of the owners of earth-sheltered homes in tornado-prone Oklahoma found that storm protection ranked only marginally below heating and cooling demands as their primary motivation. At about that same time, the Oklahoma Department of Education surveyed the state's forty-two earth-sheltered schools and found storm protection among the most frequently reported advantages.

Thanks to *The Wizard of Oz* movie, it is easy to visualize Dorothy and Toto heading for a storm cellar as a violent storm approaches. But how safe would an underground building be during an earthquake? In August 1989, *USA Today* interviewed Ta-liang Teng, a University of Southern California seismology researcher, and reported that "during a major earthquake, an underground refuge is likely to be safer than anywhere on the surface." The researcher's study found that "'strong ground motion' rapidly decreases with depth." During San Francisco's devastating Loma Prieta Earthquake of October 1989, freeway bridges over land and water collapsed, but the subway system was deemed safe and returned to service within hours. Displaced and injured people were sheltered at the Moscone Center, an underground convention center in downtown San Francisco. The city's earthquake preparedness plan continues to designate the convention center as an official mass shelter and care facility. Furthermore, depending on needs arising because of surface damage, Moscone Center is also the alternate site for the mayor's office and for the Red Cross Emergency Operations Center.

EXTERIOR MOTIVES

EASY ON THE EYES

If John Donne had been an architect, he might have written "No building is an island." Every new structure is inserted into a visual context consisting of natural scenery and other buildings. Placing a building underground is an effective way of creating new space with minimal disruption to the appearance of the landscape or visually important structures.

• In 1967, the University of Illinois needed a new library for its Urbana campus. The only affordable, conveniently located site was adjacent to an agricultural research field. Erecting a building on the site would have cast a shadow on part of the field, altering meticulously documented experimental conditions that had remained constant for nearly a century. Instead, the two-story building was constructed below a landscaped plaza.

• Visitor centers placed below ground do not distract from the sites they serve. Examples range from the Valley Forge National Historical Park near Philadelphia, Pennsylvania, to the Anza-Borrego Desert State Park near San Diego, California.

• Familiar facades remain essentially unchanged when necessary expansions are hidden within the earth. For instance, plans for additions to the White House, including meeting rooms, storage spaces, and press and media facilities, call for placing them under adjacent streets.

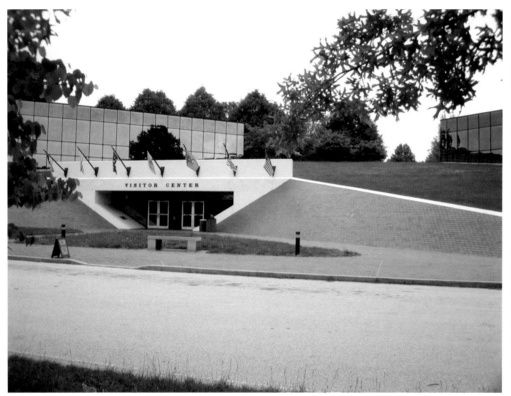

The visitor center at Valley Forge near Philadelphia, Pennsylvania, nestles unobtrusively in a hill near the historic battlefield. Sculptural skylights above the ground signal the building's presence and introduce daylight and a sense of spaciousness to the interior.

WIDE OPEN SPACES

Pockets of green space are essential elements in making cities more livable. The need for more built space in densely developed urban areas can sometimes be met by inserting new buildings under existing parks or plazas. For example, in 1992, historic but neglected Bryant Park was rebuilt and revitalized when a two-story addition to the New York (City) Public Library's main branch was constructed underneath the park. The 120,000-square-foot expansion, which is used as a closed stack area, contains 85 miles of high-density shelving that holds 500,000 microfilm reels and more than 3 million books, but it is virtually invisible beneath a lawn in the center of the park. By placing the library's new space out of sight and renovating the park above it, the city transformed a dangerous area dubbed "needle park" into an attractive community amenity. "The park . . . has spurred a rejuvenation of commercial activity along Sixth Avenue. Rents in the area are climbing and office space is hard to come by," reports *Economic Benefits of Parks and Open Space,* a 1999 publication of the Trust for Public Land.

Building an underground addition to the Metro Toronto (Ontario, Canada) Convention Centre in 1997 did more than rehabilitate a run-down plaza. It created new green space for the city by converting a former railroad switching yard into a 17-acre park located on the new addition's roof. The city insisted that creation of a park be included in the project, seeing it as

an essential element in making the shore of Lake Ontario accessible and appealing to downtown visitors, workers, and residents. For 150 years, the lake front had been an industrial area isolated from downtown by the railroad. The convention center addition spans the tracks in two ways. Extending southward from the existing convention center, it tunnels 210 feet under the tracks and beyond, with most of its 1.1 million square feet of space sprawling under a park on the opposite side. In addition, a glass-enclosed pedestrian bridge connects Railway Lands Park with the surface level of the original, aboveground convention center.

LAND SAKES!

Deciding whether to place a building or an urban park on a piece of land is one thing. It is quite another to figure out how to shoehorn a new building into an area where all the suitable land is already developed. In a densely built urban area, available parcels may be priced unattractively high, or there may not be any vacant land at all. Land scarcity can be particularly important when an existing building's tenant needs to expand its operational space.

In 1998, Planet Hollywood planned to open a Sound Republic music club in the basement of the Paramount Building in New York's Times Square. Because the basement was too shallow for the desired use, it had to be expanded downward. The relatively easy part was digging down 5 feet around the perimeter of what would become the dance floor area and excavating 9 feet further down to provide for the dance area itself. In a technologically tricky operation, contractors had to construct temporary supports for the twenty-two-story build-

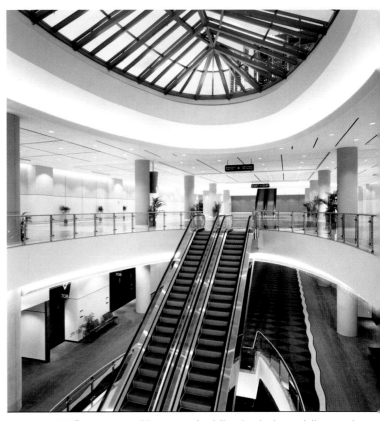

Bregman + Hamann Architects designed the main lobby of the underground portion of the Metro Toronto Convention Centre to be bright and spacious. Daylight pouring in through the multi-faceted skylight falls in geometric patterns on the upper level's polished granite floor. Coordinated color schemes and a broad opening around the escalators extend the roomy lobby to both levels of the building. Courtesy of B+H Architects

ing while they extended nine structural support columns downward. They also removed three support columns from the central area. To ensure adequate support for the building, they installed steel beams to transfer loads to nearby columns before demolishing the unwanted pillars. After sinking $13 million into the deepening hole, financially strapped Planet Hollywood ran out of funds for the project and never quite completed it. A year later, the World Wrestling Federation (now World Wrestling Entertainment) paid $9 million for the space and outfitted it as a restaurant and night club.

Such examples are not unusual. New construction at New York City's Carnegie Hall also illustrates the problem and an increasingly popular solution. It is widely reported that Peter Tchaikovsky conducted the inaugural performance at Carnegie Hall's concert hall in May 1891. However, public performances actually began at Carnegie Hall earlier that year, before the main auditorium was finished. These concerts were presented in an underground chamber music hall, one floor below the larger, ultimately more famous, auditorium. In 1997, after decades of being leased out for use as a movie theater, Carnegie Hall reclaimed the underground space to house a new intermediate-size concert auditorium. Two years later, construction of the state-of-the-art auditorium and its support spaces began. To accommodate the flexible-

configuration theater, it was necessary to deepen the basement under the historic, eight-story building by 12–30 feet. Nearly 7,000 cubic yards of bedrock were broken loose with explosives, hydraulic hammers, and chemical expansion agents. Construction equipment and rubble were transported in and out of the basement through a 9-by-12-foot doorway and raised through a sidewalk opening. Some columns supporting the century-old, unreinforced masonry structure overhead were removed, and others were extended 16 feet down to the new foundation level. The result, the Judy and Arthur Zankel Hall, is a three-story underground facility containing a 650-seat theater with two levels of seating and an orchestra pit. The external appearance of Carnegie Hall is virtually unchanged.

Sometimes, vacant land is available but is not suitable as a building site. It is generally impractical, for example, to erect a building on a steep slope. Underground buildings offer a practical solution. In his 1996 book *Geo-Space Urban Design*, Gideon Golany explained how structures can be constructed on slopes as great as 85 degrees by terracing the slope and inserting the buildings horizontally into the hillside. A professor of urban planning at Penn State and recipient of several Fulbright research scholarships, Golany had studied the use of underground buildings in Israel, China, and Japan. "Like any other pioneering idea, geo-space urban design will require time for adjustment and application," he wrote. "Yet, the growing

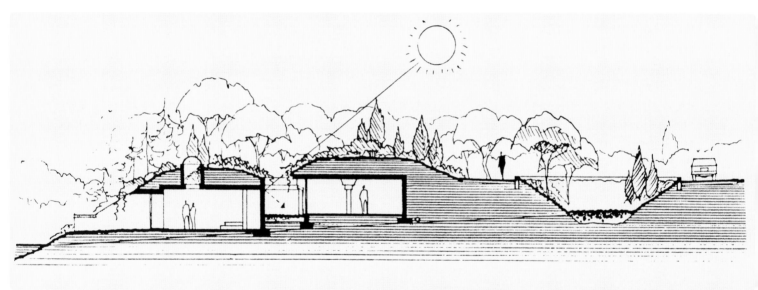

Building his Cherry Hills office as two structures did more than give Malcolm Wells and his staff separate spaces. It created a recessed courtyard for conventional at-grade entrances. The white wall of the southern building reflects sunlight into the windows of the northern office. Courtesy of Malcolm Wells, Architect

complications facing our expanded cities will soon bring to light the necessity for visionary solutions to very real problems."

In 1971, Malcolm Wells chose an unsuitable building site for his new architectural office in Cherry Hill, New Jersey. Economically priced because of its size and location, the 60-by-90-foot plot presented an ideal challenge for the outspoken advocate of underground construction. "Used by the state highway department as a storage yard for various paving materials, it had very little going for it," Wells wrote in *An Architect's Sketchbook of Underground Buildings*. "On one side was a six-lane freeway; on another a badly polluted stream." He dug down, erected a pair of small buildings, covered them with soil, and let natural vegetation

gradually envelop them. In 1978, he told the *AIA [American Institute of Architects] Journal*, "Now, when we tell our clients how to find choice building sites, we always urge them to pick the *worst* ones . . . to restore a bit of the trampled continent."

THE ROOT OF THE PROBLEM

Although he ascribes many benefits to underground buildings, Malcolm Wells is most passionate about their ability to enhance the natural environment. He described standard architecture as "the practice of building dead boxes on living land" in a 1994 article in the environmental journal *Earthword*. Wells went on to explain, "If all life depends on the survival of green plants, if green plants can live nowhere but on the surface of the earth, if buildings and paved areas are destroying that garden, then we'd better build below that miraculous mantle."

Nestling buildings inside the landscape allows rain to nourish plants and replenish groundwater reserves rather than flowing down sewers. Vegetation-covered buildings support an ecosystem of plants and animals that is visually appealing and environmentally healthy. Since 1988, Wells has worked in an underground art gallery he built on Cape Cod. "Only one building type leaves a green 'footprint' on the land," he wrote in *DESIGNER/ Builder* in April 2000. "It attracts and harbors wildlife. It can actually restore eroded, worn-out land. Conventional buildings destroy land during construction—as does an underground construction—but [conventional buildings] can never bring the land back to life [as can underground buildings]."

Natural terrain is often not level. Malcolm Wells used his Underground Art Gallery to redefine a steep slope into an attractive and functional space.

Courtesy of Malcolm Wells, Architect

SHELL GAME

COVER CHARGE

It took seven years to build Bill Gates' estate on a lake shore near Seattle, Washington. In 1999, two years after construction was finished, King County assessed the estate at nearly $110 million. The compound contains more than 40,000 square feet of living space for Gates' family and guests. Accompanying structures, like a thirty-car garage that converts into an enclosed basketball court, bring the total built space to about 66,000 square feet. A significant portion of the complex, including that garage, is underground. Recessing much of the buildings' bulk into the hillside makes the site look more like a forest and less like a cluster of multistory structures. It also provides some measure of privacy from curious occupants of passing boats and planes. Gates paid for elaborate electronic features, top-quality construction materials, and extensive landscaping. He also paid to make some structures strong enough to

support earth covers, to waterproof subgrade surfaces, and to install tiebacks to bond the underground walls with the surrounding soil to create a stable, earthquake-resistant mass. Cost was not his primary concern.

In general, however, builders must carefully consider how certain desired features will affect the cost of a proposed structure. When an underground option is being considered, whether for quantifiable reasons like energy cost savings or for unmeasurable qualities like privacy, construction expenses must be considered. Does an underground building cost more than a comparable aboveground structure? The answer depends on several factors. Excavation, backfilling, and reconstruction of the landscape generally increase the cost of construction. Building the structure strong enough to support the earth cover, perhaps including shrubs and trees, often adds to the cost. Particularly when part of the building will lie below the water table, drainage and waterproofing treatments may be expensive. In general, many builders estimate that placing a building underground adds roughly 10 percent to its cost.

In some cases, building underground is actually cheaper than surface construction. For example, Mutual of Omaha estimated it saved $5 million (in 1979 dollars) by placing a three-story addition to its international headquarters underground, where it did not have to be faced with expensive stone to match the existing structures. Building the Walker Community Library underground, stacking the parking lot and badly needed open space on the roof, saved the city of Minneapolis $125,000 in land acquisition costs in 1980, even accounting for the building's increased structural requirements.

PAY NOW, OR PAY LATER

Even when building underground costs more initially, it may still may be cost-effective. This can be determined through a life-cycle cost analysis that takes into account the economic benefits that will accumulate during the useful life of the building. The most obvious savings is in energy consumption, which will almost certainly cost less than half of what it would in a surface building. Primarily because of their fire-resistant construction materials, many underground buildings merit reduced insurance premiums. Initial, and perhaps replacement, costs of HVAC (heating, ventilating, and air conditioning) equipment are significantly lower because of the earth cover's ability to stabilize temperatures and shield the building from wind-driven air intrusion.

Building maintenance is another significant area of reduced expense for underground buildings. The exterior of the structure is shielded from the sun's ultraviolet abuse and from stressful freeze-thaw cycles. Roofs are not exposed to wind, rain, or ice. Because of its largely inaccessible exterior, an underground building is less vulnerable to vandalism and the associated repair costs. During the 1970s, the city of Santa Ana, California, built three elementary schools, the main structures of which were mostly underground. The lower incidence of vandalism enabled the city to trim its payroll by three employees.

John E. Williams presented an analysis comparing life-cycle costs for typical underground and aboveground structures in *Alternatives in Energy Conservation: The Use of Earth Covered Buildings*, a 1975 report sponsored by the National Science Foundation. He concluded that for the first five years of a building's existence, the total cost of an underground building exceeded that of an aboveground structure. After that, however, the costs for aboveground buildings accumulated significantly faster than for earth-covered buildings. After thirty years, the total costs for surface buildings averaged four times their initial construction cost, but for subsurface buildings, the average was only three times the initial cost.

Expenses are one component that affects total life-cycle costs. Another crucial factor is the estimated length of the building's useful life. The design life of surface structures varies, depending on the objectives of the owners who build them. Certain types of commercial buildings are expected to serve only a decade or two before being discarded or rebuilt. At the other end of the spectrum, important buildings may be designed for 100 years of use. With proper maintenance and repair, they may last even longer.

How long can an underground building reasonably be expected to last? Estimates vary widely. Frank Moreland, an architect and engineer with an interest in earth-covered concrete structures, had to wrestle with that issue while preparing a 1981 report for the Federal Emergency Management Agency. A life-cycle cost analysis was required in the report, *Earth-Covered Buildings: An Exploratory Analysis for Hazard and Energy Performance*. Moreland tells of one concrete expert who insisted such buildings would last "forever." Other experts, including engineers and property appraisers, offered estimates ranging from 2,000 to 5,000 years. "For the equations, we were more modest than that," Moreland says, "and we used 300 years. With that, we showed that nothing [aboveground] competes."

OUTLIERS

Oklahoma and Texas were particularly well represented in the first modern wave of underground construction. Living in the hearts of Tornado Alley and the Bible Belt, their citizens pragmatically embraced both the storm protection and the fallout shelter benefits underground construction offered. Several other states had similar concentrations of earth-sheltered homes, but Oklahoma and Texas had more community-oriented subsurface structures. In particular, by 1980, Oklahoma boasted twenty-five school buildings that were either completely or partially underground, representing more than half of the country's total. Texas was host to six of approximately twenty-seven earth-sheltered business buildings in the United States. Perhaps it was that level of visibility that attracted the attention of two teams of researchers.

According to a 1979 Oklahoma State University survey, the owners of earth-sheltered homes in Oklahoma reported that the most important factors in their choice of building type were reduced heating and cooling demands, increased storm protection, and reduced maintenance needs. Factors grouped around the middle of the importance scale included reduced insurance costs, enhanced security from crime and vandalism, increased personal privacy, and reduced noise. Five years later, another study of owners of earth-sheltered houses in Texas and Oklahoma yielded similar results. In each case, however, some homeowners expressed uncommon motivations that departed from the main categories. A Texas Tech University research team concluded its discussion of the reasons people chose to live in earth-sheltered houses with the comment, "Several respondents said they just wanted to do something different."

DEEP THOUGHTS OF ED PEDEN

Ed Peden's way of doing something different was to locate his business and his home in a decommissioned intercontinental ballistic missile bunker near Topeka, Kansas. One of the early missile base types, the Atlas-E installation housed its nuclear missile horizontally in a rectangular bunker. To prepare for launch, the top of the bunker slid open, and the missile was rotated to a vertical position. The 90-by-40-foot missile chamber now serves as a hangar for the ultralight aircraft Peden builds. His factory is in an adjacent underground chamber that originally housed the operations and maintenance equipment for the missile.

The Peden family's four-bedroom home is 120 feet away from the factory building, down a corrugated steel-lined tunnel, in what was once the launch operations center. The living room is a spacious expanse with a 15-foot-high ceiling. A skylight provides sunshine and a view of the sky near one end of the room, where an equipment hatch once operated. The rest of the 2,800-square-foot house has been partitioned into a two-story configuration. Accented with wood walls and balcony railings, the interior of the house seems remarkably conventional.

Peden is a self-described "eccentric," but some of his reasons for moving into the bunker are conventional. Energy conservation, not surprisingly, is one. An attractive purchase price is another—he bought the 33-acre parcel, including the underground structures, for $40,000 in 1984. Included in the deal was a landing strip, an ideal accessory for an aircraft builder. Then there is security. "I consider myself the fourth pig," he told *Airman* magazine in July 1997. "Nobody is going to huff and puff and blow this place down. We're not too worried about burglars either—there are easier places to break into."

It took Peden $100,000 to complete the work on this ultimate fixer-upper. Built in 1961, the Atlas-E site served only four years before being retired with the advent of the next generation of missile silos. For the next twenty years, it deteriorated through exposure to natural forces and curiosity seekers. By the time Peden first saw the site, it was virtually an underground swimming pool, where accumulated rain water stood 8 feet deep. Despite the damage, he was intrigued with the unique facility's potential.

As a former high school history and current events teacher, Peden sees the country's retired missile silos as a special resource. Rehabilitating them not only serves the functional needs of their new occupants, but it preserves a certain amount of Cold War history. After completing work on his own home and factory complex, he embarked on an additional business venture, brokering sales of former defense installations, including bunkers and missile silos. During its first seven years, his firm, Twentieth Century Castles, sold twenty-seven such properties for purposes as diverse as coil spring manufacturing and laboratory rat breeding.

Numerous light fixtures and a 6-by-10-foot skylight above the spiral staircase brighten the Pedens' living room. Under the bedroom-level deck, a mirrored wall reflects light and creates an illusion of extended space. Courtesy of Twentieth Century Castles

SECLUSION IN THE CITY

Philip Johnson was the first recipient of the Pritzker Prize, architecture's equivalent of a Nobel Prize. As a consummate architect, he balances the technical skill to design serviceable buildings with the artistic inspiration to make them appealing. Johnson has designed grand skyscrapers, striking surface structures, and, in the early 1960s, a few earth-covered buildings. A classic example is a residence that was completed in 1965 in suburban Cincinnati, Ohio. "This house may be the first earth-covered dwelling of the post-war period that was designed purely on its own merit, and not as a response to the cold war or other 'external' reasons for building below the surface," architect John Carmody wrote in the 1985 book *Earth Sheltered*

Housing Design. "It predates our current conservation interest in underground structures, and represents instead an exploitation of the earth as an element of architectural form."

When the James Geier family asked Johnson to design a house for them, the architect first studied the site. The home was to be built on the shore of a small lake that was surrounded by a flat, treeless meadow. Johnson, who loved the beauty of nature, was reluctant to disturb the clearing by imposing an artificial structure on it. Instead, he decided to enhance the natural landscape by creating several small hills and hiding most of the house within them.

The side of the house that faces away from the lake is nearly invisible to an approaching visitor. Walking down a path that meanders between two grassy mounds reveals a simple but elegant stone and glass facade that fills the narrow valley. The glass front door and a transparent foyer wall beyond it reveal a glimpse of the lake. On either side of the foyer, the house disappears into the earthen mounds. The only manmade objects that rise above the hilltops are several weathered steel cylinders scattered across the house roof, hiding chimneys and vent pipes. On the lake side, the home is built literally at the water's edge. In fact, the house wraps around three sides of a pond connected to the lake by a narrow channel between the two hills that contain the living room and bedroom wings of the house.

Johnson's reasons for designing this nearly invisible house went beyond simple view preservation. They even went beyond view enhancement through contouring of the land. Johnson explained his reasoning in a November 1978 *AIA Journal* article: "The Geiers had ponies at that time, and they could graze on the roof. The dwelling affords complete privacy from the main road, and with the water coming onto the house as it does, you have the feeling of being on an island away from the world, although you're in the middle of suburbia." In short, Johnson said, he nestled the house in the landscape for "romantic reasons."

HEAVY SECURITY

A vault 80 feet below the surface of lower Manhattan, New York, serves as one of the world's most exclusive warehouses. Stacks of gold ingots, nearly all belonging to foreign governments or international organizations, constitute one-fourth of the world's reserves of official monetary gold. Although shipments occasionally transfer gold in or out of the facility, most of the activity in the vault involves moving the valuable bricks from one room to another as their owners buy, sell, or lend them. The most obvious advantage the subterranean location offers is security.

The vault was built in 1924 as the first step of constructing the Federal Reserve Bank of New York. The structure served the world economic community by providing a physically secure storage and transaction facility in a centrally located, politically stable place. Designed with security in mind, the massive, reinforced concrete vault is accessible only by a restricted-access elevator controlled remotely by an operator in a separate secure location. Between the elevator and the vault stands a formidable door. Blocking access to the vault's main corridor is a 10-foot-diameter steel cylinder partly visible through a door-sized gap in a wall. When several people activate combination locks in conjunction with automatically controlled time locks, an attendant is able to turn a control wheel that rotates the cylinder 90 degrees. This action reveals a passageway through the cylinder's center and aligns it with the wall's doorway.

Inside the vault are 125 rooms of varying sizes, each assigned to a depositor or serving as a "library" compartment where bullion belonging to several smaller depositors share space. A large compartment can accommodate a stack of gold bars 10 feet wide, 10 feet high, and 18 feet deep.

The steel cylinder in the vault door weighs 90 tons. Its steel and concrete frame weighs 140 tons. The gold inside the vault weighs 9,000 tons, although in the past it has amounted to as much as 13,000 tons. Try building a floor that can support that kind of load. Or, like the builders of this vault, carve a chamber out of bedrock and let nature supply a floor that can support unlimited loads.

2.

UNDERVIEW

If asked to name a skyscraper, most people could quickly list several. Skyscrapers are, after all, obvious buildings, purposely designed to attract attention. Sometimes governments build them as beacons for tourism and economic development. Malaysia's Petronas Twin Towers and New York's ill-fated World Trade Center are the most obvious examples. During much of the twentieth century, companies commonly erected signature buildings as symbols of their success. New York's Chrysler Building, Chicago's Sears Tower, and San Francisco's TransAmerica Pyramid illustrate this phenomenon.

If asked to name an underground building, most people would probably be stumped. Given time to think about it, they might come up with one or two. Underground buildings have an inherent image problem: They don't have much visibility. Very few companies have made a nearly invisible building into a recognizable corporate symbol.

Besides having a low profile in the visual sense, underground buildings present certain challenges to their designers. The issues may be different from the aerodynamic and structural details crucial to tall buildings, but effective subterranean design is certainly achievable. These design issues fall into two broad categories: those related to human perceptions and emotions, and those imposed by nature. This chapter explores the downside of building downward, looking first at the psychological aspects and then at natural forces, which are grouped into their traditional categories of earth, air, fire, and water.

GROUNDLESS FEARS

The first problem with underground buildings is that they are underground. *Underground.* Think of going there, and you might feel an urge to take a deep breath while air is still available. To dodge the bats and watch out for spiders. To bundle up against the cold dampness and make sure you have a flashlight handy. To block from your mind the word *buried.*

In an effort to defuse this negative preconception, proponents of underground buildings have expended considerable effort in a transparent public relations maneuver. "More than fifty different terms have appeared in the international literature describing earth-covered architecture," Australian architect Sydney Baggs wrote in the July 1985 issue of *Geotecture.* Those terms include gentle evasions like *earth sheltered, earth coupled,* and *earth integrated* as well as concoctions like *geotecture* and *terratecture.* Buildings are constructed *below the existing sight lines* rather than *below ground.* Nobody is fooled. The buildings are still underground, and if they are well designed and well built, people will accept their location.

Since the 1970s, architects, developers, and psychologists have cooperated on research aimed at understanding how to make underground buildings more acceptable and appealing. Study results have been mixed because of a variety of factors, including small sample sizes, unconscious bias in study design, and comparison of otherwise dissimilar underground and aboveground facilities. Some surveys show remarkable satisfaction with underground work environments (e.g., 62 percent in a 1984 study sponsored by the Underground Developers Association). Others show remarkable dissatisfaction (e.g., higher rates of anxiety, depression, and hostility among underground office workers according to a 1980 study by psychology professors Steven Hollon and Philip Kendall).

However, several relatively recent research papers suggest that the acceptability of underground buildings depends more on experience and design features than on an inherent subterranean character. John Carmody, who was associate director of the Underground Space Center at the University of Minnesota when he coauthored the 1993 revision of *Underground Space Design*, summarized several psychological studies conducted in Japan. Carmody reported that three papers published in 1990 announced the following results:

• Japanese and American attitudes toward underground buildings are generally similar.

• Subterranean work locations were viewed as acceptable by 60 to 85 percent of office workers who already worked underground but by only 25 percent of people who had never worked in such an environment.

• Dissatisfied workers in deficient underground environments were willing to accept an improvement in conditions (e.g., introduction of sunlight, addition of greenery, improvement of air circulation) as an alternative to moving to an aboveground setting.

An American study by environmental psychologist Judith Heerwagen confirms that the quality of a work environment is more important than the fact that it is underground. In the mid-1990s, Pacific Northwest National Laboratory renovated its underground analytical chemistry laboratory building in Richland, Washington. The building had been plagued with a yearly employee turnover rate of 63 percent and an annual absenteeism rate of 96 hours per person. The renovation included improving the ventilation system, installing better-quality lighting, adding interior windows in the office spaces, and lining a main corridor wall with backlit glass bricks. Heerwagen found that the turnover rate plummeted to 4 percent the following year, and the absenteeism rate decreased by half.

The 90-foot-diameter domed skylight over an underground addition to the Mutual of Omaha headquarters building has become an unusual signature image for the international insurance company. Courtesy of Mutual of Omaha

Within six months, these factors generated enough cost savings to pay for the renovation. Interestingly, Heerwagen says that opponents of the project filed a lawsuit (which they eventually dropped) complaining that the renovation was "better than a government space needed to be."

INTERNAL CONFLICTS

One type of psychological resistance to underground buildings focuses on personal emotions. Certain design strategies can increase the appeal of subsurface structures and decrease perceptions of danger or discomfort that might accompany the thought of descending into the earth.

The entrance to an underground building is a crucial design element, for example. Architects often create horizontal entries to submerged buildings to make the structure seem more conventional. One technique for doing this is to slope the ground downward toward the building. This allows people to descend the equivalent of one story while in an expansive,

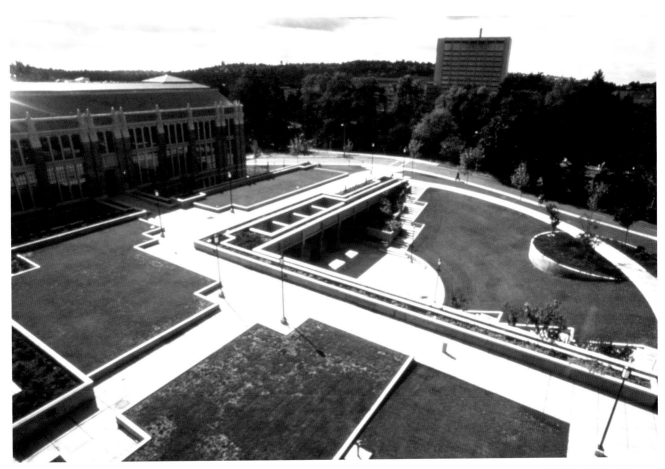

The sloping lawn and terraced stairways lead attractively down to the entrance level of the University of Washington's Mueller Hall. Far from being a foreboding shaft into the ground, the building entrance is part of a natural lounging area. Courtesy of BJSS Duarte Bryant, Architects

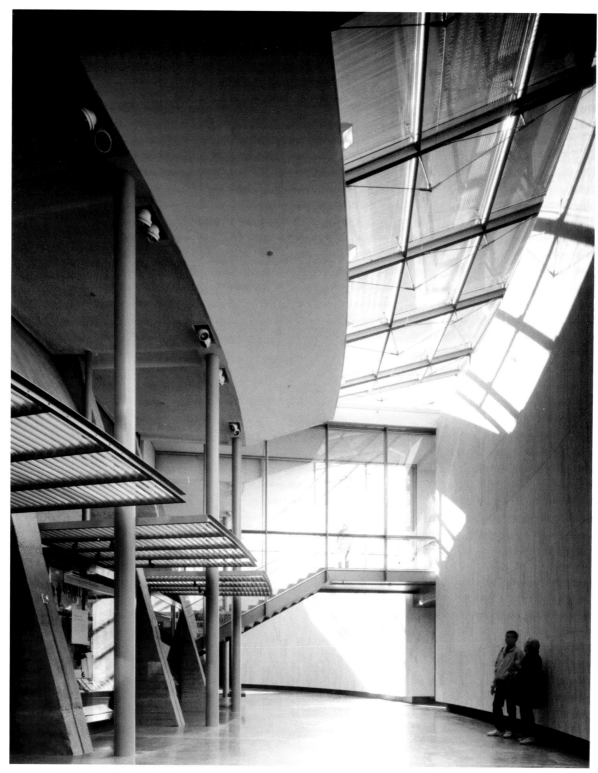

Awash in natural light, the spacious interior of the Women in Military Service for America Memorial contradicts the stereotypical image of underground space. A light-colored marble rear wall softly reflects sunlight entering through a 240-foot-long skylight. Glass-enclosed stairwells allow the free flow of daylight and contribute a sense of physical, as well as visual, lightness. Courtesy of Weiss/Manfredi, Architects; © Jeff Goldberg/Esto

open-air environment and then walk into the building in a normal fashion, perhaps even ascending a step or two at the entrance. Another approach is to bring people into the underground environment through an adjacent aboveground building. Entering at ground level and then taking an elevator or escalator to a lower level is a familiar activity. As such, it can divert attention from the fact that the lower level extends under a plaza or a street. Even in cases where direct entrance to the building is primarily vertical (via stairs, escalators, or elevators), the psychological effect can be softened by first bringing people into an attractive entrance kiosk or a relatively small, above-grade lobby.

Architects can alleviate sensations of claustrophobia among people in underground buildings by creating areas that are spacious, especially in the vertical direction. Open-air or skylight-covered atriums are particularly effective. Even in completely enclosed areas, a hallway with a vaulted ceiling or a balcony that overlooks lower levels creates a powerful sensation of roominess. Higher-than-usual ceilings are also useful; a normal-height ceiling may be perceived as confining to a person who is aware of being enclosed in an underground environment.

Another aspect of underground buildings that can be disconcerting is their vagueness of size and shape. A person approaching an aboveground building gets a visual perception of the extent and character of the structure before entering it. Not being able to see an underground building before entering it can be disorienting and may trigger a sense of apprehension about venturing into the unknown. Even with a completely subsurface building, however, architects can create visual clues to inform people about the building's character and scope. Rooftop planter boxes and pedestrian paths can be used to outline at least part of the building's perimeter. Skylights punctuating a rooftop plaza create a connection between the surface and the subsurface, for the benefit of people inside the building as well as those outside. Attractive stairwells and open-air courtyards that extend down into the building serve a similar function.

EXTERNAL CONFLICTS

Apprehension about economic and legal complications generates another category of psychological resistance to underground buildings. Particularly for residential properties, developers or potential buyers may worry about obtaining approval for building, arranging financing, or being able to sell or resell such structures. Often, the difficulties arise, not because of the characteristics of underground buildings, but because of agents' or officials' lack of experience or information. In other words, developers and owners may also have to become educators.

Building codes may present an obstacle to underground builders, depending on local laws and sometimes on the willingness of officials to grant variances. More than 1,000 homes in forty states have been built using a patented design sold in kit form by Performance Building Systems, and the company's promotional literature asserts that the system meets standard building codes and has never been denied a permit. Davis Caves, another company that has designed underground homes since 1977, claims to meet any building code, provided window escapes are not required for bedrooms—a standard the company says is commonly waived for houses made of concrete, metal studs, and fire-resistant drywall. Still, builders should investigate local building codes, which often include modifications to the standard codes. Recent moves toward performance-based codes, rather than prescriptive codes that specify how to achieve desired building performance, may more easily accommodate well-designed underground buildings.

Zoning, more than other factors, must be considered in two contexts. One is mined space, which is used almost exclusively for commercial purposes. It uses subsurface regions

below surface-level development in a way that is essentially unnoticeable. In the United States, these developments are most prevalent in and around Kansas City. Local governments in that area have developed innovative zoning ordinances to address this unusual issue. In Kansas City itself, for instance, a separate Underground Space zone is defined; it applies to a geological region that lies roughly 40 feet below the surface. Development is allowed in that zone, irrespective of the use of the land above it, with a few minimal restrictions (e.g., the need for easements on the surface to accommodate necessary ventilation shafts).

The other context involves underground development near the surface. At shallow levels, more typical of earth-integrated buildings outside the Kansas City area, zoning ordinances

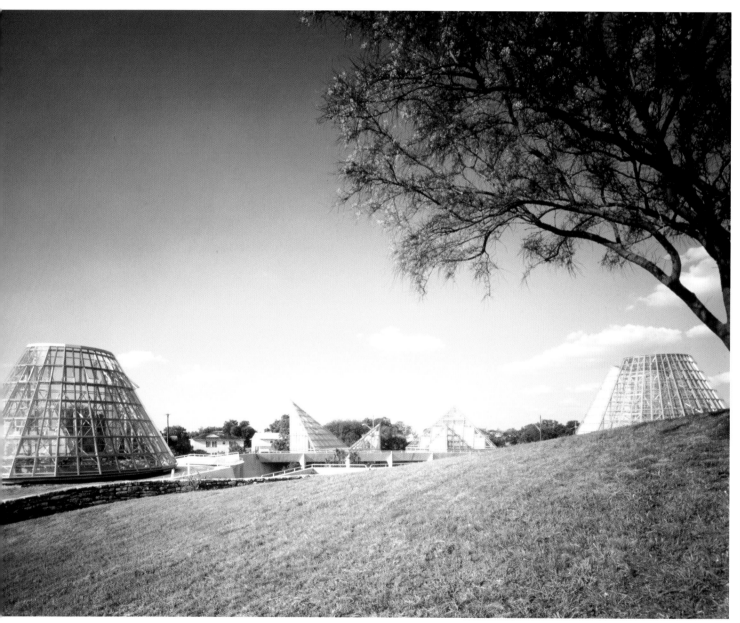

Architecturally interesting skylights not only establish the presence of an underground building, but they also hint at the structure's style. Even before entering the Lucile Halsell Conservatory in San Antonio, Texas, visitors know the underground botanical gardens will be neither confining nor boring. Courtesy of Emilio Ambasz & Associates

vary among localities. Some actively encourage earth-sheltered buildings and exempt them from such restrictions as normal setbacks from property lines. Others treat underground buildings at least as restrictively as surface structures. Developers and builders must familiarize themselves with local requirements and attitudes, and be prepared to present and justify carefully planned proposals.

Once construction is accomplished, owners and tenants generally find that their insurance premiums are lower in underground buildings, although they may need to search for an agent or a company that is willing to handle unconventional structures. One reason for lower premiums is that most underground buildings are constructed of fire-resistant materials such as concrete and metal. Forest fires have been known to burn over the top of a subsurface structure without damaging it. In addition, the buildings are sheltered from storm damage. Several companies that build underground houses tout lower insurance costs as one of their selling points. The R.C. Smoot Construction company, which builds earth-sheltered residential, commercial, and multifamily housing structures, for example, claims insurance discounts of 60–70 percent for homes it builds in Texas.

During the underground building boom of the 1970s, it was difficult to secure financing for underground houses. In part, this reflected the fact that many inexperienced people built their own homes without the guidance of a professional. A 1979 study by three Oklahoma State University professors found, for instance, that 70 percent of the owners of earth-sheltered houses had built them without consultation with an architect or an engineer.

By the late 1970s, financing opportunities were improving, partly because of government-supported educational programs encouraging energy conservation. Perhaps most notably, the state of Minnesota built single- and multiple-family earth-sheltered residential units in various parts of the state, opened them temporarily for public inspection, and then sold them on the open market. Lenders and real estate appraisers were among the groups invited to tour the completed buildings. In 1981, the federal Department of Energy issued a report titled *Financing Earth-Sheltered Housing—A Report on a Project to Facilitate the Loan Process.* This document offered specific suggestions for appraising these unconventional buildings. Furthermore, it reassured lenders that federal agencies such as the Federal Housing Administration and the Veterans Administration were willing to guarantee loans on such properties, that private as well as public mortgage insurance was available, and that both the Federal Home Loan Mortgage Corporation (FHLMC or Freddie Mac) and the Federal National Mortgage Association (FNMA or Fannie Mae) would purchase mortgages on acceptable earth-sheltered homes.

Resale value is one of the factors that lenders consider before approving a mortgage. Earth-sheltered houses represent a very small share of the real estate market, so resale value is difficult to assess. Occasionally, such houses are completely unmarketable. On the other hand, some sell at a price well above both their initial cost and their appraised value. Attractiveness and usability of design, quality of construction, and compatibility with the character of the neighborhood are significant contributing factors, just as they are for aboveground houses.

WHAT IN EARTH . . . ?

When asked how he created his masterful sculptures, Auguste Rodin once explained, "I choose a block of marble and chop off whatever I don't need." Creating an underground building is like that, only the process is turned inside out. Like Rodin, the builder must choose his material carefully to ensure a successful result.

CAN YOU DIG IT?

The nature of the underlying earth is important for any building project; only by knowing its load-bearing properties can design engineers plan an adequate foundation system that will support the weight of the building. This is also true for underground buildings. In addition, the rock or soil that surrounds the building will exert horizontal forces on the walls. Granular soil that compacts and drains well is most hospitable. Clay-like soil that drains poorly and expands when wet poses structural problems as well waterproofing challenges. Solid rock is difficult and expensive to excavate.

The earth directly affects the building it surrounds, but it also creates a physical connection to other nearby structures. Most underground buildings are built using a technique known as "cut and cover." A sufficiently large hole is dug into the earth, the building is constructed inside the hole, and then the space around and above the structure is filled with soil. While the hole is open, appropriate measures must be taken to keep the sides from collapsing. If another building is close, its weight spreads through the soil and increases the pressure on the perimeter of the hole. If the new building is being immersed in rock, the shock from blasting may jar nearby buildings enough to cause damage. Some of the examples in later chapters of this book describe techniques for dealing with these kinds of problems.

Whether or not the excavation for the subsurface building penetrates the water table is another important consideration. Although some buildings are successfully constructed below the water table, waterproofing is significantly less problematic if below water table construction can be avoided. In addition, building below the water table creates a potential for groundwater contamination. Furthermore, if construction of the new building effectively lowers the natural water table, it might undermine nearby buildings that were designed for pre-existing conditions.

The presence of underground utility lines may also present a problem for the construction of a subsurface building. New mapping techniques using ground-penetrating radar, magnetic and electric sensing, and seismic sampling are less expensive and more accurate than traditional practices of drilling test holes along suspected paths of buried lines. Finding the lines is not the only problem, however. In some cases, it may be impractical to relocate the utilities so a below-grade structure can be built.

Excavating for an underground building can irrevocably alter the site. A one-story structure buried in sandy soil could be removed and the site restored to essentially its original condition. However, excavations that disturb more complex geological layers or carve cavities into bedrock can never be completely undone. If an underground building becomes obsolete, alteration or demolition is generally more complicated than it would be for an aboveground building.

One such demolition effort was undertaken in Canada's Alberta Province in 2001. In 1964, the government had built a two-story, 77,000-square-foot bunker to serve as an emergency relocation center that would house national and regional government officials in the event of a nuclear war. Decades later, after the Cold War ended, the bunker became surplus property. A government-sponsored study concluded that the facility might be recycled for various uses, citing a night club, a storage facility, and an arena for mock-combat paintball games as potential examples. In the mid-1990s, the bunker was sold to a pair of businessmen for $312,000. The new owners put the property back on the market a few years later. According to a report in the *Toronto Star*, they began to get inquiries from an interesting array of potential buyers, including a white supremacist group, a car-smuggling ring based in the United States, and the Hells Angels motorcycle gang, which reportedly made an offer exceeding $1 million.

At that point, the Canadian government, anxious to preempt any sale that might place law enforcement agencies in an untenable position, repurchased the property for $1.3 million. Then they paid a demolition contractor $856,000 to dismantle the bunker. Rather than attacking the subterranean fortress with explosives, the contractor opted to take it apart in a more environmentally responsible way. First, workers removed hazardous materials like asbestos. Then they took out fixtures, wiring, and pipes, recycling as many of the items and materials as possible. Finally, they brought in powerful excavators and concrete crunchers to break up the 18-inch-thick walls and 2-foot-thick floor. Steel reinforcing bars (rebar) imbedded in the concrete were removed for recycling, and the crushed concrete was added to the material that ultimately filled up the gaping hole. A surface layer of good-quality soil suitable for growing crops finished the reclamation process. Based on the appraisal the government obtained in 1999, it could expect to sell the farmland for around $130,000.

LET ME SEE

With the exception of hard-rock space such as recycled mines, most underground buildings are covered with a layer of soil 18 inches to 3 feet thick. That is enough to provide the benefits of underground space, but it is also enough to block out daylight. From a technological standpoint, this is not a serious problem; installing electric lights is easy. Studies show, however, that artificial lighting, even using "full spectrum" bulbs that mimic sunlight, is not a completely effective substitute for daylight. The color, quality (degree of glare or diffusion), and direction of natural light varies throughout the day.

Lack of natural light is not unique to underground buildings; aboveground buildings often have windowless spaces. Several studies have established the importance of daylight for office

Rows of south-facing daylight monitors on the roof of the Holaday Circuits factory admit plentiful natural light to the underground building. Compared with slanted or horizontal panes, vertical glass surfaces like these transfer less heat between indoor and outdoor areas. Courtesy of David J. Bennett, FAIA

workers. On the other hand, some evaluations of windowless classrooms suggest either that students are affected to a lesser extent or that the lack of natural light is offset by the benefits of a distraction-free, windowless environment. In any case, additional psychological factors related to being below ground may make daylight even more important to people in underground buildings than to people in aboveground, windowless enclosures. In 1995, Swedish researchers Rikard Küller and Lennart Wetterberg found that "there may be a seasonal variation of hormones related to the length of the day, and that this normal variation may become disturbed in subterranean environments. . . . The low complexity of the visual field, including the lack of windows, may have a profound influence upon people working underground."

Psychologically and physiologically, then, it is important that architects find ways to bring daylight into underground buildings. Perhaps most intuitive but least obvious is ordinary windows. Many underground buildings have exposed wall space, either because they are built on a sloping site or because a recessed courtyard or a covered atrium penetrates vertically through the building. More obvious, perhaps, are skylights. They may consist of clear glass that allows views of the sky, mountains, or nearby buildings; or they may be translucent in order to eliminate glare or protect valuable artwork. A variant of the skylight concept, called a daylight monitor, consists of a vertical window mounted atop the roof; an adjacent vertical shaft allows daylight to pass down into the building's interior. A series of vertical, translucent panels mounted inside the shaft or below it can diffuse sunlight and eliminate glare.

More contrived light paths can be provided by various devices such as fiber optic cables and light pipes (ducts with highly reflective coatings on the interior surface). A classic example was incorporated into the Civil and Mineral Engineering Building at the University of Minnesota. The building is a hybrid consisting of three stories of near-surface construction and two stories of deep, mined space separated by a 30-foot-thick layer of limestone. Above the roof, movable mirrors that follow the daily path of the sun direct its rays down through a shaft to the lowest level of the building. A series of mirrors positioned at intervals through the shaft bounce the sunlight back and forth between the walls of the narrow channel until it reaches the lowest level of the building. A lens disperses the light beam over a ceiling panel, casting a 10-foot-square patch of sunshine onto the floor 110 feet below the surface.

Less reliance on artificial lighting can result in reduced energy consumption, not only for the lights themselves, but also for climate control systems that have to counteract the heat generated by electric lights. However, such savings depend on bringing daylight into the building without admitting direct beams of summer sun that can overheat the interior. This can be done in a variety of ways. Vertical windows can be shielded with a roof overhang that blocks direct rays of the summer sun but fully admits rays from the winter sun, which travels in a lower path across the sky. A flat skylight, which can admit three times as much light as a vertical window the same size, can be glazed with translucent panels or specially treated materials that do not transmit radiant heat. A lining of laser-etched panels can make a pyramid-shaped skylight reflect light from higher angles (the summer sun) but admit light from shallower angles (the winter sun).

LET ME SEE OUT

People love windows, not only because they let sunlight in, but also because they provide opportunities to look out and see the sky, the scenery, the weather, other people, and other

buildings. Being able to look out a window is not only enjoyable; it can also produce measurable psychological and physiological benefits. Several studies of hospital patients, for example, found less depression, quicker recovery times, and less need for pain medication among patients who could look out a window at a pleasant nature scene.

Besides conventional exterior windows, there are alternative ways to provide adequate views in underground buildings. Interior windows overlooking hallways or lobby areas can provide visual relief by offering views of larger expanses of space. If those views include landscaped areas in an atrium or recessed courtyard, so much the better. Decorating rooms and hallways with potted plants also helps. A 1996 study published in the *Journal of Environmental Horticulture* found that even in rooms without any windows, adding live plants to the environment made workers feel more attentive, work more efficiently, and have lower blood pressure.

Two stories below ground, patrons of Walker Community Library in Minneapolis have a surface-like view of a recessed courtyard. The courtyard appears to wrap around the corner of the building, although this is an illusion quite effectively created by a large mirror. In addition, a skeleton ceiling suggested by an array of metal bars supports overhead light fixtures and creates a comforting sense of spaciousness by revealing layers of crisscrossing conduits and ducts under a true ceiling 20 feet above the floor.

Artistic representations of nature, if well executed, can also enliven and add visual interest to the interiors of underground buildings. In a 1986 study, environmental psychologist Judith Heerwagen found that workers in windowless offices hung twice as many visual images on their walls as occupants of offices with windows. Comparing the content of the im-

ages, she found that people in windowless spaces used 30 percent more nature scenes containing neither people nor manmade objects. Some decorators of windowless underground spaces add large-scale visual relief by covering some walls with murals. Particularly when they skillfully employ perspective to create an illusion of reality and depth, these images can make the space more appealing.

WHERE'S THE CANARY?

In the days before electronic monitoring equipment was developed, miners kept a canary in a cage to gauge air quality. If the bird showed signs of respiratory distress, the miners knew a dangerous gas was present even though they could not see or smell it. Like miners, occupants of underground buildings rely on good ventilation and filtration systems to supply them with abundant supplies of healthful air. The same can be said for occupants of many aboveground buildings. According to the National Energy Management Institute, nearly half of all commercial buildings have indoor air quality problems. The Environmental Protection Agency has labeled the problem one of the top five current health risks. At least as much as aboveground buildings, underground facilities must ensure that their occupants can breathe.

Particularly in a building whose occupants are conscious of being underground, ventilation systems must not only introduce enough clean air but also circulate it effectively throughout the enclosed space. "While HVAC systems can be effectively designed to ventilate underground spaces, the perception of stuffiness may be as important as the actual conditions," John Carmody explains in *Underground Space Design*. He describes an example in which workers in a windowless factory complained about stuffiness: "While the system in fact was providing adequate ventilation, workers felt confined in a windowless plant where they could not feel a breeze. After ribbons were attached to the ventilation supply grills that visibly demonstrated the air flow, the complaints became negligible."

Underground buildings are susceptible to the same kinds of indoor air pollution as tightly sealed aboveground buildings designed for energy efficiency. Materials used in the construction of the building can release annoying or hazardous fumes. For instance, plywood, particle board, upholstery, and drapery fabrics can emit formaldehyde. Carpet, cleaning agents, paint, felt-tip markers, and correction fluids can release volatile organic compounds. Contamination can be controlled by bringing a flow of fresh air through the building or by thoroughly filtering air that is recirculated. Green plants that add visual appeal to the interior spaces also help clean the air and replenish its oxygen content. Unfortunately, this benefit is sometimes thwarted by treating the plants with fertilizers and pesticides that foul the air.

Underground locations may also be more vulnerable than aboveground buildings to certain types of air contamination. One example is the Minnesota Library Access Center, an archive facility on the Minneapolis campus of the University of Minnesota. Most of the structure consists of two 44,000-square-foot chambers carved out of a sandstone formation 82 feet below the surface. Groundwater flows toward the center from the former site of a coal gasification facility that contaminated the soil with coal tar. After the Minnesota Library Access Center building opened in 2000, some employees noticed the "rotten egg" smell of hydrogen sulfide gas. According to a fact sheet issued by the university, the gas is produced by the decomposition of a certain type of mold that feeds on the contaminated groundwater. Disputes over treatment strategies and financial responsibilities raged between the university, the former owner of the coal processing plant, and the Minnesota Pollution Control Agency. A year after

the facility opened, the pollution agency approved a plan to drill a well that would divert groundwater before it reached the Minnesota Library Access Center area, but the issue of financial responsibility remained unresolved.

Another contaminant of particular concern in underground buildings is radon, a colorless, odorless radioactive gas emitted by natural deposits of uranium in the soil. Breathing air with high concentrations of radon greatly increases the risk of developing lung cancer. Several strategies can help reduce radon exposure. First, before construction begins, the site should be tested. If a significant amount of radon is found, it may be possible to move the construction site enough to lessen the exposure or to include protective measures into the building design. Radon infiltration can be blocked by thoroughly sealing the shell of the building and any ventilation ducts that provide air for the interior. Maintaining a positive air pressure inside the building also discourages seepage of radon into the interior. The ventilation system should be designed to guarantee an ample supply of fresh air circulating effectively through the interior space.

Yet another type of pollution became a problem at the Moscone Convention Center in San Francisco. The 650,000-square-foot convention center was constructed in 1981, and a 570,000-square-foot addition was built in 1992. Approximately 95 percent of each of these components of the convention center complex is underground. The subterranean space includes driveways and twenty loading docks so trucks can deliver exhibition materials to the exhibit level 40 feet below the surface. When a major event is being set up or dismantled, as many as forty propane-fueled forklifts are used to load and unload trucks. Several steps were taken to improve air quality following a five-month period in 1996 when sixty-five workers reported symptoms typical of carbon monoxide poisoning. Countermeasures included improving the building's ventilation system, outfitting the forklifts with catalytic converters, using an emissions-reducing additive in the propane fuel, and reminding truck drivers not to let their trucks idle unnecessarily. In December 1997, Moscone Center was used as a test site to evaluate a new carbon monoxide sensor. The sensor proved more accurate and easier to use than existing detection devices, and carbon monoxide exposure levels for workers were found to be within acceptable limits.

WHERE'S THE FIRE?

There's good news and bad news about fires in underground buildings. On the positive side, fires and explosions in underground locations are better contained and less likely to spread to other structures than those occurring above ground. On the negative side, however, they are more challenging to handle in terms of evacuating people, controlling smoke, and putting out the flames.

A discussion of fire-related characteristics of underground buildings is complicated by the broad range of sizes and types of subterranean structures. Just as a log cabin in the forest and a skyscraper in a major city require different fire prevention and response strategies, so do small and large, shallow and deep underground buildings. In general terms, according to *Underground Building Design,* "Well-known techniques for fire suppression, smoke control, and evacuation using stairways appear sufficient for structures extending one to three levels into the ground." This is particularly true for modern designs that incorporate a significant amount of daylighting through windows and skylights. Nevertheless, certain factors require somewhat different consideration in subsurface environments.

BETWEEN A ROCK AND A HARD PLACE

Emergency evacuation of underground buildings presents some unusual challenges because escape paths lead upward. People tire more easily walking up stairs than down, so evacuation takes longer. Not only will evacuees be in the stairwell longer, but they will probably be breathing more heavily from the exertion of climbing. Moreover, they will be moving in the same direction as any smoke that finds its way into the stairwell, rather than descending away from rising smoke as they would in an aboveground building. These factors are further complicated by the fact that lifelong conditioning prompts people to flee downward in a burning building.

Fires in underground facilities have been rare, especially in very deep spaces or large, public spaces. This is good news, but it leaves a void of experience for predicting problems during evacuation. A few researchers have examined this issue, however. In one Japanese project, a 65-foot-diameter, 40-foot-tall dome-shaped room was built 270 feet below ground. Various experiments were conducted in the chamber, including psychological studies. In one experiment, reported in the 1997 annual report of Japan's National Institute for Resources and Environment, people were challenged to find their way through a maze in the chamber. When no exit signs were provided, some of the people "completely lost their way. With visual or sound signs, they promptly traveled to the exit." Some subjects reported experiencing panic.

Other researchers have also concluded that visible, easy-to-interpret escape route indicators are particularly important in underground spaces, where occupants may be disoriented easily by the lack of windows that show where "outdoors" is. A 1990 study of subway evacuation in England found that verbal directions given by security officers and/or a public address system were more effective than a nonverbal alarm or an announcement without specific instructions. Visual information is also very effective, but underground locations with limited window space are particularly vulnerable to power outages that often accompany fires or other emergency conditions. Battery-operated exit indicators or backup power supplies are possible solutions. Also promising are new photoluminescent systems. Like children's glow-in-the-dark novelties, these materials store light and release it during periods of darkness. Using the material to mark such guideposts as doorways, stair treads, and even stairwell walls has performed well in experiments.

A primal fear of entrapment may be more prevalent among people who are surrounded by soil than those above ground. Yet in deep underground spaces, escape paths may be so long or difficult to climb that it is safer for people to wait in designated refuge areas until danger passes or they can be rescued. That presents a real credibility problem. The perception of the safety of an environment may be at least as important as its physical reality. Creation of containment zones, a strategy that has been used in aboveground buildings, is vital for safety. Physical barriers, including curtains of air, can be used to keep smoke or fire from spreading from one part of the space to another. In an evacuation mode, this means ensuring the safety of stairwells; in the case of refuge areas, it means protecting people by confining smoke and flames with noncombustible barriers and effective ventilation.

An example of a large underground facility designed with refuge areas is the Olympic Mountain Hall in Gjøvik, Norway. Built as a stadium for ice hockey competitions at the 1994 Winter Olympics, the facility was carved out of solid rock. The main entrance, a 330-foot-long pedestrian tunnel, is 26 feet wide; three additional tunnels that can be used for evacuation bring the total escape path width to 72 feet. By accepted standards, this would be adequate for 3,300 people. The arena, however, holds 5,800 people when configured for ice hockey games. The designers turned a hallway that encircles the arena into a 38,000-square-foot refuge area. If a fire were to start in the arena, the spectators would be directed to go to the hallway and wait

there so the tunnels could be used to bring in fire fighters and equipment. During this period, each spectator would be entitled to occupy a space about 2½ feet square.

BURNING QUESTIONS

It may be generally true that where there's smoke, there's fire, but if the smoke is thick enough, you may not be able to find the fire. That was the situation when a fire started in a food warehouse located in a former limestone mine near Kansas City on December 28, 1991. The 170-acre warehouse, which had been in use since 1950, was not equipped with a sprinkler system. An employee heard a sound, saw some smoke, and reported the event. Within minutes, fire fighters arrived, put on face masks and air tanks, and headed for the rear of the cavern. They could not see far in the thick smoke, so their progress was slow. Their air supply ran low before they could get near the fire. A week after the fire started, thick smoke was still pouring out of the warehouse. Americold, the owner of the facility, decided to try to smother the fire. They sealed off the section of the warehouse where the fire was located and pumped in carbon dioxide. Six days later, believing the fire to be out, they opened the area only to find the fire still burning. It was not until April 1992 that the fire burned itself out.

The Americold fire prompted the National Fire Protection Association to develop a new standard for subterranean spaces. Published in 1999, NFPA 520 applies to the commercial use of mined spaces that are created without disturbing the earth's surface except around the entrances and ventilation openings. It makes provisions for such elements as fire alarms, approved fire suppression systems such as automatic sprinkler systems, and acceptable numbers and sizes of exits and refuge areas.

In near-surface underground buildings, which are usually built by the cut-and-cover method, fire behaves differently than in aboveground buildings. It is more contained because it cannot burn through the roof or walls. The number and placement of windows may not only hamper access by fire fighters, but may also restrict natural ventilation during a fire. Because of these factors, heat accumulates and fires burn hotter than normal. Decreased supplies of oxygen to the fire leads to incomplete combustion resulting in denser smoke and higher levels of carbon monoxide. As the smoke- and gas-filled air gets hotter, it expands; if not adequately vented, this creates a high pressure zone in which even fire-resistant materials may be more likely to burn.

Certain precautions can help minimize these kinds of complications. For example, a mechanical ventilation system activated by a smoke detector can reduce smoke production by promoting clean burning, and at the same time reduce the buildup of heat and pressure. Automatic sprinkler systems can also be useful, although they may cause an accumulation of water that cannot drain naturally out of the below-grade building.

WATER YOU AFRAID OF?

Water can, indeed, be a significant concern in underground buildings. Even in aboveground structures, many of which have basement levels, it has been an ongoing problem. In an October 1985 *Progressive Architecture* article, waterproofing consultant Brent Anderson asserted that 35 percent of all claims against architects arise because of water problems; 15 percent of the claims relate directly to the choice of waterproofing materials. Basement levels have traditionally been considered support spaces for storage, building maintenance functions, or parking. As such, their interiors were rarely finished with decorative surfaces and accessories. Building codes have generally required basements to be treated with a minimal level of moisture protection known as dampproofing, which slows water seepage but does not block it.

In the article, Anderson quoted Raymond Sterling, then director of the Underground Space Center, as saying, "You can look at the fact that one-third to one-half of all basements leak, and think it's a terrible problem, or you can look at it and say that, by doing almost nothing, one-half of the buildings stay dry anyway." Yet nontechnical people, basing their judgement on perception rather than statistics, tend to notice and remember the unpleasantness of musty basements while taking for granted and not noticing or remembering clean, dry examples. Basements are not the right standard of comparison for modern underground buildings, though. As Mike Oehler, who wrote *The $50 and Up Underground House Book*, is often quoted as saying, "An underground house has no more in common with a basement than a penthouse apartment has in common with a hot, dark, dusty attic."

Moisture problems arise within underground buildings in two different ways: condensation on interior surfaces and infiltration through leaks in the building shell. Vital elements of prevention include proper design of the surrounding drainage system as well as the structure itself, and skillful construction work. If a problem is allowed to develop, correcting it can be difficult and costly.

CONDENSED VERSION

Set a glass of ice water on a table in a humid room, and before long the outside of the glass is wet. That happens because cold air cannot hold as much water vapor as warm air. The air that touches the cold glass cools beyond its saturation point, and some of the water vapor condenses (turns to liquid). In an underground building, the example is turned inside out. Air inside the structure is often warmer than the earth that is in contact with the structure's walls, floor, and even roof. If the air is humid enough or if the temperature difference between the air and the surface is large enough, the interior surface will become damp.

Using a dehumidifier or effectively circulating fresh air through the building can prevent the accumulation of humidity generated by common activities like cooking, using water for various purposes, and even breathing. Installing an effective layer of insulation between the earth and the outside surfaces of the building can control troublesome temperature differences.

Dampness is unsightly, and it can cause materials like drywall and carpet to deteriorate. It also supports the growth of mold and mildew, which not only look bad but also contaminate the air with irritating or toxic fungi. This problem is not limited to underground buildings. A 1991 study by the Business Council on Indoor Air found mold or mildew in 35 percent of the 695 aboveground commercial buildings it sampled.

FILL 'ER UP

The other type of moisture problem is leakage of water into the building. Inside deep, mined space, this can be controlled by installing drainage systems and moisture barriers between the cavern faces and the shell of the building. Near-surface structures require a combination of drainage and waterproofing that is dictated by the characteristics of the surrounding soil. Waterproofing and drainage strategies are described for several of the buildings featured in the remaining chapters of this book. As an introduction, the following two examples illustrate some of the basic techniques.

Vail, Colorado, receives 30 inches of precipitation a year, much of it coming from snowfalls that total 300 inches. Nevertheless, the city decided to build its new public library underground, primarily to conserve energy and preserve the landscape. The building, which was completed in 1983, occupies a sloping site that allows two window-filled walls to be exposed,

while the other two are earth covered. Before backfilling soil against the two subsurface concrete walls, they were sprayed with bentonite, a type of clay that expands ten to twenty times when it gets wet, compressing itself into a barrier too dense for water to penetrate. The bentonite layer was covered first with a waterproof membrane and then with 2–4 inches of rigid foam insulation. The roof was waterproofed with the bentonite and membrane system and insulated with 6 inches of rigid foam. Furthermore, the top of the building was designed to encourage drainage, with a soil cover that varies from 23 inches to 14 inches thick accentuating a 7-inch slope of the concrete roof slab. *Solar Age* reported in September 1985 that the library director

The book stacks and reading rooms of the Vail (Colorado) Library nestle under a field of mountain grass. A "Danger Keep Off Roof" sign warns unsuspecting passersby, not because the roof is weak, but because it is a full story above ground at the rear of the building and drops off precipitously.

had opposed the decision to build an earth-covered structure because of persistent leakage problems in the flat roof of the former, aboveground library. However, the article states, "after two years of working under it, she happily reports that the flat [underground] roof has never leaked."

In 1986, New York University built a two-story underground addition to its law library. The addition extended below a garden, under a block-long section of a street, and beneath an existing building. Waterproofing was complicated by the fact that the building penetrated 4 feet below the water table. During construction, water flowed into the pit that had been hollowed out to contain the building. Pumps operated continuously, removing 500 gallons per minute. Waterproofing strategies were tailored to each component of the building:

• Several layers of waterproofing material were installed to keep the floor of the building dry. A first layer of panels containing bentonite was covered with a thin, protective layer of concrete. Then a concrete foundation pad was poured; to resist the hydrostatic pressure from an underground stream flowing beneath the site, this pad was nearly 3 feet thick. The foundation was covered with filter fabric, which contains open cells through which water can drain. Finally, a 4-inch-thick concrete floor slab was poured.

• The walls were also protected with bentonite panels. Outside each wall, a brick wall was erected, leaving a gap of 2 inches, through which water could drain away without being pressed against the bentonite.

• The roof of the building consisted of a 15-inch-thick concrete slab. It was covered with a 100-mm-thick sheet of high-density polyethylene like that used to seal landfills. The membrane was supplied in 30-foot-wide rolls to minimize the number of seams, which were heat sealed. The membrane was covered with a layer of insulation, a sheet of filter fabric, and a layer of drainage-promoting stones before being topped with concrete that was sloped to encourage water runoff.

It is understandable that designers devise elaborate waterproofing systems consisting of a combination of technologically sophisticated components. At best, leaky buildings are troublesome and expensive to repair; at worst, they can be unsalvageable.

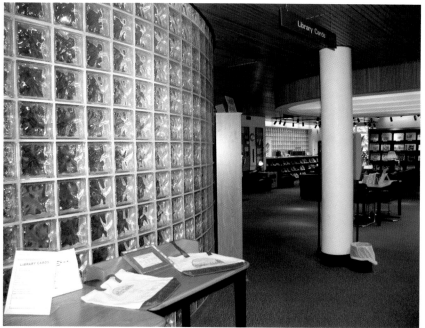

Glass brick walls in the Vail Library are visually less confining than conventional opaque partitions. The translucent wall at the rear in this photograph (to the left of the white pillar) allows daylight to enter the reading room from a skylight-covered hallway. Courtesy of Dianne Gum

• For years, Skidmore College's permanent art collection was jeopardized by being stored in a leaky building under a campus walkway. In 2000, the Saratoga Springs, New York, school moved the collection into a new, aboveground museum and gallery facility.

• In 1967, the first free-standing underground library in the United States was built at Hendrix College in Conway, Arkansas. The highly innovative structure was plagued with several persistent problems, including water leakage. Following the construction of a new aboveground library in 1993, the underground building sat vacant until it was demolished in 1998.

• Fort Worth, Texas, built a new central library building underground in 1978. Twenty years later, the 125,000-square-foot structure was still the nation's largest subsurface public library. For most of those twenty years, its roof leaked. By 1992, the city had seen enough soggy books and acted decisively by constructing a two-story-tall, two-block-long additional building atop the underground library. The shell was completed in 1994, but it sat empty above the active library until 1998, when funding became available to finish its interior. By October 1999, the new aboveground space was ready for use. Five months later, patrons were hustled downstairs to the original, subgrade building during a devastating tornado that ripped through downtown Fort Worth, breaking the windows and skylight of the aboveground addition as well as tearing off part of its facade. The $7-million addition sustained more than $1 million of damage.

PART II

PRIVATE SPACE

3

Down to Business

Mention underground businesses, and people think you mean merchants who improperly sell controlled goods, employers who hire illegal immigrants, or workers who ask to be paid in cash to avoid being taxed on their earnings. However, the term could also apply to businesses whose dealings are aboveboard but whose physical locations are below ground. Hundreds of such businesses employ tens of thousands of people in the United States alone. They operate in big cities and rural locations. They range from small newsstands and shoeshine services to supermarkets and exclusive boutiques. They include corporate headquarters, factories, and high-volume warehouses and distribution centers.

Compared with other applications of underground space, a much larger proportion of businesses use mined space rather than shallow, soil-sheltered space. Usually, this mined space is a byproduct of mineral extraction. A played-out iron mine in New York state was used in the 1960s for commercial storage and as nuclear fallout shelters for major corporations. In Kansas, a 660-foot-deep salt mine has been converted to a secure storage facility for valuable items such as master copies of classic movies and television programs. The type of mine most commonly recycled for commercial purposes, however, is limestone. Many converted limestone mines are clustered in an area around Kansas City, where they account for more than 10 percent of the local business and industrial space. In that area, some 4,000 people work underground for 400 companies in thirty underground industrial parks, and four of the five largest industrial parks are underground. Those complexes contain approximately 90 percent of all the commercial underground space in use throughout the world. Although the greatest concentration of limestone mine industrial parks is around Kansas City, several other significant examples are scattered throughout a triangular region reaching from the Kansas City area up to Pennsylvania and down to Tennessee.

Businesses use both deep and shallow underground space for a variety of reasons. Sometimes, it simply works better than aboveground alternatives. In other cases, it may be more environmentally responsible or simply more economical.

Build It in the Basement

Underground factories were widely used after World War I and throughout World War II, most extensively in Europe. Hidden from view and protected by mountains of rock, they were invaluable to both Allied and Axis powers for the production of war materials. More utilitarian than comfortable, the factories were generally cramped, dreary, and inadequately ventilated.

When the war ended and their strategic value diminished, most were either abandoned or converted to nuclear bomb shelters. Development of underground factories during peacetime has taken place at a much slower pace than other uses of subterranean space. In the United States, postwar underground factories date to the mid-1950s, with dozens operating by the end of the twentieth century.

The recycled limestone mines of the Kansas City area offer many advantages for light manufacturing. For example, the ability to maintain a constant level of optimal humidity facilitates commercial printing operations and the production of paper envelopes and cardboard boxes. Similarly, a reliably constant temperature permits fabrication of uniform parts for such products as tools and modular office assemblies. In Pennsylvania, another former limestone mine provides not only constant temperature but also a vibration-free environment for a polishing facility for some of the world's largest and most precise telescope mirrors.

In contrast to those located in mined space, manufacturing plants submersed in soil are scattered through a broader area. In northern Illinois, a plant for manufacturing metal and plastic fasteners was recessed into a hillside in 1980 for two reasons: to minimize energy consumption and to reduce a high employee turnover rate related to uncomfortably hot working conditions in the existing, overcrowded factory. In 1964, a Texas plant, which still produces surgical sutures and medical needles, was built underground so its production would not be disrupted by severe weather or even a nuclear war.

BRUNSON INSTRUMENT COMPANY

It was 1955, and A.N. Brunson was frustrated. Over the past twenty-eight years, his ingenuity and diligence had turned a one-person machinery repair business into a manufacturing operation producing precision instruments used for surveying and navigation. Lately, traffic around his factory in downtown Kansas City had grown so heavy that the only time he could perform delicate instrument calibrations was between 2 A.M. and 4 A.M. Action tempered his frustration, however; after years of planning, he was finally breaking ground on a new facility.

Reasoning that bedrock would provide the ultimate vibration-free floor for his factory, Brunson had considered the possibility of relocating into one of the city's abandoned limestone mines. He was unable to find a suitable location, however. Some mines had been mined so exhaustively that their roofs were unstable. Others had been mined haphazardly, leaving randomly spaced roof support columns that obstructed the potential work space. Ultimately, he decided to create his own cavern, mined specifically to the size and configuration he needed.

Because Brunson's primary objective was the creation of factory space, he proceeded differently than the miners who had been burrowing under Kansas City for three-quarters of a

The understated entrance to Brunson Instrument Company belies the fact that the facility contains 220,000 square feet of space, 125,000 square feet of which is currently used for administration and for manufacturing precision optical measuring devices. Courtesy of Brunson Instrument Company

century. Whereas they had focused on the material they were removing, he focused on the void that would be created by removing the material. He carefully planned where columns should be left to support the roof, aligning them to accommodate assembly lines and storage space. By blasting along a boundary between two layers of the sedimentary rock, he was able to shape a stable, nearly flat ceiling, in contrast to traditional mining techniques in the area that created fractured, arched ceilings. For Brunson, the mined limestone was a valuable byproduct; selling it as he removed it from inside the bluff helped pay for the construction. The net expense was about one-third of what building a comparable aboveground structure would have cost.

It took five years of blasting and excavating to build Brunson's factory, but the results were impressive. Vibration problems ceased. The temperature inside the factory is remarkably stable, varying less than 2°F regardless of the weather outside; this minimizes energy use and alleviates calibration problems caused by expansion and contraction of materials. Humidity is easily controlled, eliminating problems with rust formation. The work space is shielded from exterior noise and dust. As for security, well, the roof consists of 75-foot-thick rock, the stone walls are at least 15 feet thick, and there is no back door for burglars to jimmy.

Holaday Circuits

The facade of the Brunson Instrument Company consists of a doorway leading into the exposed rock face of a natural bluff. By contrast, the Holaday Circuits headquarters and manufacturing plant in suburban Minneapolis looks like a building. It just doesn't look like as large a

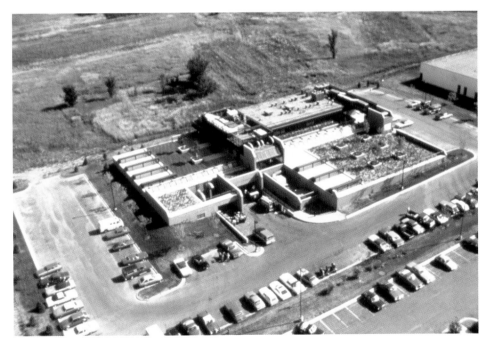

The rooftop trees and bushes were still immature in this photograph of the newly built Holaday Circuits facility. As they grew, they became increasingly effective at shading the roof and reducing solar heat gain. Rooftop grass also helps cool underground buildings through transpiration and evaporation.

Courtesy of David J. Bennett, FAIA

building as it actually is. An 8,000-square-foot, single-story structure housing the corporate offices is the most noticeable component, although some peripheral features suggest additional space. Outside the office building, two enclosed stairwells rise above the landscaped plaza. Paved sections of the plaza are interspersed with banks of skylights. Along the lower portions of the sloping site, short concrete walls define the perimeter of the 27,000-square-foot subsurface factory that produces electronic circuit boards.

Architect David Bennett selected several types of lighting for the underground factory. Fluorescent fixtures illuminate areas where the manufacturing process requires an unvarying level of light. The ceilings of two large production rooms contain rows of south-facing daylight monitors. A skylight consisting of slanted glass panels extends the full length of the

The 8,000-square-foot above-grade portion of the Holaday Circuits headquarters represents less than one-fourth of the building's total bulk. Courtesy of David J. Bennett, FAIA

building above a main corridor. When the natural light drops below a selected level, automatic sensors turn on electric lamps above the skylight, illuminating both the interior and the exterior of the building at the same time.

Energy conservation was a significant factor in the decision to place the bulk of the building underground. Only 40 percent of the structure's exterior walls are exposed to the Minnesota weather. Three-fourths of the roof area is blanketed with a 14-inch-thick layer of soil, and rooftop trees provide summer shade.

Efficient land use was the other main reason for immersing the building in the earth. Local zoning ordinances specified a minimum proportion of open space that had to be provided on the site. Placing much of that open space on top of the building reduced the amount of landscaped area that would have to be located adjacent to the building. This reduced the cost of the project by decreasing the amount of land Holaday had to purchase. It also made the site more visually attractive by incorporating green areas throughout the complex rather than creating a bulky, blank-walled building trimmed with a ribbon of landscaping.

STORE IT IN THE CELLAR

Underground storage is not a new concept. For thousands of years, people of various cultures have stored food and other essentials in natural or manmade underground receptacles to protect it from light, heat, animals, and insects. Until electricity became readily available in rural areas, American farmers stored perishables in root cellars. During World War II, this strategy was employed on a massive scale when the U.S. government stashed perishable foods in naturally cool limestone mines in the Kansas City area. Within a decade after that war, businesses began to commercialize underground storage.

MINE'S IN KANSAS CITY

Space Center Executive Park in Independence, Missouri, offers a whopping 5 million square feet of developed space, but you would hardly know it was there. Like the phantom baseball players who walked into the *Field of Dreams* cornfield, 1,000 employees disappear into it every day to work for forty firms. Factories, warehouses, and offices occupy spaces ranging from 1,500 to 800,000 square feet inside what used to be a limestone mine supplying aggregate for concrete construction projects. Each day, 500 tractor-trailer rigs circulate on its 5 miles of indoor roads, and freight cars lumber along its 2-mile railroad network. Vehicular entrance portals and nine vertical ventilation shafts allow fans to push 500 million cubic feet of fresh air through the complex every day.

The Kansas City area, including nearby Independence, is home to approximately thirty of these underground business parks. At SubTropolis, one of the largest, fifty tenant companies employ more than 1,300 workers. Warehouse operations account for 70 percent of the occupied space at SubTropolis, with another 8 percent being used for cooling and storing refrigerated and frozen foods. Factories occupy 15 percent of the space, and offices represent the remaining 7 percent. Tenants range from small, local companies to major corporations like Hallmark Cards and Safeway Foods. One of the largest tenants is the United States Postal Service's distribution center for collector stamps. It's not strictly business at SubTropolis, though. Twice a year, a black-tie charity ball in the complex attracts 1,000 participants.

Converted limestone mines offer many advantages, including:

• Vehicular entry. The mines were dug horizontally into bedrock bluffs, removing a 12- to 18-foot-thick layer of limestone, 100–200 feet below the top of the cliff. Workers go into a mountain, not down into the ground. They drive into the complex and park their personal vehicles out of reach of destructive or uncomfortable weather.

• Stable temperature. Regardless of the season, temperatures remain constant in each mine; depending on a mine's location, that base temperature is generally between 55°F and 65°F. In a building inside a mine, lights and body heat can stabilize the temperature at a comfortable 70°F. Heating and cooling bills run as much as 90 percent less than for surface buildings.

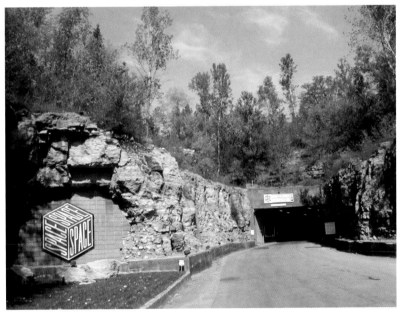

Barely noticeable exterior features disguise the extent of the underground commercial space in and around Kansas City. The 30 million square feet of currently leased space represents only 10 percent of the mined-out space that exists in the region. Furthermore, active mines in the area generate an additional 6 million square feet of caverns every year. Courtesy of Space Center Kansas City, Inc.

Even subzero freezer space can be maintained efficiently. It takes about two years of constant cooling to chill a 20-foot-thick layer of the rock surrounding a freezer chamber to -8°F, but after that is accomplished, the temperature in the chamber would stay below 0°F for months even in the event of a total loss of power.

• Minimal construction. The roof, foundation, and one or more walls of a new tenant's space have been formed by the mining process. What remains is to define the rest of the space with cinder block walls, route the utility lines, and install finishing touches like ceiling panels and smooth floor surfaces. Completion of a new building generally takes only two to four months and costs a fraction of what of a comparable aboveground building would cost.

• Low cost. In addition to the lower construction costs and utility bills, tenants pay lower insurance premiums because of their high level of security, low risk of fire, and isolation from severe weather. In Kansas City, property taxes are also lower because underground space is assessed at about one-fifth the rate for surface buildings. In total, monthly costs in that vicinity average one-third to one-half of what they would above ground.

• Increased productivity. After moving into underground space, some businesses have reported worker productivity increases of 25–30 percent, and some have experienced a 25 percent decrease in absenteeism. The reasons have not been scientifically verified, but managers speculate that the comfortable year-round temperature is a

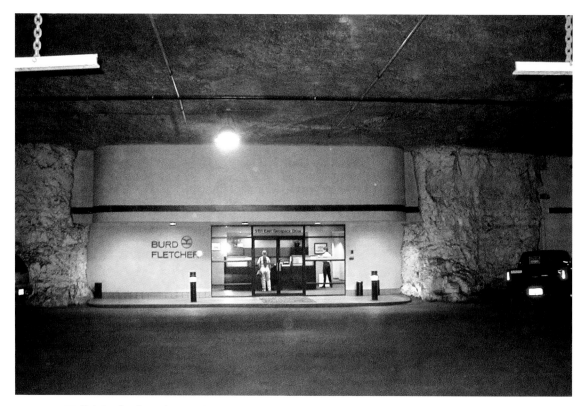

Originally, limestone miners left randomly spaced pillars to support cavern roofs. After developers discovered the advantages of recycling the chambers, mining companies began spacing the columns on a regular grid pattern. Now the pillars help delineate roadways and define tenant spaces. Courtesy of Space Center Kansas City, Inc.

major factor. Workers also have fewer distractions such as noise from traffic or storms; furthermore, they do not have to worry about their cars being damaged by hail or being encrusted with snow and ice when it is time to go home.

Mined space certainly has advantages, but it also has limitations. It is not appropriate, for example, for heavy industrial activities that generate a large amount of heat, use or produce hazardous materials, or create strong odors. Even though the parks use positive ventilation to circulate fresh air through entrance tunnels and vent shafts, truck drivers are asked to minimize emissions by not letting their engines idle unnecessarily. On a less tangible plane, businesses that rely on a high level of visibility to attract customers would not be very successful tucked away inside a mountain.

The occupancy rate in Kansas City's underground industrial parks averages about 95 percent, but that may be due to careful planning as much as to market demand. For example, SubTropolis owns roughly 50 million square feet of mined space, only 10 million of which is developed. Of that, only 4.3 million square feet is leasable, after allowing for areas like roadways. Space can easily and quickly be developed by sealing and painting exposed rock surfaces, pouring smooth concrete floors, and installing utilities and fire sprinkler systems. Hunt Midwest, the park's owner, develops additional space only as needed. In the spring of 2001, with all of its available space leased, the company developed another 470,000 square feet, increasing its enormous inventory of leasable space by 10 percent in a six-month period.

Mine Is Different

The extensive conversion of limestone mines to industrial parks in the Kansas City region is an unusual phenomenon. Yet other mined spaces around the United States are used for commercial purposes as well, primarily for storage. Each of them seems to have a unique character, as the following examples demonstrate.

Picture this: Seventeen million historic photographs and negatives are headed for shelter 200 feet below ground in a former limestone mine in Boyers, Pennsylvania, 60 miles northeast of Pittsburgh. The Bettman archive, which includes the United Press International collection, constitutes an irreplaceable visual documentation of the twentieth century. Its current owner, Corbis, intends to preserve the delicate documents by freezing out deterioration. Film that experiences temperature fluctuations and is handled frequently will last only thirty to fifty years. At National Underground Storage, the Corbis collection will be stored at -4°F at 40 percent humidity, conditions that are expected to preserve it for at least 500 years.

Question: What is the difference between a problem and an opportunity? Answer: creative thinking. Example: Kentucky Underground Storage. Bill Griffin bought a played-out limestone mine in northeastern Kentucky in 1977, envisioning some kind of commercial potential. After all, part of the cavern had already been used as a mushroom farm; cleaning out the manure that nurtured the culinary delicacy would not pose much of a problem. At 60°F, the natural temperature in the 32-acre mine was inhospitable to rodents and bugs. Griffin, a wholesale grocer, thought it might make a handy mega-refrigerator. It turned out that was not going to be profitable enough to cover the mortgage payments, so he decided to develop much of the space as a commercial storage facility. There was just one problem: Water literally dripped from the ceiling. Turning the liability into an asset, Griffin decided to bottle and sell the pure spring water. The strategy not only got rid of the cavern's excess moisture, but it also generated enough revenue to finance the development of Kentucky Underground Storage. More than

100 companies store everything from microfilm to recreational vehicles in the 1.4-million-square-foot, 30-foot-high cavern. And, the by-product keeps on flowing; Highbridge Spring Water passed the $3-million mark in annual sales in 1999.

Roots run deep. It is not surprising that Bill Griffin's cavern had once been used for cultivating mushrooms, which thrive in the dark. On the other hand, men working deep in a copper and zinc mine in southern Canada were bemused when the orange and apple seeds they spat out during lunch breaks sprouted and grew nearly 6 inches high before withering. The phenomenon led to the creation of an experimental underground greenhouse in Saskatoon, Saskatchewan. Since 1991, Prairie Plant Systems has used it to grow various flowers, herbs, food crops, and medicinal plants 1,200 feet below ground in an inactive chamber of a copper and zinc mine. The biotechnology firm found that a combination of metal halide and sodium lights provides effective artificial sunlight that also warms the cavern to an ideal growing temperature. Many types of plants grow faster and bigger there than they do in surface-level greenhouses. In addition, the deep chamber's isolation protects the plants from diseases, stray pollen, insects, and storms. In 1999, the company formed a subsidiary, SubTerra, to operate a similar facility in a former copper mine in White Pine, Michigan. One of its first projects was the cultivation of genetically altered tobacco plants whose seeds contain a protein that can be used in the treatment bone marrow cancer.

Spend Your Bottom Dollar

Modern underground shopping centers are a worldwide phenomenon. Europe's largest underground mall, near the Kremlin in Moscow, Russia, opened in 1997. In North America, both Canada and the United States have many examples, dating to the 1930s. However, the country with the most extensive experience is Japan, where the first underground shops opened in 1930. Placing shopping malls below ground, usually under streets and parks, became so popular in that space-strapped country that by 1995, twenty cities had them. By 2000, about eighty subsurface malls, some with more than 200 stores, encompassed a total of nearly 10 million square feet. Besides using space efficiently, underground malls provide protection from nature's discomforts, from mildly bothersome drizzle to major disasters. When a magnitude 7.2 earthquake destroyed much of downtown Kobe, Japan, in 1995, the relatively unscathed, 150-store Santica underground mall became the disaster relief headquarters. On the other hand, after an accidental gas explosion in an underground shopping center killed fifteen people and injured 220 in 1980, the Japanese government severely tightened development regulations and building standards. Construction ceased for a few years but then resumed under the new guidelines; at least six large subterranean malls were built in Japan between 1986 and 2001.

Shopping Around Underground

North America has two categories of underground shopping centers, neither of which is quite like the Japanese model. The first type forms a sort of underlayer for a metropolitan center. Often developed in connection with subway stations, these retail districts consist of clusters of shops linked by underground walkways. Sometimes, the walkways have developed into broad corridors lined with stores. The systems often connect with basement levels of high-rise buildings, allowing patrons to circulate between sheltered parking garages, of-

fices, shops, and apartment complexes without being exposed to rain, snow, wind, or extreme temperatures.

One example of this type of development in the United States is Crystal City in Arlington, Virginia, across the Potomac River from Washington, DC. Relatively modest in length, this nine-block-long, underground corridor system links twenty high-rise office and residential buildings. Some stretches of the system consist of hallways with low ceilings and flat walls embellished with decorative touches like patterned brickwork, colorful tiles, mirror panels, and murals. Other sections are decidedly more lively, consisting of retail malls dotted with atriums and open-air courtyards encircled with glass walls and doors. Nearly 200 stores include shops selling curiosities like marionettes, model kits, and comic books; national chains selling books, recorded music, and clothing; a fast-food court, as well as one-of-a-kind eateries; staples like a post office, a liquor store, and a popular supermarket; and a subway station.

Known as "The Tunnels," Houston's underground, climate-controlled passageways zigzag for more than 6 miles, linking more than fifty downtown buildings. Since Will Horwitz built the first segment in 1935 to free the patrons of his downtown movie theaters from jaywalking tickets, a succession of businesspeople have tacked on additional pieces. Many people who work downtown rely on the tunnels to keep them cool and dry as they walk between parking garages and various buildings during steamy or rainy weather. With about 100 dining options and another 100 businesses, the tunnels offer convenient opportunities for workers to eat lunch, shop, and obtain routine medical services during the workday. Some high-rise buildings connect to the tunnels through sunken plazas where workers can venture outside without contending with surface street traffic. The subsurface refuges are particularly welcome on blustery days, when surface winds whip through the deep canyons created by the skyscrapers that cluster in the city center.

During the late 1990s, some Houston developers were planning tunnel extensions and additional access points. At the same time, others were building skybridges between buildings for protected passageways at less expense than digging tunnels and maneuvering around buried utility lines. The biggest problem to date with Houston's tunnel system, however, was its vulnerability during tropical storm Allison in June 2001. During a two-day period, the storm dropped as much as 40 inches of rain on the city, causing widespread flooding. Admittedly, the storm's ferocity was rare, with some areas flooding deeper than the predicted 100-year maximums. Basements of some downtown buildings avoided severe flooding because of effective waterproofing and drainage systems. However, particularly near the downtown-area Buffalo Bayou, the tunnels turned into underground rivers as water not only poured in from the surface but also seeped through the walls from the soggy earth that surrounded them. Water rushed through the tunnels with enough force to shatter glass partitions and knock down a cinder block garage wall. Buildings connected with the tunnels were more prone to flooding, but they were not the only buildings that were breached. In the tunnels themselves, extensive cleanup and repairs were needed in some sections, while others were operating normally within days after the deluge.

Houston touts its tunnel system as the largest underground walkway and retail system in the United States. In Canada, Montréal and Toronto have even longer underground pedestrian systems with significantly more commercial development. Montréal's system seems to be the largest overall, with about 20 miles of walkways and 2,000 retail establishments. It consists of several distinct sections that are accessible from one another only by riding the subway. On the other hand, the 7-mile-long Toronto system, with more than 1,200 stores and eateries, is continuous and can be traversed completely by foot. In both systems, some tunnel sections are

simply hallways, others are shop-lined corridors, and still others are multilevel shopping malls in the subsurface levels of tall buildings. Climate was a major factor in the development of both the Montréal and Toronto systems, although the catalyst was bitterly cold winters, in contrast to Houston's sweltering summers.

Toronto's system started early but got off the ground slowly. Around 1900, the T. Eaton Company department store built a tunnel to connect its main store with its bargain annex. At least four more under-street pedestrian tunnels were built by 1917. In 1929, the Royal York Hotel built a tunnel under Front Street so its guests would have comfortable access to the railroad's Union Station. Another twenty-five years later, the city's new subway system encouraged the vertical separation of automobiles and pedestrians. A defining moment came in 1967 with construction of the first phase of the Toronto-Dominion Centre, an office tower with an underground shopping concourse. About that same time, the city government began actively encouraging downtown property owners to install walkways under their buildings to ease surface congestion and traffic conflicts. Initially reluctant to spend money on these tunnels, developers soon discovered that the facilities were popular with the public and that revenues from stores built into them could more than offset their construction costs. Today, the Path shopping area is convenient for more than 100,000 employees in office buildings connected to it, and it has become a destination attracting another 225,000 visitors each day. In contrast to Houston's tunnels, which are completely owned and maintained by the businesses to which they connect, ownership of Toronto's Path System tunnels is mixed: Businesses own and maintain the tunnels under their own property, while the city develops and controls the portions that run under streets.

The seed of Montréal's system was an office tower with an underground mall and pedestrian tunnels leading to a railway station and a high-rise hotel. In the mid-1950s, architect I.M. Pei and urban planner Vincent Ponte collaborated on the design of the Place Ville Marie, a 3-million-square-foot mixed-use structure that would include offices, banking facilities, shops, entertainment venues, and underground parking. The result was a forty-seven-story tower with equal amounts of space aboveground and in a four-level complex underneath the building and a surrounding plaza. The subterranean development included a 126,000-square-foot retail mall with 1,600 stores and 200 restaurants. The underground structure extended under an adjacent street to connect with a railroad station. The complex was completed in 1962, and the following year Montréal was selected as the site of the 1967 World's Fair. The ensuing construction boom included additional mixed-use tall buildings with lower-level shopping areas and new subway stations linked to other buildings via pedestrian tunnels.

FOCUSED FORUMS

North America's other category of underground shopping centers is the single-destination mall, as opposed to tunnel-connected clusters of stores. Often built in a subway station or under a commercial building, these centers sometimes extend outward under an associated surface plaza. They are common not only in major cities such as Los Angeles and Philadelphia, but also in moderate-size cities. For example, the fashionable boutiques, art galleries, and restaurants of First Plaza Galería in Albuquerque, New Mexico, have served customers for thirty years from underneath a mid-rise building and a skylight-accented dining patio. In North Carolina, the Asheville Mall shopping center was enlarged by 15 percent in 2000 by building 88,000 square feet of retail space under a new parking deck; because of the site's uneven terrain, the new underground food court has a full wall of windows.

One of the United States' most famous subterranean malls is also one of its oldest. Built during the 1930s, New York's Rockefeller Center was the first real estate development project in the world to combine offices, retail stores, restaurants, and entertainment venues in a single complex. Its outdoor Lower Plaza leads to a 24-acre underground mall and 1½ miles of store-lined walkways that link the Rockefeller Center buildings and connect to the subway system. Although never as commercially successful as its designers and owners hoped, the shopping area has served as a long-term experiment for ways of attracting customers underground.

The original Lower Plaza design incorporated sound ideas that are still effective. A block-long promenade leading to the broad, open-air plaza slopes gently downward, adding the physi-

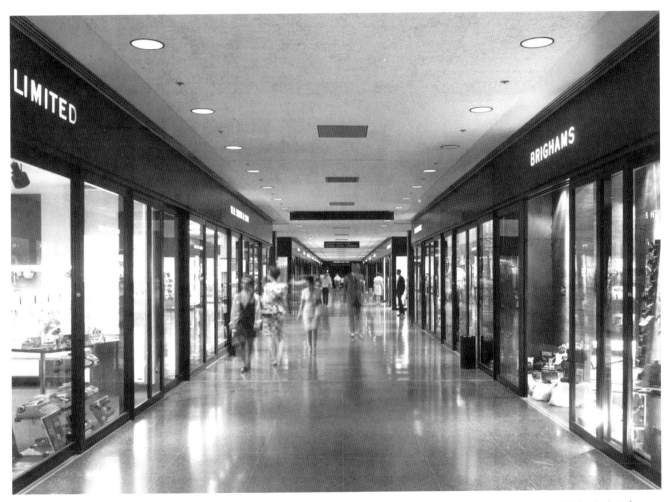

Renowned architect Mies van der Rohe included an underground shopping concourse in his design for the Toronto-Dominion Centre skyscrapers. Convenient for downtown workers and easily accessed by the subway, the 1968 mall evolved into today's Path System. Courtesy of B+H Architects; photo by Ron Vickers

cal pull of gravity to the greenery's aesthetic attraction as visitors walk toward the plaza. The complex's designers provided no similarly enticing exit path from the plaza, encouraging people to wander into the shops around its perimeter as they looked for an alternative to backtracking up the promenade. An attractive garden extends down the center of the promenade, luring pedestrians away from the pavement and stone walls of the surface street. Several times a year, the plants are changed to reflect the season, introducing variety to refresh the interest of regular patrons.

The slender, seventy-story General Electric Building (formerly the headquarters of RCA) soars skyward at the end of the promenade, creating a visual sense of motion that draws people forward toward it.

Despite these clever devices, the first stores established around the Lower Plaza were unable to attract enough customers to stay in business. John D. Rockefeller, the driving force

In early November, Rockefeller Center's ice rink is open and the promenade leading to the Lower Plaza is decorated with autumn flowers. One story below street level, shops and restaurants surrounding the plaza are faced with large windows and glass doors.

behind the center's development, decided that the plaza needed an exciting focal point. In 1936, he heard about a new process for artificially creating outdoor ice skating surfaces, and he promptly arranged for a temporary installation. The rink, which debuted on Christmas Day that year, was an immediate success. Ever since, the center of the plaza has become a skating rink during the fall and winter. During warmer seasons, the area is transformed into an outdoor dining area filled with umbrella-shaded tables.

When Rockefeller Center was declared a New York City landmark in 1985, the Landmarks Preservation Commission decided not to include the underground mall among the designated areas. "At that time we didn't feel the concourse rose to the same level as the spaces that were above it," former commissioner Kent Barwick told the *New York Times* in 1999. Landmark status restricts the kinds of renovations that can be done to a building, and Barwick recalled that the members thought "Rockefeller Center should have the right, within reason, to experiment and try to reanimate that area."

In 1999, new owners renovated the 224,000-square-foot underground shopping area in conjunction with a redevelopment of the center's first-floor retail spaces. Larger, multilevel

stores with internal escalators help unify the above- and below-ground stories. Also, the decor of the mall's two 400-foot-long interior corridors was changed drastically. The black glass and marble that characterized the original Art Deco style were replaced with silver limestone, creating a brighter environment. Shiny brass accents on door and window frames retain some of the original style. Dropped ceilings hide the ductwork for newly installed air conditioning and accommodate recessed lighting designed to provide more even illumination in the concourse.

WORLD TRADE CENTER SHOPPING CONCOURSE

The underground shopping center at the World Trade Center was larger and more financially robust than the shops at Rockefeller Center. The 430,000-square-foot mall extended underneath and between the twin towers and five other buildings that comprised the World Trade Center. Located on the first subsurface level, this retail concourse sat above six basement levels that housed parking, support services, mechanical equipment, and rail transit lines. Designed in the 1960s, built in the 1970s, and remodeled in the 1990s, the concourse was spacious and inviting. By 2001, it hosted seventy-five stores and was one of the highest-volume malls in the United States. Sales amounted to more than $900 per square foot of space annually, more than 2½ times the national average of $341. Eager to capitalize on this performance, Westfield America signed on to lease and manage the property in late April 2001.

On September 11, 2001, when highjacked airliners crashed into Tower 1 and then Tower 2, the underground concourse proved to be no less vulnerable than the buildings that stood above it. Surviving as long as the skyscrapers did, however, it protected escapees from jagged pieces of the buildings that pelted the open plaza above. Fredric Fastow, whose office was on

With a mezzanine at the plaza level, the spacious entrance lobbies of the World Trade Center towers united the below-grade concourse with the surface level. Photo by Wendy Terry

the sixty-sixth floor of Tower 1, told *Columbia College Today* what happened when he reached the lobby level: "We were led underground through the shopping concourse rather than out onto the main plaza, where metal was raining down." The protection offered by the concourse roof was obvious throughout the World Trade Center complex. Jim Usher, whose office was below the concourse level of Tower 2, told *CEE News* that surface-level exits from the lobby were blocked off by the time he got to them. "Stuff was flying through the air. It was all over the place. They [security officers] did not want people exiting there." Going back down one floor, he walked through the concourse to the neighboring building. "I went out on to Liberty Street at 4 World Trade. Debris was still falling, but it was more on the paper side. It was not hunks of metal or anything dangerous."

When the twin towers finally crumbled, more than 1.5 million tons of debris fell. "Most of the entire plaza level of the trade center . . . has collapsed," the *New York Times* reported. "The concourse, one floor below, shows a similar pattern." As with the towers themselves, however, the concourse survived long enough to allow thousands of people to escape. The *Wall Street Journal* reported on November 1, 2001, that as far as could be determined, no mall employees or customers were lost on 9/11.

Plans to rebuild the World Trade Center site include a retail component, and a large portion of it will probably be underground. Westfield America is committed to, and bound by, its lease and management agreement with the Port Authority of New York and New Jersey. It plans not only to replace the demolished space, but to increase it by 40 percent.

Independently in the Ground

Some businesses stand alone, even when they are built underground. Take BMW Competition and Sports Cars, Ltd. of Greenwich, Connecticut, for example. It sells luxury automobiles in an affluent community, and it does it with style. After nearly thirty years in that business and environment, the company's president, Andy Feuerstein, struck out on his own path to create a new home for his dealership. A technologically astute innovator who uses the latest developments to support his business activities, Feuerstein did not want to operate from a standard-issue box-with-windows surrounded by a sprawling parking lot full of cars for sale. Rather, he wanted to welcome customers into an elegant, architecturally compelling building where they could concentrate on a selection of display automobiles.

The new building, designed by architect Marc Spector, should do that and more when it is ready for occupancy in 2003. The design features an 18-foot-high, glass-fronted showroom overlooking tasteful landscaping and a customer parking lot. A gently curving wall made of local granite rises behind the nearly transparent showroom, providing an attractive background and separating it from a small office wing. The dealership's inventory of new cars will be stored neatly out of sight in an underground section of the building, where the vehicles are protected from weather and vandals. Cars brought in for servicing will be whisked out of sight to another underground portion of the building, to be worked on and stored in a protected environment until their owners reclaim them.

Hidden underneath the parking lot is a two-story service and storage building that represents three-fourths of the dealership's floor space. The upper floor, called the mezzanine level, is designed as a parking facility for the new vehicle inventory as well as vehicles that have been left for servicing. The lower level contains the service department, including service bays, car washing and detailing areas, employee locker rooms and offices, and a parts warehouse. To create a safe and comfortable environment in the service department, the architect

provided 18-foot-high ceilings, effective ventilation, and plenty of lighting. All of the waste fluids from the service department will be used to fuel the building's heating, ventilation, and air conditioning systems. This will not only save energy costs but will also reduce the need to stockpile the materials and transfer them to an offsite recycling facility.

Unlike most dealerships, BMW Competition and Sports Cars will not be surrounded by acres of automobiles. This architectural model shows the office and showroom portion, which represents only one-fourth of the building's floor space. An additional 74,000 square feet will be tucked away under the parking deck and the visible building. Courtesy of Marc B. Spector AIA, Spector Group

THE LOWDOWN ON OFFICE SPACE

Candy magnate Milton Hershey had a sweet idea when he added an aboveground office building to the company campus in 1935. He made the revolutionary building windowless and equipped it with air conditioning and the best available lighting system to create a comfortable work environment with consistent levels of abundant light. The idea made so much sense that the following year Herbert Johnson decided to incorporate the concept in a new office building for the Johnson Wax company headquarters complex. Realizing that an effective workspace needed more than uninterrupted walls and efficient mechanical and electrical systems, he searched for an innovative architect who could meet the challenge. He almost got more inventiveness than he wanted when he turned the project over to Frank Lloyd Wright. One of Wright's creative touches was to temper the windowless ideal with narrow bands of translucent glass that would admit diffuse daylight into the building.

During the next several decades, windowless office spaces became increasingly popular with developers, though not with the people who worked in them. During the 1970s and 1980s,

several surveys of employee preferences revealed that office workers overwhelmingly wanted to have access to windows. Various reasons were identified, but the two most prevalent were to be able to see out and to have daylight shine in.

What does that mean for underground office buildings? About the same thing it means for aboveground buildings: They should be designed with such worker preferences in mind. In fact, underground does not necessarily imply windowless. A building recessed horizontally into a hill, for example, can have a full wall of windows. Even buildings that are completely below grade can have windows, as the following two examples show.

MUTUAL OF OMAHA

Down was the only reasonable way to go when Mutual of Omaha needed to add more office space to its headquarters campus in the late 1970s. The new facility had to be near several existing buildings but could not interfere with the visibility of the fourteen-story structure that served as a symbol of the international insurance company. Leo A. Daly Company, Architects, placed the addition immediately in front of that tower in a way that enhanced the older building's appearance and almost completely hid the 185,000-square-foot, three-story expansion.

The most visible element of the new structure is a window. More precisely, it is a 90-foot-diameter glass dome that rises gently to a height of 15 feet above ground level. It is a window, because it lets sunlight pour into the heart of the building, and it allows occupants to look up and out to see the sky and the adjacent tower. Yet it is more than a window: It is an expansive focal point for the building below, and it is a new symbol for the company.

Surrounded by a stone courtyard that matches the facade of the tall building, the dome is ringed with greenery that replaces what was once a nondescript parking lot. From outside, the dome's bronze-colored glass is more decorative than ordinary window glass. From inside the building, the 505 tinted panels, insulated with half an inch of dead air above an inner layer of clear glass, provide both a temperature barrier and the appearance of being outdoors. Glass has a reputation for being fragile, but this dome is designed to withstand snow loads of 30 pounds per square foot and wind loads of 20 pounds per square foot. This is Nebraska, after all.

Placing the new building underground accomplished its primary purpose of creating new workspace while preserving the company's physical image. It produced several other benefits as well. Construction of a new aboveground structure faced with the same type of stone as the trademark tower would have cost $5 million more than the below-ground version. The earth-sheltered sub-grade building uses one-third as much energy for heating and cooling than a comparable above-grade version would. Furthermore, the third subterranean level of the building, which sits on the earth itself, easily supports the load of the company's information archives, which included 6.5 million files when they were moved into the building in 1981. This substructure, coupled with a specially designed, motorized, compact filing cabinet system, allows the company to store more than 2.5 million pounds of records in 13,000 square feet—half the space they formerly occupied.

Building underground produced benefits, but it also raised challenges. For one thing, water permeated the soil above the floor level of the lowest story, where the company's valuable paper files would ultimately be stored. This was addressed by artificially lowering the water table around the building. A drainage system channels the water into sumps from which it can be pumped as necessary. A sloping roof directs rainwater to the drainage system. Furthermore, the architects specified several layers of roof waterproofing: a liquid-rubber

membrane, followed by a protective asphalt-impregnated fiber mat, then 3 inches of gravel, 3-inch-thick high-density Styrofoam board, another 1½ inches of gravel, and finally, a fiber layer to provide a base for 2 feet of soil. "At each stage of the waterproof layer, there were field tests by flooding specific areas of the roof," John S. Savage, a vice president of Leo A. Daly Company, told the Going Under to Stay on Top conference in 1979. "Leaks were found at every one of those tests."

The other problem raised by building downward was the fact that the 45-foot-deep structure would be located close to the original headquarters building and connected to its basement-level lobby by a short, underground corridor. Planning, excavation, and construction had to be done carefully to avoid undermining the 250-foot-tall building's shallow foundation, which is

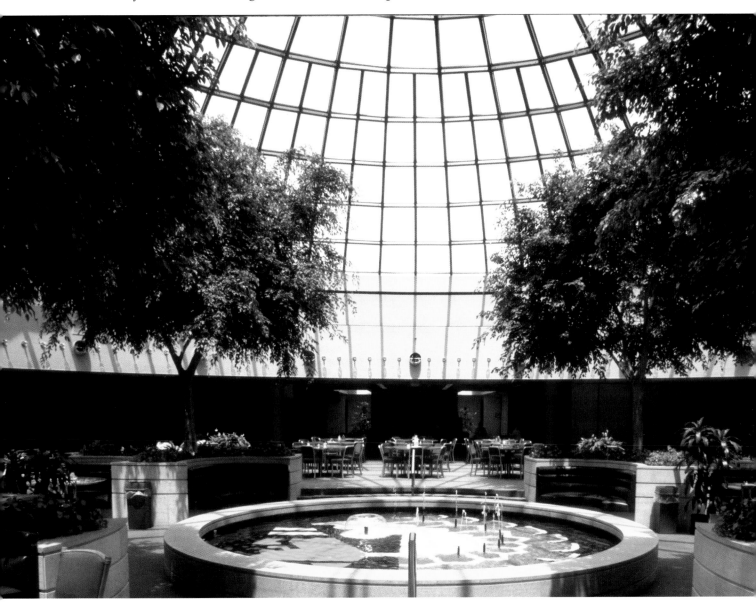

On the top floor of the Mutual of Omaha addition, a dining and lounge area serves as a gathering and relaxation area for 5,000 employees who work in the underground building and in connected aboveground structures. The windows and glass walls that separate surrounding rooms from the atrium are like windows in any other building, except they don't get rained on. Courtesy of Mutual of Omaha

only 14 feet deep. The three floors of the underground building were designed to be successively smaller, with each deeper floor ending farther from the adjacent structure. This allowed the weight of the older building to be distributed through a terraced soil base that is broader at its deeper levels. Excavation began in the portion of the site that was farthest from the tower. When the full depth had been cleared, the terraced sections approaching the older building were sculpted. Ground movement was carefully monitored so procedures or designs could be modified if the foundation seemed to be in jeopardy. Completion of the underground building within the resulting 150,000-cubic-yard hole restored stability to the site.

CAMELSQUARE OFFICE PARK, BUILDING K

What you see is not what you get at Building K of the CamelSquare Office Park in Scottsdale, Arizona. What you see is a one-story building with offices that face the parking lot and the other ten buildings in the complex. What you get is a four-story structure that houses more than one-third of the office park's space in suites that overlook two quiet atriums.

The center of the rectangular building is devoted to the two open-air atriums connected by a wide hallway. Running down the center of the hallway is a narrow mini-atrium. All three areas are landscaped with bushes and trees planted 36 feet below ground level. Sunlight enters through the roofless spaces above each atrium, but it enters in moderation. The rectangular building's north-south orientation minimizes the direct sunlight penetration in the summer and maximizes it in the winter. In addition, the building's floors are terraced around the court- yards, with the higher floors set back farther from the atrium opening, limiting the amount of direct sunlight that reaches their windows. And there are plenty of windows. Except for a contrasting wooden door, the entire front wall of each office suite is glass. Glass is used also for balcony railings around the atriums, providing safe barriers without interfering with the sense of spaciousness.

Fresh air also enters the building through the roof openings above the courtyards. Stabilized by the large thermal mass of the building's earth enclosure, the courtyard temperature at the lowest floor level varies between 50°F in the winter (when the exterior temperature may fall below freezing) and 85°F in the summer (when the outside temperature may exceed 110°F). Consequently, heating and cooling the office spaces in this building use only 40 percent as much energy as the above-grade buildings in the complex. Air seems to circulate naturally through the

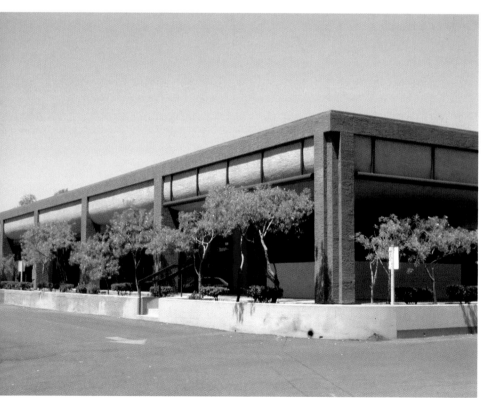

CamelSquare's Building K appears to be only one story tall. "(Architect Kenneth) O'Dell planned the visible floor to give a feel for the size and scale of the rest of the building," *Earth Shelter Living* reported in 1982, "and to allow visitors to slowly enter what might be perceived as an unusual space."

corridor between the two courtyards; on a summer day when the outside air is still and stifling, a barely noticeable breeze accentuates the naturally cooler environment in the passageway.

As bucolic as it sounds, the building has not been problem free. During the excavation phase of its construction in 1981, builders were surprised to find groundwater at a depth of 34 feet. Construction was delayed while engineers designed a drainage system. Digging below the eventual bottom floor level, they created a half-mile-long system of intersecting trenches, each 2½ feet wide and 6 feet deep. These drainage channels were then lined with filter cloth to keep silt from being washed in and clogging them. French drains (6-inch-diameter perforated plastic pipes) were laid in the trenches, which were then filled with 1½-inch-diameter rocks. This system allows water from the surrounding soil to flow easily into the trenches and collect in the pipes, which carry it to underground sumps. Pumps are used to remove water from these reservoirs. During the first year of the building's occupancy, 65 million gallons of water was collected and removed. Most of it was turned over to the Salt River Project, the public water supplier for the greater Phoenix area. However, about 5 million gallons was used on the landscaping at the CamelSquare Office Park, saving its owners an estimated $20,000 in watering costs.

Considering the amount of water that would otherwise have flooded Building K's lowest level, the drainage system has worked well, but not perfectly. In 2001, a trace of water still seeped through the wall of at least one office. To Pete Kunka, who has leased the suite for a decade, it is an annoyance that is offset by the building's advantages. Looking around the courtyard in front of his office, he explains, "The temperature's more comfortable here than above ground, and it takes less energy to keep it that way. It's great."

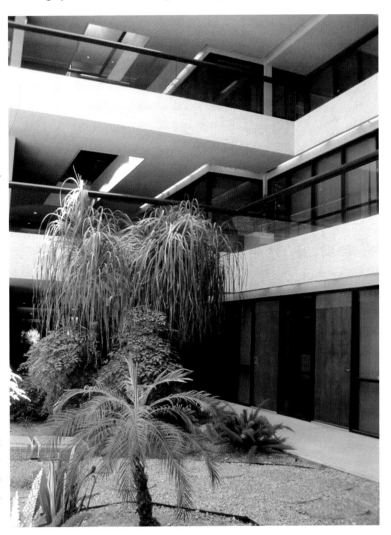

Originally called CamelSquareGardens, the building has 570 windows and another 4,800 square feet of glass balcony shields around the atriums. One of the three elevators also features glass walls so visitors can enjoy the interior scenery in a building that is virtually turned inside out.

SNUG AT HOME

Along with food and clothing, shelter has always been one of mankind's basic needs. In-the-earth dwellings are virtually as old as the hills, even in flat terrain. Natural caves provided the earliest in-ground shelters for humans at least 50,000 years ago. Pit houses, recessed partly into the ground, were built as much as 23,000 years ago in eastern Europe. Bronze Age dwellings were dug into stream banks at Beersheba in Israel 6,000 years ago. At least 2,400 years ago in Cappadocia, now part of Turkey, entire cities up to twenty stories deep were carved into the ground to protect as many as 20,000 people from enemy sieges.

Subterranean dwellings are not merely a curiosity of ancient times, however. According to recent estimates, between 30 and 40 million people live in hand-hewn underground homes in China. In Spain and France, perhaps another 100,000 people live in homes carved into rocky hillsides. Far from being primitive caves, these houses are equipped with modern conveniences secured behind facades fitted with conventional doors and windows. In several Australian mining towns, most of the residents live in houses dug into sandstone hills, sometimes the construction is financed by selling gemstones discovered during the house's excavation.

In the United States, an enormous variety of earth-sheltered homes have been built since the early 1960s. Located from Alaska to Florida, they range from small, subsistence-level cottages to elegant mansions. Some appear quite conventional, while others are whimsical, futuristic, or simply unusual. The styles reflect not only personal tastes of the homes' owners and designers but also the reasons they were built underground. Early examples were characterized by strategies for surviving nuclear war. As that threat became less likely, the focus shifted to designing ecologically responsible homes. The 1973 Arab oil embargo triggered a substantial wave of building earth-sheltered houses to reduce energy use. This economic motivation was so strong that, according to researchers at the University of Minnesota's Underground Space Center, the number of earth-sheltered houses in the United States mushroomed from about 50 in 1976 to an estimated 1,500–3,000 by 1980. The same researchers reported receiving a few requests per week for information on earth-sheltered houses in early 1977 but getting between ten and twenty requests per day the following year. In the spring of 1978, they published a report on effective design concepts for earth-sheltered houses; the report proved so popular that commercial publisher Van Nostrand Reinhold printed 100,000 copies the following year under the title *Earth Sheltered Housing Design.*

Statistics on American underground houses are elusive, but experts suggest that by the late 1990s the number was between 5,000 and 7,000. In 1999, underground architecture guru Malcolm Wells estimated that at any given time, approximately 100 earth-covered houses are being built in the United States. There are some indications that interest may be rising again,

spurred at least in part by increasing concerns about dependable energy supplies. Frank Moreland, an architect who has promoted subsurface buildings since the 1960s, reports building eight underground houses in the decades prior to 1990 and six between 1990 and 1998.

The earth-sheltered homes described in this chapter include some structures that have received little or no publicity and others that have been praised by the architectural community. Examples from each decade since the 1960s reflect a variety of lifestyles and tastes.

TUCKED UNDER A BLANKET

Economic and environmental concerns are intertwined as prime motivators for building underground houses. Energy conservation is often the driving force, whether prompted by a desire to reduce heating and cooling costs or to conserve natural resources. Mid-1990 statistics indicate that 11 percent of U.S. energy consumption is used to heat and cool residential spaces. One of the most effective ways to minimize home energy requirements is to tuck the house under a blanket of earth. "Typically, a 65 percent reduction in energy costs for heating and cooling is achieved," Frank Moreland told the American Concrete Institute in January 2000. A side benefit of that thermal efficiency, according to Moreland, is that "power outages or extreme weather takes days to affect internal temperature."

ECOLOGY HOUSE

Massachusetts architect John Barnard built his first underground house on Cape Cod in 1973, patterning it after ancient Roman houses in which the rooms surrounded a courtyard. Reasoning that the inward focus of the living areas made outward-facing windows unnecessary, Barnard decided to recess a courtyard-centered house into the ground. The courtyard became an open-air atrium separated from the surrounding rooms by glass walls. The enclosed rooms were covered with a foot of soil, which was replanted with grass, shrubs, and sometimes a vegetable garden.

By building underground, Barnard sought to create a haven with many advantages over aboveground houses. The design provided privacy for the occupants and shielded them from noisy surroundings. Most of the air entering and circulating through the house passed through a filtration system, limiting dust and pollen. Because of its reinforced concrete construction, the house was rated twice as fireproof as a conventional brick residence, which resulted in lower insurance costs. Covered by earth, the exterior walls were shielded from the weather and needed no maintenance, and there was no exposed roof to periodically reshingle. Easily assembled structural steel framing, poured-in-place reinforced concrete walls, and precast concrete roof panels resulted not only in saving trees from the lumber mill but also in a 25 percent reduction in construction costs.

The fact that Barnard dubbed his home "Ecology House" suggests his primary motivation. With the exception of a 15-by-22-foot opening above the courtyard, the building was hidden under the ground. "There's so little change in the natural growth that visitors wouldn't know the house was there except for the signs, the parking area and a fence surrounding the atrium," asserted a February 1974 article in the *AIA* [American Institute of Architects] *Journal.* Furthermore, the house used fewer natural resources for heating and cooling than a conventional house. Initially, it cost about one-third as much to heat as a comparable aboveground building, and Barnard later showed that covering the atrium with a clear plastic bubble during the winter reduced heating costs even further.

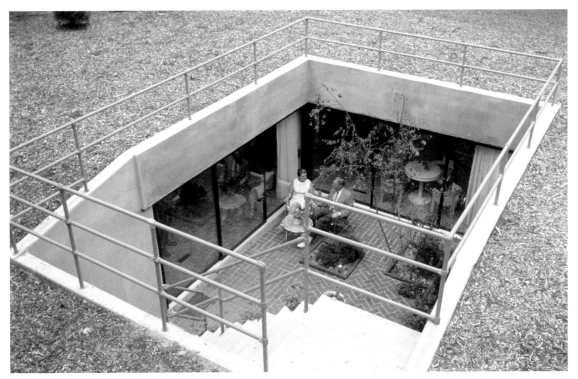

The Ecology House atrium was both a front porch and a backyard patio. The entry stairs descend along the courtyard's shortest wall. Lowering the top of this south wall allowed additional sunlight to reach the interior of the house. Jack Lane Photographs

This first version of Barnard's underground housing vision was a small example, suitable to use as his vacation cottage but substantial enough to demonstrate the soundness of his idea. Its 1,200 square feet encompassed one bedroom on the east side of the atrium, a kitchen and dining area on the north side, and a living room on the west side. A bathroom and utility room occupied the northeast corner of the building but did not open onto the courtyard. A stairway provided access to the house along the south side of the atrium, which was slightly less deep than the other three sides in order to allow sunlight to better reach the living areas.

Pleased with the results, Barnard opened the house to the public during the summer of 1973, charging a small admission fee that he donated to charity. During two months, 10,000 people visited the house. Public reaction led Barnard to design several variations of his atrium house, including a three-bedroom model in which the kitchen and dining rooms were nestled between two atriums. He also designed several homes for sloping lots where one side of the house was at ground level and the rest was recessed into the slope. Besides these standardized plans, Barnard created customized underground house designs for individual clients.

COZY QUONSET

Buying standardized plans from an architect or builder is one way to save on the cost of building a home. Another way is to do the designing yourself, preferably working with a technically competent advisor. This process can be simplified by using commercially available components and getting technical guidance from the supplier. For example, in 1997, Judi and Jeff Fahrnow built their underground vacation cabin on an isolated, wooded site more than thirty miles from Miles City, Montana, using a kit for an arched steel building commonly

A COUPLE OF CULVERTS

In 1979, the Underground Space Center at the University of Minnesota published *Earth Sheltered Housing Design* to document the recent wave of construction. Along with general design principles, authors John Carmody and Raymond Sterling described a group of notable examples. One of those examples, which "clearly demonstrates the potential of earth sheltered housing to be well integrated into its environment," was a Quonset-like creation built in River Falls, Wisconsin, in 1972. Dubbed the Clark-Nelson House, it was designed by architect Michael McGuire for two university professors. Two 24-foot-diameter steel culverts were buried parallel to each other on a slope, with a 15-foot-long tunnel connecting them. The longer culvert, located upslope, contained two private suites consisting of a bedroom and a sitting room or studio. The downslope pod enclosed a common area consisting of a kitchen and living room. Besides an access hallway, the connecting tunnel contained a laundry room and the mechanical equipment for the home.

The structurally efficient semicircular arch of each culvert formed the east and west walls and the roof, which was covered with at least 6 inches of soil. The north and south ends of the culverts were sealed with windows and glass doors. Skylights in each shell and in the connecting hallway further lighted the interior of the 2,500-square-foot home. The earth-covered culvert design saved energy, used small amounts of inexpensive building materials, barely disturbed the landscape, and accommodated what Carmody and Sterling called "the owners' interest in new building forms." The house was "comfortable in winter and summer (without air conditioning)," McGuire told the *AIA Journal* in 1978. "There is no sign of dampness or basement effect that one could expect during humid Wisconsin summers."

Using an existing component like a culvert or a Quonset seems like an efficient way to construct a modular underground house. It does not appear, however, that such elements are widely used. Apparently because of liability concerns, manufacturers and distributors of such components shy away from selling them for unconventional uses. Suppliers speak cryptically about disasters from previous attempts. Perhaps some frugal builders were not as careful as McGuire or the Fahrnows in balancing the loads while covering their thin steel shells with heavy earth.

known as a Quonset. Originally developed for military use during World War II, Quonsets are designed to be strong, lightweight, inexpensive, and easy to assemble—just the qualities the couple was looking for. Furthermore, placing the structure underground minimized heating and cooling costs.

The construction process was straightforward, if somewhat tedious. The 30-by-60-foot building consisted of 121 arch-shaped, 18-gauge steel panels, each about 2 feet wide, which were bolted together with angle iron brackets. During the initial assembly, the nuts and bolts were left slightly loose to allow enough flexibility to square up the structure when installing the vertical end walls. Then two workers had to go back through the entire structure, one on the inside and one on the outside, and cooperate in tightening thousands of nuts and bolts to ensure the building's structural integrity.

To avoid stressing the building with unbalanced soil loads, backfilling was also a multistep process. The 15-foot-high building had been assembled in a 10-foot-deep hole. The first stages of the backfilling process consisted of alternately placing soil on each side of the structure, 3 feet at a time. After the hole was refilled, the alternating soil placement continued until earth berms rose to within a foot or two of the top of the arch. Then dirt was piled on top of the structure and allowed to flow down to meet the side berms. Thinnest at the very top, the house's earth envelope was ultimately at least 12 inches thick.

During the course of a year, the outdoor temperature in the area ranges from about -20°F to 110°F, so adequate insulation was essential. The interior surface was coated with a ¾-inch-thick layer of sprayed-on foam, and the exterior faces of the vertical end walls were covered with straw bales before being finished with stucco. In the summer, the interior of the house stays below 80°F without air conditioning. During the winter, a wood stove and a propane heater keep the inside temperature above 65°F.

Built at a cost of about $30 per square foot, the Quonset cottage functions as an eight-room house. A great room accommodates living, dining, and cooking activities. Besides an office and a spare room, there is a separate bedroom, as well as a 10-by-40-foot sleeping and storage loft. The bathroom boasts a whirlpool tub as well as a shower stall. Support spaces include a 6-by-20-foot laundry room and an 8-by-20-foot pantry.

ELEGANT ECOLOGY

Energy-efficient, environment-conserving underground houses do not have to be modest, in either size or appearance. A Dallas-area home built in 1991 sprawls for 4,200 square feet under 4 feet of protective soil. Designed by Frank Moreland, this house costs its owner 20 percent less in utility bills than his previous home, which was only half as large. Furthermore, because the reinforced concrete structure is rated as "semi-fire resistant," owner William Coleman saves $1,000 a year in insurance premiums.

Economic savings are a nice bonus, but they were not the main justifications for building this luxurious home (see pages 62, 63), which cost about $200 per square foot. Energy resources are limited, and Coleman wants to slow their depletion. He also likes living under a hilly lawn rather than in a view-blocking building. "I wanted to make a statement that you didn't have to live in a cave in order to save energy and reduce the wear and tear that all of us put on the environment," he told the *Dallas Morning News* in August 1998.

Unlike a cave, this house is filled with natural light. Rather than a simple skylight, the house is topped with a raised roof section whose walls consist of three rows of glass bricks. Vertical walls descend through the earth and the concrete roof to connect this clerestory (i.e., windows near or above the roof) space with the living areas. Diffuse daylight filtering through the glass bricks bounces off the white-painted shaft walls to illuminate the rooms below. Even more light enters the house through its at-grade west wall, which is largely glass. To meet building code requirements, the house's three bedrooms are situated along this wall, with its doors and windows providing emergency exits.

Gently sloped to promote proper drainage, the roof was formed in a twenty-five-hour continuous pour of seventy truckloads of high-strength concrete. The roof is supported by the house's perimeter walls and a central pillar, so none of the interior walls are load bearing. Consequently, a future owner would be free to remove or reposition walls to create any desired room layout. This could be a useful feature, since Moreland predicts the lifetime of the structure will be at least 1,000 years.

PRO-AM HOME BUILDING

Owners of underground homes tend to be impassioned about some purpose such as energy conservation or storm protection. So impassioned, in fact, that they are willing not only to think outside the box but to live there as well, even though underground houses often arouse curiosity and trigger teasing from friends and neighbors. With this high level of interest in their unconventional new home, it is not surprising that many of these owners become personally involved in the process, even doing part or all of the work themselves. Often, they take advantage of workshops, stock plans, kits, and custom design services offered by companies that specialize in earth-sheltered buildings. Many of these companies were started by people who built their own subsurface homes and want to share their experience with others.

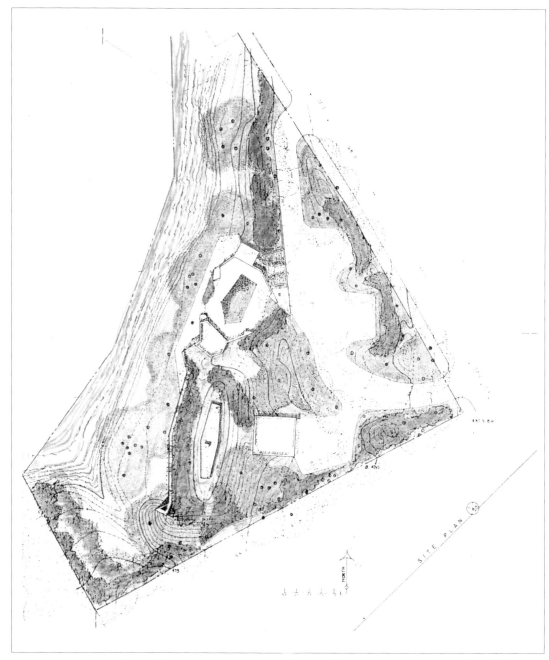

The white square near the bottom of the lot plan represents the William Coleman family garage, half-buried in the edge of a hill. To its left, an elongated hexagonal raised roof section more than 60 feet long rises slightly above the lawn. Farther to the left, the house's west wall truncates the hill. The subtle exterior of the house is so intriguing the owners had to post a "No Tours" sign to discourage curious strangers from intruding on their privacy. Courtesy of Frank L. Moreland, Architect

Davis Caves

In 1975, Andy Davis moved his family from a rural home to a small town in central Illinois. That winter he was stunned to find himself paying $167 one month to heat his rented house. The United States was in the throes of an energy crisis. International crude oil prices rose steadily through 1975 and 1976, although not as drastically as they had in 1974, when the price more than tripled in response to an oil embargo by the Organization of Petroleum Exporting Countries. Determined to keep his family comfortable despite rising costs and uncertain fuel supplies, Davis began to think about how he could build an energy-efficient house.

"He sat there [in his easy chair], barely talking to his wife and kids for weeks, brewing up an idea in his mind," longtime friend Dan Tackett recalls in a memoir posted on the Davis Caves website. "The thinking spell lasted so long that his wife thought he had taken ill." The idea of building underground came easily, prompted by Davis's observation of the temperature stability inside an Arkansas mine he had visited a few years earlier. The time-consuming part was working out details, like how deep the house should be, how to build it strong enough to support the earth covering, and how to keep its interior dry. When he was satisfied he had solved these issues, he began talking about it. "My family at first ignored my idea," Davis

On one side of the Coleman family's 1,500-square-foot living room, natural light enters from the clerestory windows around the raised roof section. On the other side, daylight comes in through a window wall. Without having seen its exterior, a visitor would not suspect that the building is covered with 800 tons of concrete, soil, and grass. Courtesy of Frank L. Moreland, Architect

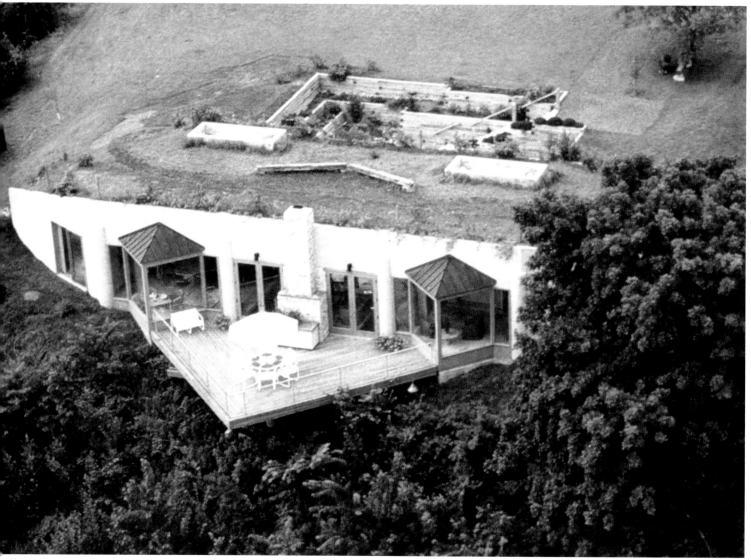

More conventional in appearance than Andy Davis's rock-encrusted cave, this second-generation design is not likely to conjure up visions of Fred and Wilma Flintstone. Built in Missouri in 1985, it features a sunken garden on one side and a raised deck on the other. Courtesy of Davis Caves (daviscaves.com)

wrote in a 1978 issue of the journal *Underground Space*. "I did not push it—just kept talking and explaining. My wife soon accepted the idea, but the children did not want to be different. They were afraid their friends would call us 'Flintstones.' However, they finally decided I was going to go ahead with my plan and at that point they all decided to help."

Davis bought a low-priced site that was too hilly to be practical for traditional building. He dug out space for his house, laid out a semicircular arrangement of rooms, and poured concrete footings for the walls. Then he framed and poured the reinforced concrete walls, floor, and roof. He finished the interior walls and the exposed front of the building by cementing on a layer of rocks whose sizes range from about 3 to 12 inches. Finally, he covered the structure with 4 feet of soil. The system accomplished Davis's objectives of dryness and strength. In fact, when a wayward herd of cattle rambled across his roof one day, not only was the house undamaged, but the people inside did not even hear the ruckus.

The Davis family particularly enjoyed the energy savings. Tackett recalls that for years Davis enjoyed telling how, during the winter of 1976–77, he heated his "cave home" for $2: "Those two bucks, Andy often boasted with a grin, covered the cost of oil and gas for his chainsaw to cut [wood] for his small Franklin stove, the cave's only source of heat. The home's energy saving features and its very uniqueness made headlines around the country—in newspapers, magazines [including *People, Money,* and *Mother Earth News*] and on network television news shows." Public interest was so great that Davis immediately started a company to franchise his designs and supply support services to people who wanted to build similar houses. Within three years, the company sold 120 franchises.

Despite its founder's death in 1995, the Davis Caves company continues to design and build residential and commercial projects. Though most of the buildings look more conventional than Davis' original cave house, they are still covered with at least 3 feet of soil. Reinforced concrete is used for the 8-inch-thick walls and 10-to-12-inch-thick roofs. The interior is finished with metal studs and fire-resistant drywall. This combination of construction materials not only reduces insurance rates but also meets all building codes and, in many locations, elevates the structure to a category that does not require emergency exits from bedrooms. At least one exposed wall provides abundant natural light, which may be further increased using optional skylights. Gravity flow drainage systems of gravel and tile, supplemented with external bentonite waterproofing, keep the buildings dry. The earth cover and an exterior layer of extruded Polystyrene insulation moderate temperature fluctuations. The company asserts that the houses produce year-round energy savings of 50–80 percent and that the interior temperature will never drop below 50°F, even without heat during the winter.

Like this front door, windows around the perimeter peer out from notches in the hilltop that contains a NestEgg home in Prescott, Arizona. Only an observation room atop the house extends above the ground. Courtesy of Formworks Building Inc. (formworksbuilding.com)

NestEggs

Another underground housing concept that took root in the mid-1970s uses conventional building materials in an unconventional way. Developed by brothers Gene and Dale Pearcey, the system is available as customized plans or in kit form from their respective companies, Performance Building Systems and Formworks Building (which calls the homes NestEggs). The process begins with assembling a grid of reinforcing steel and covering it with concrete. In this case, however, the steel framework is assembled in an elongated arch shape or a dome. Then, rather than pouring concrete into forms that contain the grid, the builders of this system cover the frame with shotcrete (also known as gunite, this process uses compressed air

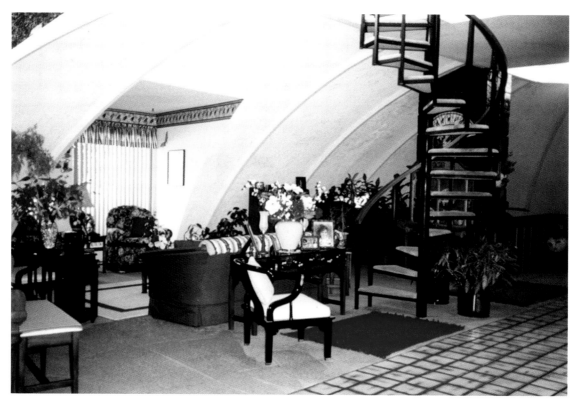

Window alcoves in both levels of this two-story NestEgg home accommodate straight, vertical windows. A spiral staircase leads to a rooftop observation room overlooking the countryside. Courtesy of Formworks Building Inc. (formworksbuilding.com)

to propel wet concrete through a nozzle and spray it onto a surface). After applying a bentonite waterproofing layer to the shell's exterior, the building is covered with several feet of soil.

Because of the strength inherent in its arched shape, this type of building can be constructed with only a 4-inch-thick concrete shell. In contrast, straight-walled, flat-roofed underground buildings require shell thicknesses on the order of 12–18 inches. The seamless, curved shell effectively resists hydrostatic pressures from the surrounding soil. Of more than 1,000 homes in forty states built using this patented system since 1979, Formworks reports that none have leaked. The structures are not only watertight, but they are also airtight. An interior fire that started accidentally in one smoldered for eight hours without erupting into flames. "Damage was limited to heat and smoke. The building itself was structurally undamaged," Gene Pearcey writes. "The local fire chief told the home owner that even a very airtight conven-

tional home would have burned to the ground because the heat itself would have caused the roof to catch fire."

Given the number of homes built with this system over more than twenty years, it is not surprising that some of them have experienced extreme conditions. Several in California and Idaho, for example, have remained undamaged in earthquakes exceeding 7.0 on the Richter scale. Others have withstood tornadoes, hurricanes, and blizzards. During the late 1980s, one of these houses was even subjected to a simulated nuclear blast test conducted by the U.S. government. Located 600 feet from "ground zero," the house was undamaged by a blast comparable to the Hiroshima atomic bomb.

ALTERNATE ALTERNATIVES

Let's face it: Living underground is unconventional. Not surprisingly, some people who build their homes below the earth's surface espouse other non-mainstream notions. The superior energy efficiency of subsurface houses appeals directly to individuals who prefer not to rely on conventional power sources derived from nonrenewable resources.

Extensions can be added to the basic NestEgg dome. Shorter ones serve as window alcoves, while longer ones enclose hallways and rooms. Courtesy of Formworks Building Inc. (formworksbuilding.com)

EARTHSHIPS

One of the most unconventional earth-integrated housing concepts is also one of the most ecologically intense. Conceived by architect Mike Reynolds, Earthships are built of discarded automobile tires, empty aluminum beverage cans, and dirt. In addition to using recycled materials, these houses are designed to be independent of public utility systems, employing solar panels to generate electricity and using stockpiled precipitation and household gray water to sustain indoor plants that cleanse and humidify the air. Owners often grow their own fruits and vegetables in the house-long solarium that is an integral part of each Earthship.

After fifteen years of thought and experimentation, during which he built and lived in a succession of increasingly refined designs, Reynolds began publicizing the concept in 1986. In the early 1990s, he wrote a three-volume series of books titled *Earthship* that describe how to plan, design, and build such a home. People who want to build an Earthship can plan it themselves after studying the books, or they can order detailed, customized plans from Reynolds. They can do all the construction work personally, hire laborers to help, or arrange for Reynold's company or another contractor to build it for them.

Nancy Roux, a middle-aged massage therapist, built her own Earthship in Mountainair, New Mexico. She sought help only with excavating and backfilling the site, positioning the 700-pound roof beams, and framing the solarium windows. After four years of part-time effort, she was able to move into the house. Three years later, she was still putting the finishing

Earthship owner/builder Nancy Roux left part of an exterior wall unfinished to display the tires and cans used in its construction. The section is part of a retaining wall extending beyond the west end of the house; behind it, the house is bermed to roof level. The bottom of the window is about 3 feet above the floor level inside the house.

The south wall of an Earthship is all glass, designed to brighten the building's interior and to capture heat from the winter sun. The structure's other three sides are recessed into the earth or are heavily bermed. Rather than being earth-covered, the roof is a shallow basin that catches rain and snow. The precipitation drains into cisterns, where it is stored for watering plants. Courtesy of Dobson House Bed & Breakfast (newmex.com/dobsonhouse)

touches on the exterior. Full-time effort and more helpers can reduce construction time to several weeks.

Load-bearing walls are 3-foot-thick stacks of soil-filled automobile tires, with empty aluminum cans and packed earth filling voids between them. Builders spend 15–30 minutes and untold amounts of energy sledgehammering each tire full of compacted dirt. Each resulting "brick" weighs about 300 pounds. Depending on the particular design, a 2,000-square-foot home uses roughly 1,000 tires. Inside the house, thousands of empty aluminum cans embedded in mortar form the non-load-bearing walls, stairs, built-in planters, and even free-form bathtubs. Interior and exterior walls are finished with a smooth covering of plaster, mortar, or stucco.

WOOD YOU TEACH ME?

Building materials for underground homes described so far in this chapter include concrete, steel, mortared stones, automobile tires, and aluminum cans. Would wood work? Survivalist Mike Oehler says "yes." In 1971, he built a simple, one-room home on his 40-acre homestead in Idaho, using timber he cut from the site. "The original house that I built in 1971 for $50 is still the functioning bedroom in my palatial $500 underground house which I completed in 1974," he wrote in the January/February 2001 issue of *Countryside and Small Stock Journal*. "I love my snug, little pine-paneled, forty-windowed, wall-to-wall carpeted, 370-square-foot underground home."

Oehler's structural technique, which he calls post/shoring/polyethylene (PSP), consists of the following steps:

- Dig a hole slightly larger than the intended structure.
- Embed upright wood posts around the perimeter of the building. To keep the bottom ends of the posts from rotting, Oehler chars them over an open fire and then inserts them into plastic bags before standing them in the post holes.
- Place boards between the outer surfaces of neighboring posts to form exterior walls.
- Cover the exterior surface of the board walls with polyethylene sheeting to seal out moisture.
- Backfill the space between the plastic-covered wall and the sides of the original excavation.

Construction of the roof follows a similar procedure of placing wood girders between the walls' upright posts, laying beams between the girders, and covering the surface with boards. After waterproofing the roof with roofing felt or tar paper and adding a layer of polyethylene sheeting, the building is covered with soil.

To enable other people to build their own versions, Oehler explained his system in *The $50 & Up Underground House Book* in 1978. Determined to prove that underground houses do not have to be bunker-like, he began teaching one-day workshops covering design principles. In 1993, he replaced the in-person workshops with a set of video tapes and workbooks.

After thirty years of satisfaction with his underground home, Oehler decided to move. Civilization was creeping too close to his treasured seclusion, so he planned to build a new home on a more isolated part of his homestead. "And though I may modify it to put one layer of the new inexpensive rubberized swimming pool liner material on the roof, the home is going to be post/shoring/polyethylene construction," he wrote in the *Countryside* article. "Twenty-nine years of field testing the system has convinced me. P/S/P? You bet!"

Wendy Martin is not quite as confident. She used Oehler's book as a guide for building her underground home in Calais, Vermont. "The PSP system is OK for quick and cheap," she wrote to the *Homestead* Internet mailing list in 1999, "but we have redone three of the walls and will be doing the remaining one this summer." She reported that mice, moles, and the roots of trees and bushes had penetrated the single layer of polyethylene, causing the walls to leak. She replaced it with multiple layers consisting of a sheet of inner-tube-like rubber, 6-mil-thick plastic sheeting, a Styrofoam insulation panel, and another 6-mil plastic sheet, followed by a layer of cardboard to protect the plastic during backfilling. Martin also wrote that when she unearthed and rebuilt the walls, she nailed the exterior wall boards to the upright posts, a step Oehler's book apparently omitted. She found that without having done that initially, the walls had developed bulges from the earth's side pressure. Despite having to redo much of the construction, she remained dedicated to underground living. "I like it here," she wrote. "You couldn't make me live in a regular house!"

Cordwood(n't) Masonry

At first glance, builder/author Rob Roy seems to have built underground houses out of wood. His favorite building material is surplus log ends from a lumber mill. Arranging the log ends much as one would for stacking firewood and affixing them with liberal amounts of mortar creates a system Roy calls "cordwood masonry." One of his most publicized projects is an underground home called Log End Cave, which he built near the Canadian border in east-

ern New York in 1978. Truly a "cave" (i.e., underground structure), the house could barely be called a "log end" creation. The underground portions of the house were built of concrete blocks, while cordwood masonry was used only for the relatively small above-grade walls.

"We lived in Log End Cave, summer and winter, for three years," Roy wrote in his book *Complete Book of Underground Houses: How to Build a Low-Cost Home.* "We've seen the outside temperature vary from -40° to 90°F, while the interior temperature ranged from 58° to 77°F." His growing family needed more space, however, and enlarging the underground home would have been too difficult. In 1982, Roy built Earthwood, a larger cordwood masonry home that is somewhat earth sheltered. A berm protects the northern exposure of the cylindrical, two-story house—about 40 percent of the wall space. Once again, he used cordwood masonry for the exposed surfaces, and concrete blocks for the earth-covered ones. The roof, supported by radially arranged 5-by-10-inch pine rafters, is covered with 8 inches of soil and native grass.

Like Michael Reynolds and Mike Oehler, Rob Roy chooses to rely on alternative energy resources rather than the commercial power grid. "The house gets all its electrical energy from wind, solar, and 'son' power," Roy wrote in the Fall 1992 issue of *Back Home*, "the last being 16-year-old Rohan, whose mountain bike is mounted to a commercially available generator." Apparently, Rohan provided only backup power, however, as the photovoltaic panels and windmills normally generate enough electrical power.

Deeply Introspective

Some people build houses underground to preserve natural vistas. Although the site must be disturbed during the construction process, it is subsequently restored to its original state or even improved with artful landscaping. Often, scenery-loving owners also want to enjoy views while inside their homes. One way to do that is to include large windows. Another way is to create unique, scenic interiors.

Don't Metz with the View

The hilltop property architect Don Metz owned in the White Mountain community of Lyme, New Hampshire, offered a beautiful view of the countryside. It was also a lovely scene itself. "I was bothered by the prospect of anything other than the low-profile, 'anti-building' solution I knew the site demanded," Metz told *Architectural Record* in 1974. So he designed an earth-covered house that blended with the site, borrowed money to build it on speculation, and acted as general contractor to supervise—and participate in—the construction. The 2,800-square-foot home sold before it was completed in 1972.

The single-story home and its attached garage nestle into the hill crest, its 16-inch-thick soil cover welcoming the area's native grasses and wildflowers. The house's 60-foot-long south face is almost all glass, inviting not only visitors but also daylight and warm winter sunshine. A roof overhang denies entrance to overly warm summer sunbeams, which come from a higher angle. The Winston House (named for its first owners) looks very much like a contemporary surface residence from the front, except for the frizz of vegetation on the roof. From the rear, its only visible features are back-to-back daylight monitors and a small enclosure hiding the necessary rooftop vent pipes.

Success frequently breeds sequels. Pleased with the way his first underground house turned out, Metz promptly started planning an earth-covered home for his own family on top

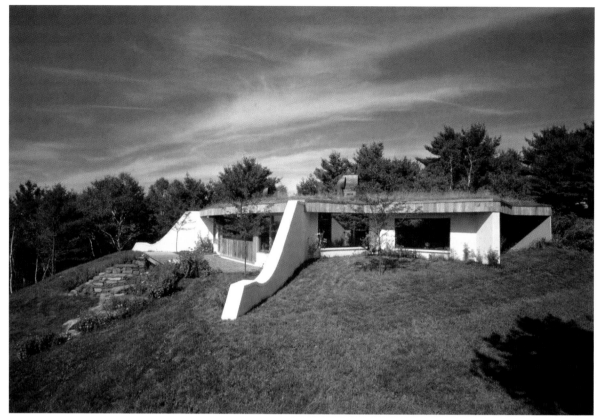

A pair of stone retaining walls, visible in the hill at the left side of the photograph, clear an opening for the glass walls of Baldtop Dugout's basement level. Courtesy of Don Metz, Architect

of a neighboring hill. Doing much of the construction himself, he completed Baldtop Dugout in 1979. This time, he covered only the roof and most of the north wall, where the front door opens between two roof-high hills. Daylight streams into the house through two skylights as well as through windows in the exposed west, south, and east walls. Embellishing on the more subtle versions he used on the Winston House, Metz designed sweeping wing walls that project outward from the southwest and southeast corners of his home. Their light-colored surfaces reflect soft, indirect light into the building's interior. Their primary function, though, is to interrupt wind currents that would otherwise bleed heat from the house through the large glass surfaces.

Along with various styles of skylights, extensive windows are an important feature of all the earth-sheltered houses Metz has designed. In 1982, when *Architectural Record* selected another of Metz's creations as a House of the Year, the magazine noted the importance of allowing abundant daylight into the building from a horizontal perspective. "The horizontal line of sight is our natural aspect," Metz said, "whereas light from above adds to our sense of being 'down under.'"

VIEWS WITHOUT WINDOWS

Hills and trees surround Glenn Young's rural home in eastern Texas, midway between Houston and Dallas. Yet, inside the house, the views include a Mexican beach, an Egyptian desert, a Mediterranean villa, a jungle with a waterfall and Mayan pyramid, and cloud-sprinkled skies. There is even a "cosmic portal"—a spiral of stars adorns the curved walls and ceiling of

the arched passageway leading to a meditation room. Only the home office is not decorated with painted scenery; a clean, white interior establishes its uniqueness within the exotic abode. For seeing the outside world around the house, Young uses a closed-circuit television system rather than windows.

The curved surfaces within Young's house are particularly well suited to the artistic landscapes, which were created by Houston artist James Perez. The 3,000-square-foot home consists of a cluster of five connected domes. The smallest, 10 feet in diameter and little more than 5 feet high, contains only the meditation room. The largest, 38 feet in diameter and 19 feet high, is an expansive space in which equipment and furniture groupings establish living, dining, and cooking areas. Other domes are divided more formally, with interior walls defining bedrooms and bathrooms.

Young and his friend John St. Pé built what they call the "invisible dome home" in 2000 using a building system promulgated by the Monolithic Dome Institute of Italy, Texas. Although such domes are usually built above ground, they can easily be modified to support the additional weight of an earth cover. The basic construction process begins with framing and pouring a concrete footing and floor. Then a fabric "airform" of the desired size and shape is attached to the footing and inflated using a fan to force air into the interior. A 3-inch-thick layer of polyurethane foam insulation is sprayed onto the interior surface of the inflated airform. Anchored by hooks inserted into the insulation foam, a grid of reinforcing steel bars is fashioned over the interior surface. Finally, a 3-inch-thick layer of shotcrete is sprayed over the

Wood and brick surfaces create visual warmth inside Don Metz's Baldtop Dugout. Masonry walls and floors enhance the house's passive solar qualities. Courtesy of Don Metz, Architect

The interior surface of each room in Glenn Young's home has been covered with murals, so a walk through the house is a trip through time and space. Paintings in the great room depict Mediterranean architecture and scenery.
Courtesy of Monolithic Dome Institute and Dome Contractors Inc.

One of the bedrooms in Young's underground dome home features the scenery of Acapulco Bay, Mexico. A doorway is barely noticeable beside the chest of drawers. Courtesy of Monolithic Dome Institute

rebar to complete the continuous wall and ceiling structure. The airform is left in place to act as a waterproofing membrane.

After finishing Young's house, the two men were so enthusiastic about the process that they started a business, Dome Contractors, Inc., to design and build monolithic dome structures. Using spherical or elliptic domes of high or low profiles, they can create a variety of shapes for residential or commercial uses.

Young uses many adjectives to describe his subterranean home: quiet, secure, private, low maintenance, long-lasting, energy efficient. He is proud of the fact that, following a detailed topographic profile he created before excavating a 200-by-75-foot hole 30 feet down into the hilltop, he was able to accurately reconstruct the original landscape. There was a less tangible, personal benefit, too. When a writer for *Monolithic Dome Roundup* magazine asked why he wanted an underground home, Young replied, "I like to be different. Being underground is futuristic, and I like that."

INSIDE & OUTSIDE UNDERGROUND

Gerard Henderson went over the top with the design of his underground home in Las Vegas, Nevada. Following the 1962 Cuban Missile Crisis, the former Avon Cosmetics executive built it as a haven from a potential nuclear war. However, the unusual structure is more a mansion than a bunker. It encompasses 16,000 square feet of "outdoor" and "indoor" living areas in a cool, secure chamber 25 feet below ground. Originally, the only visible features on the property were trees and a cluster of boulders. To enter the hidden world, a person opened a

High, sloping ceilings and expansive windows create a sense of spaciousness and establish a strong connection with the subterranean grounds of Gerard Henderson's home.
Courtesy of Thomas "Tex" Edmonson, Owner

wrought iron gate, walked into a cave-like opening in one of the boulders, and descended in an elevator. In the 1980s, the boulders were removed and the entrance was incorporated into a surface house, which is now used as a caretaker's residence.

Insulated from the noise of the outside world, the subterranean chamber contains a fanciful garden area bordered by two ranch-style brick houses. The main house looks and feels like any other luxury home—beautifully draped and carpeted, equipped with elegant fixtures, and decorated with distinctive antiques. It includes two spacious master bedroom suites and a 1,900-square-foot living room designed for entertaining. The companion building is a one-bedroom guest house.

The "outdoor" garden area features flagstone patios and a lawn of variegated-green carpet that resembles grass. A four-hole putting green graces the lawn, and a 15-foot waterfall feeds the heated swimming pool. Exposed sections of the chamber walls are covered with murals that depict scenery from New Zealand, Colorado, South Carolina, and Southern California. An arrangement of rocks from Utah accents the transition from real space to the murals' virtual space. The tops of realistic replicas of trees disappear into a flat, sky-blue ceiling that is dotted with painted clouds. Besides their role as landscaping, the artificial tree trunks

The weather is always perfect for "outdoor" activities at the Las Vegas underground estate. Next to the guest house, a mock boulder conceals an electric barbecue grill. Courtesy of Thomas "Tex" Edmonson, Owner

mask such utilitarian elements as the vent duct for the barbecue grill and the chimney for a wood-burning fireplace in the main house. A computer-controlled lighting system automatically varies the illumination to mimic daylight patterns from dawn through sunset and dusk. At night, the ceiling sparkles with simulated stars and a faux moon.

The expanse of the underground chamber, its flat roof, and the thickness of its earth cover imposed substantial load-bearing requirements on the structure's design. A grid of 24- and 36-inch steel girders supports a 10-inch-thick concrete slab roof that was poured onto a deck of corrugated steel panels. Exterior surfaces of the concrete shell are sealed with a three-layer waterproof membrane that is covered with rigid foam panels to provide thermal insulation and also to prevent membrane punctures from soil abrasion.

As a homeowner, Henderson loved this underground home and a similar one at his Colorado ranch. As an entrepreneur, he believed they represented the wave of the future. Along with Kenneth and Jay Swayze, the builders of his two houses, Henderson formed the Underground World Home Corporation to market the concept. For the 1964–65 World's Fair in New York, they built a three-bedroom prototype, which 516,000 people visited during its first six months on exhibit.

Henderson's heirs eventually sold the Las Vegas home. The current owner, Thomas "Tex" Edmondson, retains a local booking agency, Activity Planners, Inc., to make the unique venue available for corporate special events. Each group of guests is treated to a guided tour that acquaints them with the house's many amenities and its colorful history.

SHAPE UP DOWN THERE

"No house should ever be *on* a hill or *on* anything," Frank Lloyd Wright wrote in *An Autobiography*. "It should be *of* the hill. Belonging to it. Hill and house should live together each the happier for the other." Energy crises and international conflicts come and go, but aesthetic appreciation is enduring. A desire to live in harmony with the beauty of nature has been an important motivation throughout the modern history of earth-integrated housing.

THROW ME A CURVE

William Lishman got the idea for his underground house from nature, but it was not mountains, seashores, or deserts that inspired him. It was an igloo. A naturalist who helped found Operation Migration, which uses ultralight aircraft to guide migrating birds, Lishman enjoys living in a rural area northeast of Toronto, Ontario. During the early 1970s, Lishman built a small igloo and discovered two surprising characteristics of the structure: It could be kept comfortably warm using only the heat generated by the bodies of its occupants, and it could be illuminated with a match flame that was amplified by the curved, white walls.

At that time, Lishman was living in a drafty, hard-to-heat conventional house that sat exposed to the weather on top of a hill. Intrigued with the idea of building a snug home, he read everything he could find about energy-efficient and earth-sheltered housing. Guided by the mind of an inventor and the eye of a sculptor, he devised a plan consisting of an underground cluster of connected domes.

Creative thinking often outpaces practical considerations. Fifteen years passed before Lishman's vision was clarified into a set of construction plans and he had amassed the financial resources to begin building. Then he sliced away the top of a hill and poured a concrete foundation, embedding rubber tubes into the slab to carry water for in-floor heating,

"The idea of putting a square home under the earth made no sense," William Lishman recalls on williamlishman.com. "Caves are not boxes, and the box is not a shape that lends itself to the immense load of earth above." As shown in this construction photograph, the only flat surfaces in his house are in two entrance foyers. Originally built as solariums, they were eventually converted to more energy-efficient wood-frame rooms. Courtesy of William Lishman

and including ample conduits for possible wiring needs in the future. He built steel frames for seven onion-shaped domes, welding a network of rebar between arched vertical trusses. After moving the frames into position on the foundation and linking them together, he covered them with a mesh known as expanded metal lathe. The final construction step was applying gunite. For the last interior layer of gunite, Lishman mixed powdered marble with the concrete to create an attractive wall finish. Modeled after a ferro-concrete technique used for building boats, Lishman's construction system resulted in a watertight structure.

The exterior surface was also treated with multiple layers. First came a waterproofing coat of tar. The next layer, which was thin near the top of the dome and several feet thick near the bottom, consisted of dry sand. A network of tubes was embedded into the sand to circulate air warmed in two solariums attached to the house. The sand layer was covered with a layer of vermiculite insulation and a rubber membrane before adding a final layer of topsoil and seeding it with grass.

The interior of Lishman's curvaceous home is decorated more with form than with images. In fact, he remarks that it is difficult to hang pictures on the nonflat wall surfaces. Rounded cupboards, countertops, and furniture were custom made. Even the door hinges for the unique, truncated ellipse-shaped interior doors had to be hand crafted. Some visitors are distracted by the acoustic characteristics of the hard, curved interior surface, but Lishman himself likes the effect. "With two tiny speakers, I get almost 'concert hall' quality music," he says.

DUNE DOMES

Architect William Morgan's first earth-roofed residential buildings are nearly invisible inside grass-covered dunes on the seashore of Atlantic Beach, Florida. Within the sandy mound

nestle two egg-shaped, one-bedroom apartments. On the ocean side, all that is visible is a pair of oval openings that enclose small patios. At the rear of each patio is a glass wall that forms one end of the apartment's living room. On the landward side of the dune, twin paved walkways curve around a greenery-filled island of soil before joining at a vertical concrete swirl that frames a wood-paneled exterior foyer. The dune itself, which was removed during construction of the apartments, was carefully resculpted to its original contours after the building was completed.

Each cozy, 750-square-foot unit is a two-story apartment. The front door is at the loft level, which contains an interior foyer, a bathroom, and an open-ended bedroom that overlooks the living area below. A kitchen and dining area occupy the lower-level space under the loft. The wood of the loft structure and interior stair wall compliment the concrete surfaces of the

Door panels and floors are among the few flat surfaces in William Lishman's home. The door frame conforms to the curvy contours of the walls, but hexagonal bathroom tiles introduce linear accents. Courtesy of William Lishman

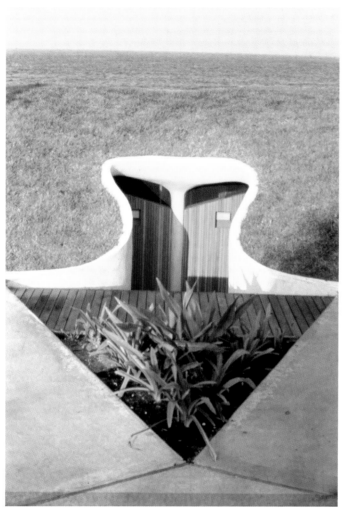

Down a short flight of stairs, the entrances to the two dune houses face each other across an outdoor foyer. The mirror-image apartments are covered with at least 22 inches of sandy soil. Courtesy of William Morgan Architects; Photo by CPS Larry Amato

perimeter walls. One long wall of the apartment curves in an oval arc reminiscent of the dune itself. The other long wall, which separates the apartment from its twin, is straight, offering visual contrast and a flat surface for interior decoration.

The design of the dune houses was groundbreaking in two ways. First, it was one of the first subsurface buildings to use the earth cover as a structural element. "We designed the shells in careful balance with the surrounding earth so that the inward pressure of the earth presses uniformly on the shell, locking or post tensioning the gunite shell in place," Morgan told the authors of *Earth Sheltered Housing Design*. "The structure actually is stronger because of the earth pressing on it." Second, the design process employed computer modeling rather than blueprints—an innovative approach in 1974. Even the elliptical shape of the shell was determined by a computer analysis devised to maximize floor space and optimize the load-bearing characteristics of the structure.

To turn the computer-generated design into to a physical reality, Morgan and his design engineer came up with a grid-based system. First, a reinforced concrete floor pad was poured, with rebar extending upward from a raised perimeter edge. The builder then used chalk to mark a grid on the surface of the floor. For each intersection point of the grid, a pole was fashioned to represent the desired height of the shell at that spot. Using those guideposts, the builder formed arches of rebar that spanned the oval foundation and created a three-dimensional gridwork. Covering the gridwork with mesh provided an adequate surface onto which a half-inch-thick layer of gunite could be sprayed. After hardening overnight, this shell was sturdy enough to act as a form for a 2-inch-thick layer of concrete that was sprayed onto its interior. The following day, another 2-inch- thick layer of concrete was sprayed onto the exterior surface. Finally, a liquid bituminous waterproofing layer was brushed onto the outside of the shell. The entire process, from excavation to earth covering, was completed in six weeks.

An environmentally conscious architect, Morgan designed the dune houses to blend with the natural landscape and preserve the view of their neighbors. Twenty-five years after building them, he reports that the rental units, which he still owns, are never vacant. About the same time that he designed and built the dune houses, he devised an alternative, straight-

Artistic lighting and a 17½-foot-high ceiling supplement the contrasts of color, texture, shape, and floor levels to create an interior that is both spacious and cozy. Courtesy of William Morgan Architects; Photo by Alex Georges

walled version of two- and three-bedroom duplexes to be constructed with concrete block walls and precast concrete panel roofs. Planned for construction in dunes on Amelia Island, Florida, the project was halted by opponents who objected to disturbance of the landscape, even though it would ultimately be reconstructed to its natural profile. Morgan reports that, ironically, dunes in that area were eventually flattened for construction of a golf course community.

I Get the Point

In sharp contrast to the flowing curves of his dune houses, William Morgan's Hilltop House crowns a shallow hill with the crisp lines of a square pyramid. The result is a harmonious and intriguing interplay of geometrically different elements, combining a circular, grass-covered mound with a cap of triangular planes punctuated with rectangular openings. The imaginative design constitutes Morgan's answer to a client who requested a "why has someone not thought of it before?" house.

Built in 1975 near Gainesville, Florida, the house encompasses 3,300 square feet, much of it hidden within the hilltop. Enclosed by grass-covered berms, the main floor consists of three rectangular wings emanating from a central foyer. One wing contains a kitchen and dining room, another holds a study, and the third consists of two bedroom suites. An outdoor patio adjoins each of these rooms, cutting through the hillside to provide abundant window space and exterior doorways. On the fourth side of the central hall, the house's front door faces an open-air court that leads to a two-car garage embedded in the hill's southeast face. Above the central portion of the house, a second-story "observatory" room with four windowed walls overlooks the surrounding citrus groves.

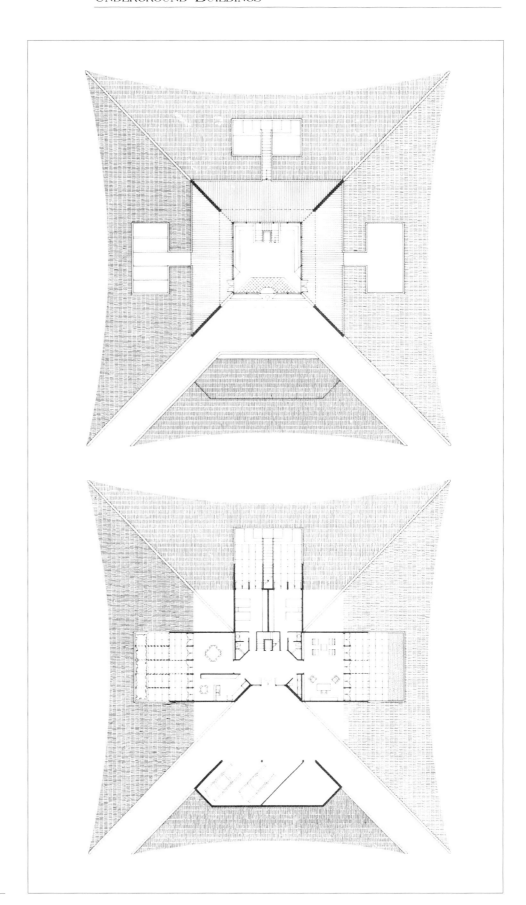

Generous patios, which are half-covered under the grassy roof of the Hilltop House's main floor, take advantage of Gainesville's warm, rainy climate. The front doors are recessed under the observatory room's roof overhang, and an un-roofed corridor between the house and its two-car garage creates a conventional entrance to an unconventional dwelling.

Courtesy of William Morgan Architects

"It is a building as landscape," Morgan said of Hilltop House in an April 1978 *AIA Journal* article. Some twenty-five years later, he is still passionate about the concept of earth-integrated architecture. "I can't think of another building system that's so vastly underutilized," he says. "I think we in the design profession have been too timid. Earth building has such great potential, *tremendous* potential. But we seem to be afraid of ourselves when it comes to the idea of shaping our environment. Up with the earth!"

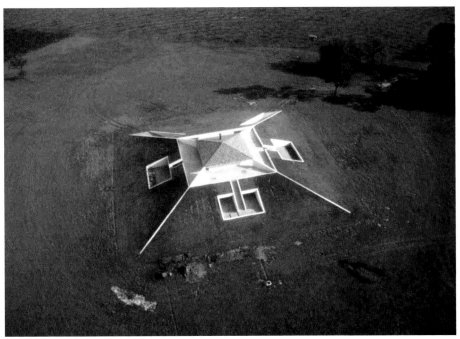

Rectangular patios grace three sides of the Hilltop House. On the fourth side, two elongated portals serve as the entrance and exit for the garage. A narrow, vertical slice in the upper level of the hill separates the garage from the house. Courtesy of William Morgan Architects; Photo by CPS Larry Amato

PART III

SINKING YOUR TAX DOLLARS INTO THE GROUND

5

SUBTERRANEAN SCHOOLS

The sharp increase in the birth rate following World War II is well known as the "baby boom." Two generations later, the educational institutions of North America are bracing for a "student surge." The National Center for Education Statistics estimates that U.S. elementary and secondary school enrollment will increase by half a million students between 1999 and 2005, partly as a result of a "baby boom echo." Between the mid-1970s and 1990, the U.S. birth rate rose by 25 percent. Increased immigration is also swelling school enrollment. Between 1970 and 1990, the foreign-born population of the country doubled to about 20 million.

Statistics presented in the *School Planning and Management 2001 Construction Report* are impressive:

- In 2000, spending on U.S. school construction topped the previous yearly high by nearly 18 percent.
- Of the $21 billion dollars spent by public school districts in 2000, 45 percent funded new construction, and 30 percent paid for expansion projects.
- Spending levels are expected to remain essentially constant for several more years.

Well-conceived new school buildings can generate both economic and educational benefits. Graffiti-resistant designs and materials can reduce maintenance costs, for instance. Energy efficiency can generate substantial savings. Kindergarten through high school institutions spend approximately $6 billion a year on energy costs, according to a February 2002 *ENR* [*Engineering News Record*] report. Putting that in perspective, the magazine points out that saving 25 percent of the energy expenses would pay for 30,000 additional teachers. New school designs promote better student performance by blocking out external noise and by drawing more daylight into the classrooms through windows and skylights. Underground construction can provide all of these benefits.

IT'S ELEMENTARY, MY DEAR ARCHITECT

The United States' first wave of underground school construction was triggered, not by economic necessity or educational strategy, but by basic survival needs. In 1962, during the heat of the Cold War, the nation's first underground elementary school, designed to double as a fallout shelter, was built in Artesia, New Mexico. The following year, a junior-senior high school opened under the city of Laredo, Texas. These schools proved to be pleasant, successful learning

environments. Subterranean schools quickly became popular through the south-central portion of the country, where they sheltered students from destructive thunderstorms and tornadoes as well as potential atomic bomb attacks. As the following examples show, underground school construction eventually spread across the county. Although it remains a small percentage of the nation's K–12 infrastructure, it still surfaces as the best solution for certain problem situations.

A Is for Abo

The city of Artesia sits on the plains of southeastern New Mexico. If the proverbial crow flies 100 miles to the west, crossing the Pecos Plains and the Sacramento Mountains, it arrives at the Trinity Site, where U.S. scientists detonated the first atomic bomb on July 16, 1945. As the Soviet Union became a nuclear power and international tensions mounted, Artesia's townspeople were well aware that a Strategic Air Command base and an Atlas missile site were within a 50-mile radius of the city. It is no wonder that, in 1962, the community built its new elementary school to double as a fallout shelter. Designed to house 540 students, it could harbor 2,160 community residents in the event of an enemy attack or a violent storm. Completely recessed into the ground, the building was roofed with a 21-inch-thick concrete slab.

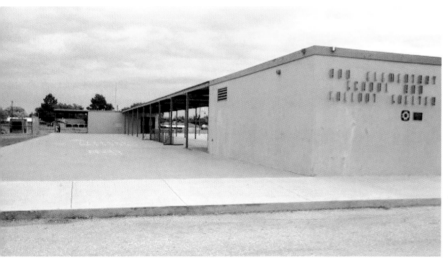

The director of the US Department of Defense Office of Civil Defense presided over the dedication of Abo Elementary School and Fallout Shelter on June 12, 1962. The facility was called a "pilot project for the atomic age." Forty years later, all its sturdy, simple exterior needs is a little paint. Courtesy of Artesia Public Schools

Other than two full-size basketball courts on the roof, the building's only visible features were three windowless blockhouses that enclosed the stairwells leading down to the school. Covered, open-air walkways connected the small entrance structures that marked three corners of the rectangular building. The district called the facility Abo (AH-bo) Elementary School, naming it after a nearby 7,000-foot-deep geological formation that contained a major oil deposit.

From the beginning, the school attracted nationwide attention. A pre-dedication open house, planned as a local event, drew an unexpectedly large crowd, including 3,500 people from thirty-eight cities in twelve states. The formal dedication was an even bigger event. During the next several years, the school was featured in all forms of national news media.

Architect Frank Standhart, who designed Abo School, was an early proponent of windowless schools and had previously designed several aboveground versions. He believed them to be superior educational environments because uninterrupted walls prevented external distractions, created more display space, and eliminated the tasks of washing dirty windows and replacing broken panes. He asserted that complete control of classroom lighting eliminated glare, produced uniform intensity throughout the room, and improved conditions for audio-visual presentations. In addition, better temperature control in windowless buildings contributed to comfort, and filtering the entire air supply reduced dust and other allergens.

Standhart estimated that recessing the building into the ground would increase its cost by about 30 percent. The U.S. Department of Defense's Office of Civil Defense contributed

the additional funding with the understanding that the psychological effects of attending school underground would be evaluated. The unique school attracted several researchers who examined physical as well as psychological factors. The school district conducted vision exams during the first four years of the school's existence and found no harmful effects on the eyes. Students with severe asthma and allergy problems were transferred from other Artesia schools to Abo, and their health improved along with their attendance records. One federally funded study evaluated factors such as academic achievement, absences, physical health, and overt behavioral problems. "We conclude that the Abo Elementary School and Fallout Shelter had no detrimental effects on the achievement of its pupils," its 1972 final report stated. On a less formal level, five years after the school opened, Abo Principal Dean Robinson declared, "We have, I believe, the happiest, most contented students and teachers you would find in any school building in New Mexico. I doubt if anyone in Abo School would trade positions with anyone else if they were given the choice."

What was the fate of this exemplary school? In 1995, it was replaced with a new, aboveground structure. Several factors contributed to the change. For one thing, after three decades of use, the underground building needed repairs and improvements. Getting machinery down into the building to fix the mechanical equipment and ductwork would have involved unearthing a wall, creating an opening in it, and then resealing and recovering the structure. Necessary removal of asbestos and lead paint would have further inflated the cost. Increasing enrollment and changing activities meant more space was needed for additional classrooms and features such as a multipurpose room large enough to accommodate basketball games. Despite the recognized advantages of the underground experience, the district decided to construct a replacement school above ground because it would be easier to add on to, easier to access for repairs, and less expensive to build.

Demolishing the retired, underground school was another expense the district chose to avoid. Instead, the building has become a subterranean storage shed.

A Hill with a School Inside

Terraset Elementary School in Reston, Virginia, became the flagship of the second wave of U.S. underground school construction. Built in 1977 during the national energy crisis, it was placed underground specifically for fuel conservation. Built for essentially the same cost as a comparable aboveground facility, the school was designed to save half the energy costs of a conventional school building.

During the school days, the building is filled with active bodies and humming equipment, both of which generate heat. The earth cover prevents this heat from escaping, and most areas need to be mechanically cooled during school hours in all seasons of the year. Less-protected areas near windows need to be heated during cold weather, as does the entire building when it is not occupied. A heat reclamation system collects excess heat during school hours and releases it into the building when and where it is needed.

Energy conservation influenced the school's shape as well as its placement underground. The classrooms are located in four circular chambers that cluster around a central media center. Approximately one-third of each chamber's wall consists of windows that peer out between the earth berms that cover most of the school's exterior. Making these exposed walls round minimizes their size with respect to the area they enclose, which in turn minimizes their energy loss. This actually amounts to fine-tuning, because 75 percent of the energy loss from a typical one-story building occurs through the roof, which at Terraset is covered with at least

2 feet of soil, grass, and shrubs. The only exposed roof features are a pyramid-shaped skylight and a few concrete boxes that enclose vent pipes.

When planning Terraset, architect Douglas Carter and the Fairfax County school district had to address another issue besides energy conservation. Every bit as practical but less quantifiable was the question of community acceptance of an underground school. "We held a series of community meetings in and around Reston, and we did get some of the really predictable reactions," Carter reported at the Going Under to Stay on Top conference in 1979. "'You can't send my kid to a buried school. I just won't have it.' . . . 'What are you going to do when the kids sit on that cold, damp basement floor?' There were questions about mildew in summer, and there were all kinds of negative reactions." To counter these emotion-based objections, Carter constructed a model of the proposed building, with a removable roof. That was effective, he said: "With the roof off the building, they could see that there were really no areas in the building where their children could not see out."

Another lesson Carter learned during the community review process was that word choice is important. At first, he described the building as "a buried school," he told the *AIA Journal* in November 1978. Realizing that this provoked unpleasant images, he consulted with his staff to

Shrubs and grass cover the ground-level roof of Terraset Elementary School. The sunken front courtyard was originally covered with a solar collector consisting of water-filled glass panels supported by a network of metal trusses. Unable to solve persistent leakage problems, the school eventually removed the collector. Courtesy of Terraset Elementary School; Photo by Mike Savage

come up with more positive terminology. Building on the Latin root *terra* (earth), they coined the word *terraset* to explain that the school was "set in the earth." The word proved so useful that it was adopted as the official name of the school.

Fostering public acceptance was important for the project's success. It was also essential that the architect and engineers design the building so it would perform as touted. One of the most persistent concerns with an underground building, for example, is that its roof might leak and require expensive and troublesome repairs. Before covering Terraset with soil, its builders conducted three leakage tests. Each time, the entire roof, which had been sealed with rubberized-asphalt, was flooded with water. A few leaks were found and fixed before the earth cover was applied. "It's the only roof we have in the school district that hasn't had a leak," a school engineer told *Smithsonian* magazine in February 1979.

As Abo Elementary School had a decade earlier, Terraset attracted a great deal of attention when it was completed. Perhaps because of the nation's intense interest in energy conservation, and perhaps because of Terraset's proximity to the nation's capitol, the school had to cope with an almost disruptive level of publicity. "Since school opening some two months ago, between 10,000 and 12,000 people have visited the building," Carter wrote in the July 1977 issue of *Civil Engineering* magazine. A continuing demand for information and tours led to construction of an adjacent visitor center operated by the Terraset Foundation.

SMALL SPACE? SUBMERGE SCHOOL.

Architect Ralph Allen's first recessed school buildings were constructed after Abo and before Terraset. The reason he sank them into the earth received less national attention than the Cold War or the energy crisis, but it was a problem that continues to plague school districts with limited amounts of space and/or finances. School campuses need acres of land, and building code requirements limit the designer's ability to squeeze a school into a below-standard area. In neighborhoods, where schools are usually built, houses occupy most of the land. Even if a large enough parcel is available, it may be prohibitively expensive.

This was Allen's dilemma when he designed Fremont Elementary School in Santa Ana, California. It was a new school in an existing neighborhood, and the readily available site was only 2.8 acres. The smallest site for other schools in the community was about 4 acres. Allen's solution was simple but innovative. Rather than spreading the building, playground, parking lot, and landscaping out in a single layer, he saved space by stacking two of the components. The school building nestled half a story down into the ground, with earth berms covering much of the exterior wall area. The berms placed the school's roof at the crest of a shallow hill, an ideal place for a playground.

The rooftop play yard made a lot of sense, but Allen and school personnel feared it might also make a lot of noise in the classrooms below. The concrete roof, which was heavily reinforced to bear the impact of hundreds of hopscotching feet and dribbling basketballs, was poured in two layers separated with acoustical insulation. The classrooms stayed quiet (free of external noise, at least). They also stayed cooler in the summer and warmer in the winter. Decreased energy demands, lower maintenance costs, and savings from not having to buy a larger parcel of land combined to offset the 8-percent higher cost of building the structure underground.

Like Abo Elementary and many other schools built in the early 1970s, Fremont's classrooms are windowless. Educators of that era tended to favor such distraction-free environments, even in aboveground buildings. Robert McDonald, Fremont's principal in 2002, points

to this as the structure's least attractive feature by today's standards. One of Fremont's virtues, McDonald says, is its adaptability. In accord with popular education theories of the time, it was built as an open-plan structure with few interior walls. As teaching methods changed, it was easy to insert and remove walls to create any desired arrangement.

McDonald is pleased with the building's overall performance. Plans to modernize the building involve relatively minor improvements such as repainting rooms; replacing carpet; and upgrading the alarm, public address, and electrical systems. Rest rooms will be

Fremont Elementary School nestles unobtrusively in a quiet neighborhood. Placing the building half a story below grade makes both the school and the rooftop playground essentially ground level.

reconfigured to accommodate more adults, reflecting the fact that since the school was designed the student-teacher ratio has decreased from 30-to-1 to 20-to-1. "It's a very solid building," he says. "We've had several earthquakes since [it was built in 1973], and there's been no problem with that."

SON OF SUBMERGED SCHOOL

It is not unusual for designers of underground schools to produce sequels. Four years after Abo Elementary School was built, Frank Standhart designed Goddard High School in Roswell, New Mexico, with the classrooms and offices safely below ground. Two years after Terraset Elementary School opened, the Fairfax County school system built Terra Centre Elementary School using a revised version of Douglas Carter's set-in-the-earth design. Nearly twenty years after Fremont Elementary School opened, Ralph Allen was asked to design a new subsurface school in Los Angeles, California.

Allen was chosen specifically for his experience with designing underground school buildings. Kenneth Moffett had already made up his mind that was the kind of school he wanted. Moffett had been superintendent of the Lennox School District in Los Angeles almost as long as Fremont Elementary had been open in Santa Ana. The need for a new school arose when the California Department of Transportation (Caltrans) announced that one of the existing schools would have to be demolished to clear the way for construction of a new freeway. Moffett faced the task of negotiating the design and construction of the replacement school with Caltrans, which would pay for the project.

Two substantial problems faced the Lennox district, and Moffett wanted the new school to incorporate solutions to both of them. One was noise. The district sat in the flight path of Los Angeles International Airport, and every five minutes or so, commercial planes roared over at elevations as low as 200 feet. Administrators in the district had tried to minimize the classroom disruption by covering their schools' windows with boards and bricks. Moffett knew he could eliminate the noise in the new school by placing it at least partially underground.

The other major problem was crime. "Every weekend, we'd have young adults breaking in to take typewriters or other pieces of equipment," Moffett told *The American School Board Journal* in January 1993. He knew that surrounding the building with soil would make it much less accessible to thieves. On the other hand, he wanted the exterior of the school to be inviting

A grassy park adjacent to Fremont School supplements the concrete playground on the building's roof. After recess, students walk down a half-flight of stairs (left of the trees at the center of the photograph) to the classroom level. The school's main entrance is behind the shallow berm and retaining wall.

and the interior to be enlivened with daylight. He and Allen found a solution: Large portions of the building's exposed walls were constructed of 3-inch-thick, solid-glass bricks. Although it was expensive, the material was soundproof, bulletproof, and graffiti resistant.

At first, Caltrans rejected the plans as unnecessarily expensive. Moffett thought he could justify the design by explaining how the building's thermal efficiency would save energy costs. Caltrans replied that the offset was not equitable because the school district would enjoy the savings, while the extra construction cost would come from the state's transportation budget. Recognizing the validity of this argument, Moffett tried another approach. "I suggested a swap," he wrote in the April 1994 issue of *The American School Board Journal*. "The district would accept a smaller parcel of land for the new school if Caltrans would agree to fund construction of a more expensive underground facility." This tradeoff balanced the equation, and Caltrans agreed. The new school would occupy 9.3 acres rather than the usual minimum of 12 acres.

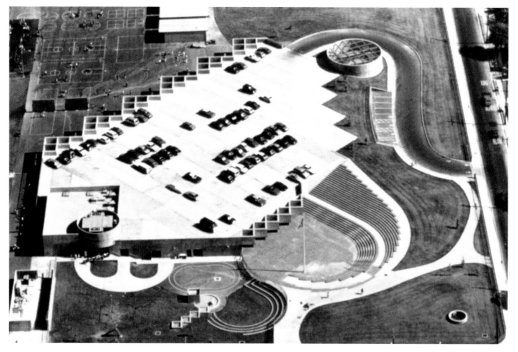

Moffett Elementary School's recessed front courtyard is also an amphitheater that can be used for student assemblies. Courtesy of Ralph Allen & Partners, Architects; Photo by Harvey Spector

Based on his visits to existing underground schools, Moffett knew that the space economy was realistic. Allen once again produced a design that made double use of part of the site's area by placing a parking lot for more than 100 cars on the roof of the recessed school building. As at Fremont, this school was lowered half a story into the ground, with grassy berms raising the surrounding terrain to roof level.

Superintendent Moffett had worked diligently to create a new school that would provide a good learning environment, safety and comfort for the students, and a source of pride for the economically deprived community. After all the negotiations and compromises, the structure was completed in 1990 and named Moffett Elementary School. "I was surprised

and pleased when school board members decided to name the new facility in my honor," Moffett wrote in his 1994 article. "The new school, nestling in a green rolling hillside, really does look like a park."

IT'S NOT SO ELEMENTARY

Many of the earth-integrated schools built since the 1960s serve the elementary grades. Two of the most recent examples, however, are designed for students on opposite ends of that age range.

NEITHER UP NOR DOWN

La Marina Preschool in Manhattan Beach, California, was about to lose its lease. The landlord, the local school district, needed the space for its own use. To stay in business, owner Janis Weaver needed to build a new facility that would retain her existing clients and attract new ones. Searching the heavily developed local area, she found a piece of available land in just the right place. That is when the numbers started to add up to a problem.

Weaver figured the new school would have to be licensed for at least 90 students to be economically viable. California requires that preschools provide at least 35 square feet of interior space and 75 square feet of exterior space for each child. Those numbers compute to at least 9,900 square feet. The land she wanted to use had only 8,000 square feet. At that point, she turned to architect Patrick Killen.

Moffett Elementary School's translucent facade bathes this entrance lobby and the school library in daylight. Solid glass bricks were substantially more expensive than masonry bricks or concrete walls, but Kenneth Moffett believed that an attractive school would create a sense of pride in the students and enhance their learning experience. Courtesy of Ralph Allen & Partners, Architects; Photo by Harvey Spector

Stacking spaces seemed a natural solution, but Killen knew the building code would not allow it. "You can't put the [preschool] kids in a basement, nor can you put them on a second story," he explains. In a moment of inspiration, he envisioned a compromise. If the building was recessed only half a story into the ground, it would not be considered a basement. If earth

La Marina Preschool's side yard provides a gradual transition from floor level to rooftop play terrace, integrating all levels into a single space. Courtesy of Studio 9one2 Architecture

berms on the sides of the building brought the ground level up to the top of the structure, that surface would not be considered a second story. Or so he hoped.

After further studying the building code, conferring with the state architect, and submitting sketches for review, he gained approval for his design. About 40 percent of the structure's volume is below grade, with the floor 40 inches beneath the natural surface level. Grassy terraces on the building's side yard provide additional play space as well as access to a playground on top of the structure. Segments of block wall interspersed with sections of wire mesh enclose the play terrace. Although the wall rises about one story high in places, views into the playground diminish the apparent bulk of the school building.

At the front of the school, a ramp and a few steps offer alternate routes down to the entrance level. Killen allotted precious extra space in front of the main entrance to acclimate visitors to the recessed level of the building before they enter it, minimizing any feelings of being below ground. The area forms a small amphitheater that is used for puppet shows and story telling. Although useful psychologically and functionally, the amphitheater presented a significant design challenge. Killen worried that rainwater would accumulate in the recessed

courtyard. "Fortunately for us, the site cooperated," he reports. The ground slopes down about 10 feet at one corner of the site. As a result, buried drain lines could run downhill, allowing gravity to carry water away from the building.

Weaver admits that her initial reaction to the idea of a partially submerged building was "shock." She immediately asked how enough light would get into the building. Killen responded, "We could do this really cool pyramid right in the center of the building that would allow light to go down into that lower space. The children could play around it up above, and it would sort of quadrant off the different age groups for the kids."

Along with an array of other colorful geometric shapes scattered around the play terrace, the pyramid adds visual interest to the subtle building. Inside, it adds physical and visual space to a central reading area that is surrounded by classrooms. The lower third of the pyramid is a tile-covered base wall that elevates the skylight portion 2½ feet above the playground's surface. The upper faces of the pyramid, produced by Kalwall Corporation, consist of shatterproof, fiberglass-reinforced panels bonded to a gridwork of small steel beams. The 2-inch-thick laminated panels contain a layer of translucent insulation that controls temperature fluctuation and allows diffuse daylight to enter the school.

Based on her own first impression, Weaver was sensitive to the reaction of her current clientele. She called a meeting, where she explained the concept and displayed drawings and a three-dimensional model of the proposed building. The parents readily accepted the design. In

Recessed halfway into the ground, La Marina Preschool is appropriately scaled for its pint-size pupils. Courtesy of Studio 9one2 Architecture

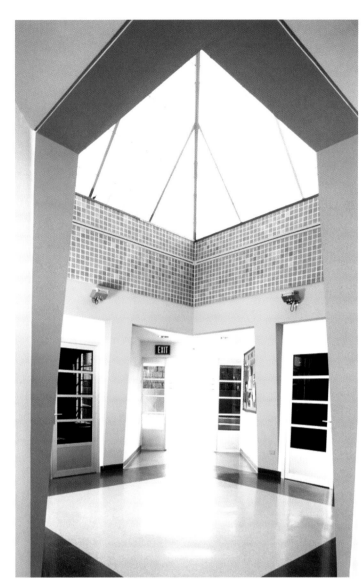

Bright colors, daylight, and high ceilings make La Marina Preschool's interior cheerful and comfortable. Glass-paneled exterior doors, which open onto a recessed courtyard, look much as they would in a ground-level building. Courtesy of Studio 9one2 Architecture

fact, after it was built, the school proved attractive to a broader community. "Everybody loves it," Weaver proclaims. "I get people coming in off the street—people who don't have children—who just want to see the building. I've had architectural students come in to see the building. People have come in who wanted to know who the architect was." In 1999, the school earned a design award jointly sponsored by *Business Week* and *Architectural Record*. Furthermore, the appeal is not only aesthetic. The school, which had barely been able to maintain full enrollment before the move, soon had a long waiting list.

WELL-GROUNDED PREP SCHOOL

Administrators of the National Cathedral School in Washington, D.C., a Protestant Episcopal school for girls, consider physical fitness as important an element in the curriculum as any of the academic subjects. Nearly 90 percent of their middle and high school students play on one of the school's thirty-eight sports teams. By the late 1990s, existing facilities for physical education classes, team practices, and competition events were completely inadequate. The gymnasium, built in 1954, had only one basketball court and no support areas such as locker rooms or showers. The outdoor tennis courts and a poorly drained playing field could not be used in inclement weather. The school needed a bigger, better athletic facility. The problem was figuring out where to put it.

Although the school is situated in a park-like setting with a large expanse of open space, there was no place to put the new athletic center. National Cathedral School shares a 52-acre campus with three other schools and the Washington National Cathedral. The campus, known as the Cathedral Close, adheres to a master plan developed by landscape architect Fredrick Law Olmstead. The plan allows buildings to occupy only 14 percent of the land. Even the site of the existing gym was unavailable for the new facility because it was slated for conversion to academic uses. Given those restrictions, there was no place to put the new athletic center except underground.

"By going underground, we actually opened up amazing possibilities," says Anita Beatty, the director of communications for National Cathedral School. In 2002, the school built 99,000 square feet of space, nearly all of it out of sight under grass. The new athletic center includes a competition gymnasium with bleacher seats for 400 spectators. In addition, there is a multi-purpose gymnasium room suitable for practicing various indoor and outdoor sports for physical education classes as well as school teams. Ceiling-hung nets can be lowered to partition the space into three sections, each accommodating a full basketball court. Around the perimeter of

the multi-purpose gymnasium, a track suspended from the ceiling allows runners to practice while other activities take place on the gym floor below. There are lockers and showers for both home and visiting teams. An athletic trainer's facility allows for prevention and treatment of injuries. There are classrooms, a studio for dance and aerobics, and a fitness center for students; offices and a conference room for the administrators; and a trophy room for everyone. There is even a 40-foot-high, free-standing climbing wall designed to present several difficulty levels on its various faces.

A small, stone building above the middle third of one end of the athletic center serves as an entrance pavilion. Kenneth Wiseman and his colleagues at Cannon Design shaped the Gothic

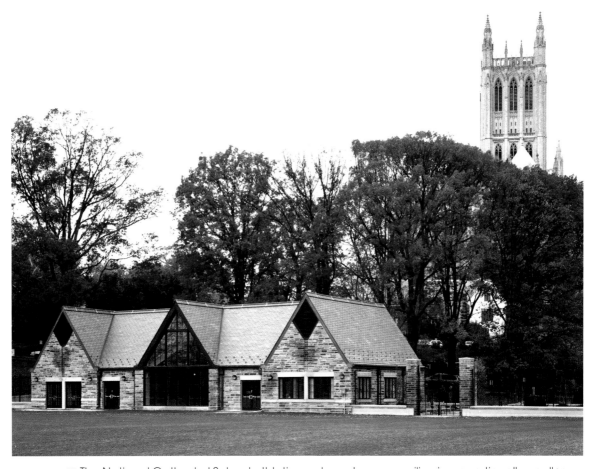

The National Cathedral School athletic center entrance pavilion is proportionally smaller than the tip of an iceberg. It contains less than 5 percent of the facility's total space, most of which lies unseen below a lawn-like soccer field. Courtesy of Cannon Design

Revival pavilion to blend with the architecture of other structures on the Cathedral Close. The 4,400-square-foot, one-story entrance pavilion is the only part of the athletic center that rises above ground level. In the center of the pavilion is an atrium that houses the climbing wall. The rugged peak just reaches the floor level of the entrance lobby. On two sides of the atrium, stairways zig-zag down into the athletic center alongside the climbing wall.

The site's natural slope is now terraced into two levels of grass. The upper level, a practice field for outdoor sports, covers the athletic center. The lower grass level is a compe-

tition soccer field. The 18-foot vertical separation between the two fields is defined by a 280-foot-long stone and glass facade, the only exposed wall of the subsurface athletic center. Between the windows, trellises lead wisteria vines up the surface of the wall, softening its appearance.

Construction of the athletic center substantially increased the amount of green space on the National Cathedral School campus. The turf-covered structure replaced 30,000 square feet of hard-surface tennis courts, a paved sitting area, and a playground. "From outside, it's more beautiful than it was," Beatty says, "and once you're inside, it's just stunning."

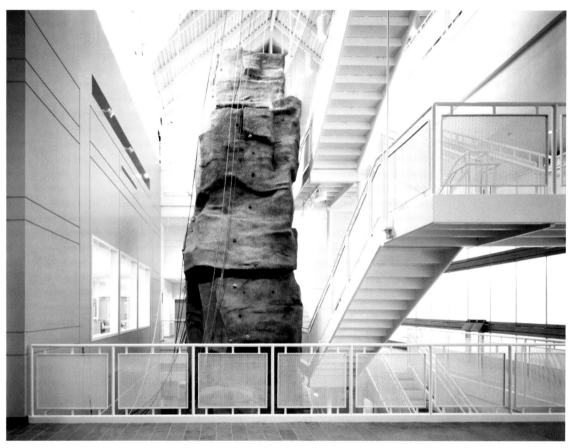

Like an enormous, craggy exclamation point, a towering climbing wall rises through three underground levels of the NCS athletic center. Broad windows allow climbers (on the rock or stairs) to see into gymnasiums, the fitness center, and a combination conference room and trophy gallery. Courtesy of Cannon Design

HIGHER LEARNING IN LOWER BUILDINGS

Strangely, even though earth-sheltered schools built since the 1960s have generated impressive economic and educational records, recent construction seems almost exclusively to employ conventional, aboveground concepts. Moffett Elementary, La Marina Preschool, and the National Cathedral School athletic center are rare exceptions. College campuses, on the other hand, tell a different story. Rising enrollments demand more buildings, but options are limited by a shortage of available land and by concern for preserving both open space and

views of beloved, historic buildings. As a result, institutions of higher learning are turning increasingly toward underground construction. In fact, college campuses represent one of the richest concentrations of subterranean architecture in North America. It would take an entire book to describe them all, so this chapter presents a very small, illustrative sample.

LOW-PROFILE CELEBRITY

Harvard was the first U.S. college to establish a library. Nearly 350 years later, Harvard was among the first American universities to erect an underground building to house part of its collection. The Nathan Marsh Pusey Library, completed in 1976, attracted widespread attention and helped trigger a wave of subterranean campus construction that is still gaining momentum across the nation.

Pusey Library's reputation may be high profile, but its physical stature is definitely not. Visible enough to establish the building's presence, its subtle exterior features only hint at its 87,000-square-foot, three-story-deep totality. It nestles under a grassy quadrangle that slopes gently toward one corner. The main entrance is located at that corner, where the building's walls rise two-thirds of a story above grade. The glass walls are hidden behind grass-covered berms that rise to roof level around the exposed perimeter. A shallow, stone wall that rises above berm-top level acts as a retaining wall for the soil that covers the building. Between the inside faces of the berms and the building's walls, a recessed, brick-paved corridor creates a one-story-deep "light moat" along the transparent walls.

Only 10 percent of the building's walls are exposed, however, with the rest being earth covered. At the opposite corner from the entrance, the floor of the library's upper story is 14 feet below grade. A 40-foot-square sunken courtyard occupies the center of this end of the building, which is only two stories deep. Like the exposed walls near the main entrance, the walls surrounding the landscaped courtyard are mostly glass.

Design and construction of Pusey Library presented several challenges:

• Excavation was complicated by the fact that the lowest level of the three-story portion of the building had to be hollowed out of bedrock.

• The structure sinks 24 feet below the groundwater level, so effective waterproofing was essential. The exterior walls are made of concrete infused with ironite (small metal particles that expand in the presence of water), and during construction a layer of liquid neoprene was applied. A network of perforated pipes is buried in a bed of sand under the building's concrete foundation slab. Similar pipes are enclosed in a 3-foot-thick layer of gravel that surrounds the subsurface walls. Water seeps into these pipes and drains to four pumps that operate continuously, with diesel generators standing by in case of a power failure. Under the flat, landscaped earth cover, the building's roof slopes to the exterior edges and is covered with another network of perforated pipe that rests above a surface sealed with both a neoprene membrane and a tar-like sealant.

• Because the structure was watertight, designers had to ensure that if the surrounding area became saturated, the water pressure would not float the building up out of position. A series of steel girders ties the structure to bedrock.

• The library was built to contain irreplaceable archives, so it had to be fireproof. The concrete structure itself could not burn, but the contents could. If a fire is detected, the innovative fire suppression system identifies the affected area and auto-

matically fills it with Halon, an inert gas that immediately extinguishes fires but does not harm books or people.

In the years since Harvard built Pusey Library, the university has continued to search for ways to expand its physical plant without diminishing the green space that defines its campus. Building underground is an important component of the solution. Between 2001 and 2010, Harvard will undertake construction of between one and two million square feet of space. *Harvard Magazine*, in its May-June 2002 issue, called underground construction "an increasingly common, if expensive, tactic in Harvard's plans." At that time, for example, the school was finalizing plans to replace its aboveground vivarium, which houses mice used for neuroscience research. The new 70,000-square-foot facility will be located underneath a courtyard adjacent to the Biological Laboratories building.

MINNESOTA PIONEERS

Limited space and established walking paths are two constraints that affect new construction on most college campuses. In many cases, planners must also ensure that a new structure will not block the view of one or more stately, historic buildings. Architect David Bennett solved all three problems by placing Williamson Hall underground at the University of Minnesota's Minneapolis campus:

• The subsurface building, which is partially covered with grass and ivy, preserves the openness of the campus quad it occupies.
• A wide, paved path, running diagonally across the top of the square building, supports the natural movement of pedestrians.
• A small entrance kiosk and a raised skylight structure are visually subtle compared with the three- and four-story buildings that surround the quad.

When designing Williamson Hall, Bennett took into account the two distinct functions to be housed in the structure. First, he divided the space into two triangular portions by placing

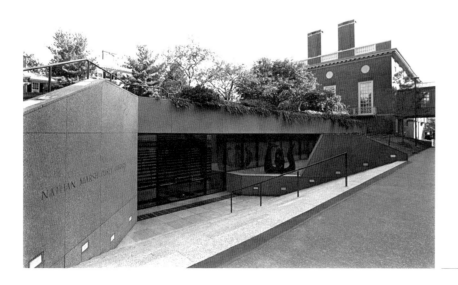

The front door of Harvard's Pusey Library is located at the lowest corner of a sloping plaza, placing it only partially below ground level. A rooftop walkway, beginning at ground level at the opposite corner of the building, descends (left of photo) beside the entrance foyer. A metal sculpture (right of glass doors) marks the beginning of the light moat. Courtesy of Harvard University News Office; Photo by Kris Snibbe

the building's main corridor directly below the rooftop's diagonal pathway. On one side of the corridor, the main campus bookstore occupies an open, two-story-tall room; a balcony level that overlooks the store provides some office space. The other side of the building is split into two floors and divided into offices for the university's admissions and records staff. A triangular, recessed courtyard bordering the main corridor provides daylight and exterior views to both halves of the building.

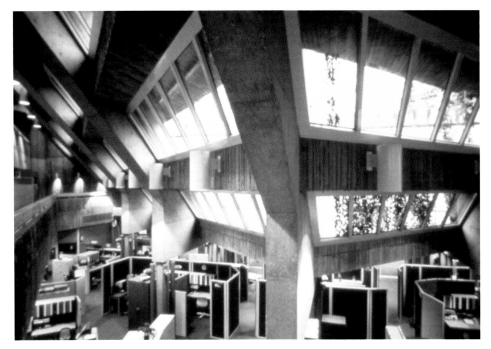

The sloping glass panels along Williamson Hall's recessed courtyard resemble windows more than skylights. They offer views of exterior foliage, for example. Also, they admit daylight from a range of horizontal to vertical angles, which is more natural than light shining only downward into a building. Courtesy of David J. Bennett, FAIA

During the design process, the bookstore managers and the university's building committee insisted that the architect incorporate more glass and omit the sun-screening louvers he had planned for the courtyard windows. As soon as the building opened in 1977, however, some of its occupants complained that their offices were too sunny. The problem was addressed in two ways. One was applying solar rejection film to some of the windows. The other was growing Engleman ivy in several rows of planter boxes that extend across the courtyard's window banks. As it matured, the ivy spilled over the shallow planters, and its leafy vines shaded the windows. In the fall, Engleman ivy loses its leaves, so the windows are exposed to warm sunlight in the winter. The innovative landscaping solution was only partly successful. Office workers asked to have the ivy trimmed to improve their view through the windows. "After Williamson, I am less willing to rely on landscape materials as functional elements," Bennett told the *AIA Journal* in January 1983, "because clients don't seem to understand the importance of maintaining them."

Despite the almost excessive daylighting, some workers could not conquer the stereotypical image of subsurface structures as being dark and gloomy. Shortly after Williamson Hall opened for business, Bennett chatted with a salesperson in the bookstore. "When I asked her how she liked working in the building, she looked up at me, and shading her eyes from the sunlight pouring across her counter, complained that she was not too happy about being underground, shut away from the outdoors, not knowing what time of day it was," he recalls. "Evidently the 'idea' of being or not being in what was defined as an underground building was far more meaningful than the actual physical experience. In subsequent years I observed this phenomenon time and again [in several underground buildings]."

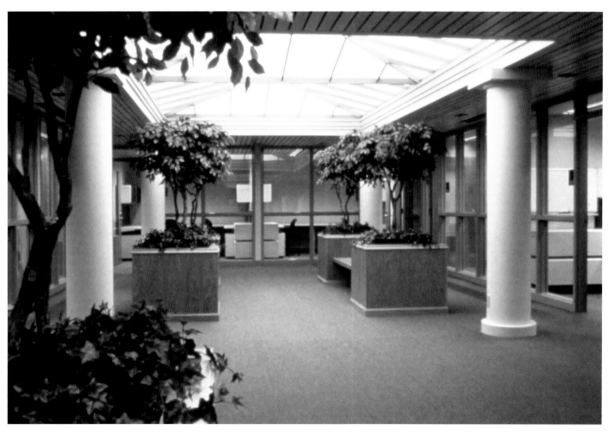

Full-spectrum fluorescent bulbs mounted above this artificial skylight in the Civil and Mineral Engineering building make the space seem nearer the surface than its actual 112-foot depth. The lights can be programmed to gradually change intensity, mimicking natural sunlight patterns throughout the day. Courtesy of David J. Bennett, FAIA

Even before Williamson Hall was built, members of the University of Minnesota's engineering faculty had been experimenting with underground construction. Completion of the bookstore and office building offered additional study opportunities for several groups of faculty members, including architects and psychologists as well as engineers of various disciplines. Interest in underground construction was so high on the campus that a research organization called the Underground Space Center was created the same year Williamson was finished. The following year, the university committed itself to construction of an even larger and more complex subsurface facility—the Civil and Mineral Engineering building. In addition to

providing instructional and administrative space, the structure was planned as a demonstration project for commercial-size underground buildings. By 1982, it was built and ready for use.

With 150,000 square feet of space, the Civil and Mineral Engineering building is nearly twice as large as Williamson Hall. Designed for a wider range of functions, it includes classrooms, laboratories, offices, and lounges. The most dramatic difference, however, is that it employs both of the two basic types of underground construction. A near-surface component, containing 60 percent of the building's space, was excavated from the site's 53-foot-deep soil layer using cut-and-cover techniques. The remainder of the building was formed by mining a chamber out of a deep layer of sandstone. To reach the sandstone layer, builders had to blast two vertical shafts through a 30-foot-thick layer of harder limestone. The building's two lowest stories, reaching a depth of 112 feet from the surface, are accessible only through elevators and stairs in these two shafts.

The concept of students and faculty working daily in a rock cavern so deep in the ground was unprecedented. To provide the best possible physical and psychological atmosphere for the spaces, architect David Bennett incorporated some of the latest innovations in natural lighting. Two of the most unusual are the heliostat and ectascope systems.

The heliostat transmits sunshine from the building's highest feature, a slim tower, to its deepest level. A movable mirror inside the glass-capped cupola follows the sun and reflects daylight down through a slender shaft. At the shaft's bottom, the sunlight passes through a lens that disperses the beam over a 10-foot-square, translucent "skylight" panel in the ceiling of the building's deepest level. The original sun-tracking mechanism did not work well, but since it was replaced in 1987, the heliostat has been reliable and effective.

The ectascope system is supposed to act as a surrogate window, providing a live, three-dimensional view of the nearby surface landscape. A mirror mounted on a lower panel of the diamond-shaped cupola reflects the view down into a narrow shaft. A system of lenses and

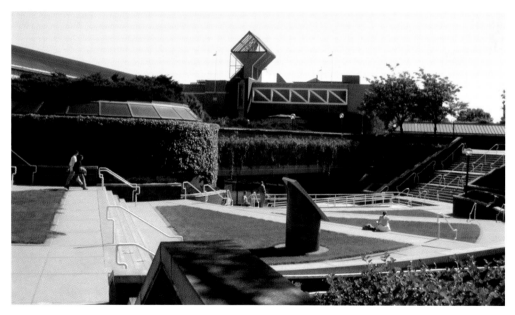

The tallest feature on the Civil and Mineral Engineering building is a glass-topped cupola containing reflectors that project sunlight and exterior views down into the building. Only 5 percent of the building's space is above ground level, which is approximately at the bottom of the clerestory windows on the cylindrical section of the building (left center).

mirrors inside the shaft transmit the view to the building's lowest level, where it is reflected horizontally through a 2-by-3-foot "window." A person standing at the right spot can "look out" the window and see the outdoors. "When the lenses are clean, the image is spectacular in clarity, but because the image cannot be seen from more than one small area, it has little impact on the visual environment in the overall space," Underground Space Center Director Ray Sterling told attendees of the International Symposium on Unique Underground Structures in 1990. Unfortunately, when the Civil and Mineral Engineering building was constructed, protective enclosures for the mirrors and lenses were omitted because of budget limits. As a result, the ectascope's essential components frequently get dirty enough to inhibit its operation. Cleaning them is tedious, and they are easily scratched. Simpler mirror systems for projecting remote views have worked better in smaller buildings. Today, however, newer technologies, like high-definition video imaging, offer greater promise for transmitting remote views underground.

The Civil and Mineral Engineering building and Williamson Hall were conceived and built as experimental underground structures as well as functional campus facilities. As a result, they have been more thoroughly documented than most subsurface structures in North America. Their shortcomings, successful features, and construction challenges are detailed in numerous articles in technical journals, conference proceedings, and books. Bennett, Sterling, and others associated with their design and construction have openly exposed their problems for the benefit of designers of future buildings. Published papers describe difficulties like air quality problems, water leakage through skylights and walls, confusing layout designs that may disorient visitors, and inadequate drainage designs that had to be supplemented after construction. This does not mean these two structures are poorly designed or poorly built. They are, in fact, award-winning buildings whose designers and owners are also researchers and educators.

STRIKINGLY UNSEEN

How do you gracefully add on to a group of buildings that is already architecturally complete? That was the dilemma faced by the University of Michigan in the 1970s, when it addressed the need for expanding its law library. For more than forty years, the law school had occupied a quadrangle framed with stately buildings. There was a bit of space available in one corner of the quad's perimeter, but it served as a major pedestrian access path for the complex. Space, however, was not the only impediment to adding a structure to the quad. The law school buildings were ornate Gothic structures beloved by the alumni. "They . . . told me, 'You must get a Gothic architect,'" library director Beverley Pooley told the *AIA Journal* in January 1983. "I said, 'That will be extremely difficult, because he'll be extraordinarily old. And even if we got the architect, who could possibly bid on [constructing] it?'"

Architect Gunnar Birkerts responded by recessing the 77,500-square-foot building so completely under the quad's open corner that it is nearly invisible. "This is probably the most esthetically satisfying large underground building to have penetrated American soil," architecture critic Andrea Dean wrote in the *AIA Journal* article, "though on approach there's almost nothing—arguably not enough—to see, certainly nothing that says 'building.'" There is not even a visible portal; normal access to the structure is through the adjacent Legal Research Building, and two emergency exit stairwells are subtly tucked behind landscaping. The design delighted alumni, students, and staff.

Birkerts, whose childhood in Latvia taught him to treasure daylight during winter's short days, was particularly sensitive to the need to draw sunshine into subterranean buildings. He

Ivy is growing in some of the small planters embedded in the limestone wall that slopes away from the base of the University of Michigan Legal Research Building. Glass lines the opposite surfaces of the L-shaped light moat. Besides letting daylight into the law library addition beneath the grass, the windows also give students in the underground building a unique view of the older, Gothic facade.

Courtesy of Robert Darvas Associates, Structural Engineers; Photo by Deidre Calarco

skillfully illuminated the three-story-deep structure by admitting, reflecting, and dispersing natural light with windows, mirrors, and light-colored stone surfaces in two separate areas. The smaller one, a 56-foot-deep triangular, glass-walled light well, is located at the outer vertex of the L-shaped building. Because of an open interior plan and 15-foot-high ceilings, all three stories benefit from this daylight source.

The other skylight is a 150-foot-long expanse that forms the inner edges of the L that wraps around the Legal Research Building. Birkerts lined this entire wall of the library with 26-foot-long panels of bronzed glass that slope downward just past the floor of the uppermost subsurface level. A series of 3-foot-deep beams placed perpendicular to the glass surface support the slanting skylight and also act as baffles to keep direct sunbeams from overheating or over illuminating the building's interior. In a very practical but playful way, Birkerts covered the faces of the beams with mirrors. This not only allows them to reflect the daylight more effectively throughout the subterranean spaces, but it also creates intriguing visual effects. The mirrors reflect ribbon-like images of the sky and the building's elegant, Gothic neighbor. Along the skylight's edge, the upper two floors end as terraced balconies, allowing light to sparkle into them and to continue to lower levels.

Opposite the glass faces of the large skylight, forming the other face of a V-shaped light moat, is a limestone wall. The light-colored surface reflects sunlight through the skylight, enhancing its effectiveness. At the same time, the texture of the stone gently diffuses the sunbeams, helping to eliminate glare. The limestone wall continues slanting downward, away

Mirrors on the skylight support beams create a kaleidoscope-like effect that can be seen in all three levels of the law library addition. Courtesy of Robert Darvas Associates, Structural Engineers; Photo by Deidre Calarco

from the Legal Research Building, to the bottom of the law library addition, dispersing light that has found its way through the mirror-supplemented skylight.

A Light Touch

Underground buildings are almost a tradition at Cornell University in Ithaca, New York. In 1970, the university built a two-story campus store under a green quadrangle. In 1982, it added a subterranean reading room, designed by Gunnar Birkerts, to Uris Library. A decade later, it built Carl A. Kroch Library, a 97,000-square-foot structure extending 52 feet below ground.

Kroch (pronounced "Crock") Library was built as an expansion to a seven-story-tall existing facility. Patrons enter Kroch Library through its below-ground connection to Olin Library. The only external hints of a building under the campus's oldest quadrangle are its skylights—four shallow, 10-foot-square pyramids of glass. The row of skylights marks a three-story-deep atrium that serves as a focal point for the building's people-oriented spaces. Study spaces and offices surrounding the atrium are faced with glass so their occupants can enjoy the natural light and the visual expanse. While designing this appealing "people space," the architecture firm Shepley Bulfinch Richardson and Abbott found an effective way to also fulfill the building's role as a repository for the university's rare materials collection. Along one edge of the building, separated from the atrium by solid walls on the back of the people-oriented rooms, the books and manuscripts are shielded from daylight's damaging ultraviolet rays.

Kroch Library's roof consists of a 14-inch-thick concrete slab covered with varying amounts of soil. Taking advantage of the depths of the vertical shafts under the skylights, the architects lined their walls with mirrors to magnify and manipulate sunlight. "It disperses the light that enters the space while perceptually making the skylights . . . seem much bigger than they are," reported Cornell students who evaluated the library's lighting effectiveness in a 1997 project for Dr. Alison Kwok's architecture class. "It also at times can provide a visually interesting shimmering effect on the interior walls. . . . The shafts are fairly deep, allowing more than one or even several reflections to occur, [sometimes] making it look as if there are two suns."

The building's main corridor intersects the atrium, dividing it into two wings. After the library opened, its staff installed cases to display rare publications in the western half of the atrium area. This raised the problem of protecting the valuable artifacts from harmful sunlight. The skylights are glazed with low-emissivity glass to reduce ultraviolet penetration, but the effect is not thorough enough to protect fragile documents. Making the display cases of dark glass would protect the books, but people would barely be able to see them. Instead, the university decided to restrict the abundant natural light flowing through the skylights by suspending

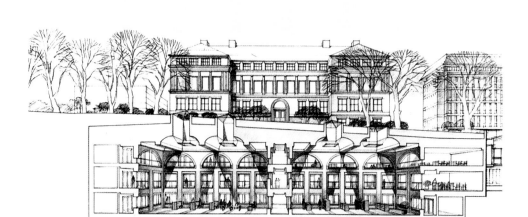

To minimize the weight of several feet of soil on the Kroch Library roof, designers concocted a lightweight mixture of fine bark, peat moss, nutrients, and sand. Using sand rather than dirt encourages water (which is heavy) to drain away quickly. The roof's slope also encourages drainage. *Courtesy of Shepley Bulfinch Richardson and Abbott*

horizontal panels of dark gray fabric below the bases of the shafts in the west atrium ceiling. It was this visible countermeasure that prompted Kwok's architecture students to study Kroch Library's lighting, comparing the retro-fitted west atrium wing with the as-designed east wing.

The students' measurements showed that the fabric scrims functioned as intended. At similar locations on the upper and lower levels of the two wings, the students found up to three times

as much natural light in the east wing as in the west wing. While this made the west area more suitable for displaying rare books, it restricted the positive effects of daylight for the people using that part of the atrium and its surrounding rooms. "It is our belief that the installation of these devices has not only negated the original integrity of the building but has also caused many problems in terms of personal comfort and how the space is to be used by its occupants," the students asserted.

For occupants of underground buildings, perception may be more real than facts. In experiments with aboveground and underground rooms having the same size and lighting intensity, psychologists have found that people in the underground rooms perceive them as smaller and dimmer. Relatively minor building modifications, such as covering skylights or lowering ceilings, may affect the ambience of an underground room significantly more than they would in a comparable aboveground setting.

RECESSED PEDESTAL

Roberts Hall deserved a better setting than the parking lot that cluttered what should have been its front lawn. The elegant Gothic structure, built in the 1920s, housed the Materials Science and Engineering Department on the University of Washington's Seattle campus. By the mid-1980s, the department needed more space, and architect Dutch Duarte took advantage of the opportunity. He slipped eleven laboratories, two classrooms, a 100-seat auditorium, and a string of offices into an underground building, converting the nondescript parking lot into a grassy forecourt and visually placing Roberts Hall on an elegant, shallow pedestal.

The first level of the four-floor historic building was actually situated one story below ground level, with the surrounding earth forming a moat as it sloped down toward the building. Duarte placed the new structure, Mueller Hall, at this lower level so its rear wall replaced the embankment in front of Roberts Hall. The moat remained, in the form of an open walkway between windowed walls of the two buildings. To create a front entrance for Mueller Hall, Duarte sculpted a lawn that slopes down toward a paved entryway.

Designing Mueller Hall as an attractive building that compliments the existing structure was the main artistic challenge. The biggest mechanical design challenge was venting the laboratories, where demonstrations and experiments could generate harmful vapors. Separate ducts for fifteen fume hoods scattered throughout Mueller Hall snake through the shallow space between the ceiling and the roof of the compact, 15,000-square-foot building. Ultimately, the ducts congregate at one end of the building, extend under a sidewalk to the outer wall of an adjacent five-story building, and run up past its roof. Bricks matching the exterior of the surface building cover the duct bundle, creating a shallow, nearly unnoticeable extension to the facade. This solution inconspicuously places the external vents for the system a safe distance from people walking on Mueller Hall's rooftop plaza.

Preparing the underground building's roof for landscaping presented another set of technical challenges. For one thing, effective drainage is essential, not only to prevent leaks into the building, but also to keep soggy soil from damaging the building as it contracts and expands during freezing and thawing cycles. Atop a waterproof membrane that covers the roof, perforated pipes collect excess water and carry it to connections with the campus-wide drainage system. "It drains so well," Duarte reports, "that the grass didn't stay as green as we'd like it. We ended up having to fertilize it considerably more often."

To minimize the weight on the building's roof, plans called for a layer of lightweight filler material to underlie the soil. This is where Duarte and his landscape architect really got

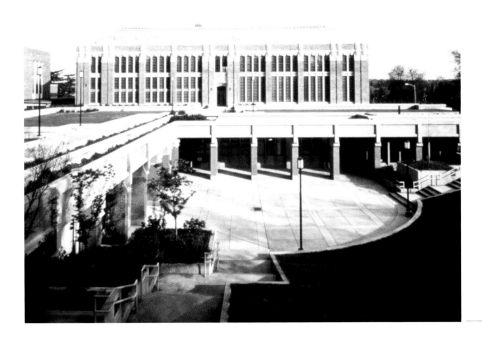

A roofed corridor along the front of L-shaped Mueller Hall shades two walls of windows. Brick columns visually link the new building to its older neighbor. Courtesy of BJSS Duarte Bryant, Architects

creative. They decided to use Styrofoam-type packing peanuts. The theory was good, but the installation process was a nightmare. The slightest air movement disturbed the peanuts, and the contractor struggled to keep them in place until they were covered with soil. Furthermore, once they were covered, the peanuts compacted more than preliminary tests had predicted. Restoring the intended surface level took the addition of another 3 inches of a special lightweight soil. "It was probably the only negative thing—a learning experience—that we wouldn't do again," Duarte concludes.

INTEGRATED LEARNING CENTER: IT'S A LIGHT CENTER

"These underground offices, which many feared would be bunkerlike, let in more natural light than any other building on campus," reported the *Arizona Daily Star* on May 12, 2002. The newspaper ran a pair of lengthy feature stories to mark the end of the first semester for the Integrated Learning Center at the University of Arizona in Tucson. The abundant light was no accident. "Daylight is absolutely essential to creating a human atmosphere," architect Jim Gresham was quoted as saying.

So, how did Gresham bring enough of the precious daylight into a completely underground building? Mainly windows—lots of windows. Walls along a recessed entry plaza and around a large, sunken courtyard consist almost entirely of glass: 10-foot-tall panels frosted at the bottom and tinted green to reduce glare. To shade the windows, the courtyard walls are set back 18 feet from the edges of the 50-by-200-foot opening in the mall. "You can walk down a covered arcade and look to one side to see sunlight and trees and plants, and look to the other side and see into the building," explains project manager George Casey.

Before even soliciting bids from architects, the university administration had decided that the new building would have to be completely underground. Intended primarily to provide services to the freshmen class and to house an Information Commons equipped with 250 computers for all students, the Integrated Learning Center had to be located in the heart of campus. The only available space, however, was a mall that Casey describes as "darn-near sacred to everybody." Unable to conceive any other solution to the dilemma, the planning committee decided the new

Light-colored walls, plenty of uncluttered space, and lots of windows keep the ILC from conforming to the stereotype of dark, inhospitable, underground buildings. Courtesy of Gresham & Beach Architects; Photo by Douglas Kahn

building would have to go under the mall, out of sight. Gresham limited the aboveground features to four subtle skylights, two compact elevator kiosks, a cylindrical vent shaft tower, and a railing around the courtyard opening. These simple shapes, covered with unadorned aluminum, look more like minimalist sculptures than the defining features of a 119,000-square-foot building that houses, in addition to the sprawling Information Commons, two large lecture halls, two auditoriums, ten classrooms, and numerous offices and meeting spaces.

A great deal of effort went into keeping the Integrated Learning Center completely below grade. Excavation went as deep as 33 feet. Through the length of the Information Commons, the floor level gradually steps upward to the basement level of the adjacent main library, creating a new front entrance for that facility. Structurally, the building was designed to carry rooftop loads as heavy as fire trucks. To keep the basic roof load as small as possible, the design team even had to concoct what Casey calls "a sort of magic mixture of sand, red mesa loam, perlite, and nutrients" that would enable grass to grow in a relatively shallow bed. Inexperienced in underground building design, the architects brought an experienced consultant on board—architecture professor and former Underground Space Center Associate Director John Carmody.

"The university didn't want us to give them a facility that felt like it was completely underground," Casey says. "For the most part, I think we have done that." Users of the facility seem to agree. "In a University of Arizona survey of 800 students that asked what was wrong with the building," the *Arizona Daily Star* reported, "the most popular answer was 'nothing.'"

UNDERCOVER PUBLIC SERVICE

Anyone who has given a carefully selected gift to a toddler can chuckle at the comment that youngsters have less fun with a toy than playing with the box it came in. Kids often do, in fact, get enormous enjoyment out of climbing in, crawling through, and eventually demolishing the innocuous container while the expensive gadget awaits its eventual turn in the spotlight.

This is a bit like what an adult may experience when going to see a historic place only to find it anticlimactic after wandering through an imposing visitor center that dominates the landscape. Some public facilities are designed to be monuments, but many exist simply to serve the public. Underground construction is one option that can keep the container from overshadowing the contents.

CAPITOL OR LOWER CASE?

Among the images people least like to see overshadowed are those that proclaim a sense of identity. In the United States, that category includes buildings that declare citizenship. The dome on the nation's Capitol is a powerful symbol of the United States. From Rhode Island to Alaska, Americans see their state capitol buildings as emblems of their character as Buckeyes, Volunteers, Cornhuskers, or Golden Staters. When population increases and expanding bureaucracies demand more space for a legislature, how can an addition be built without obscuring the view of an architecturally significant and symbolically important capitol building?

In recent years, unobtrusive, underground additions to capitol complexes have been proposed in various states, including Washington, Idaho, Kansas, Michigan, and Maine. Underground chambers have already been built in several other states. Often, their subterranean nature offers more benefits than the simple preservation of historic vistas. In April 1998, for example, Tennessee state senators and representatives held committee meetings in the underground Legislative Plaza next to their capitol building, learning only after the fact that a tornado had heavily damaged downtown Nashville while they deliberated undisturbed.

TEXAS STATE CAPITOL EXTENSION

Preserving the views of the historic capitol building and of the 26-acre park surrounding it was a prime consideration in the design of an addition to the Texas capitol campus. By the late 1980s, the century-old capitol building was housing twice as many employees as the 750 it had been designed to accommodate. The capitol complex had to be enlarged. However, the

view of the beloved building, which is a National Historic Landmark, had to be preserved. The only solution was to put the addition underground. Yet planners did not want it to be a nondescript add-on that prompted images of second-class citizens being relegated to the basement. In fact, the planners insisted that its architectural presence be comparable to that of the capitol itself, even calling it an *extension* rather than an *addition* or an *annex*. In other words, the underground building had to be inconspicuous and impressive at the same time.

Architect Kirby Keahey and his associates at 3D/International Inc. used various design elements to create a dynamic interplay between the new building and its elder sibling. For one thing, they are balanced in size. From outside, the extent of the underground extension is not obvious, but from the inside, it is apparent that the subterranean structure encompasses nearly as much space as the original capitol. Like the original building, it is four stories tall, although the lowest two levels are used only as a parking garage. Still, the upper two floors contain 215,000 square feet of office space as well as support areas like a bookstore and a 350-seat auditorium. Two-thirds of the state representatives and one-third of the senators are housed there, along with their aides.

Two dozen conference and committee hearing rooms and the capitol dining hall are located in the extension, promoting the movement of people between the aboveground and underground structures. To maintain a sense of continuity between the two buildings, walls, floors, and decorative elements were finished with similar materials, including limestone, granite, and woods native to Texas. Structural pillars visible in the extension's corridors are disguised as columns, which are a common design element in the historic capitol. The new columns are simplified versions of their older counterparts, a detail that skillfully acknowledges the differences in age and character of the two buildings.

The most dramatic feature unifying the two buildings is the rotunda theme. Nearly all state capitols are constructed around a circular ceremonial space, and in most cases this rotunda is capped with a dome. The historic Texas capitol building is a dramatic example of this traditional style, with its pink granite dome towering over the government complex. Inside the building, a visitor looking upward from the rotunda floor sees a golden lone star sparkling high above in the center of the inner dome. The capitol extension is built around a similarly proportioned rotunda, but in keeping with the subterranean nature of the building, the rotunda is inverted.

At the bottom of the inverted rotunda, a drain is inconspicuously incorporated in the golden star. On the far side of the courtyard, backlit by daylight, a door leads to the corridor connecting the underground complex with the original Texas capitol building. The skylight above the corridor is visible in the lawn at the top of the photograph. Texas House of Representatives, Photography Department

Defined by a ring of elegant columns, this 60-foot-diameter rotunda culminates 40 feet below ground level. A mosaic replica of the historic dome's inner surface, with its lone star focal point, forms the floor of an open-air courtyard serving both floors of the underground building.

Besides creating the architectural presence of this distinctive rotunda effect, the roofless courtyard brings sunlight, fresh air, and even weather clues into the recessed building. When designing the structure, Keahey had taken great care to introduce sources of daylight and natural views. Most of the people who would have offices in the extension resisted the idea of working in an underground building until the architect showed them artists' renderings of what they would see through their windows. The renderings were transformed into reality when the addition was completed in 1993. From the inverted rotunda, a central gallery extends toward the aboveground building. Through the glass roof of this elegant corridor, workers can see the historic capitol dome majestically overlooking their work space. Walking down either floor of the two-story corridor, a person can turn right or left into one of three hallways lined with offices. Upon entering one of the offices, the person finds a rear wall of windows overlooking one of the building's six skylight-covered light courts. Keahey's team designed each of these long, narrow courtyards to look like a street lined with trees, benches, and lampposts.

Lovely sketches reassured the future occupants, but converting those sketches into reality took a great deal of effort and skill. Before construction could begin, space for the structure had to be created within the earth. This was no simple digging operation. A 450-foot-square hole had to be opened to a depth of 65 feet—in solid limestone. The site abutted the capitol building, an officially recognized National Historic Landmark that was badly in need of repair and renovation, so blasting the hole was out of the question. Instead, blocks of stone were cut out with a diamond-blade saw. This task was painstaking, but it did simplify the next phase of construction by providing straight, smooth surfaces. Leaving a gap for groundwater to drain away from the building, with the help of pumps when necessary, concrete walls were poured around the perimeter of the hole. If leaks ever develop, the exterior waterproofing layer can be repaired by injecting a sealant through the wall.

As happens with many construction projects, the newly completed building experienced a few minor leaks. This is not a problem restricted to underground buildings, however. In fact, it rained the day the historic capitol building was dedicated in May 1888, and the cast-iron dome that was sheathed in 85,000 square feet of copper reportedly "leaked like a sieve."

California State Office Building

In the late 1970s, the California state architect did not have to worry about preserving historic views when he planned a new office complex to be built half a block off the Capitol Mall in Sacramento. Located a full two blocks and a couple of buildings away from the capitol, the new structure was unlikely to interfere with views of the tall dome. Rather, he faced two other concerns. Influenced by the relatively recent oil embargo and by growing concerns for environmental stewardship, the state architect wanted a design that would conserve energy. Furthermore, he wanted to create a one and a half-block-long structure that functioned as a single unit despite the fact that a four-lane road divided its construction site into two separate pieces.

The Benham Group (now Atkins Benham), an architectural and engineering firm headquartered in Oklahoma City, submitted an imaginative proposal and won the contract to de-

sign the complex. Like the site itself, the structure would consist of two parts. For the northern portion, a half-block parcel, they planned a six-story aboveground building with one basement level. On its south side, facing the intervening street, the upper two-thirds of the building's facade sloped downward at a 45-degree angle for both utilitarian and aesthetic reasons. It was covered with a grillwork of solar collectors that could supply more than half of the complex's energy needs for heating and cooling. In addition, it subtly pointed toward the remainder of the complex across the street, visually uniting the two pieces.

The single-story structure on the full-block parcel was hidden under an urban park, so attention directed toward it by the taller building's sloping face focused on attractive landscaping. To establish a physical connection between the two structures and allow them to function as a unit, the subsurface building continued underneath the street and into the basement level of the aboveground building. Here again, the design generated both pragmatic and aesthetic benefits. Placing more than one-fourth of the 264,000-square-foot complex underground increased its energy efficiency dramatically. The complex was designed to use only 29 percent as much energy for temperature control as allowed by the commercial building code, saving an estimated 10,000 barrels of oil per year at the power-generation plant.

From an aesthetic standpoint, hiding 75,000 square feet of office and meeting space under grass, shrubs, and trees creates a pleasant environment for people outside the building. Yet the architects also wanted to ensure that the people working inside the building were happy with their surroundings. A wide, roofless corridor through the center of the underground building is landscaped with live plants and water fountains, providing an attractive view from office windows. Four smaller, open-

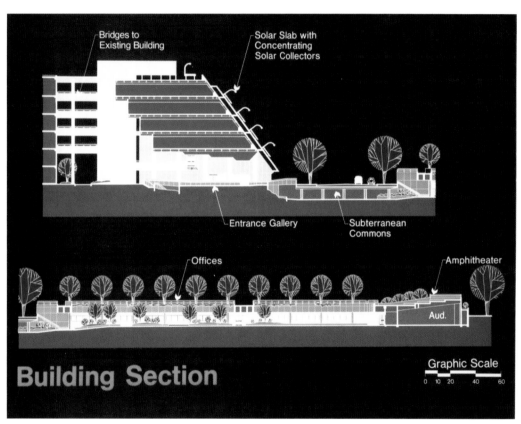

Building Section

A slight repetition at the right end of the upper drawing and the left end of the lower one show where the two parts overlap to form the section drawing of the California State Office Building. The underground placement moderates the temperature in the southern part of the building. It also leaves an unobstructed path for sunlight to reach the solar collectors on the northern, aboveground portion of the complex. Courtesy of Atkins Benham

air courtyards on the east and west edges of the structure increase the window opportunities. This arrangement means that no office space is further than 25 feet from a window with an exterior view. Furthermore, within the offices, glass partitions define space without sacrificing visual contact with the outdoors.

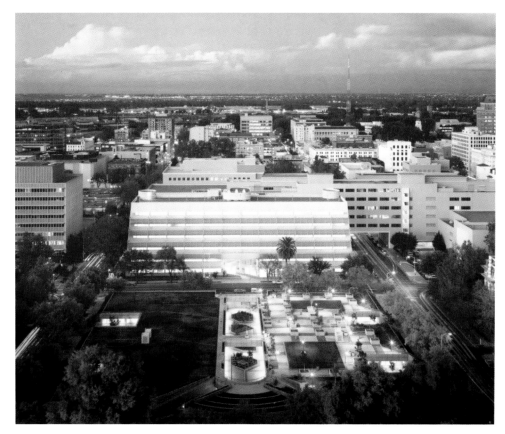

Three of the four perimeter light wells are visible in this photograph (some light from the fourth peeks through the tree at the lower left). The half of the underground building below the lawn on the left was designed to support a medium-density housing structure, although none has yet been built there. Courtesy of Atkins Benham

U.S. CAPITOL VISITOR CENTER

Creating more work space for legislators and their staffs is the driving force behind most capitol expansions. However, in the case of the most recent addition to the U.S. Capitol in Washington, D.C., that objective was almost an afterthought.

Since the first phase of construction was completed in time for the first session of Congress in 1800, the Capitol building has been enlarged several times to accommodate the expanding nation's growing legislative body. Each addition significantly altered the building's appearance:

• In 1850, major additions were designed for the house and senate wings, doubling the building's length and dwarfing the shallow dome atop the structure. The project included installing a more majestic dome formed of 8.9 million pounds of cast iron and 5 million pounds of masonry.

• To better showcase the grand new dome, large marble terraces were built along the north, south, and west sides of the Capitol around 1890. As a secondary benefit, space under the terraces accommodated more than 100 new rooms.

• The Capitol building was designed to have two front faces and no back side. In 1960 the east front of the building was extended outward 33 feet, adding another

102 rooms to the Capitol. A decade later, plans were announced to expand the west front of the building, which faces toward the White House and the Washington Monument. Following a public outcry over further changing the building's appearance, however, that proposal was discarded.

In 1991, the Architect of the Capitol issued yet another plea for expansion. This time, the goal was to better serve the large numbers of tourists who visit the building—as many as 18,000 a day. To avoid altering the building's appearance, the architect developed plans to build the new visitor center underground. In fact, the virtually invisible addition would enhance the beauty of the Capitol by restoring the carefully planned landscaping that had been disrupted by a utilitarian parking lot on what should have been the east lawn. Faced with budget deficits, however, congress was unwilling to authorize a massive project whose primary objectives were comfort and aesthetics.

A more persuasive reason surfaced in July 1998, when a gunman entered the tourist-filled Capitol building, fatally shot two police officers, and seriously wounded a visitor. The incident dramatically demonstrated the need for an enclosed facility where thorough security checks could be made before visitors were allowed to enter the Capitol. Seed money for the visitor center, which would be financed primarily through fund-raising, was authorized promptly, and construction was scheduled for completion by the 2005 presidential inauguration.

A fourth objective was incorporated to maximize the usefulness of the building addition. Architect of the Capitol Alan M. Hantman summarized the strategy when he told the *Washington Post* in November 2000, "We're digging as big a hole as we can." Specifically, that means excavating a 196,000-square-foot area to a depth of 60 feet. The three-story structure recessed into it will provide 430,000 square feet for the visitor center and support facilities, like a new Capitol cafeteria and an out-of-sight loading dock for the mundane but essential delivery of supplies. In addition, the structure will contain an extra 150,000 square feet of expansion capacity that will be built as two chunks of undefined "shell space" flanking the visitor cen-

Light-colored sandstone and limestone walls, a 30-foot-high ceiling, and a view of the Capitol dome will dispel any sense of confinement in the Great Hall of the U.S. Capitol Visitor Center. Courtesy of RTKL Associates

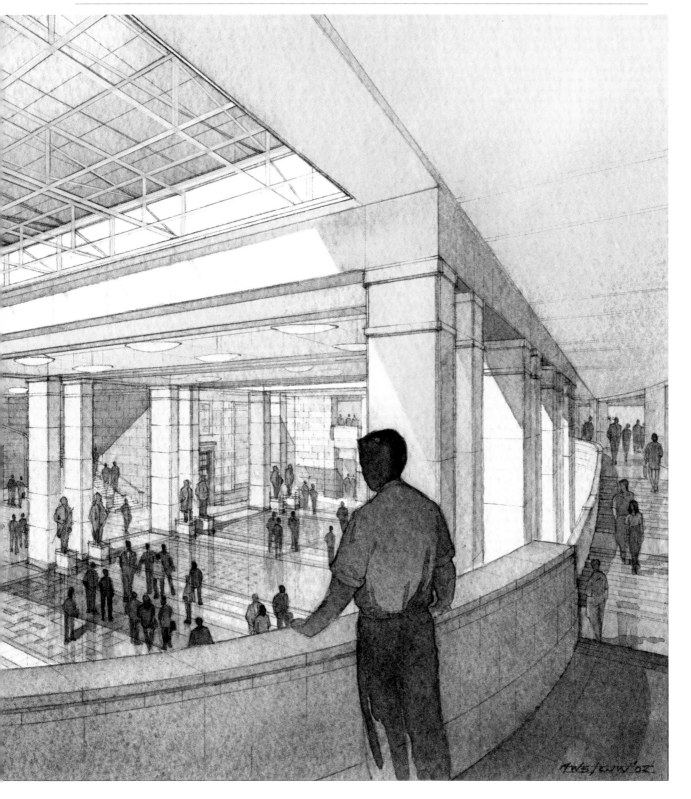

ter. In November 2001, two months after the terrorist attacks on the World Trade Center and the Pentagon, congressional leaders announced that some of the previously undesignated space would be finished as secure offices and meeting rooms for the House Intelligence Committee.

To maximize security and minimize disruption for legislators and visitors, builders will use a "top-down" construction technique. After completing a shallow excavation of the site, workers will outline the future structure by building a slurry wall. Working in sections about 10 feet long, they will dig a 75-foot-deep trench along the edge of the excavation site. As each section of trench is being dug, it is filled with a clay-and-water mixture that keeps the surrounding soil from caving in. When the desired depth is reached, a cage of reinforcing steel is lowered into it, and concrete is pumped into it from the bottom. The heavier concrete forces the slurry up and out of the trench, where it is recovered for use in the next section. While the slurry wall is being constructed, other workers will drill shafts into the soil and pour reinforced concrete support columns in the interior of the building site. When the slurry wall and columns are finished, workers will construct the new building's roof. With the site now completely enclosed, the remainder of the soil will be dug out between the walls and columns, and the rest of the structure will be built.

This visitor center will not be a timid kiosk through which tourists pass before encountering the grandeur of the Capitol. Generous, 15-foot ceiling heights are designed to nip claustrophobia in the bud. The focal point, a two-story Great Hall, will feature granite floors and sandstone walls like those in the Capitol rotunda. Skylights in its ceiling will provide a stunning view of the towering dome while admitting abundant amounts of daylight. Two 280-seat theaters will show informative films about the Capitol building, and another 450-seat auditorium with a separate entrance will be available for use by entities like the Library of Congress, even when the visitor center is closed. Security screening rooms, located underground a full 300 feet from the main Capitol structure, will establish a safe envelope for the building and the people in it while still preserving the image of accessibility for a symbolic structure that was described by a former Architect of the Capitol as "the physical embodiment of our democratic system."

DROP IN FOR A VISIT

Whether they are integrated with a historic structure like the U.S. Capitol or they stand alone near a tourist attraction, visitor centers are good candidates for underground construction. Building them below ground is one of the most effective ways to keep attention focused on the main attraction without cluttering the scene with a distracting ancillary building. The concept of a comprehensive visitor center was pioneered in the mid-1950s by the National Park Service in response to the post-World War II boom in park visits and in preparation for the fiftieth anniversary of the Park Service in 1966. As part of its Mission 66 planning effort, the Park Service decided that modern visitor centers should provide services for the comfort of visitors, exhibits and interpretive programs to make their visits more informative and responsible, and offices for the site's administrative staff. One of the visitor centers designed and built as part of this program was at the Jefferson National Expansion Memorial Park, site of the Gateway Arch.

GATEWAY ARCH VISITOR CENTER

The Gateway Arch in St. Louis, Missouri, is one of the most visually impressive monuments in the United States. People recognize the graceful stainless-steel arch that towers 630

feet high even if they do not know that it commemorates the westward expansion of the nation during the nineteenth century. Another thing they may not realize at first, or even second, glance is that there is a 70,000-square-foot visitor center on the grounds. It is not just tucked away in a remote corner. Stretching between the two bases of the arch, it is tastefully concealed underneath a tidy lawn.

Space for the visitor center was excavated at the same time as the holes for the two 60-foot-deep foundations for the arch. Although the arch was completed in 1966, it was another ten years before funding was available to complete the underground visitor center. Some of the center's space is devoted to administrative offices, mechanical systems, and portals for the tram that carries tourists up to an observation deck inside the apex of the arch. However, most of the football field-sized building is devoted to the Museum of Westward Expansion and two theaters where documentary films are shown.

The newer of the two theaters was added to the visitor center in the early 1990s by modifying an existing 60-by-80-foot room. To accommodate a four-story-high projection screen, the floor had to be lowered 17 feet at one end of the room. Moving across the room, the excavation depth decreased in steps to create platforms for successive rows of seats. More than 48,000 cubic feet of material was removed.

Two major factors complicated excavation of the new theater space. First was tight space limitations, not only for the excavation itself but also for transporting machinery into and rubble out of the room. A simple monorail system was hung from the roof beams to transport equipment and spoil. The largest piece of equipment used was a compact skid-steer loader. At the beginning of the excavation process, workers were able to drive it into the room. When the digging was done, the hole was too deep to drive the vehicle out. Furthermore, the machine was too heavy to be carried out by the monorail, which hung from a beam that also supported the weight of the roof and its overburden. Ultimately, workers had to disassemble the skid-steer loader and send it out in pieces.

The second complication was the fact that, other than two relatively small veins of clay, the material to be removed consisted of solid rock. Blasting would

At ground level, the inner edges of the Gateway Arch are 530 feet apart. Just inside each base of the arch, a ramp leads down into the invisible visitor center.

Courtesy of Gateway Arch, St. Louis, MO (gatewayarch.com)

have been too noisy and disruptive to keep the museum open during the theater construction; furthermore, it would have caused some fracturing of the rock that would remain in the walls and floor. Instead, engineers devised a procedure for cutting the rock into carefully shaped blocks and lifting them out. Each block was created by drilling a series of 2-foot-deep holes along the desired edge line, inserting a rock splitter into one hole after another to create a guided crack in the rock, and then using an impact hammer driven by the skid-steer loader to deepen the crack. Using this three-step technique, workers were able to cut and remove 113 cubic feet of rock each hour. To conform to the size of the corridor leading from the room and the load limitations of the structural roof beams that supported the monorail, each block had to weigh less than 1,000 pounds. Final shaping of the wall surfaces was accomplished with a precisely controlled jet stream of sand and water.

Construction of the big-screen Odyssey Theatre in the Gateway Arch visitor center was not a trivial task. However, its successful completion shows that even though an underground building may be set in stone, its size and shape are not necessarily immutable.

OLIVER H. KELLEY FARM VISITOR CENTER

Visitors to a Minnesota living history farm leave their cars behind and walk into a building that burrows into a hillside. Moving through the hill, they also seem to walk through time. When they step out on the far side, they are immersed in the rural atmosphere of 1860. The Oliver H. Kelley Farm's visitor center is virtually a time tunnel that transforms the smell of automotive exhaust into the sweet aroma of boiling molasses and highway noise into the soft clop of hooves and creak of yokes on an oxen-pulled plow.

Behind the end walls on both sides of the glass corridor, the Kelley Farm Visitor Center is covered with native grass growing in 2½–3½ feet of soil.

Half an hour's drive from Minneapolis, just outside Elk River, Minnesota, this living history museum's visitor center slices through a shallow hill to transport tourists and students to the historic home of the founder of the farmers' association now known as the National Grange. Only 10 percent of its walls and roof are visible. The structure appears to consist of a two-story tall, glass-enclosed corridor. Only inside the linear lobby do visitors begin to realize that 6,000 square feet of exhibition and administrative space are concealed inside the hill.

When it opened in 1981, the Kelley Farm visitor center earned an excellence award from the Minnesota Society of the American Institute of Architects. Nevertheless, its visual effectiveness has been tempered by a few persistent func-

tional problems. "The opening was delayed last year when leaks developed because a waterproofing product was substituted for the multi-ply PVC membrane waterproofing specified by the architect," *Earth Shelter Living* magazine reported in 1982. "It is now being corrected." Minor water leakage in the walls and ceiling continued, however, with further repairs planned as late as 2001. Moreover, during cold winter days the sun warms the flat glass panels that form the roof arch, causing significant expansion that stresses the moisture seals and produces unnerving noises.

HIGHWAY REST AREAS

Highway rest areas serve some of the same functions as visitor centers, often providing information as well as amenities like rest rooms, drinking water, and vending machines filled with snacks and soft drinks. The state of Minnesota conducted a protracted experiment with underground rest areas, building six of them between 1979 and 1990. Two of the earliest versions were replaced with aboveground structures in 1999, and another one of the same vintage was slated for a similar fate in a few years. Some problems with these structures were directly related to their underground nature. For example, it would have been difficult and expensive to expand them to accommodate larger numbers of users and to meet modern design criteria for more spacious toilet facilities. Furthermore, Minnesota Department of Transportation (Mn/DOT) staff described them as dark, unwelcoming, confining, and poorly ventilated—problems that could have been addressed at the design stage but would be difficult to solve retroactively. Other problems were somewhat related to the structures' underground location but may have been aggravated by poor construction quality. For instance, leaky roofs and walls were hard to repair because their exteriors were inaccessible.

The other three underground rest areas along Minnesota highways have performed somewhat better. One, which was designed and built at the same time as the three described above, was characterized by a Mn/DOT spokesperson in 2001 as "the most successful of the earth-sheltered buildings built by the department in the 1980s." The building, located at Anchor Lake, is well integrated with its scenic surroundings. A short trail leads from its front door through the woods and onto an observation deck on the structure's roof, where stairs along the building's exterior wall provide a convenient return to the starting point.

Circular brick facades of the Enfield rest area building reflected 1970s architectural styles. Small windows admitted little natural light and restricted visitors' ability to see into the building and, once inside, to see their cars and companions in the parking lot.

Another pair of rest areas that were designed in the mid-1980s have also been successful. In 1996, the Hayward facility, the newer of the two, was honored by the Federal Highway Administration with an Award of Excellence, citing its "preservation of existing land forms and vegetation." At the west end of a small hill, an exposed section of the building houses a spacious lobby; natural light enters through clerestory windows mounted high above the doorway. On the west side of the lobby, protected with earth-covered walls, is an office for Mn/DOT staff. The eastern wing of the structure, which houses the rest rooms, is completely earth covered. The subtle building is only part of the rest area design, which also includes a manmade, 3-acre wetland that Federal Highway Administration described as "a visual element providing an opportunity to view wildlife and providing a buffer between the rest area activities and surrounding agricultural fields."

In 2002, the Montana Department of Transportation built its first underground rest area at Sweetgrass, near the Canadian border on Interstate 15. The architect created the design with three goals in mind. First, energy conservation was maximized by sheltering the building in the earth. Second, security was enhanced by providing large windows in the at-grade lobby wall that faces the parking lot. Third, the structure's low profile is easily adaptable to other sites around the state with terrain that ranges from rolling prairies to the Rocky Mountains.

Bookin' It Below

Underground library buildings have become commonplace on college and university campuses, with dozens of examples scattered across the United States. Some cities have also turned to an underground solution for the need to build or expand their public libraries, especially where little or no surface space is available for the construction. Such buildings help protect library materials by maintaining stable temperature and humidity conditions and restricting ultraviolet light, and they provide patrons with quiet, distraction-free reading areas.

Los Angeles Central Library Extension

A new wing added to the Los Angeles Central Library in 1993 more than doubled the facility's space without creating a mammoth structure that would dominate the historic main building. The original library, which was completed in 1926, consists of two 4-story sections

A hill beside the Hayward rest area conceals part of the structure, and it may also hide a future problem. "The flaw of this project," says Mn/DOT Safety Rest Area Program Manager Carol Reamer, "is that the portion of the building that will most likely require expansion in the future is earth sheltered (i.e., covered), while the mechanical rooms are earth bermed. Expansion of the toilet rooms in this building will be costly if required."

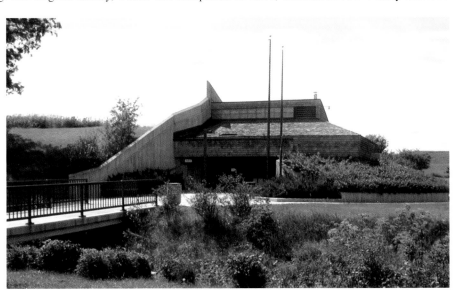

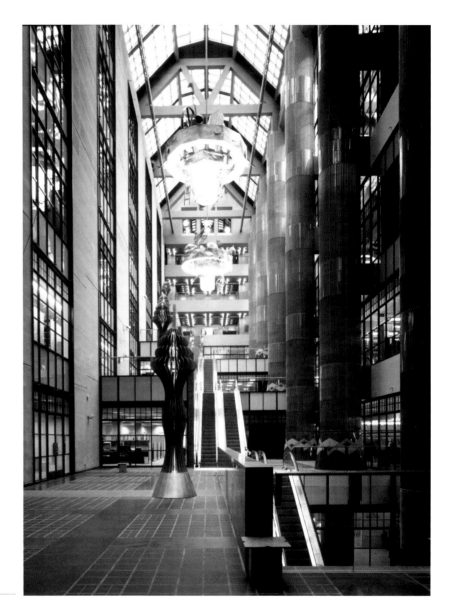

The Tom Bradley Wing's atrium light fixtures are works of art as well as functional elements. A 13-foot-tall, brushed aluminum lantern stands beside the escalator on each landing. Three fiberglass and aluminum chandeliers (two shown here), 18 feet in diameter and weighing 1,750 pounds, are proportioned appropriately for the monumental space. Courtesy of Hardy Holzman Pfeiffer Associates, Architects; © Foaad Farah/HHPA

separated by a pyramid-topped square tower rising approximately another four stories high. The library addition, encompassing 328,000 square feet, is also eight stories tall, but the lower four floors are hidden below ground. This allows the original tower to maintain its prominence over the addition as well as the original building. The library extension, named the Tom Bradley Wing in honor of a former Los Angeles mayor, houses most of the reading rooms and book stacks, leaving the main building available for administrative offices, public services, the circulation desk, and a film and video collection.

A rotunda inside the central tower acts as a spacious focal point for the original building. Similarly, architect Norman Pfeiffer designed the new wing around a lofty central feature: An eight-story-high, glass-topped atrium serves as a broad central corridor. Daylight streaming in from overhead is supplemented by huge chandeliers to ensure that enough illumination reaches the atrium's lower levels. Glass walls define both sides of the broad corridor, adding to the atmosphere of spaciousness. The transparent wall on one side is punctuated with vertical opaque panels for visual relief. Along the opposite wall, huge stone columns rise through the multi-

story space, unifying the above- and below-ground levels of the building. This juxtaposition of the modern element of crisp-edged planes and the classical detail of massive terra cotta columns symbolically integrates the modern wing with the historic library building.

WALKER COMMUNITY LIBRARY

Different motivations were involved in the design of the Walker Community Library, a branch of the Minneapolis Public Library. Completed in 1981, it was built to replace, not enlarge, an older structure. It is not near any architecturally significant buildings that might be eclipsed by its design. Instead, the main reason for placing this building underground was the limited amount of space available for its construction.

Faced with the task of fitting an 18,000-square-foot building and at least twenty-five parking spaces on a 20,000-square-foot site, the design team explored several options. A tall, narrow building would leave space for surface parking, but it would increase both the required number of library staff members and the need for patrons to use stairs or elevators, which would inconvenience the elderly and the disabled. Alternatively, a shorter building could be placed above a surface-level parking area; however, designers were concerned that patrons would not feel safe using the shadowy lot. Furthermore, allowing air circulation underneath the library would increase energy requirements for winter heating.

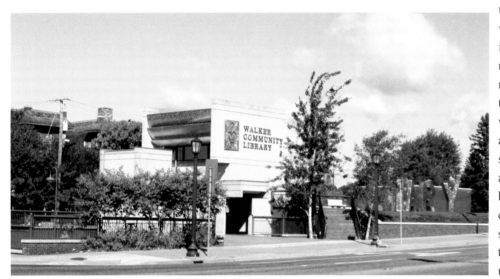

Large block letters of shiny metal spell out the word "LIBRARY" in a serpentine label atop the largely invisible Walker Community building. An assortment of levels in the aboveground portion of the building adds visual interest.

The solution was to place nearly all of the building underground and use part of the roof for a thirty-five-space parking lot. Most of the remaining roof area was landscaped with grass, paved paths, and park benches. A small portion, representing about 5 percent of the building's area, was built above ground as an entrance kiosk with an elevator and stairways. Besides fitting into the available space, the underground design generated some additional benefits:

• The rooftop plaza created open space that was both attractive and useful as a site for community events like an annual art fair.

• Shielding the building's walls from the weather would reduce heating and cooling demands by 40 percent compared with a comparable aboveground building, according to the architect's estimates. This resulted in smaller initial expenses for equipment as well as lower annual energy costs.

• Both the interior of the library and the outdoor, sunken courtyard are isolated from the noise produced by high levels of pedestrian and vehicular traffic on the adjacent sidewalks and streets.

The actual library space, located on the lowest level of the building, consists of a two-story-tall portion housing adult and juvenile bookshelves and reading areas, and a one-story-tall section housing the circulation desk and staff work areas. Above this administrative section, one floor below ground, is a meeting room that is available for community use even when the library itself is closed. The southeast corner of the nearly rectangular building is notched to accommodate a 1,500-square-foot, open-air courtyard that provides outdoor reading space and a landscaped view through the library's windows.

COVERT CONVENTIONS

How can a city provide a convention center large enough to hold thousands of people and acres of product displays without cluttering the area with a bulky box of a building? Some cities have discovered that the necessary bulky box can be concealed by placing it underground.

CLEVELAND CONVENTION CENTER

The city of Cleveland, Ohio, built its first underground exhibit hall in 1922 as a basement under an elaborate new public auditorium. Civic leaders decided to build the facility after three frustrating episodes between 1874 and 1909. In each case, the city attracted a major event even though it had no structure to house the show. Each time, the city erected a temporary hall, hosted the event, and then demolished the building. Resolved not to have to engage in such an exercise a fourth time, the city built a state-of-the-art facility to accommodate anything from a stage production to an industrial exposition.

The elegantly decorated auditorium, which is still in use, fills an entire city block. Inside, on the ground floor, the column-free main hall is 300 feet long and 215 feet wide, with an 80-foot-high glass ceiling that conceals an array of electric lights. With movable seats placed on the floor and stage to supplement fixed chairs in two tiers of balconies, the hall was designed to seat up to 13,000 people. A booklet commemorating the building's dedication described its impressive features, including one of the biggest stages in the country, which was equipped with a 10,010-pipe organ and the largest steel and asbestos curtain ever made.

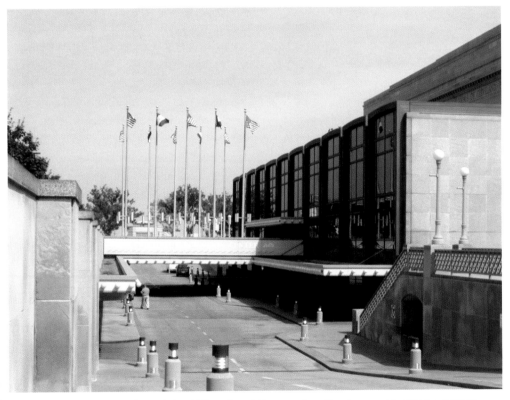

Between the original Cleveland Convention Center and its 1965 addition, a service road descends one story. Vehicles turn left into a parking garage underneath the landscaped mall. As part of the expansion project, a three-story registration lobby was added between the 1922 hall and the new service road. Corridors under the road connect the original structure and the lobby (right) with the lower two stories of the addition (left).

From the marble-and-brass lobby outside the main hall, a 10-foot-wide marble staircase beckoned visitors to the lower-level "great Exhibition Hall." The 121-by-235-foot hall, which was supplemented by two adjacent 50-by-23-foot meeting/display rooms, may not have been as elaborate as the grand hall upstairs, but it was equipped with the latest technology. A ventilation system circulated air at a rate of 4.5 million cubic feet per hour while cleaning and humidifying it and adjusting its temperature. A sprinkler system protected "life and the valuable exhibits" from fire, and a central vacuum cleaning system made maintenance easy. Each of the forty columns supporting the exhibit hall ceiling was equipped with a panel that opened to reveal connections to telephone lines, hot and cold water, compressed air, natural gas, high- and low-pressure steam, a vacuum line in addition to the vacuum cleaner fitting, wires for both alternating and direct current electricity, and drainage pipes for both acids and water.

In 1965, Cleveland added a new 208,000-square-foot underground exhibition hall, doubling the convention center's capacity. The addition was placed beneath the downtown mall, a two-block-long lawn bordered by city and county government buildings. Seven 30-foot-wide, 17-foot-high doorways were cut into the adjoining wall of the original underground exhibit hall to connect it with the addition. Designed to hold the bigger exhibits and larger numbers of people characteristic of modern conventions, the addition measures 670 feet by 515 feet. The structure was built three stories deep to provide high ceilings in the exhibit area and also to sandwich a one-level parking garage between portions of the convention center and the surface mall.

Roof support columns are spaced at 30-foot intervals through most of the exhibition space. To maximize usable space, the column grid is offset 45° from the perimeter walls in part of one exhibit hall, creating 60-foot clear spans parallel to the walls. The ceiling height is generally 17 feet, except in a 300-by-120-foot area called the Great Hall. Here, with no parking garage above, the ceiling rises 30 feet above the floor. However, because columns were eliminated from this area, the roof is supported by nine 7-foot-deep steel girders that reduce the vertical clearance to 23 feet underneath them.

Over the years, regional and national conferences and exhibitions continued to grow, both in the size of the exhibits and in the number of exhibitors and attendees. By the 1990s, Cleveland saw a need to have a larger convention center. The occupancy rate for its existing facility was only 30 percent of what convention centers in comparable cities were achieving. A lively debate ensued, with one faction supporting additions to the underground center and other factions proposing various sites for a new aboveground facility. City officials hope to make a decision in 2003. One city councilor summarized his concern about an expansion that would be hidden from public view when he asked a Cleveland Public Radio interviewer, "Should we spend three or four hundred million dollars and not have an architectural statement that is of civic pride to Clevelanders as well as a statement to those that are coming to this region?"

GEORGE R. MOSCONE CONVENTION CENTER

The voters of San Francisco decided in 1976 that the architectural statement they wanted to make with their new convention center was "keep it inconspicuous." Specifically, the citizens voted to build the center underground, if possible, and to design the structure so that a public park or two-to-three-story retail and entertainment buildings could later be built on its roof. Named for the San Francisco mayor who was assassinated in 1978, the George R. Moscone Convention Center opened in 1981. It contains 650,000 square feet, and only a 30,000-square-foot, glass-

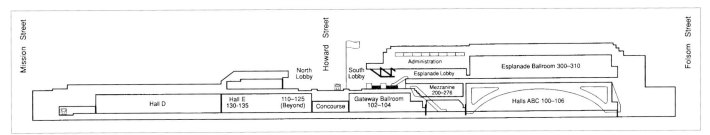

When it was built in 1981, the Moscone Center was completely underground except for a small entrance pavilion. An expansion, completed a decade later, added a ballroom above one end of the original exhibition area and doubled the underground space by building the wing shown in the left half of this drawing. Near the center, the flagpole base indicates ground level. Courtesy of The Moscone Center

walled entrance pavilion is aboveground. Downstairs are a main exhibit hall, a ballroom, thirty-one meeting rooms, and support spaces like a kitchen and loading docks for trucks.

The main exhibit hall is twice as wide and three times as long as a football field. There are no columns in the room to block views or limit placement of exhibits. The ceiling is 37 feet high, although near the side walls the vertical clearance is interrupted by concrete arches that support the roof. When the 1984 Democratic National Convention was held in the room, there were mixed reviews. On the plus side, the huge room allowed honored guests to sit on the delegate floor rather than relegating them to balconies away from the action, as had been done at the previous two conventions. More problematically, the arches did obstruct the views of spectators seated near the walls; to compensate, images of the podium were shown via closed circuit television on large screens mounted in the hall.

The Moscone Center was designed to hold as many as 24,000 people at one time. To provide adequate emergency exits, the designers included eighteen 20-foot-wide stairways; in

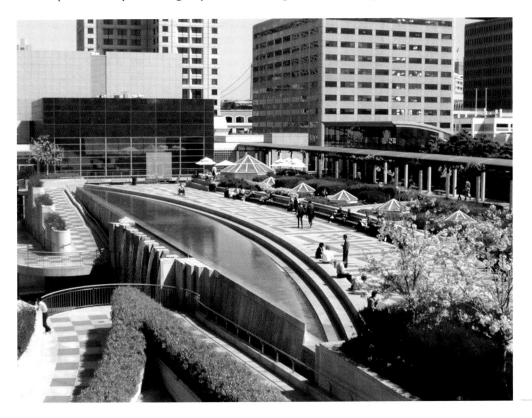

Pyramid-shaped sky-lights, a 60-foot-long pond, and a 20-foot-high waterfall decorate one end of the lawn above Moscone North. The glass-enclosed structure (right center) rising above the covered walkway is the rear of the convention center entrance pavilion. On the opposite side, its front doors are one story lower.

At the top of the Moscone North escalators, a glass wall faces southward at street level. The lower-level exhibit spaces at the bottom of the escalator extend northward underneath the Yerba Buena Esplanade.

addition, a 27-foot-wide truck ramp at each corner of the building could be used as emergency pedestrian exits. Smoke detectors, automatic water sprinklers, and fans for smoke removal were also provided.

As large as it was, the Moscone Center was in need of expansion within a few years of its completion. The aura of the host city, the increase in trade show activity, and the need for larger column-free spaces demanded it. In 1989, construction began on two additions. A 126,000-square-foot ballroom was erected on one third of the main exhibit hall's roof, and a 650,000-square-foot underground addition was built across the street, connected to the existing structure by a broad corridor beneath the roadway. The new subsurface wing, with its own aboveground entrance pavilion, was named Moscone North, and the original underground portion became Moscone South.

In keeping with the original mandate, community-oriented attractions were planned for the roofs of the entire underground convention complex. The first section, completed on Moscone North's 10-acre roof between 1993 and 1995, is called Yerba Buena Gardens. Half of the space is devoted to the Esplanade, a landscaped park that includes a memorial waterfall, outdoor dining areas, and a lawn that can seat 3,000 people during open-air performances. The rest of Yerba Buena Gardens is occupied by two buildings designed to present visual and performing arts. The second phase of surface development, built atop Moscone South, was completed in 1998. Called the Rooftop at Yerba Buena Gardens, it is devoted to educational and recreational facilities for children and the young-at-heart. Components include a glass-enclosed professional-size ice-skating rink, a twelve-lane bowling center, an interactive arts and technology center, a restored antique carousel, a playground, and a childcare center.

In 1999, the Rudy Bruner Award Foundation honored Yerba Buena Gardens with a gold medal and a $50,000 cash prize. The biannual prize recognizes excellent examples of visionary urban revitalization with significant social impacts. Award Director Emily Axelrod made an architectural statement of her own: "We really liked the fact that Moscone's exhibit space is underground—it keeps the sidewalks alive."

SUNKEN SLAMMERS

By their nature, correctional facilities must be built for security. This usually means they present formidable, unwelcoming facades. Placing them underground can make them less conspicuous, less menacing, and even more secure; however, it can also dredge up mental images of medieval dungeons.

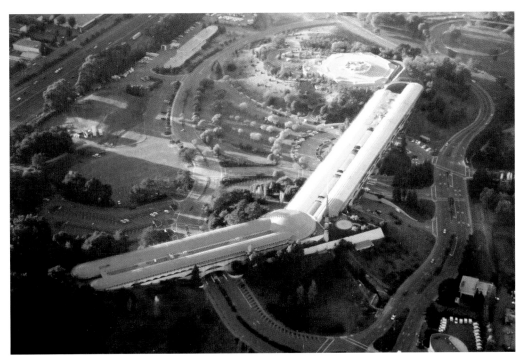

Frank Lloyd Wright's vision of the Marin County Civic Center was that it would "bridge these hills with graceful arches" and appear to "melt into the sunburnt hills." Barely noticeable from ground level, a newer hexagonal jail is clearly visible from the air. Courtesy of Jill Hill's Real Estate Guide for Marin County

This ambivalent mixture of the pros and cons of stashing convicts underground is evident in the story of Old New-Gate Prison in East Granby, Connecticut. In 1773, what was originally America's first chartered copper mine became its first colonial prison. Establishing the prison was an attempt by Connecticut's government to confine and profitably employ criminals rather than administering customary corporal punishments that ranged from flogging to ear cropping to hanging. Housed some 70 feet below ground in the mine, prisoners were required to work at various jobs, including mining copper, making shoes, and manufacturing nails. As progressive as the notion was, the devil was in the details. There were no cells in the prison. Inmates had the run of the mine and were free to prey on each other. The country's first prison riot broke out in 1774. Confining people below ground in a facility with few exits to the surface promised a level of security that did not materialize; the first prisoner escaped eighteen days after he was incarcerated. Escapes continued to plague the institution until its surface guardhouse was replaced with a more secure version, after being burned down in a 1782 riot.

A modern example of the negative image of underground prisons is provided by a special facility added to the Oklahoma State Penitentiary in 1991. Called "H-Unit," it is the most secure part of the maximum-security prison, designed to house death row inmates as well as others being held in disciplinary or administrative segregation. It was built at ground level, but its two-story walls are covered with thick earthen embankments. Except for a small, Plexiglas-covered opening in the door, each cell is windowless. Inmates must remain in their cells at least twenty-three hours a day. Visitation rooms for family members and attorneys are located inside H-Unit. Amnesty International issued a highly critical evaluation of the facility in 1994. Despite the extraordinary security measures, two prisoners escaped from the unit in 2001 by

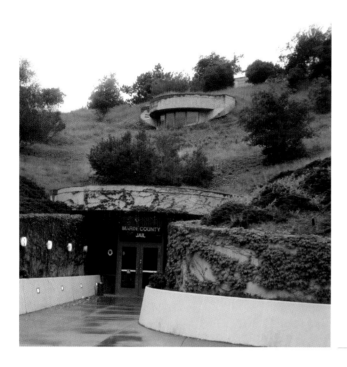

It's a matter of perspective: Frank Lloyd Wright afficionados see an unimposing facade that defers to the master's bold architecture. Naturalists see a building that defers to nature. Inmates see a formidably secure place of incarceration. "It is a brooding presence," writer John Blower declared, recalling his one-night stay in the facility.

unfastening stainless steel toilets from the concrete wall, crawling through maintenance space behind the wall, reaching the roof through an air duct, and scaling two fences separated by a gap laced with razor wire.

The Old New-Gate and H-Unit examples conform to the distasteful stereotypical image of an underground prison. Two other American examples offer a different perspective.

CORRECT ME IF I'M WRONG, MR. WRIGHT

On the list of architectural no-no's, upstaging a Frank Lloyd Wright masterpiece ranks near the top. Imagine, then, the challenge faced by the architectural firm Daniel, Mann, Johnson & Mendenhall in planning a new jail in San Rafael, California, north of San Francisco. The jail would have to stand near and be connected to Wright's last major project, the Marin County Civic Center. Sometimes described as a horizontal skyscraper, the structure is so striking it has been used as a movie set, is treasured by county residents, and attracts 10,000 tourists a year.

The Civic Center consists of two wings connected by an 80-foot-diameter hub that houses the county's main library. The 584-foot-long Administration Building wing was completed in 1962, and the 880-foot-long Hall of Justice wing was finished seven years later. By the late 1980s, the county needed a larger jail than the 110-bed facility contained in the Hall of Justice wing. Seeking to place the new jail as close as possible to the Hall of Justice courtrooms without interfering with Wright's Civic Center design, Daniel, Mann, Johnson & Mendenhall suggested hiding the facility in the hillside 60 feet away. Aaron Green, one of Wright's associates who completed the civic center's design and supervised its construction after the master architect's 1959 death, supported the underground option.

Rather than *underground,* the 110,000-square-foot, 362-bed facility might more accurately be described as *in ground.* A short concrete wall rises above the hilltop but is obscured by trees and bushes. From the parking lot in front of the Civic Center, the only two visible

Although individual cells of the Marin County jail do not have exterior windows, they receive daylight from the glass-walled light court at the end of the pod and from ceiling skylights at the apex of the triangular common area. Courtesy of DMJMH+N; Photo by John Livzey

features of the jail are a recessed doorway at the base of the hill and a 10-foot-wide window peering out of the ground two stories above it. On top of the roof, broad skylights at each corner of the hexagonal building admit sunlight down into the structure. Inside, six triangular bays radiate outward from a central administration area. In a typical two-story block, forty cells line two sides of the triangle, and the third side consists of a window wall that separates the living area from a daylight-filled exercise yard extending to the building's outer wall. The interior of the triangle is a common area where inmates eat meals and interact during parts of the day.

The architects used several techniques to keep the jail inconspicuous. The main driveways into the Civic Center parking lot pass underneath the sprawling building's two long wings. Hidden behind a bulge of the hillside, even the jail's unimposing entrance will not distract entering visitors' view of Wright's famous design. An earth embankment obscures the sight of delivery trucks and prisoner transport vehicles as they drive up the back side of the hill. For security as well as aesthetics, prisoners walk to and from Hall of Justice courtrooms through a tunnel secreted inside the hill. As a crowning touch, the plush landscaping that helps hide the underground building is nurtured with gray water from the jail itself.

ENCIRCLED BY THE LONG ARMS OF THE LAW

Like the Marin County jail, the correctional facility in Oak Park Heights, Minnesota, is *in ground* rather than *underground*. In the late 1970s, the Minnesota Department of Corrections gave architects two starting points: a carefully developed set of conceptual features for a secure, effective prison and a sloping site with a large natural channel coursing down its backside, leading away from an access road that crosses the hilltop. Ordinarily, such topography would present problems for building a large project, but the architects saw a way to turn the site's physical characteristics into a tool for meeting the prison's design criteria.

The first task was enlarging the gulch, removing 1.3 million cubic yards of dirt to create an 8-acre, 30-foot-deep hole in the hilltop. Then a ring of three-story-tall buildings was constructed around the perimeter of the roughly triangular hole, their rear walls butting up against

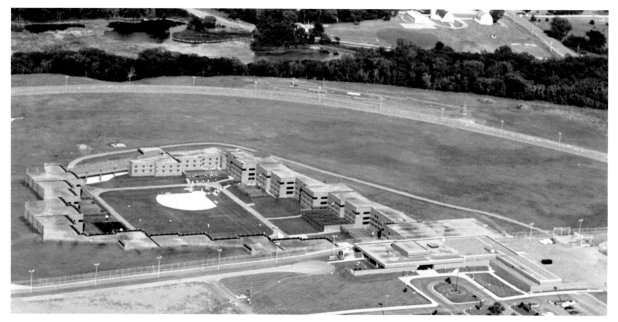

At the Minnesota Correctional Facility, only the administration building (lower right) rises no-ticeably above ground level. In the three-story buildings surrounding the recreation yard, inmates live on the lower two floors and work or attend classes in the top story. Courtesy of Minnesota Department of Corrections

the edges of the excavation. This placed the roofs of the buildings at or near the level of the surrounding terrain and created a large interior yard between the buildings.

This design strategy resulted in several benefits. One is energy efficiency. The surround-ing earth shelters about half of the exterior walls of the complex, shielding the buildings from blustery winds and temperature fluctuations in the severe winter climate. Even in the event of a seventy-two-hour power failure, designers predicted the interior temperature of the complex would drop only about one degree.

Another benefit is real and apparent security. Corridors and community rooms separate the cells from the outer wall, which itself is backed by an entire hillside. "In nineteen years of operation we've never . . . had an escape, or even an attempted one," Warden James Bruton told a *Pulse* newspaper reporter in 2001.

A third benefit is psychological. Each of the prison's 400 single-person cells features a narrow, vertical window looking out onto the central yard, which contains a baseball field. Planners expected that this relatively normal view, rather than a more typical vista of guard towers and tall fences topped with barbed wire, would contribute to an atmosphere focused on rehabilitation rather than punishment. Originally, it was possible to let fresh air into the cell by opening the slender window; after a 1995 energy audit, however, the windows were sealed shut.

Finally, the design is community friendly. The absence of guard towers, intimidating fences, and enormous walls preserves a pleasant view for a nearby residential development. Making the prison nearly invisible is kind to its neighbors' sensitivities and probably to their property values as well.

7

DEFENSE DUGOUTS

Prehistoric humans sought shelter in caves, not only from the weather, but also from predators and rivals. During recorded history, that strategy has evolved into increasingly sophisticated underground constructions for defense.

Modern use of subsurface structures for defense grew out of the highly successful use of trenches by soldiers in World War I. Between 1929 and 1940, the French government built an elaborate underground system of tunnels and multistory bunkers along 150 miles of its border to protect against invasion. The Nazi army eventually entered France by skirting around the end of the system. Throughout World War II, underground fortresses were used extensively by participants on both sides of the conflict, by combatants and commanders alike. After Adolph Hitler committed suicide in his Berlin "Fuhrerbunker" at the end of European hostilities, General Dwight Eisenhower, who had commanded Allied forces from a 130-foot-deep bunker in London, returned to the United States and was elected president.

During the decades that followed World War II, a new kind of warfare developed. Based more on threats than on physical battles, the conflict concentrated on the development of nuclear weapons in increasing numbers and escalating levels of sophistication. This struggle, which became known as the Cold War, spurred the development of underground strongholds sturdy enough to withstand atomic bombs.

By 1991, when the collapse of the Soviet Union ended the Cold War, the U.S. government had built approximately 100 secret underground facilities in a strategy known as continuity of government (COG). In the event of enemy attack, civilian and military leaders would keep the government functioning and direct combat efforts from these secure locations. With little perceived threat remaining during the 1990s, some of the installations were decommissioned, some were converted to peacetime use, and some were opened to public inspection. The COG policies remained in effect, however, as was demonstrated on September 11, 2001. Immediately after terrorists attacked the United States, demolishing the World Trade Center skyscrapers in New York City and heavily damaging the Pentagon in Washington, D.C., government leaders were whisked to "secure, undisclosed locations," including a bunker underneath the White House.

This chapter explores examples of the underground component of defending the United States' territory, its government, and its people. In addition to describing some COG bunkers, the chapter examines public and private emergency preparedness facilities for natural disasters as well as wars or acts of terrorism. It also looks at missile defense silos and how they have been converted to peacetime uses.

BUNKERS: A COG IN THE DEFENSE WHEEL

A country's defensive strategy can have many components. One tactic may be to intercept incoming threats through techniques ranging from customs searches to antiballistic missile networks. These kinds of defense activities can potentially protect both people and structures.

Another component is to provide secure refuges for people. At one level, a government may try to shelter as many citizens as possible. Building dedicated shelters for a large population is very expensive, but the cost can be reduced by building dual-use structures. During the first half of the Cold War, for example, the United States designated as civilian shelters sturdy, nearly windowless buildings such as school gymnasiums and office building basements. The Scandinavian countries have made a concerted effort to build a variety of public underground facilities, such as sports halls, community centers, and concert halls, that can double as civilian shelters. At the end of the twentieth century, for example, 75 percent of Norway's population had access to such a shelter. Since the 1960s, China has also made a concerted effort to construct underground civilian refuges. In Beijing, the network is large enough to shelter as many as 2.5 million inhabitants of the capitol city. Much of this system consists of long, narrow tunnels that provide escape routes out of the city; however, in the interest of economic efficiency, newer installations are being designed for dual use.

Apart from the public shelters, governments often create highly secure shelters for top government officials. Because of its geographic separation from hostile nations, the United States did not see the need for such a system until after World War II. As the Cold War developed, it became clear that even a distant enemy could quickly attack the country with nuclear missiles. When retired General Dwight Eisenhower became president, he promptly began expanding the bunker-building program begun by his predecessor, Harry Truman, at the end of World War II. To ensure that order could be maintained following a nuclear attack, the first COG bunkers were designed to shelter the president, military leaders, and the justices of the Supreme Court. Concerned that the American system would be crippled unless all three branches of the government were preserved, Eisenhower proposed a congressional bunker as well. It took a year to convince the leaders of the Senate and the House of Representatives to agree in principal and to select a site. The three-branch federal relocation center system was not finished until a few months after Eisenhower completed the second term of his Presidency in 1961.

Because secrecy was an important factor in the probable success of COG bunkers, information on many of them is sketchy. Descriptions released after certain facilities were decommissioned, along with a few investigative articles, paint an interesting, if incomplete, picture.

MOUNT WEATHER

A primary relocation site for the U.S. president, the 200,000-square-foot bunker inside Mount Weather in rural Virginia was also the designated refuge for the cabinet secretaries and the Supreme Court justices in the event of a national crisis. In addition to the underground facility, the 434-acre complex is home to numerous aboveground buildings that house federal emergency preparedness services.

The amount of surface activity helped conceal the subsurface shelter, which remained a closely guarded secret for decades, with few breaches. Although it apparently inspired the setting of the 1962 novel *Seven Days in May,* that fact did not become public knowledge until

years later. When a TWA jet airliner crashed nearby in 1974, killing its ninety-two occupants and attracting reporters to the area, government officials declined to comment on the nature of the complex. That aroused the curiosity of journalist Richard Pollock, so he searched congressional hearing records for information and sought out people who had seen the facility. *The Progressive* magazine published his detailed account in March 1976. Pollock reported that the Soviet Union not only knew about the facility but had even tried to buy a nearby estate, a deal that was discovered and blocked by the U.S. State Department. In December 1991 and August 1992, following the demise of the Soviet Union, *Time* magazine published additional accounts detailing the findings of investigative reporter Ted Gup. Those three articles form the basis for practically all of the information currently available on the Mount Weather Special Facility.

The U.S. government has owned Mount Weather since 1902, when the National Weather Bureau began using it as a launch site for weather balloons and kites. The Bureau of Mines took it over in 1936; consisting of greenstone, a very hard type of granite, the site became an ideal testing ground for new mining technologies. By the early 1950s, the drilling and blasting tests had created a 1,300-foot-long shaft with a cross section measuring almost 7 feet square, extending as deep as 300 feet below the surface. Government officials searching for a site to build the country's first large COG bunker found what they needed, and it was only 48 miles, as the helicopter flies, from Washington, D.C.

In 1954, the Bureau of Mines began expanding its test tunnel to create the government relocation complex. Crews worked twenty-four hours a day for three years to hollow the desired chambers out of the granite. When the underground complex became operational in 1958, it included twenty office buildings up to three stories tall. Among the support facilities were a kitchen, a dining hall, sleeping areas, recreation space, a hospital, a power plant, and a sewage treatment plant. A studio for radio and television broadcasts was included, and a few prominent newscasters secretly agreed to enter the bunker and use their familiar voices and faces to help calm the public in the aftermath of a disaster. Several reservoir ponds as much as 10 feet deep and 200 feet wide were built inside the cavern to contain water for human use and for cooling the huge computers. Space and thirty days' worth of supplies were provided for several thousand people, although, as in other relocation facilities, most of the occupants would have to take turns sleeping in the 2,000 cots.

To ensure that the cavern would not collapse, twenty-one thousand 8-to-10-foot-long rock bolts were inserted into the ceilings of the chambers and passageways, securing the exposed surfaces to deeper layers of rock that were undisturbed by the construction process. The entrance to the underground facility could be shielded with a 20-foot-square, 5-foot-thick, 34-ton blast door.

Time magazine reported that the Mount Weather Federal Relocation Center went on full alert only once during the Cold War. In November 1965, a sudden blackout left much of the northeastern part of the country without electricity. Concerned that the power failure might have been caused by an enemy attack, the center's director called all staff members to report to the base immediately. More than 80 percent of them did, despite the fact that their families were not eligible to enter the protective structure. On September 11, 2001, helicopters whisked several congressional leaders to Mount Weather after hijacked airliners hit the World Trade Center and the Pentagon. Since the primary objective is continuity of government, not personal safety, the officials left immediately without their families. "When you're called to go somewhere and do something for the job, you do it," House minority leader Richard Gephardt later told KMOV TV.

MOUNT PONY

Probably the only major COG facility to have been featured in a real estate sales brochure was one built into Mount Pony, east of Culpeper, Virginia. Between 1969 and 1992, this 140,000-square-foot, three-story bunker stood ready to ensure the economic survival of the United States in the event of nuclear war. As many as 540 executives and support personnel from Federal Reserve Board offices in Washington, D.C., and Richmond, Virginia, could be whisked there in less than half an hour by helicopter.

Mount Pony is only 500 feet high, but it hides a sizable structure. Rectangular in plan, the bunker's lowest floor measures 460 feet long by 140 feet wide. The two upper floors are successively narrower, to conform to the hill's gentle slope. The steel-reinforced concrete walls are a foot thick, but only 2–4 feet of soil covers the structure's roof. In an emergency situation, the windows peering out of the hillside could be shielded with lead shutters.

In addition to men's and women's dormitories equipped with 200 beds, there were two important components to what was known as the Federal Reserve Communication and Records Center. The communications center resided in a 10,200-square-foot room housing seven large computers that routinely served as the central node for all electronic transfers of funds between American banks. On the lowest level of the structure sat a 23,500-square-foot, 11½-foot-high vault that served dual duty. As part of the Federal Reserve System's normal operations, it preserved records of the nation's banking transactions. Also, as part of the continuity of government program, it stored cash that could be distributed to keep the nation's economy functioning after a nuclear attack, even one that destroyed the nation's currency printing capability. Various groups and media accounts have estimated that the amount of money stored inside Mount Pony was between $1 billion and $2 trillion.

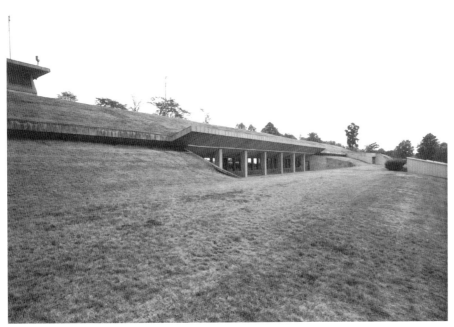

Once destined to shelter the nation's key banking personnel, the Mount Pony bunker will now protect Humphrey Bogart. *The Maltese Falcon* and *Casablanca* are among the original negatives and film prints to be stored here beginning in 2003. Fragile, one-of-a-kind treasures will enjoy ideal temperature and humidity while being protected from accidental or malicious damage. Courtesy of Library of Congress

After the Cold War ended in the early 1990s, the Federal Reserve phased out its operations at Mount Pony and put the property up for sale. A brochure distributed by a commercial real estate firm described it as a "high security office and storage facility" that "offers such unique features as a heliport landing pad, an indoor pistol range, an incinerator, maintenance shops, and a cafeteria." In 1997, using funds donated by a private foundation, the Library of Congress purchased the bunker for $5.5 million and began planning a restoration and expan-

sion to house its new National Audio-Visual Conservation Center. The facility will enable the Library of Congress to store its enormous collection (numbering more than 150,000 motion pictures, 85,000 television shows, and 2.5 million audio recordings) in a controlled climate that will help protect them from deterioration. In addition, a new laboratory will improve the library's ability to restore and preserve these treasures.

GREENBRIER

The only (formerly) top-secret, underground federal relocation center as yet opened for public tours is the congressional bunker, which was built between 1959 and 1962. In contrast to the Mount Pony facility, congress's bunker was not imbedded into a mountain of protective stone. Nor was it surrounded with barbed wire and armed guards like Mount Weather. Instead, it was built on the site of a historic, five-star resort in White Sulphur Springs, West Virginia. Much of it lies beneath a wing of the Greenbrier Hotel. It is accessible from inside the hotel, or it can be entered through a 430-foot-long entrance tunnel that is covered with 25–100 feet of soil and landscaping.

Three-foot-thick, steel-reinforced concrete walls and 25-ton, 20-inch-thick blast doors on the two vehicular entrances testify that the facility was designed for physical security. Nevertheless, it was less heavily fortified than the COG bunkers at Mount Pony and Raven Rock, and this made secrecy an essential element in protecting it from assault. At the same time, its intimate proximity to a popular 750-room inn made secrecy extraordinarily difficult. The solution was, essentially, to hide the bunker in plain sight. Well, maybe not the entire, two-story, 112,544-square-foot, 153-room bunker, but enough of it to deflect suspicion.

Construction began in 1959 and was publicized as the addition of a new wing that would expand the resort's conference facilities and its diagnostic clinic. Indeed, the new 89-by-186-foot exhibit hall with an expansive ceiling height of 20 feet became a well-used amenity. Few people realized that its clandestine purpose was to serve as a chamber for joint sessions of congress during a nuclear war. Similarly, two new auditoriums, with seating capacities of 130 and 470, served private-sector conferences while awaiting their potential need as emergency Senate and House chambers. Hidden from the public, and even from most Greenbrier employees, was the remainder of the bunker, including:

- eighteen 60-bed dormitories that could accommodate 1,080 occupants on a rotation of three 8-hour sleeping shifts
- a 400-seat cafeteria with reassuring country scenes painted on false windows but an unnerving black-and-white, diagonal checkerboard floor tile pattern designed to discourage lingering
- a fully-equipped hospital, complete with operating room and intensive care unit, a dental office, and a laboratory
- a television studio with a full-color backdrop depicting the U.S. Capitol dome
- recreation space equipped with exercise equipment and board games
- a 3,000-book library

The existence and purpose of the Greenbrier bunker remained a closely guarded secret for three decades. Suspicions aroused by the enormous size of the construction project (4,000 truckloads of concrete, for example) were dampened by labeling the new exhibition hall as a

fallout shelter. The vault-type doors were either concealed behind false walls or made ordinary by posting "Danger—High Voltage" signs on them. Government employees assigned to maintain the completed site blended into the hotel staff by repairing television sets; no one realized the amount of work the fifteen technicians accomplished could have been done by two or three

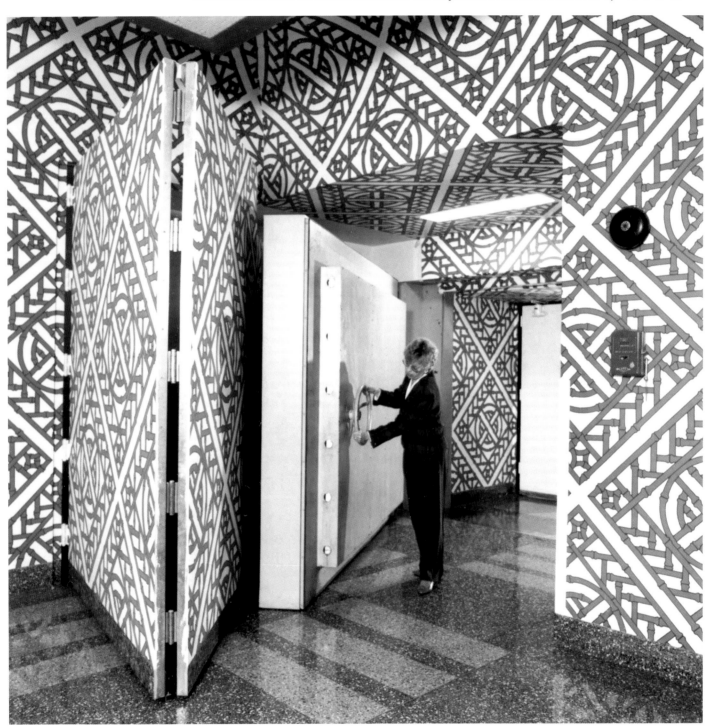

The only entrance from inside the Greenbrier Hotel to Greek Island (the code name for the COG bunker) was disguised by a false wall and secured by a vault door. Each year, the government paid the resort $50,000 for its cooperation with the clandestine operation. Courtesy of The Greenbrier

devoting full attention to the task. Even the senators and representatives who would have been whisked to Greenbrier in an emergency did not know about it; only a few congressional leaders were ever told about the plan. Greenbrier President Ted Kleisner estimates that only 900 people ever knew about it during the thirty years it served as a COG facility.

On May 31, 1992, investigative reporter Ted Gup, writing for the *Washington Post*, broke the secrecy in a feature article that described the bunker in detail and related its history and mission. By then, the Soviet Union no longer existed to threaten the United States. Furthermore, technological advances had so increased the speed and accuracy of nuclear missiles that evacuating 1,000–3,000 Washingtonians, including not only senators and representatives but also their families and aides, seemed futile. Nevertheless, Fritz Bugas, who had managed the clandestine facility since 1970, described the reaction of the people who had so tenaciously guarded the secret for so long: "My immediate feeling and reaction was one of devastation," he told a PBS interviewer. "We took great pride in what we did. When all this was exposed in the newspaper, it obviously hurt us a great deal."

Bugas is not only a devoted public servant; he is also a realist. After the newspaper exposé, the government promptly emptied the Greenbrier bunker and turned it over to the hotel. The hotel, in turn, decided to offset the substantial costs of maintaining the historic Cold War relic by conducting tours of the facility and renting its rooms for group events and "unique theme parties." Bugas stayed on to oversee the bunker's new role.

Kleisner envisions other ways to profitably use the former federal relocation center. He has proposed turning the exhibit hall into a casino open only to the Greenbrier's overnight guests. Asserting that the attraction would mitigate the resort's seasonal attendance patterns, he spent eight years convincing the West Virginia legislature to permit such an operation, if approved by county voters. When first put on the ballot in November 2000, the measure was defeated, but Kleisner immediately began campaigning for the next try.

IN THE GROUND IN AN EMERGENCY

Ensuring the continuity of government by protecting high-ranking government officials is essential to the national security. However, crisis situations must also be dealt with on an operational level. Potential threats must be identified and monitored. National, state, and local officials must continue providing and coordinating essential services such as police and fire protection. Public utilities must try to keep their systems operating. Even private businesses need to minimize the damage to their operations. Often, government and business leaders look underground for this kind of protection.

CHEYENNE MOUNTAIN

Even though it was not intended to shelter thousands of disaster refugees, the Cheyenne Mountain Operations Center near Colorado Springs, Colorado, is nearly twice as large as the Greenbrier bunker. At any given time, somewhere between 400 and 1,500 military and civilian personnel are working in a cavern carved out of the hard-rock mountain. Their job is to monitor the sky. In addition to the original task of watching for airborne threats to North America, they also track earth-orbiting objects ranging from active satellites to bits of baseball-sized debris left over from previous space missions. This information helps ensure that the international space station and shuttle flights will not collide with other objects, and it allows prediction of when and where man-made objects will fall to earth.

Two thousand feet of granite cover the Cheyenne Mountain Operations Center. Two people devote their daily work shift to tightening the rock bolts that ensure the structural integrity of the man-made cavern. Courtesy of North American Aerospace Defense Command (NORAD)

Planning for the operations center began in early 1956, a year and a half before the Soviet Union launched the world's first artificial satellite. The primary purpose of the operations center was to monitor information from scattered surveillance installations designed to detect an attack on North America; if one transpired, the center would immediately report it to the President. The United States and Canada formed an alliance called the North American Air Defense Command (NORAD; "Air" was eventually changed to "Aerospace") to operate the center. To make the complex as impregnable as possible, it was built inside Cheyenne Mountain.

Excavation began in 1961, and work continued twenty-four hours a day. Fifteen months and 468,000 cubic yards of granite later, a network of tunnels totaling three miles in length had been created. Seven long chambers are arranged somewhat like an oversized tic-tac-toe board. Three shafts, each measuring 45 feet wide by 60 feet high by 588 feet long, are criss-crossed by four shafts measuring 32 feet wide by 56 feet high by 335 feet long. Access to the complex is through a 22½-foot-high, 29-foot-wide tunnel penetrating 1,750 feet into the mountain. Forming part of the tunnel wall is a 3-foot-thick, 25-ton blast door that takes 45 seconds to swing open and reveal a perpendicular shaft leading into the operations center. Fifty feet down that shaft, a similar blast door further secures the top-secret area. The access tunnel does not end where the operations center branches off; rather, it continues another 3,250 feet before re-emerging from the mountain. Both ends of the access tunnel are always open to allow the shock wave of a bomb blast to blow harmlessly past the operations center.

Excavation was only the first step in creating the Cheyenne Mountain Operations Center. The next phase, which was not finished until mid-1964, consisted of designing and building a $2.7-million concrete dome to reinforce the ceiling at the intersection of two of the internal shafts. Blasting of the tunnels had exposed a geological fault at that location that, if left uncorrected, would have left the complex vulnerable to collapse. The remainder of the ceiling area could simply be reinforced with rock bolts (a total of 115,000, some extending more than 30 feet into the exposed face) or with chemical bonding agents. The development of a new type of epoxy resin to seal rock faults was one of several technological advances accomplished during the operations center's construction. Another innovation was a new "smooth wall" mining technique that retained more of the mountain's natural integrity by selecting the best type of explosive and the optimal size, depth, and spacing of holes drilled for placing the charges.

In the meantime, construction began on the buildings that would occupy the spaces that had been carved out of the 4.5-acre site. The computer-intensive nature of the installation dictated unusual structural designs. Because 1960s-era computers operated with vacuum tubes rather than silicon chips, it was important that they be protected from jolts that might result from an earthquake or a bomb exploding nearby. The solution to this constraint was to construct freestanding buildings that were not only isolated from the walls and ceiling of the shaft, but also free to move with respect to the floor. The steel-walled buildings were mounted onto a total of 1,319 enormous springs, each formed of a 2½-inch-diameter steel bar, coiled into a 4-foot-long, 1,000-pound spiral capable of supporting 65,000 pounds. Together, they allowed each building to sway up to 12 inches horizontally in response to a natural or man-made seismic event. Corridors linking the buildings were kept flexible to isolate any movement. Of the fifteen buildings erected inside the shafts, twelve are three stories tall.

In addition to airborne shock waves, a nuclear blast would produce electromagnetic pulses that could debilitate the center's mainframe computers. To shield the sensitive equipment, the steel skeleton of each building was covered with .375-inch-thick, low-carbon steel plates, with all joints being welded along their entire length. Since the facility would be operated by trained professionals rather than panic-prone civilians or politicians, there were no amenities like false windows painted with pastoral scenes. The walls were simply painted standard military shades of tan and pale green. That is not to imply that no concessions were made for the comfort of people who work in the complex. By 2001, support facilities included a dining hall, medical and dental treatment rooms, a small store, a barber shop, a chapel, and two physical fitness centers with exercise equipment and saunas.

Public tours inside the mountain began in 1967 but were suspended from 1980 through 1984 for security reasons. In 1999, concerns related to global terrorism again halted the tours. Since then, most public access has been limited to a multimedia presentation in a visitor center outside the bunker.

UGFs as EOCs

State and city governments, as well as the federal government, have a responsibility to detect actual or potential emergencies, alert their citizens, and help them deal with the events. The emergencies may arise naturally as with storms or earthquakes, or they might result from accidents, or they could be caused by malevolent acts—civilian or military, domestic or foreign. Personnel monitor and manage such situations from facilities called "emergency operations centers" (EOCs), which must be secure enough to continue functioning throughout the emergency. One way to accomplish that is to build the facility underground.

A classic example is the Federal Emergency Management Agency regional operations center in Denver, Colorado. Known as Building 710, it has been in operation since 1969. The 36,000-square-foot structure is completely buried, except for a surface-level lobby. At the bottom of the stairs leading from the lobby, vault-type doors stand ready to seal off the EOC. In its Cold War configuration, one floor of the two-story building was reserved for the command center, offices, and conference rooms; the other floor housed dining facilities and triple-level-bunk dormitories for up to 300 people. In 2000, the still functioning building was added to the National Register of Historic Places in recognition of its architectural and historic significance.

A number of state and local EOCs also operate out of Cold War bunkers, some of which were partially funded by the federal government in an effort to ensure the survival of local and regional levels of government. Other agencies have built modern facilities below ground to protect them from the very emergencies they are charged with managing. The following examples illustrate the variety:

• In the early 1960s, Massachusetts built its state government bunker in Framingham with 18-inch-thick walls, under 40 feet of earth, and mounted on springs allowing a foot of sway. Still staffed around the clock some forty years later, the center prepares for bad storms or other potential crises by housing seventy-five people representing a variety of public and private operations, security, and relief agencies.

• In the late 1970s, Montgomery County, Pennsylvania, built its 18,100-square-foot EOC 16 feet below ground. FEMA provided a third of the $1.7-million construction cost. The facility still houses the county's emergency preparedness and emergency medical services as well as its response center for telephone calls placed to the 911 emergency number.

• When it first became operational in 2000, a consolidated communications center to handle all of the 911-number telephone calls in Morgan County, Alabama, set up shop temporarily in the county courthouse basement. However, plans had already been formulated for construction of a stand-alone permanent home. The single-story underground facility includes administrative offices, the dispatch center, workrooms, a conference room, and overnight lodging for employees working during an extended crisis. Construction on the 10,000-square-foot building began in early 2002, with occupancy expected eleven months later.

Some jurisdictions tuck their EOCs permanently underneath other government buildings. A few more examples illustrate the possibilities:

• The Minneapolis, Minnesota, city hall got a facelift—no, make that a foot-lowering—in 1989, when it became home to the city's new Emergency Preparedness Center. Working between the 5-foot-thick granite foundation walls of the 98-year-old stone structure that covers a full city block to a height of four stories (plus towers), construction crews lowered the basement floor 4 feet. This created enough vertical clearance to install two levels of glass-fronted office and meeting spaces overlooking a centrally located communications center. The double-height communications room was topped with artificially lit, false skylights. Perimeter walls of the complex were fitted with frosted-glass windows illuminated with lights that automatically brightened and dimmed to simulate nature's dawn-to-dusk lighting cycle. The 10,500-square-foot, technologically sophisticated expansion cost $3.8 million.

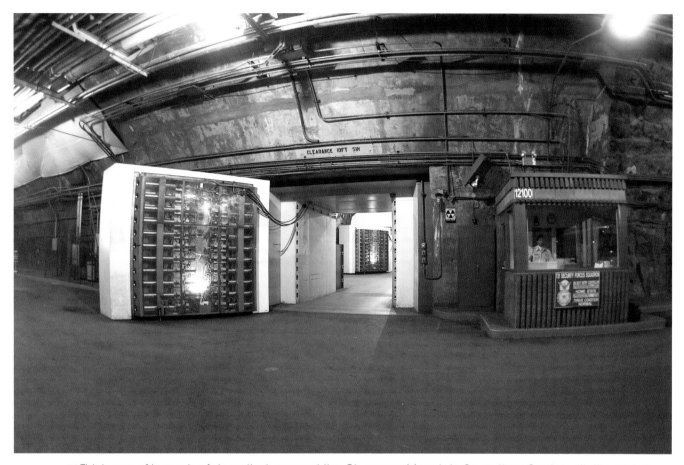

This is one of two sets of doors that connect the Cheyenne Mountain Operations Center with the access tunnel. (The wide-angle lens used to capture this photo distorted the image; this section of the tunnel is straight, not curved.) On September 11, 2001, the blast doors were closed for nearly three hours following terrorist attacks on the United States. It had been more than twenty years since the doors were shut under threatening circumstances. Courtesy of North American Aerospace Defense Command (NORAD); Photo by Eugene Chavez

• In 1994, Ohio opened a new building that houses dispatch operations for the state's highway patrol, transportation department, and natural resources department. The basement of the 90,000-square-foot building contains an EOC equipped to accommodate representatives of fifty-four state agencies. Overhanging one wall of the computer workstation-filled command center are five 13-foot video display screens. Another room on the underground level can function as a conference room for the governor and his cabinet officers. Nuclear hardening is not an archaic notion; the walls of the building's radio transmitter room are lined with copper to block electromagnetic impulses and maintain direct contact with the nation's president in the event of a nuclear disaster.

Occasionally, a lucky agency will save the taxpayers millions of dollars by finding a bargain-basement deal on an ultrasecure building to house its emergency preparedness operation. If that sounds far-fetched, consider the experience of Burlington County, New Jersey. In 1963, Burlington bought a recently decommissioned Nike missile base on 38 acres of land for $32,000. Not only did the underground missile storage facilities provide an ideal environment

for the county's EOC, but other components of the base were easily adaptable for a police, fire, and first-aid academy, a fire and rescue training facility, and an earth-bermed police target range. By the early 1970s, however, the surrounding area was becoming heavily residential, creating an inappropriate atmosphere for the often noisy training activities. The county sold the site in 1973 and used the proceeds to build a new EOC.

BUSINESS BUNKERS

It is reassuring to know that the government takes steps to protect its vital functions, but what about the business sector? "Ninety-five percent of U.S. critical infrastructures are owned by organizations other than the federal government," according to Paul Pattak, a senior advisor to the President's Commission on Critical Infrastructure Protection. Pattak made the remark at a 1998 workshop, Use of Underground Facilities to Protect Critical Infrastructures, that was sponsored by the National Research Council. Other speakers made the following points that are particularly relevant to privately owned installations:

> • "Infrastructures are vulnerable and attractive targets, and attacking them can affect enterprise profitability, national security, economic health, living standards, public confidence, and many other concerns."
> • "While UGFs do not improve infrastructure survivability against electronic attacks, they do protect against physical attacks on information systems. Even in the case of electronic attacks, UGFs can be used to provide safe havens for network nodes and the storage of backup media and systems."
> • "A protective feature like UGFs can be perceived [by corporations] as an unnecessary expense; therefore, the business case has to be very strong. . . . Few corporations have a genuine commitment to emergency preparedness. Instead their emphasis is on stockholders and return on investment. That process is beginning to change, however."

During the past fifty years, corporate protection strategies have focused on two aspects: protecting key personnel and protecting assets like equipment and data.

LIFE PRESERVERS

The strategy of protecting key personnel, which was most popular during the 1960s, paralleled the continuity of government concept. In a January 12, 1966, article, the *Wall Street Journal* quoted an Office of Civil Defense official as saying, "It's safe to say now that almost all of the 500 top corporations have some sort of alternate headquarters arrangements," much like those the government constructed at Mount Weather and Greenbrier. These facilities were not widely publicized, but among the underground installations the *Wall Street Journal* described was a former iron mine in Hudson, New York, where 700 companies leased space to store important records 75–300 feet underground behind a 28-ton steel door. The newspaper revealed fascinating details about Iron Mountain, the site of alternate headquarters for three major corporations: Shell Oil Company, Standard Oil Company of New Jersey, and Manufacturers Hanover Trust Company. The Standard Oil offices, for example, were "entered initially by an elevator that descends inside the mountain, but thereafter a visitor must move on foot through a maze of corridors winding through six different levels of the structure. Jersey Standard wants its employees to hoof it; climbing back and forth from level to level may be the only exercise they are able to get for weeks."

Another rare public mention of the hideaways at Iron Mountain appeared in Ted Gup's August 10, 1992, *Time* magazine article. Gup wrote that in 1970 Standard Oil Company of New Jersey conducted a nuclear attack drill in which its senior executives rushed to Iron Mountain to staff the emergency headquarters. Emergency planners in the White House reportedly helped the company plan and evaluate the exercise. A similar drill, held by Manufacturers Hanover in 1964, was described in the 1966 *Wall Street Journal* article. Ten officials of the firm rushed to the refuge to reconstruct the records of a supposedly annihilated branch bank, correctly identifying the accounts and coming within $6,800 of reconstructing the outstanding loans.

With only scattered, tantalizing bits of information to work with, American minds quickly turned to conjuring up conspiracy theories about Iron Mountain. Much of the mental work was done for them by several people, including Victor Navasky, who edited a political satire magazine, and Leonard Lewin, a writer. Together they concocted and published a fictitious, secret government document they claimed an anonymous official had leaked to them. The crux of the 1968 *Report from Iron Mountain* was that government leaders had decided that the stability of the country depended on either the reality or the threat of war—that officials feared a permanent peace would lead to the nation's downfall. As a result, the report alleged, government leaders conspired to create conflicts with actual or imagined enemies. The report became a best seller.

Eventually, both Navasky and Lewin publicly declared the book to be a hoax written to stimulate public discussion of the absurdity of the Cold War arms race. On June 12, 1995, Navasky wrote and published "Anatomy of a Hoax" in *Nation,* a magazine he edited at that time. He detailed how he and two friends came up with the idea, convinced Lewin to write it, and even prevailed on the sympathetic editor-in-chief of Dial Press to publish *Report from Iron Mountain* as nonfiction. He stated flatly, "In fact it was more than a hoax; it was a satire, a parody, a provocation." Good hoaxes die hard, however. Over the years, the report has occasionally been rediscovered, often with no mention being made of the recantations of its creators. In fact, some people continue to believe the document's truth and discount the denials by Navasky and Lewin as further evidence of a pervasive conspiracy.

As the Cold War progressed, the Soviet Union's nuclear missile capabilities became more accurate, more numerous, and more powerful. The futility of whisking hundreds or even dozens of employees to an underground refuge quickly enough to survive an attack became

EOC ERRORS

Basement and bunker accommodations are not always successful. While some jurisdictions are building new EOCs below ground, others are repairing defective structures or constructing aboveground replacements for cramped, dreary digs:

• In 1998, unhealthy levels of radon were detected at the Montgomery County, Pennsylvania, EOC bunker. The county spent $250,000 planning and implementing repairs to the building and the ventilation system.

• "We had absolutely no room in the basement of the courthouse," explained the director of the Office of Emergency Services of Monroe County in east-central Pennsylvania. as his agency prepared to move into a spacious new ground-level EOC in 1999. Furthermore, he said, "there are no windows down there, which added to the claustrophobia."

• Ten years after its completion, the Minneapolis Emergency Preparedness Center ran out of space. "The [Emergency Communications Center] room is a tangle of equipment and wires," *City Pages,* an online news publication serving Minnesota's Twin Cities, reported in August 1998. Overcrowding and understaffing led workers to call the EOC "the dungeon." To make matters worse, a heavy rainstorm in 1997 flooded the basement; operators still had to answer emergency calls, but as one worker recalled, "we couldn't wear our headsets because they were afraid we'd be electrocuted." A $1.5-million expansion into adjacent storage space in the city hall basement added 5,600 square feet in 2001.

INSIDE IRON MOUNTAIN

Progressive Architecture magazine published an illustrated, one-page article in April 1967 about the "survival shelter and disaster headquarters" at Iron Mountain. The magazine described the headquarters installations in the following terms:

• "Manufacturers Hanover has room for twenty-four staff members; its large picture window looks out onto a grotto lighted in pastel hues."

• "Shell Oil's facility can sleep sixteen at present, or up to twenty-three if more beds are brought in, and has desk space for forty-four. Some personnel would be permitted to bring their families. The 44,000-square-foot layout is in a split-level arrangement, with space following the original mine contours and levels."

• "Standard Oil's [20,000-square-foot] encampment looks more like a resort than a last-ditch shelter: It has vivid colors on doors and ceilings, a sound system throughout, and cheerful travel posters. For the 200 people, there are fifty-nine bedrooms . . . [including] eleven dormitories. All personnel would bring their families."

increasingly apparent. The notion of protecting a company's core elements began to focus more on inanimate assets that could be constantly protected or backed up with duplicates.

EQUIPMENT AND DATA PRESERVERS

Much of what keeps the United States' economy functioning is information and machinery, especially computers. Undeniably, they need skilled people to use them; even in that respect, however, there is redundancy these days. At least in the short term, it is not as essential to save the life of a company's CEO as it is to keep competent people operating the system at all times. In an emergency, such people will already be on site, and they will be protected just as the equipment is. To the extent that potential disasters can be anticipated, supervisors can staff secure command centers; in unexpected crises, they can make their way there as soon as possible. The important thing is that when they get there, "there" is secure.

Probably the most extensive system of hardened underground bunkers built by American businesses belongs to AT&T. There is a great deal of truth to one of its corporate mottos: "Communications is the foundation of democracy." Private citizens, businesses, and the government itself depend on a reliable communications system. Throughout the 1960s, AT&T built at least sixty underground buildings to house relay and switching operations for its telephone lines. Between Boston and Miami, they were spaced at intervals of about 70 miles, and they were also scattered across the rest of the nation. To minimize the risk to these vital nodes, details of their functions and designs were kept secret. Secrecy always seems to trigger suspicion; even today, some people believe these installations harbor alien bases, UFO evidence, or a nondemocratic "shadow government."

Bits of information on the structure of the AT&T bunkers have surfaced in recent years as sites were dismantled following the shift to digital communications technologies. The buildings' designs varied; published accounts describe examples ranging from less than 20,000 square feet to 100,000, extending as many as four levels into the ground. Concrete walls, floors, and ceilings 14 inches to 4 feet thick were reinforced with 1½-inch-diameter steel rebar. Their interior and exterior surfaces were completely lined with copper and/or welded steel sheets to deflect electromagnetic interference. The floor-to-ceiling height was 20 feet, allowing room to insert room-sized compartments that were 11½ feet tall. The extra vertical space was needed for large springs that suspended the compartments from above and tethered them from below to cushion any impact from a nearby explosion or earthquake. In addition, the outer shell rested on a layer of gravel and coil springs to further cushion the sensitive equipment it contained.

Some of the underground switching center buildings are still being used by AT&T. Others have been sold and converted to other uses. In 1981 and 1995, for example, Vital Records, Inc. bought two of the structures in New Jersey to house its data protection business. Security is ensured by limited entry points into the buildings, video surveillance, and various alarm systems. In addition, entry is restricted to authorized personnel through PIN keypads and hand recognition scanners.

Still conscious of the need to protect its essential, sensitive equipment and functions, AT&T looked underground when it designed a new operations center in Bedminster, New Jersey. Located in a rural setting only an hour from New York City, the 200,000-square-foot building is nestled into a hillside, with two of its four floors below ground level. Those lower levels house the 70,000-square-foot Global Network Operating Center. Inside the GNOC,

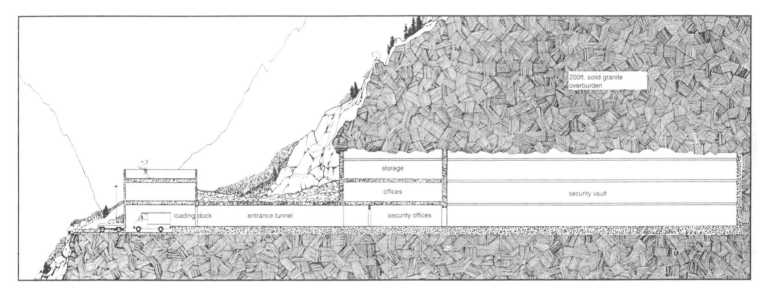

The Perpetual Storage vault, encased in geologically stable granite near Salt Lake City, Utah, provides security, controlled humidity and temperature, and protection from floods and earthquakes. An automatic Halon gas system would immediately extinguish an internal fire without damaging paper, film, or electronic media stored in the vault. Courtesy of Perpetual Storage, Inc., Salt Lake City, Utah

network managers work constantly to control the flow of electronic communications including local, national, and global telephone conversations; wireless phone transmissions; and data services like ATM transactions and Internet protocols.

Construction on the New Jersey operations center began in March 1998, and it was ready for use twenty-one months later. The scope of the project is reflected by a summary published in the March 2000 issue of *AT&T NOW*: "More than 600 construction workers poured 8,000 cubic yards of cement [i.e., concrete], welded 1,400 tons of steel, hung nine 1,000-pound plate-glass windows, and installed 180 four-by-five-foot rear-projection screens." Those screens provide real-time information to the network managers through graphics, charts, and maps illustrating global network activity as well as weather and news reports that could potentially affect traffic routing. Mounted side by side, three rows high, the screens extend a panoramic 250 feet along a 42-foot-high wall of the GNOC.

There are other notable examples of companies that rely on underground structures to protect their information processing operations, especially when those operations are essential

to conducting business. Though its business is delivering parcels, for instance, FedEx asserts that the data about each shipment is just as valuable as the goods themselves. So, in Memphis, Tennessee, the company's global operation command center is housed in a 22,500-square-foot, earth- and vine-covered, concrete building endearingly called "the bunker." In Tulsa, Oklahoma, Sabre shields its travel reservations system computers under a ground-level concrete roof 6 feet thick; security is so tight that personnel must not only pass a retina scan but also be weighed upon entering and again when leaving to ensure they neither bring nor leave unauthorized items. In suburban Washington, D.C., Potomac Electric Power Company's command center is hidden in the earth behind an ordinary, unmarked fence.

Y2K-ABOOM?

The Cold War spawned extravagant precautionary measures, in terms of personal behavior as well as building construction. Half a century later, knowing that it ended with more of a whimper than a bang, many people smiled or scratched their heads at how governments and citizens alike could have taken it so seriously. As the turn of the millennium approached, the potential Y2K crisis gave those people a small, brief taste of preparing for an event that, although unlikely, could have devastating results. The concern was that the world's enormous array of electronically controlled systems would be disabled by the confusion between whether a date ending with *00* meant *2000* or *1900*. Possible consequences ranged from minor inconveniences to extended power outages to anarchy. The seriousness of the problem was compounded by the possibility that a terrorist organization might seize on that dramatic moment in time to unleash a serious attack of some sort.

Every level of government had no choice but to be prepared for the worst. Federal, state, and local officials staffed their emergency operations centers as the end of 1999 approached. Often, these EOCs were located in basements or truly underground buildings, many of them constructed during the Cold War. The following report from the December 16, 1999, issue of the *Boston Globe* was probably typical of scenes across the country:

> About 200 officials—legislators, police, National Guardsmen—will descend 40 feet underground into a concrete-walled bunker to monitor the coming of the year 2000. . . . Those heading underground are viewing the experience as something in between a serious exercise in emergency management and a sleep-over party. "They say we can't bring alcohol in, but they didn't say anything about the parking lot, so we'll be tailgating," [one state legislator] joked. . . . [O]fficials say their time underground might be uneventful. But the hours leading up to midnight . . . will be filled with considerable tension.

Individuals varied greatly in their level of concern. Some were oblivious, and some shrugged the Y2K crisis off as a remote possibility. November 1999 polls found that 43 percent of Americans did not plan to take any special precautions, 40 percent planned to stockpile water and food, but only 10 percent described themselves as "worried." Some worried enough to buy generators and stash supplies, and a few retreated to the security of underground shelters to protect themselves.

Descriptions of underground houses for sale can always be found on the Internet, but in 1999, many of the descriptions emphasized the Y2K factor. For example, Donna Snyder told ABC News in mid-November that she figured the time would be right to sell her specially

equipped house in northern Washington state. In 1976, her husband had built a bomb shelter underneath their three-bedroom split-level home. And it was some shelter: a four-floor complex including 1,400 square feet of rooms and another 2,000 square feet of corridors, hiding places, and secret passages. An electrically controlled concrete door weighing 3 tons separates the shelter from the surface-level house. The widowed owner thought she had priced it reasonably at $349,000, but after six months on the market she had received no offers. In fact, by mid-2002, the property was still on the market at a reduced price of only $259,900.

Outside a small town in Canada's Ontario Province, Bruce Beach had also begun disaster preparations long before Y2K became an issue. In 1981, he decided to build a disaster shelter using four buses an auto wrecker had given him. After having a large hole dug, he placed the bus shells in it, welded connections between them, covered them with 12 inches of reinforced concrete and added a layer of dirt ranging from 5 to 14 feet deep. By 1986, he had acquired thirty-eight more buses, and he added them to the original shelter, arranging them to form a central hallway with bus-shaped rooms extending out on both sides. In the years that followed, he outfitted the shelter with a diesel-powered electrical generator system, connected pipes for sinks and flush toilets, and installed a conveyor system for moving furnishings and supplies in and out of the bunker. The 10,000-square-foot complex included bunk rooms, day rooms for adults and various ages of children, a kitchen, facilities for medical and dental treatment, a computer room, a chapel, and a jail cell. Though the owner had been preparing the bunker for any type of disaster for nearly twenty years, he actively promoted it as a Y2K shelter on the Internet during 1999. As the year's end approached, he proclaimed it ready to house as many as 200 people if necessary.

In late 1999, possible Y2K computer problems hovered somewhere between a genuine danger and a humorous marketing gimmick. Many people stocked up on batteries, candles, canned food, and bottled water, just in case there were any disruptions in the power or product distribution systems. On the other hand, entrepreneurs advertised a reassuring array of lighthearted options for welcoming the year 2000:

• MTV, a cable television music channel, broadcast live reports on three male and three female "bunker-nauts" who spent New Year's Eve in former tornado shelters under the New York Times Building in New York City; the channel claimed it wanted to ensure the repopulation of the earth if a millennium cataclysm resulted in widespread loss of life.

• Near Abilene, Texas, entrepreneur Larry Sanders offered his newly completed, 140-person capacity banquet and meeting facility as a New Year's Eve party site—185 feet below ground inside a former Atlas missile silo.

• In Roswell, New Mexico, home of a famous 1947 UFO incident, another former Atlas missile silo was readied for an intergalactic event: A party culminated with a midnight laser show, with one of the beams carrying more than 10,000 digitized messages to outer space.

Silo: Buy Low

Finding creative uses for decommissioned intercontinental ballistic missile (ICBM) silos and bunkers is not merely a Y2K gimmick. Since Atlas missile sites were phased out in the mid-1960s, successive generations of ICBM facilities have been built, manned, and deactivated. They were built at enormous expense and effort; construction of each Atlas-F site cost

$18 million in 1961 dollars. The Army Corps of Engineers reports that between 1958 and 1967 it built 1,200 ICBM silos for the Atlas, Titan, and Minuteman programs. During the first three years of that effort, it excavated 26 million cubic yards of soil and stone, poured more than 3 million cubic yards of concrete, and placed 764,000 tons of steel. Some silos were retained by the military for other uses when they were deactivated, some were filled with dirt and sealed shut, others were donated to local agencies or sold. Visionary new owners saw them as valuable resources that could be converted to practical uses. In addition to the applications de-

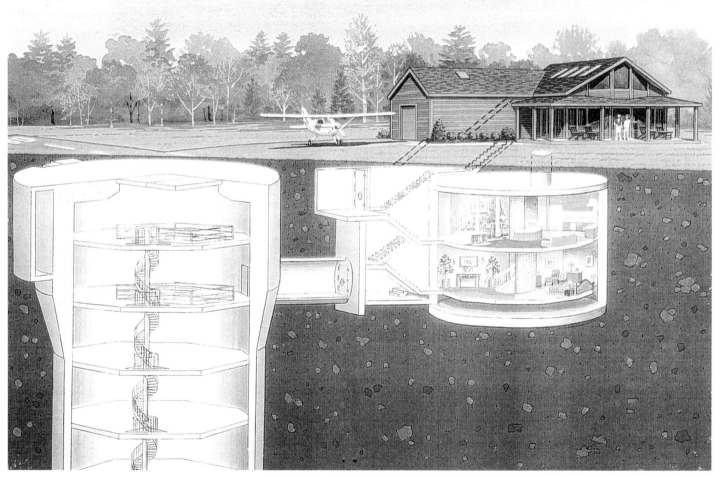

"It takes Bruce Francisco two minutes to answer the doorbell," wrote Saul G. Ferrer in the Plattsburgh, NY, *Press Republican*. The stairwell leading from the surface house to the underground living area is 125 feet long. A video surveillance system shows occupants who is at the door, and an intercom lets them announce they are on their way up. Courtesy of Bruce Francisco (silohome.com)

scribed below, other actual or proposed uses for former underground missile bases include mundane activities like data storage and museums as well as exotic uses like a rave club, a summer camp for kids, and a fireworks manufacturing plant.

IN-DEPTH LEARNING

In 1966, four small towns in northeastern Kansas decided to improve local education by consolidating their high schools. Mindful of limited financial resources, school board mem-

bers discussed the options of building a new school or adding on to one of the four existing campuses. Those traditional approaches soon dissolved, however, as one member suggested a novel solution: Why not simply renovate the local Atlas missile base?

The base had been vacated two years earlier, after only three years of service. Because it had been an Atlas-E installation, it offered more attractive space than a vertical silo. Its underground missile bay was the "coffin" type, in which the missile was stored horizontally and raised to a vertical orientation only when preparing for launch. The school board contacted the General Services Administration and the Department of Defense with an offer to recycle the empty facility. Negotiations were successful, with the purchase price being set at the token amount of one dollar.

The school district received 27 acres of land in the deal, along with the 18,000-square-foot underground building complex. The subsurface launch control and launch service buildings as well as the missile bay were converted into classrooms, industrial arts shops, faculty offices, and a bus garage. Brick buildings were erected above ground to house additional classrooms and support facilities such as the library and gymnasium. Jackson Heights High School opened in September 1969 with a student body of 154. Enrollment still holds at about that level, and the school continues to serve normal secondary education needs while providing a unique visual aid for the history teacher when discussions turn to the Cold War.

DOWN HOME

Several people have transformed portions of missile silos or their associated underground launch control centers into cozy, attractive dwellings. One particularly striking example, near Lake Placid, New York, was the subject of a feature story in the April 2000 issue of *Interiors* magazine. Real estate developer Bruce Francisco has been renovating the property since 1989, when his cousin, Gregory Gibbons, bought it for $50,000 at a government auction. The site had been deactivated twenty-four years earlier, after only seven years of service. Their efforts have focused on finishing the 2,400-square-foot, two-story, subterranean launch control center and on building an adjacent 2,000-square-foot conventional cabin on the surface. The 185-foot-deep, 50-foot-diameter silo remains an empty, unimproved chamber.

The first task in improving the 40-foot-diameter launch control center was to drain the accumulated surface water and condensation that had flooded it. Soggy, rotting drywall was stripped away, the walls waterproofed, and the ventilation system improved. Next, Francisco installed new wall surfaces, inserting areas of glass bricks to create the illusion of windows; fiber-optic lighting behind these panels gradually changes color, creating additional visual interest.

Partitioning the area created three bedrooms and two Jacuzzi-equipped bathrooms on the lower level, and an open-plan space with cooking, living, and dining areas on the upper level. To make the connection between the two floors more appealing and convenient, a carpeted, spiral staircase was created around the massive pillar that rises through the center of the structure. This nontrivial exercise involved cutting a large hole through the 3-foot-thick floor.

DIVE WAY IN

The fact that abandoned missile silos tend to fill up with water does not have to be a hindrance to productive use. At Dive Valhalla, near Abilene, Texas, for instance, it is an essential characteristic.

The largest feature of the Atlas-F installation was a missile silo 180 feet deep and 60 feet in diameter. When Mark and Linda Hannifin bought the decommissioned base in 1985, it had been vacant for twenty years. They bought it on a lark, with no real purpose in mind. It wasn't until a decade later, when they opened a scuba shop in Midland, Texas, that they realized they owned a unique commercial diving venue. Open only to diving clubs and shops by reservation, it attracts divers who want specialized training or simply an uncommon location. "Divers from all over the world are already enjoying the site for advanced openwater training in deep diving, altitude dives, nitrox, rebreathers and other specialty courses," the owners report.

Divers must either hold advanced certification or be accompanied by a certified instructor. The site's location is at an elevation of 2,520 feet, the water temperature holds steady at 60°F, and the water is 130 feet deep. Because it is groundwater filtered through the silo's concrete walls, the diving environment is crystal clear throughout its depth; to keep it that way, the owners request that no one make contact with the silted bottom. The lack of natural lighting requires divers to carry their own illumination gear. The location also demands good physical conditioning: After reaching the top of the silo some 20 feet below ground, divers must walk down a flight of stairs to reach the water surface—and climb back up those steps after the dive.

Surface 2,420 MSL

Launch Doors (Sealed)

Lights

Vent Shafts

Blast Doors

Escape Shaft

Dressing Area/ Bathroom

Stairway Stairs

Floating Dive Platform

Water Temperature
60 F

135' Depth
7.0 ph

Inertial Navigation System @ 30-60'
Possible Overhead Obstruction

To Reduce silting
Please Stay Off Bottom
Metal, Flooring, Staircases & Debris 105 -130'

A floating platform 30 feet below the silo entrance serves as a staging area in the Valhalla silo. Divers do not have to lug their air tanks down and up the steps, however; a trolley system is available to raise and lower that equipment. Courtesy of Family Scuba Center

Part IV

Unwinding Underground

IMMERSED IN CULTURE
SUBTERRANEAN MUSEUMS AND THEATERS

Beginning with the 1959 completion of Frank Lloyd Wright's revolutionary Solomon R. Guggenheim Museum in New York City, the field of museum architecture embarked on an adventurous period of bold innovation. Wright's museum, for example, tossed aside the notion of compartmentalized viewing of art in a series of exhibit cubicles, providing instead a single, continuous viewing path that spirals five times around the perimeter of the cone-shaped building.

Not only did ideas change about how to design museums, but federal legislation supporting funding of the arts helped launch a cultural building boom. Between 1970 and 2000, more than 600 new museums opened in the United States. Similarly, building and remodeling projects increased the number and quality of performing arts venues.

Dozens of subterranean museums and theaters are giving patrons a chance to immerse themselves both aesthetically and physically in underground exhibition and performance spaces. The examples described in this chapter illustrate a range of practical issues, artistic implications, and degrees of success.

HIDDEN IN A HILL

There are two ways to construct a building so that its walls are completely unobtrusive: Make the walls of clear glass or hide them under the ground. Or, so it would seem. In fact, when Philip Johnson, the first director of the architecture department of New York's Museum of Modern Art, built himself a transparent house in 1949, it became one of the nation's most visible and noticed buildings. Nestled on a 40-acre estate in New Canaan, Connecticut, Johnson's glass house got its privacy from the surrounding woods rather than from opaque walls. The only obstruction to the view through the house was an interior brick column that concealed the bathroom.

Neither the brick cylinder nor the glass walls were suitable for hanging artwork, so Johnson displayed one painting on an easel in his living room. By 1965, however, he had acquired a substantial collection of fine paintings, and he needed a place to keep and view them all. Not wanting to distract from the dramatic appearance of the glass house or to alter the natural view from inside his home, he designed a virtually invisible underground gallery. Hiding the gallery inside a gently sloping mound of earth, he placed the doorway on the side away from the house. From outside, the building was simply part of the landscape. Inside, the windowless structure was a distraction-free environment for enjoying art.

Twenty years later, architect Kevin Roche faced a similar mandate to design a virtually invisible building. In this case, the nearby structures were even more transparent than Johnson's glass house. In the mind's eye of visitors to the Wolstenholme Towne archaeological site, imaginary walls rise above recreated foundations framed with wood and filled with crushed seashells. The original foundations, unearthed during the 1970s, mark the site of the first English settlement after Jamestown colony in what is now southeastern Virginia. Established in 1619 a scant 10 miles farther down the James River, Wolstenholme Towne stood only three years before it was destroyed by Indians intent on reclaiming their land. In 1985, after completion of the archaeological excavation, the Colonial Williamsburg Foundation decided to create a museum on the site. The Winthrop Rockefeller Archaeology Museum's exhibits portray the village's brief history and also reveal how the archaeologists examined and interpreted their findings.

"The only real buildings are nonbuildings. The rest is theater," Kevin Roche told the *Christian Science Monitor* in 1986. Although he was talking about another of his underground designs, the comment certainly applies to the Winthrop Rockefeller Archaeology Museum, which was in the planning stages at that time. Courtesy of Kevin Roche John Dinkeloo and Associates

"The challenge was to design a building that would leave the area undisturbed, yet be able to comfortably accommodate visitors and present the site in an interesting manner," the architect's project description states. The only way to keep the museum from dominating the minimalist reconstructions of the small fort-enclosed town was to hide it completely under the ground. Externally, Roche's solution appears similar to Johnson's—the building is completely enclosed inside a hill. Internally, both are designed to showcase their contents in a distraction-free environment. The 7,000-square-foot museum is more than twice as large as Johnson's art gallery, however. Furthermore, it is not only a destination; it is also a portal.

Tourists approaching the site cannot see the town's schematic reconstruction, which lies behind a hill. Rather than following a path over or around the hill, the visitors walk directly into the mound. "Walking through the underground museum, you feel as if you're inside an archaeological site," *Southern Living* reported in 1993, two years after the museum was built. At the end of their indoor tour, visitors emerge on the far side of the hill, overlooking the outlines of the tiny settlement. "The full impact of the site and one's own imagination of the events that occurred there are solemnly appreciated at the culmination of the entire experience," Roche's description concludes.

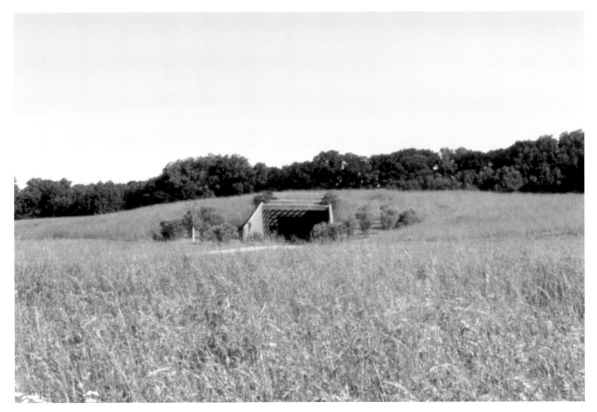

Nestled in a knoll, the Winthrop Rockefeller Archaeology Museum avoids intruding on its historic setting. The entrance and exit portals emerge from opposite sides of the shallow mound.
Courtesy of Kevin Roche John Dinkeloo and Associates

SCALING THE WALLS

The walls of underground buildings may be out of sight, but they are not out of designer's minds, either structurally or aesthetically. Their relationship to the walls of existing buildings can play important roles in the design process.

TACKED ON, TUCKED IN

The Solomon R. Guggenheim Museum in New York City boasts one of the world's most famous walls—Frank Lloyd Wright's concrete cone. Tacking an addition on to such a distinctive landmark was bound to arouse controversy. Architects Charles Gwathmey and Robert Siegel devised a two-faceted solution, which was built in 1992. As one component, they created new exhibition spaces by grafting a 135-foot-tall rectangular tower to the 95-foot-high domed spiral. Although preliminary sketches show that Wright himself considered a similar design, the addition generated heated criticism that it dwarfed and marred the curvaceous, original building.

Public outcry about the perceived desecration of Wright's masterpiece would probably have been even greater if Gwathmey and Siegel had not placed one-fourth of the addition out of sight, underground. Hidden 17 feet below a sidewalk plaza outside the museum, 10,000 square feet of badly needed office space nestles outside the public view in what is called the administrative vault. A key element in the success of the vault's design was the decision to tie

it to the dramatic form of Wright's structure. The exterior face of the original circular foundation wall became an interior wall facing nearly half the new offices. Interior designer Thomas Sansone accented the hallway walls with circular interior windows and rectangular patterns of etched glass panels that compliment the Wright style. Rather than relegating the staff to a bland basement, this unity of design visually established the subsurface space's connection to the famous structure rising above it.

WALL DONE

The technique of attaching a new underground building to an existing wall was carried out almost to an extreme degree with the construction of the Women in Military Service for America Memorial near Washington, D.C. In this case, the existing wall was not *part* of another structure, it *was* the other structure.

In 1932, the National Mall had been extended across the Potomac River to Arlington National Cemetery by construction of the Arlington Memorial Bridge. The Mall extension culminated in a new ceremonial gateway to the cemetery. Called the Arlington Hemicycle, the gateway was a 30-foot-tall, 200-foot-wide, semicircular retaining wall designed as a neoclassical facade. Despite its designation as a "gateway," however, the granite-clad hemicycle was more of a decorative dead end. Approaching it, visitors had to turn either right or left to enter the cemetery through iron gates. Fifty-five years after it was completed, the hemicycle was given a chance to become more functional when it was selected as the location of the Women in Military Service for America Memorial and Museum.

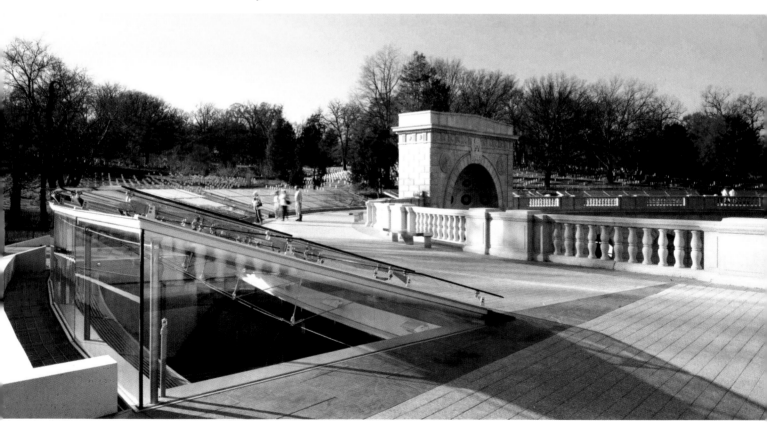

Visitors to the Women in Military Service for America Memorial and Museum can read the glass tablets' etched inscriptions directly from a rooftop terrace. Depending on the angle of the sun, the quotation shadows projected on the interior wall can be illegible. Courtesy of Weiss/Manfredi, Architects; © Jeff Goldberg/Esto

Architects Marion Weiss and Michael Manfredi submitted a design proposal that placed the memorial underground, behind the hemicycle. "We chose to bury [the building], quite simply, because we thought it was a sacred site," Manfredi says. Placing the new structure essentially out of sight preserved the area's special character.

Beginning in January 1996, workers removed 3,500 truckloads of soil from behind the wall, being careful not to disturb any grave sites. After constructing a 33,000-square-foot building, they replaced the soil and grass over most of the structure, including its theater, gift shop, conference room, offices, and a display room. Immediately behind the hemicycle, however, the roof of the memorial's exhibit gallery remains unearthed. A continuous skylight strip caps the gallery, which is a long, curved room concentric to the original retaining wall.

The exhibit gallery's 4,400-square-foot glass ceiling creates several dramatic effects. The transparent surface creates a sense of expansiveness. Daylight streaming into the entire length of the building unites the subterranean space with the surface world. At night, light from within the memorial glows through the roof. Just

Adding an 80-foot-diameter reflecting pool within the hemicycle's arc and a 200-nozzle fountain at the base of the central blind niche softened the effect of the stone facade and introduced a sense of movement to the Women in Military Service for America Memorial. "Together the (water) jets create sound representing individual voices of women blending in a collective harmony of purpose," says a National Parks Service description. Courtesy of Clark Construction Group; Photo by Michael Dersin

above the horizontal skylight, 138 glass panels are slanted upward at a 20° angle; 108 of these ¾-inch-thick, transparent slabs are designed to be engraved with quotations written by or about the women memorialized by the structure. The sun projects these quotations as shadows on the marble wall of the exhibit gallery below. "Like memories, they come and go, depending on the light and the position of the sun," Manfredi explains.

Construction of the memorial included cleaning and repairing the original hemicycle, which had been neglected for decades. Four niches in the face of the hemicycle were opened to allow visitors to walk up glass-enclosed stairs that allow them to look down into the exhibit gallery. They emerge at ground level behind the memorial, overlooking a cemetery field. Climbing another short stairway brings the visitors to the roof plaza, where they can view the cemetery, read memorial inscriptions, or look across the Potomac River at the Lincoln Memorial and the Washington Monument.

Aesthetic Expansions

Designing an addition to an architecturally significant building is always a challenge. The aesthetic aspects of the task are particularly important when the building serves as a

showcase of the visual arts. Placing the addition underground can keep it from altering the appearance of a beloved existing structure.

CALIFORNIA PALACE OF THE LEGION OF HONOR

The California Palace of the Legion of Honor, a San Francisco art museum, was built in 1924 as a three-quarter-scale replica of the eighteenth-century Palais de la Légion d'Honneur in Paris. In the context of newer building codes in the earthquake-prone Bay Area, a 1987 analysis showed the building needed extensive seismic retrofitting. The process would involve reconstructing walls and installing steel bracing within the foundation, so it presented an opportunity to restore interior and exterior details to their original conditions. Having to close the building during the extensive reconstruction also presented a timely opportunity to expand the museum with minimal additional disruption. In fact, carving out a two-story basement under the U-shaped building and its central courtyard could enlarge the space-strapped museum by 35,000 square feet. Along with expanded exhibit space, the underground addition was designed to contain offices, research and restoration facilities, a theater, a café, and a gift shop.

In 1988, internationally renowned architect I.M. Pei had undertaken a somewhat similar, if larger, challenge in expanding the Louvre in Paris. He created an underground plaza under the courtyard in the center of that U-shaped complex and topped it with a highly controversial, seven-story-high glass pyramid. Seeking to bring daylight into the California Palace of the Legion of Honor addition, architects Edward Larrabee Barnes and Mark Cavagnero also chose to insert a glass pyramid into the center of this museum's courtyard. In contrast to Pei's version, however, their shallow pyramid nestles unobtrusively behind a pedestal supporting a cast of Rodin's *The Thinker* that welcomes visitors to the gallery.

Like the Louvre pyramid, the Legion's relies on an attractively sleek structural system that is nevertheless strong enough to carry the weight of the glass panels and resist external forces like wind or earthquakes. "By the time you've designed a fitting with a minimum of excess metal in it, you've designed something quite beautiful," Tim Eliassen told *Engineering News Record* in 1988. Then president of a company that made rigging systems for yachts, Eliassen had helped design the slender steel strut and cable system that supported the Louvre pyramid. Deciding to focus on architectural applications, Eliassen subsequently cofounded TriPyramid Structures, Inc. In that role, he collaborated on the Legion's pyramid.

After being closed for three years for construction, the Legion reopened in late 1995. The following year, its total attendance soared to five times its previous average. Following that initial flurry, the number of visitors settled at about double the pre-expansion level, attesting to the project's success.

DEWITT WALLACE DECORATIVE ARTS GALLERY

Placing the California Palace of the Legion of Honor addition underground preserved the appearance of a beautiful, historic structure. In the mid-1980s, the DeWitt Wallace Decorative Arts Gallery was built partially underground at the same time that its architecturally significant neighbor was being built in Colonial Williamsburg, Virginia.

Construction in the city's historic area is limited to reproductions of historic structures, which must be erected on the structure's original foundation. At the time the decorative arts gallery was being planned, the only remaining building site was that of the nation's first public mental hospital. Built in 1773, the hospital had burned down in 1885. Even though it was a two-story structure, its modern replica would not be nearly large enough to house the 10,000-

For some shows, curators have allowed the Legion's shallow pyramid to provide a bird's-eye view of the exhibits one floor below. Frequently, however, the lenders of temporary exhibitions impose stringent lighting restrictions to protect their artifacts. When necessary, a panel is installed across the base of the pyramid to either filter or block the daylight.

Courtesy of TriPyramid Structures, Inc.; Photo by Midge Eliassen

object decorative arts collection. Moreover, adding enough basement levels to meet the museum's space needs would be impractical.

Innovative architect Kevin Roche came up with a solution that demonstrated outside-the-box thinking. He reconstructed the hospital building, including exhibit space to document its original function. From the hospital, he tunneled 65 feet to the edge of the historic district, where he built a 62,000-square-foot gallery. He limited the visual impact of the modern building in two ways. First, he immersed three-fourths of the two-story building into the ground with a combination of excavation and berming. Second, he built a 12-foot-high brick wall in front of the new building so that the view from the historic district would only be that of the type of wall that had encircled the hospital in the eighteenth century.

Visitors to the decorative arts gallery enter through the hospital. From its basement level, they step into the broad tunnel that leads to the gallery. Much more than a sunken corridor, the tunnel is a 2,160-square-foot exhibit space that serves as an introduction to the rest of the museum. At the end of this concourse, visitors find themselves entering a two-story-high central court that is generously illuminated by skylights. Other rooms on this lower level include a 240-seat auditorium, a café, exhibit space, museum support rooms, and a skylighted garden court. Upstairs, on a level half hidden by earthen berms, visitors find additional exhibit rooms and an open-air garden courtyard.

Although the Wallace gallery managed to skirt the historic district's building restrictions, it did not escape nature's challenges. One problem developed in 1988. The upper-level garden courtyard features a 3-foot-deep, 15-by-50-foot reflecting pool; in addition to 124,000 pounds of water, the pool contains numerous potted plants weighing at least 200 pounds apiece. Through several seasonal cycles, temperature fluctuations stressed the structure; furthermore, its rooftop position left it vulnerable to motion. Finally, the 9-inch-thick concrete base of the pool cracked completely through across its entire width. Water began leaking into the antiques storage room below. The problem was solved when the pool was drained, patched, and resurfaced with layers of fiberglass and resin. Besides being more flexible than the original lining, the fiberglass was also less hospitable to algae growth.

Water was also the culprit in the gallery's other major problem. Knowing that water could cause trouble in an underground structure, the designers had taken several precautions. Besides installing a system of drains and pumps, they also elevated electrical and mechanical equipment on 6-inch-high concrete pads. The museum had been open only a few years when an August 1989 rainstorm dumped an incredible 12 inches of rain on the city in a three-hour period. With water flowing 18 inches deep in the streets, it is perhaps surprising that the water rose to a height of only 6 inches in the lower level of the gallery (luckily, just the height of the equipment pads).

The Wallace gallery's central court extends 25 feet below ground, but it is awash in natural light. Under a gabled glass roof, narrow wood strips are mounted to diffuse the sunshine. Courtesy of Kevin Roche John Dinkeloo and Associates

Yet even that shallow depth was enough to cause $1 million worth of structural damage. One interior wall collapsed, hardwood flooring warped, carpet became saturated, and muddy water soaked the lower portions of display cases and drywall. At the deepest point of the building, 54 feet below ground level, the auditorium stage and three rows of seats were submerged.

Because of advance planning and quick reaction by museum staff, none of the artifacts on display or in storage were damaged. However, the museum was closed for five months while repairs were made. In addition, several changes were made to prevent a recurrence of the disaster. The drainage system around the building was redesigned, and landscaping was recontoured to channel water away from the structure. The entry points for the water that flooded the gallery had been a network of fresh-air intake vents installed at ground level; the vents were left in place, but dams were built around them to keep water from intruding.

NELSON-ATKINS MUSEUM OF ART ADDITION

The Nelson-Atkins Museum of Art, a neoclassical building completed in 1933, is a treasured landmark in Kansas City, Missouri. Four 18-foot-tall shuttlecocks scattered on the outdoor sculpture court in 1993 continue to evoke both rants and raves a decade later. The museum's subsequent decision to expand its indoor space by more than half sparked additional community concerns. Thinking "beside the box," architect Steven Holl devised a creative solution.

Holl dismissed the obvious choice of the front lawn and proposed placing the addition along the side of the original building. That preserved the appearance of the familiar facade, but it raised the prospect of disturbing the older structure's intense symmetry. The architect's solution involved recessing the addition's gallery spaces into the ground and crowning them with surface-level sculptures. When the addition is completed in 2005, a series of five glass boxes of various sizes, shapes, and orientations will rise above a new lobby and four exhibit chambers scattered along an 840-foot-long swath beside and beyond the existing rectangular, squarely placed stone box.

The innovative design prompted vivid reactions:

> • "different without being confrontational" (Nelson-Atkins Museum of Art Director Marc F. Wilson)
> • "great quartz crystals spilling neatly on the side lawn" (Wilson)
> • "crystalline sculpture" (*Architecture* magazine)
> • "like jewelry flung down the slope" (John C. Gaunt, Dean of University of Kansas School of Architecture and Urban Design)
> • "a meandering garden of lights" (architect Steven Holl)
> • "light-gathering lenses" (Holl)
> • "glowing lanterns" (Holl)

Holl's process of invention was analytical as well as aesthetic. The building's structural system contributes to its visual presence. Back-to-back interior walls running down the center of each chamber curve outward near the top, becoming ceilings. The exterior glass walls hang from these structural ceilings. Light-colored, arching interior walls and ceiling along the spine of each room disperse daylight that enters through the glass walls. In cross section, the wall/ceiling pairs form a stylized T. Space between the back-to-back vertical portions encloses the room's ventilation ducts. At the top of the chamber, this space

expands to a horizontal plenum between the ceiling and a glass roof. Solar-heated air from the plenum is circulated to warm the building in the winter. Computer-controlled screens on south-facing glass walls restrict excessive sunlight penetration. Using glass of different transparencies for the five chambers creates exhibit spaces with different qualities of illumination and adds visual interest to the building's exterior.

Clash of the Artisans

Architects who design underground buildings take great care to admit as much natural light as possible in order to counteract feelings of being buried under the earth. Curators of art galleries and historical museums, on the other hand, are keenly aware that sunlight can damage delicate objects. Underground architects like to create spacious rooms with high ceilings to alleviate feelings of claustrophobia. Curators, however, prefer to display small artifacts in small rooms to better focus attention on their details. These kinds of inherent conflicts make designing underground galleries and museums particularly challenging.

Smithsonian South Quadrangle

About 1980, Smithsonian Institution Secretary S. Dillon Ripley faced the dilemma of needing to build two new museums but having little open space left along the National Mall in Washington, D.C. One of the new museums, which would house a core collection of Asian and

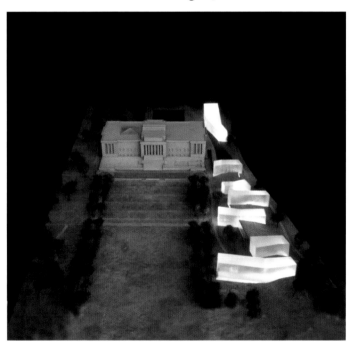

As shown in this architectural model, Steven Holl originally envisioned the Nelson-Atkins Museum of Art addition as seven glass sculptures. Because of budget restrictions, the design was subsequently trimmed to five, and the size of the lobby and library chamber (uppermost in the original model photograph) was decreased. Courtesy of Steven Holl Architects

Near Eastern art donated by Arthur M. Sackler, would be a natural companion for the Smithsonian's Freer Gallery of Art with its substantial Asian and Near Eastern holdings. The other new facility, the National Museum of African Art, together with the Freer and Sackler galleries, would be the only Smithsonian museums representing non-Western cultures. So it made sense to place the new buildings next to the existing Freer Gallery.

The specific site chosen, a 4.2-acre plot containing a small Victorian garden and an employee parking lot, is flanked by the Freer Gallery, the Smithsonian Building (commonly known as the Castle), and the Arts and Industries Building—three registered landmarks that face the Mall. To preserve views of these historic buildings and to provide cherished green space, Ripley decided the new museums should be built underground. Architect Jean Paul Carlhian designed the South Quadrangle building, a three-story subterranean structure that would contain the two new museums connected by a 24-foot high, 78-by-116-foot common gallery that could be used for joint exhibitions. While the building's upper two floors would be occupied by the Sackler and African Art museums, the lowest level would house education facilities, administrative spaces, and an exhibition hall for a new International Center.

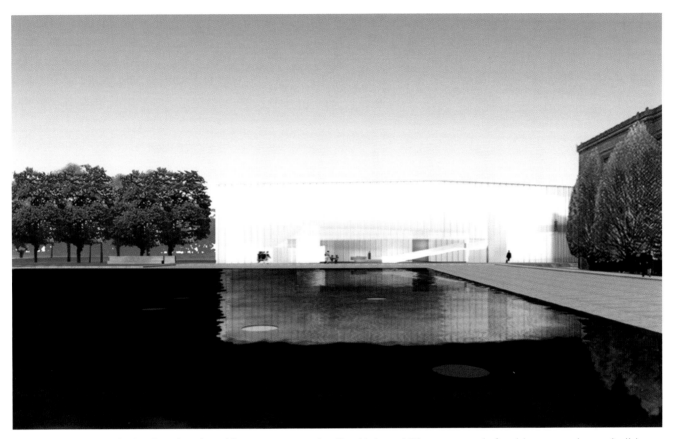

Holl buried a two-level parking garage under the Nelson-Atkins museum's front lawn, as shown in this rendering. A reflecting pool on top of the garage helps unite the new lobby (center) and the original building (right). Skylights—make that *waterlights*—in the pool's bottom bring visually interesting illumination to the garage and integrate the area with the neighboring structures. Courtesy of Steven Holl Architects

Construction began in June 1983, temporarily erasing the garden except for one large tree that was carefully preserved. To create space for the new structure, workers dug a 60-foot-deep hole as close as 13 feet to the Castle's walls. Before excavating the hole, the workers framed it with a slurry wall. To make the slurry wall strong enough to hold back the surrounding dirt as the main hole was being dug, workers anchored it with a series of "tiebacks" (steel rods angled 60 feet downward into the adjacent soil and held in place with concrete).

By the time the main excavation was complete, it became apparent that some of the tiebacks had not held securely enough. Cracks began to appear in the plaster of the Castle's interior walls. Measurements revealed that the historic building had sunk nearly 1½ inches. For months, construction paused while the Castle foundation was exposed and concrete underpinnings were installed to support it. Cracks also began to appear in the Freer Gallery when overlapping tiebacks strained the ground around the hole's corner, allowing soil movement near its foundation. Correcting this problem caused further construction delays.

Although it took a year and a half longer than expected (partly because of nonconstruction problems like a labor strike that delayed the shipment of supplies), construction was completed in 1987. The crowning touch was covering the new building with a garden lushly landscaped with mature plants and trees. Because of plans to establish this garden, design engineers for the underground structure had to account for the rooftop weights of 3½ feet of damp

soil, extensive vegetation, more than a hundred pieces of cast-iron garden furniture, and two masonry-framed ponds.

Carlhian and his associates at the architectural firm Shepley Bulfinch Richardson and Abbott showed good understanding of the principles of underground construction by designing spacious rooms, some with ceilings rising as high as 42 feet. Numerous skylights would bring daylight to all levels. Live plants, water-filled reflecting pools, and fountains would enliven the subterranean space. Separate aboveground entrance pavilions for each museum and the International Center would establish a visible presence and a comfortable, elegant entryway for each facility. Well scaled with respect to the garden and the adjacent buildings, these three aboveground pavilions represent only 4 percent of the 368,000-square-foot structure.

Ripley had been actively involved in overseeing the design of the new museums, but he retired in 1984, three years before their completion. The new Smithsonian secretary delegated oversight and operation of each museum to its director. Although they were experts in their

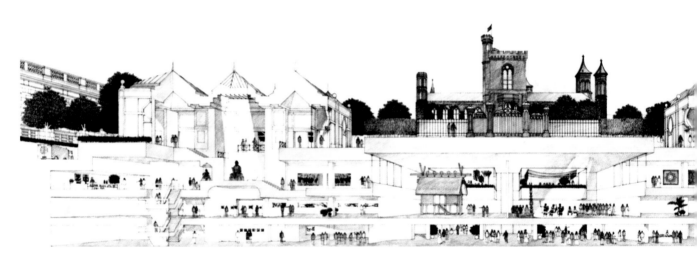

The exaggerated perspective of this rendering emphasizes the underground building in the foreground. Each of the aboveground entrance pavilions (Sackler on the left and African Art on the right, is 90 feet long. The Smithsonian Castle (the upper portion is shown between and behind the pavilions) is 447 feet long. The pavilions actually sit directly south of the Castle, not beyond its breadth, as suggested here. The relative height is correct—the new building extends as far below ground as the Castle does above ground.
Courtesy of Shepley Bulfinch Richardson and Abbott

own fields, they were unfamiliar with the special nature of underground buildings. Even before the grand opening, the curators ordered major changes that significantly altered the structure's atmosphere. They split the large common gallery with a permanent wall and boarded up interior windows designed to overlook the formerly grand space. Furthermore, they split the Sackler side of the original gallery horizontally, creating two floors in place of the intended two-story expanse. In some rooms they lowered the ceilings with plain panels, concealing exposed beams and indirect lights designed to add architectural interest and a feeling of height. They boarded over most of the skylights, although one in the Asian section was given a translucent coating that allowed a dim light to penetrate. Even though Carlhian was assured that the

modifications would be temporary, they remain in place more than a decade later. Other details languished as well; for instance, visitors in 1999 found the reflecting pool at the bottom of one grand stairwell empty and lifeless except for a rather bedraggled potted plant someone had set in it.

Following the grand opening of the Sackler and African Art museums, several newspaper and magazine articles praised the quality of the exhibits but lamented the building's modifications. For example, *Art News* reported, "to say that intention and reality don't entirely mesh here is to put it mildly." A *Wall Street Journal* writer called the museums "oppressive warrens." However, the quality of the exhibits continues to draw visitors, though it seems that in some ways the building itself is more tolerated than enjoyed.

OAKLAND MUSEUM OF CALIFORNIA

Conflict between architects and occupants is not unique to the underground Smithsonian museums (or, indeed, to underground buildings in general). The Oakland Museum of Califor-

nia offers another example. Designed and built during the 1960s, the building was so innovative that architecture historian Allan Temko claimed the most recent analogy would be the Hanging Gardens of Babylon, which were crafted in 600 B.C. The Oakland Museum's architect, Kevin Roche, launched his career with this project and eventually won a Pritzker Architectural Prize for lifetime achievement.

Roche knew that, in the 1960s, public buildings—especially museums—were expected to be impressive structures that could become a monumental symbol for their host city. In spite of this public expectation, he designed a structure that Temko described in *The Oakland Museum: A Gift of Architecture* as "a 'nonmonumental' or even 'antimonumental' monument whose premise was not to impress or overwhelm."

"One of the first considerations that guided us was that all of the citizens of Oakland were going to pay for this museum [through a bond issue]," Roche wrote in *A Gift of Architecture*. "We felt very strongly a responsibility to make that museum a place where all of the citizens would want to go." Realizing that Oakland seriously lacked open space, Roche suggested constructing a four-square-block park and tucking the proposed museum building underneath it. He terraced a sloping site to contain three park-topped levels embracing regional museums of natural history, cultural history, and art. Although portions of the structure sit atop one or two truly underground levels designed primarily for parking, much of the museum is technically above grade. A windowless one-story-high wall defines the museum's boundaries— a stark effect that softened as the lush landscaping matured and greenery cascaded down the walls. Yet the building has a distinctly underground character. The main entrance plaza and the lowest museum tier are recessed below street level; each tier is covered with plazas and landscaping that form the structure's main facade.

Predictably, the understated design aroused the ire of some architecture critics. For example, Peter Selz wrote in *Art in America,* "[Roche] has bypassed the opportunity to revivify this monumental town center manqué [i.e., unfulfilled], to set a proper, dignified scale for it and for what it might attract in the future. The four blocks of the new museum simply lie low and hide from view." On the other hand, Roche succeeded in creating, quite literally, a cultural oasis that attracts crowds of people. "To appreciate the museum it is best to come on a Sunday, when whole families arrive from the affluent hills and the plebeian flatlands, intellectuals from Berkeley and hard-hats from San Leandro, curious San Franciscans and foreign architects," Temko wrote in the *AIA Journal* a decade after the facility opened. Wistfully, he added, "But neither [the children] nor their parents realize how many possibilities of the architecture have not been fulfilled."

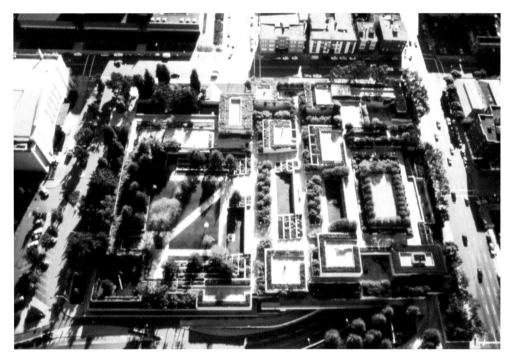

"The entire museum is built of a light-colored concrete with a sandblasted finish," says the architect's project description of the Oakland Museum of California. "The wide walls that surround the planting are just the right height to sit on, and in the intervening time since the building was finished, the planting has done what it was hoped it would, growing over the entire building, gradually submerging its form and creating a lush, colorful garden." Courtesy of Kevin Roche John Dinkeloo and Associates

Some changes to Roche's design came from the staffs of the three tenant museums. The architect designed open interior spaces and provided numerous doorways for visitors to wander in and out between the exhibits and the park. The curators promptly installed additional interior walls to create smaller gallery spaces and lowered the apparent ceiling height by hanging bulky light fixtures. They also locked most of the doors, apparently because of security concerns, although the park has no direct street access—visitors must enter it through the building.

Budget limitations caused another significant compromise. Roche had planned to top the entrance lobby of each of the three museum levels with two large skylights to brighten the interior space. City overseers struck them from the plans, saying they would be too expensive. The result is that only a limited amount of natural light can enter through the glass walls along the east side of each tier of the building. Furthermore, portions of the glass walls are blocked by exhibits, obstructing even more light and exterior views. Roof overhangs, relatively low ceilings (9½ feet), and compartmentalized interior layouts keep this light from reaching very far back into the building, a problem only partly solved by artificial lighting.

Curators do not always agree with architects, but their opinions are based on their professional expertise. On the other hand, laypersons' opinions of a building tend to be more subjective and emotional. In 1993, Dr. Dvora Yanow, a faculty member of the departments of public administration and arts administration at California State University, Hayward, conducted a study of the Oakland Museum. Under her supervision, Yanow's graduate students observed and interviewed visitors, employees, and professional staff members at the museum. As reported in the September 1998 issue of the *Journal of Management Inquiry,* they discovered a range of perceptions of the building. For instance, some visitors reported that they had passed by the museum several times without wanting to enter it, either because the windowless, concrete walls concealed its identity or because they seemed uninviting. Others commented that they felt secure in the facility, whose "walled gardens create an oasis in the middle of a hostile city."

Lucile Halsell Conservatory

Protecting art objects and antiques from sun damage or theft offers one type of challenge to exhibition curators. Construction of an underground botanical garden in San Antonio created a nearly opposite challenge: The structure would have to provide sufficient light to support 18,000 plants ranging from delicate Alpine flowers to hardy succulents. The intense sunshine of southern Texas complicated the issue; a traditional greenhouse-type structure would absorb too much sunlight and overheat.

Architect Emilio Ambasz proposed to solve the heat and light problems by building the 90,000-square-foot conservatory underground, where the earth would help cool the interior, and topping it with large skylights to admit flora-sustaining sunlight. The skylights, which include pyramids and sections of truncated cones, rise as high as 55 feet above the ground, towering above rooms recessed between 16 and 28 feet below ground level. Ambasz designed them with enough strength to withstand the area's powerful winds. Glass walls around a recessed central courtyard allow additional daylight to enter the exhibit areas, but roof overhangs block the hot, direct rays of sunshine.

Besides controlling the heat and light entering the conservatory, Ambasz had to tailor his design to a 3-acre site where the soil tends to shift. His solution was to construct each of the seven rooms on a separate foundation, allowing them to move independently.

Several architecture critics praised the innovative facility when it opened in 1988. However, in 1995, Don Pylant, the conservatory's senior horticulturist, told *Progressive Architecture* magazine that, behind the scenes, the building has been "a problem since day one." Pylant enumerated the following complaints:

• Rather than cooling the facility, the surrounding earth retains heat in the summer, making it difficult to keep the exhibit rooms at proper temperatures.

• Certain plants, particularly cacti, need to be surrounded by sunlight. They do not grow properly when lit only from above.

• The dramatic skylights were designed for aesthetic value, not to regulate the sunlight appropriately for different types of plants.

• Movement of the separate foundations generated enough strain to break the electrical conduit that connected them.

In response to the criticism, Ambasz told *Progressive Architecture* that he had designed the sculptural glass forms after being assured by the conservatory's former horticulturist that the plants could adapt to the building's environments. Furthermore, Ambasz leveled a little criticism of his own by asserting that "the courtyard was supposed to be a grand garden" and should be planted more abundantly. The conflict provides another example of the different points of view of a building's designer and its eventual occupants.

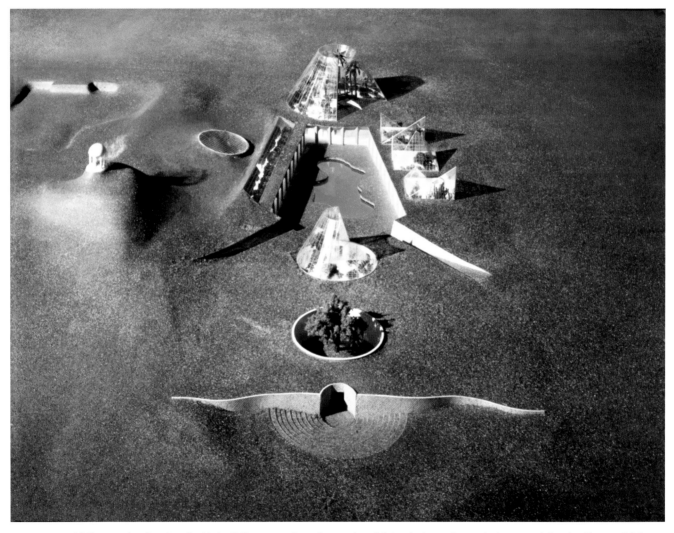

Visitors enter the Lucile Halsell Conservatory through a 16-foot-deep tunnel, shown at the bottom of this architectural model. After passing through an open-air chamber containing a single tree, the visitors emerge into a 175-foot-long, roofless courtyard surrounded by the enclosed exhibition rooms. Courtesy of Emilio Ambasz & Associates, Inc.

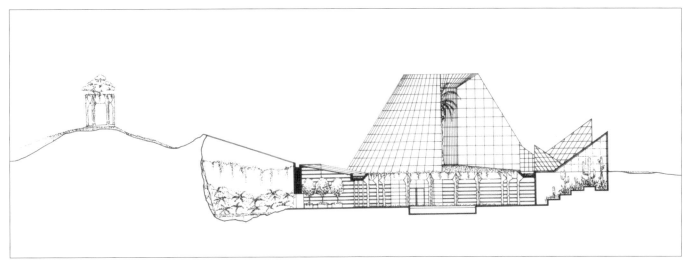

Sited on uneven terrain, the Halsell Conservatory is immersed in the earth by a combination of excavation and berming. Architect Emilio Ambasz, who once described himself as a poet rather than architect or an engineer, told *Connoisseur* magazine that the building "gets the earth to swell with pleasure." Courtesy of Emilio Ambasz & Associates, Inc.

MEDIUM = MESSAGE

Fresno, California, is the site of a unique underground museum whose primary display is the structure itself. Between 1906 and 1946, a Sicilian immigrant named Baldasare Forestiere handcrafted an increasingly intricate and elaborate personal retreat beneath his property. Working alone using a pickax, a shovel, and a wheelbarrow, he carved 100 underground chambers, patios, and connecting passageways in a network underlying 10 of his 70 acres of land.

Now operated as a private museum, Forestiere Underground Gardens began as a small refuge from the searing heat of Fresno's summers. The young immigrant labored at neighboring vineyards and orchards, and he found his small house too hot to relax in after work. When he first came to America, he had supported himself by digging transportation tunnels in New York. The subterranean coolness lingered in his mind, and he decided to create a cellar under the simple, 100-square-foot house he had built in Fresno. The cellar room was so much more comfortable than the home that he quickly dug a kitchen and a bathroom and moved into his new underground house.

Forestiere had bought this land so he could grow grapes and citrus fruits. However, he found that to be impossible because the trees and vines could not grow in its "hardpan" (hardened soil that does not soften when wet) surface. Yet he found a way to achieve his dream. He began digging more chambers, each with a hole in the center of its domed ceiling, and planting a tree in a masonry vessel under the hole where it could receive sunlight and rainwater. Through careful positioning, and utilizing floor depths varying from 10 to 22 feet, he found he could encourage trees to bear fruit at unusual times of the year. The rooms of his expanding home opened off roofless patios; around the open courtyard roofs, he planted grape vines to screen the summer sun. In winter, the leaves dropped off to admit more sunlight.

Holes in the ceilings of some rooms encourage a natural flow of air that helps cool and freshen the interior of the chamber. Even when the outdoor temperature soars above 110°F, the temperature in Forestiere's refuge hovers around 70°F. For some rooms, Forestiere fashioned glass plates he could use to cover the openings during rainy weather. Because rain could fall

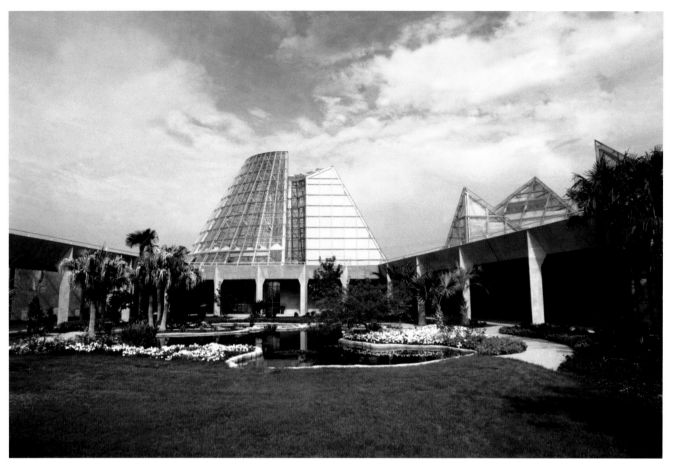

Like a glass of water at a wine tasting affair, the Halsell Conservatory's open-air aquatic garden allows visitors to cleanse their optic palettes as they move from one exhibit room to another. The garden's recessed location shields it from any views other than the sky and the display rooms' glass roofs. Courtesy of Emilio Ambasz & Associates, Inc.

into the courtyards and many of the rooms, he incorporated a gentle slope into the floors that directed rainwater down the hallways into strategically placed sump holes.

As the decades passed and Forestiere continued to dig, his tree-filled underground villa became more elaborate and exotic. He added a chapel and a library. He made one room into an aquarium with a circular glass window in its floor, and below that, he carved out another room where he could sit and look up at the fish swimming overhead. Working with no blueprint other than a mental vision, Forestiere created a veritable labyrinth of rooms and passages. What he lacked in formal planning, he offset with experience or instinct. As he dug, he encountered two types of material: dirt, which he carted out in his wheelbarrow and scattered on the surface of his property, and the sturdy, moisture-impervious hardpan, which he shaped into bricks that he used to build columns and arches. His instincts and experience were solid, and so was his construction. Even after fifty years of earthquakes in central California, the wooden doors he installed still fit and swing precisely.

As a result of highway construction and real estate development, only about 7 acres of Forestiere's 10-acre creation have survived. Some fifteen rooms stand in need of restoration, the victims of erosion and vandalism that occurred sporadically as his heirs fought to preserve

one man's lifelong effort. Andre Forestiere, son of Baldasare's nephew and current owner of the gardens, describes it as "a big earthen sculpture where he was actually sculpting the earth." "It's like two different worlds sitting side by side," he told *Sunset* magazine in March 1999. "You don't realize the modern world when you're down here. And the opposite. Once you leave the gardens, it doesn't take long for it to go away. It's like it was all a dream."

UNDERGROUND PERFORMANCES

The Juilliard School and Carnegie Hall are two examples of respected institutions with theaters constructed at the first or second basement level of multistory performing arts centers. Some other venues have been built under more surprising surfaces.

VILAR CENTER FOR THE ARTS

The Vilar Center for the Arts in Beaver Creek, Colorado, was buried in 1998. Nestled in the heart of the Vail Valley, this world-class theater is completely hidden underneath an outdoor ice-skating arena. Escalators and an elevator carry patrons down to an elegant, two-story entertainment complex paneled with knotty pine and carpeted in the colors of autumn. The upper story includes the box office, a refreshment bar, a 2,200-square-foot lobby, a 2,250-square-foot lounge, a gift shop, and access to the theater's balcony seats. The lower level, some 50 feet below the surface, includes the main level of the 527-seat theater and another 2,200-square-foot lobby.

Hardpan bricks support arches in the Underground Gardens. Forestiere, who was about 5 feet, 5 inches tall, made the doorways and passages conform to his stature. Courtesy of Forestiere Underground Gardens; © Silvio Manno

Although isolation from noise is an inherent advantage of underground buildings, the Vilar Center required careful design and construction to shield its theater from the scrape of ice skates and the cheers of as many as 600 spectators overhead. A multilayered roof effectively filters out sounds from above. The 9-inch-thick slab that forms the base of the ice-skating rink rests on neoprene pads atop the theater's steel and concrete roof. Allowing space for ductwork and lighting hardware, a plaster ceiling is suspended from the roof with springs to further reduce sound transmission.

Not all exterior sounds originate above the theater, however. A subterranean creek flowing below the building generates additional noise. Separating the center's walls from the surrounding earth with isolation springs damps out these sounds. The building's mechanical systems are housed in a separate, acoustically isolated room, and the carefully routed ductwork is well insulated. Within the theater itself, 3,000 square feet of curtain

A roofed driveway welcomes fashionably dressed patrons at the front entrance to the Vilar Center, which faces away from the ice-skating rink one story above. Escalators and stairs provide access from the outdoor mall. However, theatre managers are considering ways to remodel the exterior to increase visibility. Photo by Dianne Gum

panels hang ready to cover the walls in whatever configuration will optimize the acoustics for any type of performance.

HORTON PLAZA LYCEUM THEATRE

Designers of the Horton Plaza Lyceum Theatre also faced noise problems. Located 35 feet below an open courtyard of a four-story shopping mall in San Diego, California, the theater would have to withstand noise and vibration from large numbers of people walking on its roof during performances. To filter out the noise, a false ceiling of thick plaster was suspended on vibration isolators below the true ceiling. To keep pedestrian movement from jostling lights and sound equipment, those elements were mounted on a framework supported by the building's vertical beams rather than being hung from ceiling beams that would transmit footfall motion.

Similar in size to the Vilar Center, the Horton Plaza performing arts facility contains both a 560-seat theater and a 220-seat "black box" space in which seating can be configured as needed for specific productions. Two levels of lobbies provide access to upper and lower seating areas of the main theater. A pair of curved stairways invite patrons down into the theater complex through a circular patio marked by a mosaic-covered, 36-foot-tall obelisk.

When the Horton Plaza mall was built, a 40,000-square-foot area was reserved for the theater complex, but work on the theater did not begin until the shopping center was practically finished. In fact, the theater was completed in 1986, eight months after the mall opened for business. This meant that the theater architects had to design it within rigid constraints. They did manage to make two important modifications, however. To create the necessary clear spans, they removed four of the plaza's support columns, which had been built only 30 feet apart. Engineers accomplished this by installing horizontal beams to transfer the loads to adjacent columns. To get sufficient height for the theater complex, its builders had to excavate down 35 feet, nearly to the water table level.

Constructing the theater under a nearly complete structure meant that all construction equipment and supplies had to fit through existing openings. Those who worked on the project likened it to building a ship in a bottle.

Visibility can be a problem with underground buildings. The Horton Plaza Lyceum Theatre obelisk, sprouting from an open-air courtyard on the entrance level, signals the building's presence. Its fanciful decorations make the approach and descent fun.

Behind the Music and Dance Theater Chicago entrance kiosk, the upper level of the building rises above ground level, visually establishing its solid presence. Seating areas for patrons are located two to four stories below street level. An outdoor concert pavilion designed by Frank Gehry will be built behind the theater; his trademark freeform metal shapes appear at the right center of this rendering. Courtesy of Hammond Beeby Rupert Ainge Inc.

MUSIC AND DANCE THEATER CHICAGO

Building Chicago's Millennium Park is more like starting with a ship, building another one beside it, and at the same time building a bottle around both of them. Figuratively, the existing ship in this case is a seven-track railroad yard. In the late 1800s, the tracks were lowered below ground level to provide an unobstructed view of Lake Michigan from Michigan Avenue and Grant Park. A century later, city planners decided to reclaim the 16.5-acre railway site by roofing it with concrete and covering it with soil. This new surface was incorporated into a 24.6-acre park that included lawns, gardens, sculptures, trees, an ice-skating rink, and a large outdoor amphitheater. To maximize the benefits of the new park facility, planners also decided to carve out space underneath it for a 2,400-space parking garage and a 300-seat performing arts center.

After plans had been developed, the city found it necessary to rethink its financial commitment to the project. Coincidentally, the Music and Dance Theater Chicago, a not-for-profit corporation formed to provide a 1,500-seat facility in downtown Chicago for mid-sized performing arts companies, was suddenly faced with the loss of its intended site. City officials and the Music and Dance Theater Chicago reached an agreement allowing the group to build its theater on the city site. The Chicago architectural firm of Hammond Beeby Rupert Ainge had already designed a 1,500-seat aboveground auditorium for the music and dance consortium. After examining the new site, they decided the design could be adapted and used as an underground building that would fit within the available space in Millennium Park.

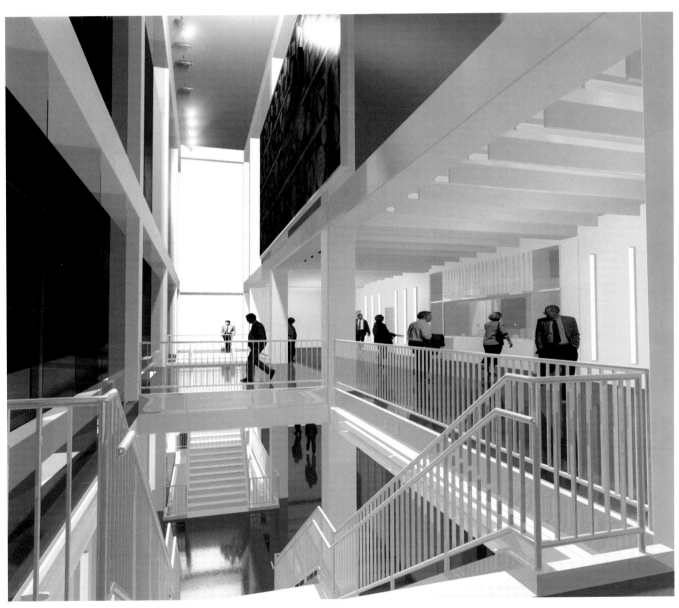

With 5,000 square feet, the entrance pavilion represents less than 4 percent of the total area of the Music and Dance Theater Chicago. As this rendering depicts, however, it is designed to be a spacious entryway to the performance levels below ground. Courtesy of Hammond Beeby Rupert Ainge Inc.

The theater, which should be completed in late 2003, includes a total floor area of 130,000 square feet. Various sections of the building have different configurations, but it will be essentially a five-story structure extending more than 40 feet into the ground. That depth puts the building well within the lakeside water table. Not surprisingly, construction was delayed while designers modified the plans for waterproofing, as well as dealing with the soil and vegetation loads from a rooftop garden. Above the theater, 18 inches of soil will support grass and shrubs, but above the support spaces along the sides of the structure, trees will be planted in a layer of soil 3–4 feet thick.

Other modifications were necessary as well. For example, working with city building safety officials, the architects redesigned the theater's exits. Particularly in an emergency situation, the exits would have to accommodate and reassure people whose natural tendency is to leave a building by heading down stairs rather than climbing upward. More lighting with colorful accents was added to offset the lack of window walls that are commonly seen in theater lobbies. The audience chamber, already an acoustically effective windowless space, needed no design changes.

As the only part of the building visible from the park or the street, the entrance kiosk is a vital element in attracting people to the theater and creating a positive image of the hidden facility. Original plans called for a solid, classical-style facade. Public reaction to the design revealed concerns that the structure would interfere with long-range views through the park. The architects responded with a transparent, greenhouse-style entrance pavilion consisting of glass panels framed in steel. They had to return to the drawing boards, though, when conditions in the bidding market dictated that most of the theater be redesigned from a steel frame structure to one of precast concrete elements. In keeping with that new design theme, the entrance pavilion evolved into a sort of three-dimensional billboard. With a glass front wall, the structure will serve as a monumental display case for a huge, Louise Nevelson sculpture that will hang from the roof much like a scenery panel is hung on a stage. At night, the pavilion will glow with colored lights as a decorative beacon to the community. This juxtaposition of a solid wall and a transparent facade creates an inviting transition from the external environment to the substantial, if unseen, theater below.

9

ROMPING THROUGH THE UNDERWORLD

Pick any leisure activity. Chances are, you can perform it underground. Earlier chapters included examples such as art galleries, music theaters, shopping malls, and even a scuba diving pool. The list of possibilities is even broader. For instance:

• In 1998, Regal Cinemas opened a thirteen-screen theater in Rockville, Maryland, with only the lobby above ground. Screening rooms do not need windows.

• Every February, more than 2,000 runners compete in the 10K and 5K Groundhog Run inside Hunt Midwest SubTropolis, an industrial park located in a former limestone mine in Kansas City, Missouri. The weather is never a problem.

• An entertainment critic at washingtonpost.com wonders, "Is there some sort of rule in Washington [D.C.] that all pool halls have to be underground?" In an informal poll, website visitors voted the subterranean Buffalo Billiards in Dupont Circle the Best Pool Hall in 2002.

• The eighteen-hole miniature golf course at Laurel Caverns Geological Park in southwestern Pennsylvania is not underground, but it looks like it is. Owners of the caverns built a 10,000-square-foot concrete cave above ground, molding its chambers to mimic natural subterranean features. As golfers progress from one hole to another, they learn about cave formations.

A subterranean location can be a real asset for a recreation facility. The novelty of an unusual setting, a sense of anticipation triggered by unfamiliar surroundings, or simply a chance to go somewhere *different* may hold special appeal for people when they seek relief from their daily routine.

SLEEP UNDER A THICK BLANKET

Tourists who want to sleep under the ground rather than under the stars have a choice of at least a dozen subterranean lodging establishments. Some are unique hideaways with a fantasy world character. Other, relatively conventional settings offer guests a chance to try out subterranean living for a night or two. Earthship Biotecture (northwest of Taos, New Mexico) offers three model homes for nightly rental, for example. At the Jackson House Bed and Breakfast near St. Louis, Missouri, in Alton, Illinois, guests can try out an aboveground, bermed, earth-covered cottage designed and built by Davis Caves. In Big Sur, California, the luxurious

Post Ranch Inn immerses travelers in the scenery with their Ocean House rooms, which are recessed into the hillside overlooking the Pacific Ocean. Vacationers who are not up to sleeping underground can opt for a simulated cavern environment in the Caveman Room of the renowned Madonna Inn in San Luis Obispo, California.

CLIFF DWELLING WITH A FULL FRIDGE

Some of America's oldest and most picturesque underground buildings are the cliff dwellings built by Anasazi Indians 900–1,000 years ago. Some of the most spectacular surviving examples are at Canyon de Chelly in northeastern Arizona and Mesa Verde in southwestern Colorado. Within a 100-mile drive of either of them is a modern cliff dwelling available for rent as a bed and breakfast suite. Kokopelli's Cave is named for a popular figure of Anasazi— and subsequent Pueblo Indian—mythology: the hump-backed flute player who symbolizes happiness and joy.

Geologist Bruce Black's dual fascination with rocks and the Anasazi culture prompted him to have a cave blasted out of a sheer cliff. He chose the site, he says, "to imitate the Anasazi cliff dwellers' locations and because the geology is right to put a cave back into the sandstone there." Indeed, the boundary between two rock formations serves as the floor of the cave, with the 1,650-square-foot cavern hollowed out of the 65-million-year-old upper layer. Black drilled three holes down from the surface through the cave's roof to provide access for power and water lines and to serve as a chimney and ventilation shaft. He installed a sewage pipe that leads to a septic tank at the bottom of the cliff. To seal the gritty walls and ceiling, he sprayed them with a thin coat of clear polyurethane that left their natural beauty exposed. After laying out plumbing lines and electrical wiring on the bottom of the cave, he covered it all with a raised wood floor.

Black's original plan was to create a unique office for his consulting business, a place where he and his clients would literally be immersed in geologic features. The cave's floor lies 80 feet below the top of the cliff, and nearly 300 feet above the valley floor. The only way to enter the "building" is to climb down the equivalent of eight stories along a sloping path interspersed with eighty hand-carved steps. The final three steps consist of a short ladder resting on the cave's 8-foot-square front patio. Black soon found that it was inconvenient to carry bulky rolls of maps in and out of the office, and that some clients were reluctant to visit him there. So he shifted to Plan B and outfitted the cave as a bed and breakfast inn that opened for business in 1997.

Far from being a primitive cave dwelling, Kokopelli's Cave could be described as luxurious. Inside the sliding glass front door is a six-room suite. In the open-plan main chamber, a large central pillar supports the roof and helps define separate areas for a living room, dining room, den, kitchen, and a walled-off bathroom. A smaller adjoining chamber, with its own patio door and balcony, serves as a bedroom. Various areas of the floor are covered with plush carpeting or flagstone. In the bathroom, a picturesque waterfall shower flows into a whirlpool tub crafted out of flagstone. Besides hot and cold running water, the

The rock surfaces inside Kokopelli's Cave reveal fossils and rock strata. In the ceiling, linear gouges show where the builder drilled and inserted explosive charges to create the cavern. Behind the living room, an horno (OR-no: beehive-shaped oven) serves as a den fireplace. Next to it, a ladder leads down into a replica of a kiva (an Anasazi-style subterranean ceremonial chamber). Courtesy of Kokopelli's Cave, © Steve Larese

kitchen boasts the usual appliances, including a microwave oven; supplies in the refrigerator allow guests to serve themselves breakfast in privacy.

"As much as we would love to have you, if you are not in good physical shape, we do not encourage you to stay with us," says Kokopelli Cave's promotional brochure. "You and your family do so at your own risk." The adventurous visitors who stay at Kokopelli's Cave are escorted down the access path when they first arrive. They have already signed a liability waiver and been advised not to bring children younger than 12 years old. Far from being frightened, however, guests routinely report experiencing a profound feeling of peace. The silence inside the cave contributes to that atmosphere. So do the stars. With its back to the nearby town of Farmington, New Mexico, the cave offers a view of the night sky unusually free of light pollution.

Cavern Fit for a King

If you've seen one luxury cave dwelling, you've seen them all, right? Not really. Despite fitting into that same category, the Beckham Creek Cave Haven is very different from Kokopelli's Cave. Here, 150 miles northwest of Little Rock in the Ozark Mountains of Arkansas, you can

drive up to the front door, or you can fly in and land on the private helipad. Bring your friends; the five-bedroom, five-bath vacation retreat easily accommodates ten people.

This is a natural, living cave. Water drips from stalactites into strategically placed planters. During the rainy season, a spontaneous waterfall flows gently over a smooth formation in the living room. The cavern continues back 2½ miles into the mountain, behind a locked door that keeps curious guests from getting lost in the labyrinth.

It may be natural, but it is certainly not unimproved. It took four years of labor to turn the cave into a 5,500-square-foot safe house. Millionaire John Hay planned it in 1984 as a survival shelter after an escalation of the Cold War. For starters, he enlarged the natural opening and then covered the gap with a 3-foot-thick concrete wall covered with quarried stone. Nine

As a natural cave, the Beckham Creek Cave Haven was not built—and waterproofed—in any traditional way. Walls and false ceilings protect some rooms from natural moisture. Where the ceiling remains exposed, sheets of plastic are sometimes hung across rooms to keep seeping groundwater from dripping on guests. Courtesy of Beckham Creek Cave Haven, www.ozarkcave.com

windows and two glass-accented doors in the wall provide light and views. Inside, silt was scooped up from the floor, and the walls were sandblasted clean and then coated with clear epoxy. Steel I-beams were installed to reinforce the roof. Walls and floors were built to define fourteen rooms, including a twelve-person dining room, a large kitchen, and a library on the main floor as well as an upstairs level with a master bedroom suite and a game room.

Several subsequent owners contributed their own improvements. Today, many of the interior walls are paneled with oak, walnut, or cedar. A full-size pool table graces the spacious game room. The fully equipped kitchen includes such amenities as a trash compactor and a bread maker. Plush carpet covers many of the floors. To make it suitable for dancing, however, the floor of the 2,000-square-foot great room is finished with glistening tile. Entertainment options include large-screen televisions, a stereo music system, and a piano. A central heating system boosts the cave's natural 64°F temperature, and dehumidifiers increase the comfort level.

Tao Klein, the current owner, bought the cave house in 1998 and turned it into a vacation rental facility. The property is rented to only one party at a time. A three-person staff stays discretely away unless their services are requested for conducting tours of the undeveloped part of the cavern, guiding horseback rides through the mountains, or solving problems. Guests can rent as many of the five bedrooms as they need, with a two-night minimum stay. "I'd like to share it with people," Klein told Associated Press reporter Kristen Everett in April 2000, "it's such a unique place."

The Beckham Creek Cave extends for miles inside the mountain, but its natural opening was only large enough for a child to walk through. John Hay, a cofounder of Celestial Seasonings Tea Company, enlarged the opening and filled it with stone walls, leaving openings for two doorways and an assortment of windows. Courtesy of Beckham Creek Cave Haven, www.ozarkcave.com

A succession of owners spent several million dollars creating and furnishing the luxurious living quarters in Beckham Creek Cave. Yet the most dramatic decor consists of the natural formations. John Hay told People magazine, "The architect was God." Courtesy of Beckham Creek Cave Haven, www.ozarkcave.com

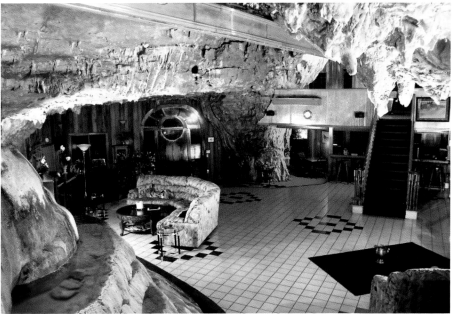

DWELL IN DOBSONS' DIGS

Taos Pueblo in northern New Mexico is one of the two oldest continuously inhabited villages in the United States (the other, also some 800–1,000 years old, is Acoma Pueblo in west-central New Mexico). Built of adobe (sun-dried bricks of mud and straw), Taos' two historic structures are apartment-style buildings rising as much as five stories high. About 10 miles to the west, a new bed and breakfast inn nestles respectfully in the ancient earth. Hand built by owners Joan and John Dobson, it blends modern Earthship concepts with indigenous adobe architecture.

Earthship inventor Michael Reynolds, whose headquarters is a 7-mile drive from the Dobson House, designed the 6,000-square-foot inn. It employs most of the standard features, including 8-foot-high south-facing glass walls for collecting solar heat, stone floors for retaining that heat, and walls constructed of earth-packed automobile tires and aluminum beverage cans. Except for the southern expanses of glass, the walls are covered with soil and native vegetation. Solar panels generate enough electricity to power the Dobsons' private living space, as well as common areas and the two 500-square-foot guest suites. Because of the commercial nature of their establishment, the Dobsons did not adhere to pure Earthship principles, however. They use propane, for example, to fuel the kitchen stove and to produce abundant hot water. A gasoline generator stands ready to produce electricity during unusually long periods of cloudiness.

The inn consists of three separate but connected structures. At the crest of a 100-foot-high hill sits the main building, which includes the owners' private quarters as well as a 1,600-square-foot great room where guests are welcome. The glass exterior walls of the circular, 60-foot-diameter room provide a 270° view. On the south side of the room, a stairway angles down below the windows into a 100-foot-long hallway that leads to the guest suites. The walls of the broad corridor consist of adobe-plastered earthen walls of a trench the Dobsons dug by hand. The doors to the guest suites face each other at the bottom of the stairway. Each suite consists of a separate U-shaped Earthship unit with its own south-facing window wall.

SEEING SUBTERRANEAN SIGHTS

According to the 2002 American Express Leisure Travel Index, 43 percent of vacationers want to spend time "sightseeing and enjoying historical and cultural activities." Underground sights range from completely natural caves to totally artificial constructions.

AU NATUREL, MORE OR LESS

Show caves are the most natural underground spaces to see. Built and decorated by nature, they usually need some amount of construction activity to make them accessible, safe, and visible. Often, developers must enlarge the entrance or create an alternate entrance because the natural opening is too small or treacherous for tourists to enter. They must clear a path by removing materials ranging from mud to bat guano, smooth the path by filling depressions and scraping off lumps of rock, and install steps and guardrails where necessary. They may need to create or enlarge passages between chambers. Finally, they must install artificial lighting for the safety and viewing pleasure of the visitors.

Many show cave owners go beyond these basic efforts and alter their caverns to serve more functions than nature tours. At Cumberland Caverns in central Tennessee, one large chamber is outfitted as a banquet hall with tables and chairs for up to 500 people. In an inter-

Guest rooms at the Dobson House exhibit the typical Earthship passive solar features of sloping glass south walls and stone floors.

Soft earth tones, natural wood accents, and skylights create a welcoming, homey atmosphere inside Dobson House. Near the top of the stairs, the corridor curves before emerging into the great room.

esting juxtaposition of elegant and rustic features, a 1,500-pound crystal chandelier hangs from the rocky ceiling.

Opening a tourist attraction in the middle of the Great Depression may not seem like a smart business move, but the owner of Meramec Caverns in Missouri made it work. Besides an aggressive and innovative marketing campaign, diversification was a major factor in Meramec's success. Blessed with an expansive natural entrance, this show cave first used the huge front chamber as an indoor parking lot. Beginning in 1935, summer visitors could drive away with a car full of 60°F air. The cavern developer soon built an outdoor parking lot, however, and found an even more lucrative use for the entrance chamber. He installed a dance floor and welcomed weekend crowds to the naturally air-conditioned ballroom. The innovations continued through the years. In 1941, the American Kennel Club held its national dog show in the cavern. Although the entrance chamber has now been turned into a visitor center complete with a gift shop, a restaurant, a snack bar, and a museum, the cavern still offers a fully equipped ballroom. Complete with sound and light systems, the hall can seat as many as 2,000 people. It serves as the venue for events ranging from a yearly Easter Sunrise Service to the annual Caveman Classic bodybuilding contest. Cave tours continue, too, offering patrons natural wonders supplemented with a stirring light and sound show, featuring a recording of legendary soprano Kate Smith singing "God Bless America," as an image of the American flag is projected onto a 60-foot-wide, 70-foot-tall limestone formation called the Stage Curtain.

Show cave owners may exploit the natural features of their properties, but they also recognize the need to preserve them. For example, Fantastic Caverns, in southwestern Missouri, offers tourists an amenity that also protects the cave's fragile features. Rather than walking, visitors ride under stalactites and between columns and stalagmites in a comfortable cart towed by a propane-powered Jeep. This makes cave tours accessible to the elderly, the physically challenged, and parents with young children. "The trams, which touch the cave floor only with their eight wheels, are less intrusive than the thousands of walking feet that might pass through on any given day," the management explains. The system also keeps inconsiderate visitors from touching or defacing the formations.

One of the newest show caves in the United States is also one of the most pristine and fragile. Kartchner Caverns, discovered in 1974, was hidden from public access until 1999, when elaborate protective measures had been planned and installed. Lying under the parched Chihuahuan Desert of southeastern Arizona, the cave's ecosystem and continuing evolution rely on an uncontaminated, 67°F, 98-percent humidity environment. That is not easy, with nearly 200,000 visitors a year walking through, sloughing off dust and microscopic skin cells, exhaling carbon dioxide, and radiating body heat. The Arizona State Parks system invested $28 million to protect the 7-acre complex with various features:

- An exterior visitor center allows curious tourists to touch reproductions of the cave's formations
- Entrance air locks consist of a separated pair of walk-in freezer-type doors, with another door at the end of the entrance tunnel
- Eighteen-inch-tall curbs keep falling contaminants on the footpaths, which are hosed down each night
- Area-specific lighting is turned on only when tourists are present
- Misters constantly humidify the cave

• Between April and September, visitors are kept out of one section of the cavern, where bats that migrate from Mexico give birth and nurture their offspring

Meticulous planning included installing sensors to monitor temperature and humidity levels in the cavern. A year after the caverns opened to public tours, Ken Travous, the director of the Arizona state parks system, told *The New York Times* that, in parts of the cave, the temperature had risen 1°F and the humidity had increased by half a percent. It was not clear, however, whether the changes were within normal fluctuations. "Asked if all these measures were working to protect the cave," the newspaper reported, "Mr. Travous said, 'We sure hope so.'"

Mine's Man-made

Adventurous sightseers can explore man-made caverns in numerous underground mines that have become tourist attractions. The experiences are as varied as the geographical locations throughout the United States and Canada and the type of material mined, including gold, silver, copper, iron, and even salt. At one end of the excitement spectrum, visitors to the former Reed Gold Mine near Charlotte, North Carolina, follow a nearly level gravel path to a point some 60 feet below ground.

Farther up the adventure spectrum is the tour of the Mollie Kathleen Gold Mine on the southwest face of Pikes Peak in central Colorado. Visitors crowd into a vertically stacked pair of elevator compartments, each originally designed to carry nine miners to work. After a two-minute ride down a 1,000-foot-deep vertical shaft, they spend half an hour exploring a series of comfortably spacious tunnels and chambers before packing themselves back into the elevators for the return to the surface. Impromptu tours of the mine began not long after it started producing ore in 1891, as curious travelers prevailed on miners to take them down for a look. Word of this friendly accommodation spread, attracting increasing numbers of visitors. Forced to choose between satisfying the tourists and pursuing full mining operations, the owners offered a compromise. Miners were working at a depth of 1,000 feet by this time, and the facility's operators began conducting public tours in a previously worked area at the 700-foot level. Although mining operations continued, they were altered in deference to the tourists. Workers drilled holes in the hard rock during the day, but waited until night to insert dynamite into the holes and blast the ore loose. Eventually, the number of tourists grew large enough to force further compromise. The miners worked only at night, allowing daytime visitors to tour the deeper, active section of the mine. The Mollie Kathleen stopped producing ore in 1961, but its popular mine tours continue. Even now, most of the guides are former gold miners or members of their families.

The Soudan Mine, in northern Minnesota, offers an even more unusual experience. Visitors, who must wear hard hats, ride an elevator down a 6-by-4-foot shaft to the 2,340-foot-deep bottom of the former iron mine. The elevators are speedier than those at the Mollie Kathleen, so this descent also takes two minutes. Half a mile below the earth's surface, two very different experiences await. The historic tour includes a ¾-mile long train ride through the tunnels and an explanation of the mining process. Alternatively, visitors can choose to take the high-energy physics lab tour. From an observation platform near the top of a newly constructed 45-foot-high, 50-foot-wide, 270-foot-long chamber, they can see a 6,000-ton detector designed to observe neutrinos (elemental particles of matter with no electrical charge, negligible mass, and very weak interaction with other particles). Neutrino beams are fired through the earth

toward the Soudan Mine detector from the Fermilab accelerator near Chicago, 450 miles away. Placing the detector so far underground filters out cosmic radiation that would interfere with the experiments. To visually enhance the scientific tour, artist Joseph Giannetti created a 25-by-60-foot mural on the wall opposite the visitors gallery. The vibrant image, which Giannetti had to paint on an uneven rock surface, combines visual elements representing subatomic particles, the mining industry, and the people who conduct both endeavors.

City Under the Sidewalk

Much nearer the surface, a completely different underground experience awaits sightseers in several U.S. cities. The most popular tourist attraction in eastern Oregon, for example, is Pendleton's Underground City. Beginning about 1870, Chinese railroad laborers built the complex as a refuge from the racial discrimination they encountered above ground. The elaborate system of tunnels and subterranean chambers was literally a complete city, containing not only dwellings but also businesses ranging from ice plants and butcher shops to bordellos and opium dens. Bigotry aside, many of Pendleton's Anglo residents frequented some of the more enticing underground establishments. Subsurface saloons became particularly popular when Prohibition was enacted in 1920. The early 1930s brought an end to both Prohibition and the underground city. In 1989, enterprising citizens restored the abandoned complex and began conducting tours of the city's historic underside.

Seattle, Washington, offers tours of an underground city with a very different character. Beginning in 1851, Seattle was built on a narrow strip of muddy land between a high bluff and the tidewaters of Puget Sound. The city grew quickly, using the abundant nearby timber for much of its construction. An 1889 fire consumed more than twenty-five downtown blocks, leaving only scattered masonry buildings standing. City officials transformed the catastrophe into a rebuilding opportunity that would solve some major civic problems, such as an inadequate fresh water supply and a shallow sewer system that flowed backward every time the tide came in.

The solution involved raising the city's streets 8–35 feet above their previous levels to accommodate an improved sewer system. Construction crews erected retaining walls along both edges of each existing street, tied them together with steel rods, and packed soil between them to support the higher road. The flaw in the solution was that the sidewalks and storefronts sat one to three stories below street level. Package-laden shoppers climbed steep ladders to reach their carriages. Pedestrians and horses occasionally fell off the road. Gradually, businesses began installing platforms to connect upper floors of their buildings to the street. Panels consisting of arrays of prism glass were inserted in some of the elevated sidewalks to serve as skylights for the original sidewalks and shopping area below. This remedy was less than ideal, however, and lower levels of the buildings were eventually turned into storage spaces, with retail activities moving upstairs. In 1907, the abandoned subsurface sidewalks and storefronts were declared a health hazard and boarded up.

In 1964, Bill Speidel, a curious business man, began exploring Seattle's underground level in the Pioneer Square district, where many of the city's original masonry buildings were still occupied. His suggestion that the unique resource be preserved and publicized elicited enthusiastic public support. Volunteers removed about 10 tons of rubbish to clear the way for tour groups. In conjunction with the 1965 Know Your Seattle Day, sponsored by the Chamber of Commerce, Speidel led the first special tours of what he called the "forgotten city." Regularly scheduled tours began in 1967 and became so popular they inspired a city ordinance

designating the surrounding area an historic site. During the 1970s, Seattle Underground provided the setting for *The Night Stalker* movie, its sequel, and a subsequent television series.

Unlike Pendleton, Seattle has not restored its underground city. Pendleton's tour is designed to recreate the active years of a functioning underground city. Seattle's tour has more of a ghost-town feel, capturing the area in its state of abandonment and looking back in history from that vantage point.

GETTIN' DOWN IN ATLANTA

Like Seattle, Underground Atlanta was created when the street levels were raised. The reasons and the outcomes are different, however. Since the city's beginnings in the 1830s, railroad lines had been a prominent feature of the downtown area. Eventually, increasing rail and street traffic created nearly intolerable congestion. During the 1920s, the city built a network of concrete viaducts over the railroad tracks, essentially elevating the street sys-

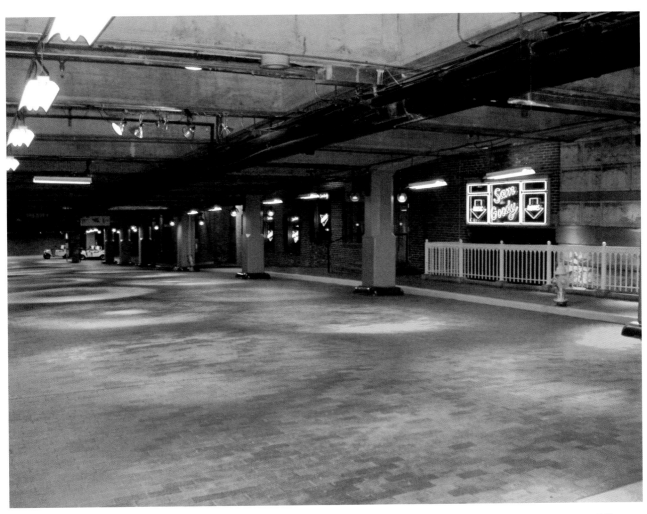

Now enclosed by city development overhead, this street in Underground Atlanta evokes a slightly surreal mood. Turning the unique setting into a retail and entertainment center has had mixed success. When the property was put up for sale in 1998, the *Atlanta Journal and Constitution* editor wrote, "Underground is not so much a failure as it is a puzzle that hasn't been solved yet." Courtesy of Underground Atlanta

tem one story. Here again, businesses turned the first floors into basement warehouses and moved upstairs, opening appropriate doorways and windows onto what had previously been the second floor.

Decades later, a pair of enterprising young entrepreneurs discovered the picturesque hidden city and saw its potential as an entertainment center. After extensive cleaning, restoring, and redecorating, Underground Atlanta opened in 1969 as a collection of restaurants, night clubs, and souvenir shops. The development "showed great promise as a funtime hideaway, as the old brick facades, cobblestone streets, gaslights, and innate secretiveness of the location offered a uniqueness that visitors coveted," wrote William Kent in the 1984 Spring issue of *Journal of Travel Research*. The enterprise was successful for several years, but then business began to decline. In 1982, Underground Atlanta closed as a result of a number of economic and management factors, complicated by nearby subway construction.

With help from the city, a new group of developers rebuilt Underground Atlanta and reopened it in 1987. Billed as a "festival marketplace," the complex included restaurants and a variety of retail businesses. As part of the redevelopment, a section of Alabama Street above Underground Atlanta became a pedestrian mall. The new incarnation of Underground Atlanta was three times the size of the first development, but much of the new space was created on top, at street level. Half a block to the south, Kenney's Alley, which was never covered over, runs through the middle of the developed Underground Atlanta, providing an open-air court surrounded by two below-grade levels devoted primarily to restaurants and nightclubs.

The enterprise continued to struggle, although the underground location does not seem to be a major factor. In fact, the *Atlanta Journal and Constitution* reported in October 1998 that "About 36 percent of the space is now empty, and much of the occupied space is temporary. The Upper Alabama Street level [i.e., the surface level] is nearly vacant." At that time, eight companies had submitted bids to buy the development. "The common theme in all their bids was a new concept for the Upper Alabama Street level," the newspaper reported. "The underground level is likely to remain pretty much what it is now—a festival marketplace with a lively smorgasbord of shops, eateries and vendors."

A NIGHT UNDER THE TOWN

Using underground spaces for entertainment is nothing new. Building a large, lavishly decorated nightclub might have been difficult during the Depression, for example, but tucking one into a spacious, geologically decorated show cave was not. In 1930, F.W. Linebarger installed a gymnasium-size dance floor into a limestone cavern near Bella Vista, Arkansas. Wonderland Cave, billed as the "world's largest underground nightclub," featured prominent big bands for two decades.

COOL JAZZ

A popular dance club and banquet facility in St. Paul, Minnesota, occupies what was once an enormous walk-in refrigerator. The Wabasha Street Caves is the latest in a string of incarnations of a cavern hewn out of a bluff above the Mississippi River. The cavity took shape between 1870 and 1880 as silica was mined for use in glass manufacturing. When the mining operation ceased, local residents took advantage of the cave's dependable temperature of 50–55°F, using it to store their food. Between 1890 and 1920, the space became a commercial mushroom farm. Then life in the caves changed dramatically.

When Prohibition became the law in 1920, the caves suddenly became a wildly popular speakeasy. Consisting of seven interconnected chambers reaching 200 feet back into the bluff, the caves provided plenty of space for public and private parties, contained the noise generated inside, excluded prying eyes, and remained inconspicuous. Prohibition ended in 1933, but the raucous times in the caves did not. John J. O'Connor, St. Paul's notoriously corrupt sheriff, openly gave known gangsters sanctuary as long as they paid for the privilege and refrained from blatant crimes in his city. Cave clientele included the likes of Ma Barker, John Dillinger, Baby Face Nelson, and Al Capone. Operating as the Castle Royal, the suddenly legal nightclub also attracted some of the biggest names of the big band era, including Cab Calloway and Harry James. By 1940, calmer times prevailed, and the Castle Royal closed.

After a false start or two in the intervening decades, the cavern reopened as a private event facility in 1992. The Wabasha Street Caves occupies the mine's three finished chambers, which total 12,000 square feet. Arched roofs, rising 10–20 feet high, are coated with stucco. Lower walls are covered with decorative brickwork. Dining areas, available for banquets and receptions, are carpeted, and the lounge area features a tile floor and a historic 60-foot-bar. Daytime guided tours exploit the colorful history of the refurbished cavern. Once or twice a week, big bands set up on the theater-style stage and belt out swing music. Regular revelers, who call themselves "cave cats," strut their stuff on the spacious hardwood dance floor while newcomers polish their moves in rooms farther back in the cavern, where illicit gambling once reigned.

Fine Wining

You would expect to find barrels of wine in a wine cave. A facility tour or a wine tasting would not be surprising. But how about concerts, formal receptions, theme parties, and corporate seminars? At some wineries, the answer is yes.

"People enjoy the caves because they invoke so many emotions—romance, awe, reverence," Marcia Kunde told WineToday.com in 1998. She should know. Kunde Estate Winery regularly conducts tours and hosts a variety of special events in its 32,000-square-foot cave network. The dining room is at the lowest level of the cavern, 175 feet below ground. On the surface, the cave's only visible features are a pair of simple, arched portals, each framing a set of double doors, at the base of a hill covered with grape vines.

Sonoma Valley's Kunde cave system is one of the largest in Northern California's wine country, but its entertainment room is not. With a maximum capacity of forty diners, its size is modest in comparison with the cave theatre at Napa Valley's Clos Pegase Estate Winery. At 2,800 square feet, the theatre represents 14 percent of the estate's cave system. It can seat 120 people for dinner, or as many as 350 for a concert or presentation. The height of its arched ceiling produces unusually good acoustics. Musician David Auerbach told the *Sacramento Bee* in October 1995 that he particularly enjoys performing in Napa-Sonoma area wine caves because "it's an adventure for the audience. The natural acoustics of caves are unbeatable."

Fine acoustics are a fortunate by-product, but the primary reasons wineries build caves are economic. Unaided by mechanical devices, the caves consistently maintain temperatures of 55–60°F and humidity levels of 85–95 percent, conditions that are ideal for aging wine. Evaporation from the aging barrels is less than 1 percent per year, compared with up to 8 percent in an aboveground warehouse. Furthermore, burying the storage space leaves the surface free for grape vines and preserves the view of attractive scenery and historic structures that entice visitors. "When you construct a building, the winery's neighbors will complain

An alcove at the end of the Kunde Estate Winery's dining room showcases the volcanic rock from which the cavern was carved. Courtesy of Kunde Estate Winery & Vinyards; Photo by Steve Bailey

about the potential impact it will have on their lives—the noise that could result from having a party or function in a building as well as the noise of machinery in the building," cave construction expert Alf Burtleson told WineToday.com. "However, you seldom hear complaints when it is a cave."

That says a lot about the noise containment properties of the earth, because wine cave construction is noisy business. A century ago, northern California's first wine caves were hand dug with picks and shovels. Modern techniques, introduced to the region in 1969, are another story. Cave builders sometimes resort to blasting; more commonly, they gouge the caverns out of rock with a roadheader. Essentially a small tunnel-boring machine, the roadheader features an array of rock-cutting bits that is pressed against the cavern wall and rotated to grind away the rock. Most commercial wine caves consist of several tunnels, which may be straight or somewhat curved. Because of maneuverability limitations of the roadheader, tunnels rarely intersect at right angles. Once the desired cavern has been created, it is sealed with 4 inches of shotcrete (sprayed-on concrete). Steel frames are used to reinforce entrance portals.

Wine cave building is not a speedy operation. The most experienced cave construction companies have waiting lists several months long. Then, depending on geologic conditions, the roadheader can grind away as little as 2 feet or as much as 15 feet in a day—slow progress for what may be thousands of linear feet of tunnels. "I've been on a waiting list for two years," Vine Cliff Winery's owner Rob Sweeney told *Wine Business Monthly* in July 1998. Construction was completed on his 15,000-square-foot cave system in 2000.

Delving into Science

Feeding the intellect is another way to spend leisure time. Several science and technology museums have either built or expanded underground, giving visitors a chance to immerse themselves in educational entertainment. More are on the way. Beginning in 2005, the Kansas Underground Salt Museum, located in part of an active mine near Hutchinson, will feature exhibits about the history and uses of salt as well as extraction techniques. A below-grade exhibit space scheduled to open in 2003 at the Shedd Aquarium in Chicago, Illinois, simulates a diving experience by taking visitors 30 feet down past coral reefs to a viewing space underneath a 400,000-gallon tank stocked with thirty or more sharks.

Underground Overlook

The Griffith Park Observatory in Los Angeles, California, which was built in 1935, is so picturesque that more than thirty-five movie makers film it every year. After hosting nearly 70 million visitors, it was showing the wear and tear of decades of constant use and needed a makeover. Its planetarium projection equipment was so outdated that repair parts could not be found. Its 27,000 square feet of space was barely able to handle the annual attendance of 2 million people, including 50,000 students on field trips. Restoring and modernizing the Art

As shown in this roofless model, the Griffith Observatory will be flanked on the west and north (right and bottom in photo) by below-grade spaces. The underground addition will be covered with grass and a paved terrace. At the far right are the parallel glass walls of the addition's only visible wall. Courtesy of Hardy Holzman Pfeiffer Associates, Architects; © HHPA

Deco observatory could be done without altering its famous facade. The difficult question was how to double its size without changing its external appearance.

The architecture firm Hardy Holzman Pfeiffer Associates solved the problem by designing a 35,000-square-foot addition that nestles under the observatory's front lawn and a western terrace beside the original building. Only two exterior features of the expansion are visible. A stand-alone cylinder beside the lawn houses an elevator entrance. The west face of the below-grade addition is exposed because the observatory stands on a mountaintop. The architect made this one-story wall an expanse of glass, allowing daylight into the gift shop and providing patrons of the café with a beautiful view toward the Pacific Ocean. The portion of the addition lying under the front lawn is 28 feet deep. A 202-seat presentation theater makes full use of that height. So does the Depths of Space exhibit hall, which features a 150-foot-long ceramic wall emblazoned with a high-definition galactic image. Support areas, which include classrooms, offices, and rest rooms, are separated into two levels.

To accommodate the massive excavation and construction effort, along with a simultaneous remodeling of the original building, Griffith Observatory closed in January 2002. The planned reopening, with all the new exhibits and equipment in place, is slated for May 14, 2005, exactly seventy years after its original opening.

KIDDING AROUND DOWNSTAIRS

New Yorkers are used to walking into a sidewalk kiosk, descending a flight of stairs, and boarding a subway train. Since 1977, however, one kiosk on a street corner in Brooklyn has led to a different world—the Brooklyn Children's Museum. After climbing a one-story high artificial hill and entering this 1907 trolley booth, youngsters and their parents find themselves, not on a flight of concrete steps, but inside a huge storm-drain pipe.

The corrugated steel culvert encloses a ramped walkway that leads down through four stories of exhibition rooms. A spiral of colorful neon lights brightens the inner contours of the 180-foot-long tube. The spiral quickens from one lazy loop between the entrance and the first exhibit level to four closer coils between the third and fourth levels. Following the succession of colors in the daylight spectrum, each loop is a different color, beginning with red at the top floor and ending with dark violet at the lower end of the people tube. At each floor, a gap between sections of culvert allows people to leave the passageway and enter exhibit rooms. The floors themselves are successively larger, each one ending in a balcony overlooking the lower levels. At the end of the culvert, the museum's fourth level houses an enormous, transparent model of a protein molecule that children can climb through. At this corner of the building, diagonally opposite the entrance kiosk, 40-foot-high glass walls reveal a recessed courtyard outside.

The culvert is even more than an intriguing corridor. It is a linear learning experience. Throughout its length, a water-filled wooden trough runs alongside the footpath, offering a succession of experiment stations. The trough changes slope and direction to provide the right conditions for demonstrating devices and phenomena like water wheels, dams, locks, whirlpools, and tidal action.

Hardy Holzman Pfeiffer Associates' architects incorporated several common infrastructure elements into their design of the Brooklyn Children's Museum, making them novel by using them in an uncommon way. The culvert pipe serving as the building's main corridor is one example. Another is a retired oil-storage tank that encloses a small theater. On top of the museum, a shortened grain silo hides a fire escape exit, giving little hint of the building con-

Concealed under a play yard and shielded from street view by an earth berm that reaches to the roof of the building, the Brooklyn Children's Museum is almost too inconspicuous.

Courtesy of Hardy Holzman Pfeiffer Associates, Architects; © HHPA

cealed below the open space. A freeway-type sign bridge spans the rooftop playground, and a standard white-on-green highway guide sign mounted on it proclaims "BROOKLYN CHILDREN'S MUSEUM." The large arrow on the sign points straight down, indicating the location of the nearly invisible building.

"From the street, people found it hard to identify [the building] as a children's museum because it was so hidden by the berms, planted material on all sides of the building, and the steps [leading up to the entrance]," Brooklyn Children's Museum spokesman Paul Pearson said in 2002. "The trolley kiosk makes it look like a subway entrance rather than a museum and public space entrance." An expansion is being designed to increase the building's visibility while adding much-needed space. The trolley kiosk and the earth berms will be replaced by an eye-catching, two-story structure that will wrap around two sides of the original building's uppermost story. The interior of the older building will be remodeled in a way that retains much of its original character. "We want to maintain the fun, underground nature of the core experience," Pearson said. "We want to preserve that sense of *down* and that sense of wonder."

UNDERGROUND? I'M GAME!

"Underground sports" is not just another term for fantasy league games. It also describes fans at Pacific Bell Park looking through one-way glass to watch San Francisco Giants baseball players warm up in subterranean batting cages. It means Atlanta Hawks working out on an underground basketball court at Philips Arena. It means football fans walking down

from street level to find their seats at Ford Field and watching the Detroit Lions play on a field 45 feet below grade. Collegiate and casual athletes participate in many kinds of sports in underground venues, too. An hour's drive south of St. Louis, Missouri, scuba divers enjoy 7 miles of tunnels flooded with crystal-clear groundwater at Bonne Terre Mine, where lead was extracted until 1962. In a former limestone mine in Kansas City, Missouri, Jaegers Subsurface Paintball Complex offers mock combat experiences for business people on team-building retreats as well as recreational paintball enthusiasts. Those are only a few examples.

HYPAR-ACTIVE

The Georgetown University administration had a great idea for making the school more appealing to students: give them a place to play. A new athletic center funded by student fees would do triple duty as a recreational facility, an intramural sports venue, and an all-weather physical education space. Two problems stood in the way of the scheme, however. The campus of the nearly 200-year-old urban university had no free space where such a structure could be built. Furthermore, new buildings that would change the appearance of the Washington, D.C., campus were subject to review by nearby neighborhood groups and by the National Commission on Fine Arts, a process that would be lengthy and possibly unsuccessful.

Architect and structural engineer Daniel F. Tully solved the dilemma by designing a 142,000-square-foot athletic center that would fit under Georgetown University's existing football field. Practically invisible below Kehoe Field, Yates Field House encloses a surprising array of athletic facilities. A 260-by-325-foot main gym, which is interrupted only by a row of five roof support columns, is large enough to accommodate twelve basketball courts. It can also be used for other sports such as tennis. One side of the main gym is configured with a four-lane, 200-meter track and includes pole vault and long jump pits. Another part of the field house contains an eight-lane, 25-meter swimming pool and a diving pool. Tully included other specialized features as well, like handball courts, squash courts, batting and golf driving cages, and a 10,000-square-foot dance room with a hardwood floor.

During the time Tully was designing and building Yates Field House, he was also awaiting approval of his application for a patent on the innovative roof system he used for the athletic center. Making the roof out of an array of hyperbolic paraboloid (hypar) shells was not unprecedented. Viewed from the floor of the gym, each of these shells looks like a huge concrete umbrella turned wrong side out, flaring out above a 3-by-5-foot concrete support column. The support columns are 17 feet tall, and the hypar shells reach a maximum height of 34 feet above the floor where their edges connect. Tully used several sizes of shells for Yates, the largest being 65 feet by 130 feet. The patent-winning innovation was to incorporate a structural diaphragm across the upturned edges of the shells, strengthening them against deformation and enabling them to efficiently support an external load, such as upper floors of a building or, in this case, a football field and athletic track. The diaphragm consists of a corrugated metal deck covered with 3½ inches of concrete. A series of vertical metal braces between the diaphragm and the shell transfer rooftop loads to the 5-inch-thick hypar surface, which gets its strength from its arched shape.

Hypar roofs were already known to be an economical way to create large spans with few support columns. "Prior to the present invention," Tully wrote in his patent application, "roofs constructed from hyperbolic paraboloid shells could not be used for any other purpose since a depth of approximately 20 percent of the span was required for the roof structure to become economical and efficient. Thus, no working surface was provided on the roof." Adding the thin

diaphragm component reduced the necessary height of the hypar shells from approximately 26 feet to 18 feet, enabling the roof to carry loads like dozens of hefty football players doing calisthenics.

It was 1979 when Tully received his patent and completed Yates Field House. In 2002, the university renovated the roof to correct some lingering problems. Besides resealing the roof, the track was removed (it will be rebuilt in another location on campus). The seam be-

Besides adding visual interest to the interior of Yates Field House, the curved surfaces of the hypar shells also scatter light to provide uniform, glare-free illumination on the activity areas. Because of a sloping site, some rooms of the underground athletic center have windows for daylight and exterior views.

tween the track and the artificial-turf football field had been the source of a persistent water leak. Redesigning the roof also allowed air conditioning to be installed in the main gym area for the first time.

LOWER THE BASKET

As the twentieth century was drawing to a close, *Sports Illustrated* published a list of the twenty "best places in the world to watch sports." In thirteenth place was the University Arena in Albuquerque, the home court of the University of New Mexico Lobo basketball team. Described by the magazine as "a mile high but 37 feet underground," the arena is more commonly known as The Pit.

After achieving national prominence during the 1963–64 season, Lobo basketball immediately outgrew its modest-capacity gymnasium. Eager to support the suddenly successful program, UNM President Tom Popejoy decided to build a new arena that would seat twice as many fans. Enthusiasm was high, but resources were low. Popejoy had to build the arena as inexpensively as possible. He discussed the options with local architect Joe Boehning, and they concluded that the most economical approach was to scoop the stadium out of the ground.

Knowing that the spectator space had to be column free, Boehning searched for the most efficient way to build the large-span roof. A stress-skin system developed by the Behlen Manu-

facturing Company looked promising. It made the entire roof a continuous truss, designed rather like an airplane wing, with flat, parallel surfaces. The upper surface, a thin sheet of steel that served as the exterior roof, became the upper component of the truss. Fifteen feet below, another thin steel sheet acted as the bottom truss member and formed the ceiling. Separating these exterior and interior surfaces and uniting them into a stable system was a web of steel struts, arranged diagonally. At that time, the largest stress-skin span had been no more than 100 feet, but Boehning needed 250 feet. Behlen designed a larger system, and an independent engineer reviewed the design. Then the company built a prototype section and confirmed the calculated results by applying increasing loads to the prototype until it failed.

Ultimately, the contractor used what amounted to an enormous Erector Set. At this point, the building site's undisturbed, relatively level ground was outlined by support columns. The builders assembled a 12-foot-wide scaffolding system between the east and west column rows to support a strip of the roof while the parts were being bolted together. Then they moved the scaffold 12 feet south and repeated the construction process, attaching the new section to the completed one. Lightweight components (nothing heavier than 13-gauge steel, which is 0.09

By several measures, the Pit is one of the most successful collegiate arenas in the country. The only college basketball facility to rank higher on *Sports Illustrated*'s list was Duke University's Cameron Indoor Stadium. In the Pit's first thirty-four years of use, attendance averaged 97 percent of capacity, and the arena ranked among the nation's top ten for average attendance each of those years. Courtesy of UNM Athletic Media Relations; Photo by Steve Bercovitch

inches thick) of easily manageable size (nothing longer than 20 feet) made the roof system economical and quick to build. Being able to erect the construction scaffolding on nearly level ground and work at a convenient height contributed to the ease of assembly.

When the roof system was complete, workers began digging under it, shaping the arena from the inside out. Trucks carried the excavated soil out by driving up a ramp that became increasingly steep as the pit deepened. During the late phases of construction, the heavily loaded trucks could not propel themselves up the ramp, and they were pulled up with a winch. The pit was shaped with sloping sides and a flat bottom. Forming and pouring

UNM's 73-foot-high Pit extends only 35½ feet above the surface. The 1975 expansion added no height, as the new mezzanine fit within the existing space. Courtesy of UNM Athletic Media Relations and Joe Boehning, Architect

the concrete for forty-eight rows of seating was a simple task, since they were placed directly on the excavated slopes.

The Lobos played their first game in the Pit on December 1, 1966. Patrons entered at ground level, walking into a concourse at the top of the arena, overlooking the basketball court 37 feet below. During its first decade, the 14,850-seat Pit was frequently filled to capacity. The UNM Board of Regents had instructed Boehning to design the arena so it could easily be expanded. His solution was to include an extra 5 feet of vertical space in the aboveground portion of the structure. In 1975, a mezzanine level was slipped into this excess space. Cantilevered over the top five rows of the original seating area, the mezzanine added 2,300 seats. Standing-room spaces on the original concourse and the new mezzanine raised the official capacity to 18,018. At the same time, the concourse was widened by moving the exterior walls outward 17 feet, creating space for more rest rooms and concession stands.

At first, Boehning wanted to design University Arena to be recessed only halfway into the ground. Cost constraints dictated the fully-recessed version that, in hindsight, he considers a very successful design. "I think one of the things that makes it a fun place is that people are fairly close together in there," he says. "It sure does help to increase the noise reverberation." Solidly contained by the surrounding earth, cheers and jeers build to legendary levels. This contributed to *Sports Illustrated*'s end-of-century ranking: "The noise created by fans, which has been measured at 125 decibels—the pain threshold for the human ear is 130—is a palpable force."

In June 1968, *New Mexico Architect* magazine bestowed a First Honor Award on the Pit. The selection jury wrote, "The absolute directness of this vast arena, the economy of its structure, the renunciation of any architectural trivialities, and the power of its space render it a building (or non-building) of national importance."

SINKING INTO THE SUNSET

"People are feeling a sense of time poverty," Peter Yesawich told the *North Carolina Citizens for Business and Industry*. "They want to take a break and indulge themselves in stress reduction." In fact, a study announced in the 2000 *National Leisure Travel Monitor*, prepared by the marketing firm Yesawich, Pepperdine & Brown, found that 60 percent of adults traveling for leisure were looking for ways to relieve stress. The survey found that about 40 percent of the nonbusiness travelers wanted to visit a spa, compared with about 20 percent who wanted to play golf. *North Carolina Citizens for Business and Industry* also reported that an International Spa Association survey conducted three months after the September 11, 2001, terrorist attacks on the United States revealed that spa bookings by business groups as well as nonbusiness users had "increased dramatically."

"In the past five years the industry has seen forty-five resorts with spas grow to 350; many of the new spas are in excess of 10,000 square feet," reported Jim France, Vice President and General Manager of the Grove Park Inn on November 4, 1998. France minced no words in announcing a new construction project for his prestigious, 85-year-old resort in Asheville, North Carolina. "We intend to build the finest resort spa in the United States."

Superlatives are not surprising where the Grove Park Inn is concerned. E.W. Grove announced in 1913 that he built the original facility "not for the present alone, but for the admiration of generations yet unborn." Later expansions were designed in keeping with that tradition. When the idea of adding a spa first arose in 1995, the one stumbling block was space. The ample grounds were already filled with amenities, like an eighteen-hole golf course and the 515-room inn itself. The only practical place to put the spa was the open area framed by the historic stone inn and the newer, perpendicular wings added in the 1980s. The scenic view from the Sunset Terrace restaurant at the base of the U-shaped structure was so legendary, however, that blocking it with a building would be unthinkable. Of course, that did not mean the new structure could not be built there. It simply had to go underground.

Uncertain at first what the public reaction would be to the idea of a below-ground spa, the management initially shied away from the words *underground* and *subterranean*. Rather, descriptions of the plan cryptically announced that the addition would not *change the existing sight line* from the inn. After all, perception of the elegance of the resort was essential. During its illustrious history, it had hosted eight U.S. presidents as well as celebrities ranging from Henry Ford and Thomas Edison to Will Rogers and Harry Houdini. It housed F. Scott Fitzgerald during part of the time he was writing *The Great Gatsby*. Besides being on the National Register of Historic Places, it consistently received the highest rankings from travel guides published by the likes of Mobile and AAA.

The owners undertook the project with great care, enlisting the services of architect Robert LeBlond of Calgary, Canada. The spa's design would "fit hand and glove with the hotel's unique architecture and historical significance," LeBlond vowed. "Architecture is based on more than wood and stone, and the spa must provide a sense of place and atmosphere of belonging, serenity, and peace. With a spirit of welcoming, nurturing, and caring, the spa will

A skylight-covered, at-grade lobby at the end (left center) of the Grove Park Inn Spa serves as the main entrance. Guests may also enter through tunnels from the newer wings extending outward from the original stone inn at the hill crest.

Courtesy of The Grove Park Inn

be living architecture as opposed to mere materiality." The result was so impressive that owners, architects, and managers were freed from any semantic concerns. In November 2001, nine months after it opened, *USA Today* proclaimed it one of the top ten spas in the world.

Many factors contribute to the Grove Park Inn Spa's success. Spa Director Ellen McGinnis relied on her twenty years of experience as she recruited a talented staff of more than 100 from Europe as well as North America. In keeping with the inn's tradition, service is of the highest quality. "And the unique architecture is certainly one of its main attractions," says Dave Tomsky, the resort's media relations director. "This cave-like environment turned out to be exceptional and unique. The guests love it."

LeBlond designed the spa to echo the architecture of the original inn, which is built of granite boulders. Other than the private treatment rooms, the interior of the spa and the exposed surface features are covered with similar stones. Local quarries supplied 4,000 tons of rock for the structure. Simulated rocks made of fiberglass adorn ceilings and curved surfaces, such as arched doorways. Skillfully hand-crafted with small bits of natural materials embedded in the surfaces, these artificial stones are visually indistinguishable from the natural stones. Fabricating imitation rocks offered several advantages. Construction took much less time than erecting support forms and cementing natural stones in place. The stone surfaces could easily be shaped to fit contours and to form a relatively smooth surface free of protrusions that guests might bump into. Finally, it eliminated the possibility that a heavy natural stone might ever fall from the surface.

To counteract any impression of coldness in the cave-like spa, LeBlond included gas fireplaces in the large rooms. Artificial lighting comes from electric wall fixtures that simu-

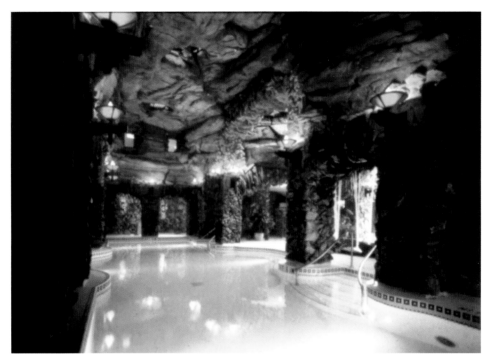

An underwater sound system enables guests to listen to music while they swim in the lap pool. A basement level below the two-story-deep spa houses mechanical and electrical equipment and provides maintenance access to the bottoms of all the spa's pools. Courtesy of The Grove Park Inn

late flaming torchieres. Fiber-optic lights embedded in the ceiling of the lap pool chamber sparkle like 6,500 stars. Waterfalls of various sizes and configurations introduce comforting sounds and visual liveliness. Skylights over various pool areas are made of glass with a clear, energy-conserving coating to provide cool, filtered natural light and create a feeling of spaciousness. The 40,000-square-foot spa includes large pool and lounge rooms as well as small, individual treatment rooms. See-through niches in walls allow glimpses into other chambers, helping dispel any sensation of claustrophobia.

"Located in the heart of the hotel complex, the spa spills fluidly down the hillside like natural spring water emerging from within the rock," Tomsky says. "Definition of the interior spaces through the play of light and shadow and the material application of stone columns, stone arches, stone walls and simulated rock ceilings, instills a sense of refuge and sanctuary."

FIFTY SITES TO SEE

Some of the buildings described in this book are not open to the public, usually for reasons of privacy or security. The fifty on this list are reasonably accessible. However, please observe these guidelines:

• Buildings such as offices and schools are not intended to be tourist attractions. Look around quietly, and observe any posted rules such as obtaining a visitor pass.

• Sites marked with an asterisk (*) have restricted access or variable hours. Use the listed telephone number or web site address to get current information or make reservations.

Brooklyn Children's Museum
145 Brooklyn Avenue
Brooklyn, NY 11213
718-735-4400
www.brooklynkids.org

California Palace of the Legion of Honor Addition
100 34th Avenue
Lincoln Park
San Francisco, CA 94122
415-863-3330
www.thinker.org

California State Office Building
8th and O Streets
Sacramento, CA 95814

CamelSquare Office Park, Building K
4250 East Camelback Road
Phoenix, AZ 85018

Cleveland Convention Center
500 Lakeside Avenue
Cleveland, OH 44114
216-348-2200
www.travelcleveland.com

Clos Pegase Estate Winery Cave Theater *
1060 Dunaweal Lane
Calistoga, CA 94515
707-942-4981
www.clospegase.com

Davis Caves Model Home *
Halfway between Chicago, IL,
and St. Louis, MO. on US Route 136
between I-155 and I-55
PO Box 69
Armington, IL 61721
309-392-2574
www.daviscaves.com

DeWitt Wallace Decorative Arts Gallery
In Colonial Williamsburg,
midway between Richmond
and Norfolk, VA, on I-64
Tickets available at the Colonial
Williamsburg Visitor Center
800-HISTORY
www.history.org/history/museums/
dewitt_gallery.cfm

Earthship Model Homes
On US 64, approximately 5 miles
northwest of Taos, NM
PO Box 1041
Taos, NM 87571
505-751-0462
www.earthship.org

Forestiere Underground Gardens *
5021 West Shaw Avenue
Fresno, CA 93722
559-271-0734

Fremont Elementary School
1930 W. Tenth Street
Santa Ana, CA 92703
714-972-4300

Gateway Arch Visitor Center

St. Louis Riverfront

St. Louis, MO 63102

877-982-1410

www.gatewayarch.com

Greenbrier Bunker *

On US 60 just west of

White Sulphur Springs, WV

Contact: The Greenbrier

300 West Main Street

White Sulphur Springs, WV 24986

304-536-7810

www.greenbrier.com/docs/

hotel_activities.html

Griffith Park Observatory

Expansion 2005

(Closed for construction until 2005)

2800 East Observatory Road

Los Angeles, CA 90027

323-664-1181

www.griffithobs.org

Grove Park Inn Spa *

290 Macon Ave.

Asheville, NC 28804

800-438-5800

www.groveparkinn.com

Horton Plaza Lyceum Theatre

Between Broadway and G Street,

and 1st and 4th Avenues

79 Horton Plaza

San Diego, CA 92101

619-544-1000

Integrated Learning Center

University of Arizona

Cherry Avenue between Fourth

and Hawthorne Streets

Tucson, AZ 85721

520-626-3918

www.ilc.arizona.edu

Kroch Library

Cornell University

Ithaca, NY 14853

607-255-3689

www.cornell.edu

Kunde Estate Winery Cave *

10155 Sonoma Highway

PO Box 639

Kenwood, CA 95452

707-833-5501

www.kunde.com

Las Vegas Underground Mansion *

Available only for corporate

special events

Contact: Activity Planners Inc.

8110 S. Polaris, Suite 4

Las Vegas, NV 89102

702-362-8002

www.activityplanners.com/

venues.html

Law Library Addition

801 Monroe Street

University of Michigan

Ann Arbor, MI 48109

734-764-9324

www.law.umich.edu/library

Los Angeles Central Library,

Bradley Wing

630 West 5th Street

Los Angeles, CA 90071

213-228-7000

www.lapl.org/central/index.html

Lucile Halsell Conservatory

555 Funston

San Antonio, TX 78209

210-207-3250

www.sabot.org/bg/conservatory.html

Metro Toronto Convention Centre

255 Front Street West

Toronto, ON, Canada M5V 2W6

416-585-8000

www.mtccc.com

Moffett Elementary School

11050 Larch Avenue

Lennox, CA 90304

310-330-4935

http://www.lennox.k12.ca.us/

moffett/Moffett.html

Montréal Shops

Numerous entrances in downtown

Montréal, Quebec, Canada

Map available at www.stcum.qc.ca/

English/metro/a-index.htm

Moscone Convention Center

747 Howard Street

San Francisco, CA 94103

415-974-4000

www.moscone.com

Mueller Hall

South Central Portion of

Main Campus University

of Washington

Seattle, WA 98195

www.washington.edu/home/maps/

southcentral.html

Music and Dance Theater Chicago

On Randolph Street, between Michigan Avenue and Columbus Drive

Chicago, IL

312-629-8696

www.musicanddancetheater

chicago.com

National Cathedral School for Girls

3612 Woodley Road NW

Washington, DC 20016

202-537-6339

www.ncs.cathedral.org

Nelson-Atkins Museum of Art Addition

(Completion expected in 2006)

4525 Oak Street

Kansas City, MO 64111

816-561-4000

www.nelson-atkins.org

Oakland Museum of California

1000 Oak Street

Oakland, California 94607

510-238-2200 or 888-Oak-Muse

www.museumca.org

Pusey Library

Harvard Yard

Cambridge, MA 02138

617-495-2417

http://hcl.harvard.edu/maps

Smithsonian South Quadrangle

Arthur M. Sackler Gallery:

1050 Independence Avenue, SW

P.O. Box 37012, MRC 707

Washington, D.C. 20013-7012

202-357-4880, ext. 245

www.asia.si.edu/aboutus/

visitorinfo.htm

National Museum of African Art

950 Independence Avenue SW

Washington, D.C. 20560-0708

202-357-4600

www.nmafa.si.edu

SubTropolis

8300 NE Underground Drive

Kansas City, MO 64161

816-455-2500

www.subtropolis.net

Terraset Elementary School

11411 Ridge Heights Road

Reston, VA 20191

703-390-5600

www.fcps.k12.va.us/TerrasetES

Texas State Capitol Extension

Congress Avenue between 11th

and 14th Streets

Austin, TX 78704

512-463-0063

www.tspb.state.tx.us

The Pit

University Boulevard and

Avenida Cesar Chavez

Albuquerque, NM 87131

505-925-5925

Toronto Shops

Numerous entrances throughout

downtown Toronto, Ontario, Canada

Path System map available at

www.city.toronto.on.ca/path

Underground Art Gallery

673 Satucket Road

Brewster, MA 02631

508-896-3757

Underground Atlanta

Central Avenue and Martin Luther

King, Jr. Drive

50 Upper Alabama Street Suite 007

Atlanta, GA 30303

404-523-2311

www.underatl.com

University of Minnesota

Civil Engineering Building

University of Minnesota

500 Pillsbury Drive SE

Minneapolis, MN 55455

http://onestop.umn.edu/Maps/

CivE/index.html

Williamson Hall

University of Minnesota

231 Pillsbury Drive SE

Minneapolis, MN 55455

http://onestop.umn.edu/Maps/

WmsonH/index.html

U.S. Capitol Visitor Center

(Completion expected in 2005)

First Street between Constitution and

Independence Avenues

Washington, DC

www.aoc.gov/cvc/cvc_overview.htm

Vail Library

292 West Meadow Drive

Vail, CO 81657

www.vaillibrary.com

Vilar Center for the Arts

68 Avondale Lane

Beaver Creek, CO 81620

970-845-8497 or 888-920-2787

www.vilarcenter.org

Vine Cliff Winery Caves *

7400 Silverado Trail

Napa, CA 94558

707-944-2388

www.vinecliff.com

Wabasha Street Caves *

215 Wabasha Street South

St. Paul, MN 55107

651-224-1191

www.wabashastreetcaves.com

Walker Community Library

2880 Hennepin Avenue

Minneapolis, MN 55408

612-630-6650

www.mpls.lib.mn.us/walker.asp

Winthrop Rockefeller Archaeology Museum

8 miles southeast of Colonial

Williamsburg, VA

Tickets available at the Colonial

Williamsburg Visitor Center

800-HISTORY

www.history.org/history/museums/

carters_grove.cfm

Women in Military Service to America Memorial

Ceremonial Entrance, Arlington

National Cemetery

West end of Memorial Drive

Arlington, VA

703-892-2606 or 800-222-2294

www.womensmemorial.org

Suggested Readings

Books

Golany, Gideon, and Toshio Ojima. *Geo-Space Urban Design.* John Wiley & Sons, 1996.

McCarter, Robert, and William Morgan. *William Morgan: Selected and Current Works (Master Architect Series VI).* Images, 2002.

The Oakland Museum: A Gift of Architecture. The Oakland Museum Association, 1989. Available at the Oakland Museum gift shop.

Park, Edwards, and Jean Paul Carlhian. *A New View from the Castle.* Smithsonian Institution Press, 1987.

Rose, Kenneth D. *One Nation Underground: The Fallout Shelter in American Culture.* New York University Press, 2001.

Roy, Rob. *The Complete Book of Underground Houses: How to Build a Low-Cost Home.* Sterling Publications, 1994.

Sterling, Raymond L., and John Carmody. *Underground Space Design.* Van Nostrand Reinhold, 1993; John Wiley & Sons, 1997.

Weiss, Marion, and Michael A. Manfredi. *Site Specific: The Work of Weiss/Manfredi Architects.* Princeton Architectural Press, 2000.

Wells, Malcolm. *The Earth-Sheltered House: An Architect's Sketchbook.* Chelsea Green, 1998.

Wells, Malcolm. *How to Build an Underground House.* Malcolm Wells, 1991.

Out-of-Print Books

Even though some new materials and technologies have arisen since these books were published, the information in them can be interesting and useful. Copies of out-of-print editions may be found in public and university libraries and through stores that sell used books.

Campbell, Stu. *The Underground House Book.* Garden Way, 1980.

Carmody, John, and Raymond Sterling. *Underground Building Design.* Van Nostrand Reinhold, 1983.

Edelhart, Mike. *The Handbook of Earth Shelter Design.* Doubleday (A Dolphin book), 1982.

Metz, Don. *Superhouse.* Storey Books, 1982.

Nelson, Susan R. (ed.) *Groundworks: North American Underground Projects, 1980 to 1989.* American Underground Space Association, 1989.

Spreiregen, Paul D. *The Architecture of William Morgan.* University of Texas Press, 1987.

Magazines

Architecture [formerly *AIA Journal*]

Architectural Record

Civil Engineering

ENR [formerly *Engineering News-Record*]

Progressive Architecture magazine [1945–1995]

Underground Space journal [1976–1985]

Resources

Web Sites

The Internet offers the broadest range of current information about underground and earth-sheltered architecture. Here are some places to start looking:

www.SubsurfaceBuildings.com

SubsurfaceBuildings.com explores underground buildings and examines their impact on architecture and the environment. Written by Loretta Hall, it supplements the content of this book by describing additional examples.

www.malcolmwells.com

"This site is dedicated to the promotion and discussion of underground buildings, earth-sheltered architecture, eco-friendly design, and energy-efficient houses . . . particularly the ideas of pioneer architect Malcolm Wells."

www.earth-house.com

Earth House is "an information resource for everything related to earth sheltered or underground homes, including listings of underground and earth-sheltered homes for sale."

http://205.168.79.27/erec/factsheets/earth.html

Earth-Sheltered Houses is "an overview of earth-sheltered homes as an energy-efficient and environmentally conscious alternative to traditional home construction." It is provided by the US Department of Energy's Energy Efficiency and Renewable Energy Clearinghouse.

www.missilebases.com

Through his company, Twentieth Century Castles: Unique Underground Properties, Ed Peden sells decommissioned missile silos for conversion to residential or commercial uses.

www.winecaves.com

This photo-rich site, which focuses on California's wine country, includes discussions of the advantages of aging wine underground and the techniques used in constructing modern caves.

Kits, Plans, Construction, and Instruction

Perhaps you are considering building an underground home or business structure, but you don't want to start from scratch. The following companies offer stock and customized plans, building kits, and construction services. Some will even teach you how to build it yourself.

Davis Caves Construction Inc.
PO Box 69
Armington, IL 61721
309-392-2574
www.daviscaves.com

Dome Contractors Inc.
7776 CR 360
Buffalo, TX 75831
903-626-3663
www.domecontractors.com

Earth Sheltered Technology Inc.
PO Box 5142
Mankato, MN 56001
507-345-7203 or 800-345-7203
www.earthshelteredtech.com

Earthship Biotecture
PO Box 1041
Taos, NM 87571
505-751-0462
www.earthship.org

Earthwood Building School

366 Murtagh Hill Road

West Chazy, NY 12992

518-493-7744

www.cordwoodmasonry.com

Formworks Building, Inc.

PO Box 1509

Durango, CO 81302

970-247-2100

www.formworksbuilding.com

Moreland Homes

PO Box 9197

Fort Worth, TX 76147

817-732-7041

www.morelandassociates.com

Performance Building Systems Inc.

PO Box 1679

Durango, CO 81302

970-247-1234 or 800-247-0090

http://www.earthshelter.com

R.C. Smoot Construction

PO Box 152076

Austin, TX 78745

512-441-0890

http://www.earthshelteredhome.com

Terra-Dome Corporation

8908 South Shrout Road

Grain Valley, MO 64029

800-481-3663

www.terra-dome.com

OVERNIGHT LODGING

Are you intrigued with the idea of living underground but leery of the quality of life in a subsurface or earth-sheltered setting? Then try it out at one of these establishments, which range from the conventional to the exotic.

Beckham Creek Cave Haven

HC 72 Box 45

Parthenon, AR 72666

870-446-6045 or 888-371-CAVE

www.ozarkcave.com

Dobson House

PO Box 1584

El Prado, NM 87529

505-776-5738

http://www.newmex.com/dobson-house

Earthships

PO Box 1041

Taos, NM 87571

505-751-0462

http://www.earthship.org/edu/rent.php

The Cave at Jackson House B & B

1821 Seminary Street

Alton, IL 62002

618-462-1426 or 800-462-1426

www.jacksonbb.com

Kokopelli's Cave Bed & Breakfast

206 West 38th Street

Farmington, NM 87401

505-326-2461

http://www.bbonline.com/nm/kokopelli

Ocean House at Post Ranch Inn

California Highway 1,

30 miles south of Carmel

Big Sur, CA 93920

800-527-2200

www.postranchinn.com

ARCHITECTS

The following architecture firms have experience designing underground buildings, as evidenced by projects described in this book:

BJSS Duarte Bryant

108 First Avenue South Suite 200

Seattle, WA 98104

206-340-1552

www.bjssdb.com

Bregman + Hamann Architects

481 University Avenue Suite 300

Toronto, Ontario, Canada, M5G 2H4

416-596-2299

www.bharchitects.com

Cannon Design
3299 K Street NW Suite 500
Washington, DC 20007-4415
202-337-6022
www.cannondesign.com

David J. Bennett, FAIA
DJB Architects, Ltd
5715 Clinton Avenue South
Minneapolis, MN 55419
612-866-5823
718-796-5208
http://djbarchitects.home.att.net

Emilio Ambasz & Associates Inc.
8 East 62 Street
New York, NY 10021
212-751-3517
www.ambasz.com

Gresham & Beach Architects Inc.
177 North Church Suite 755
Tucson, AZ 85701
520-882-0698

Gunnar Birkerts Architects Inc.
1830 East Tahquamenon
Bloomfield Hills, MI 48302
248-626-5661
www.gunnarbirkerts.com

**Hammond Beeby Rupert Ainge
Architects**
440 North Wells Street
Chicago, IL 60610
312-527-3200
www.hbra-arch.com

Hardy Holzman Pfeiffer Associates
902 Broadway, 19th Floor
New York, NY 10010
212-677-6030
www.hhpa.com

Malcolm Wells
673 Satucket Road
Brewster, MA 02631
508-896-5116 (fax)
www.malcolmwells.com

Don Metz
Metz & Thornton, Architects
PO Box 52
Lyme, NH 03768
603-795-4445

Ralph Allen & Partners
520 North Main, Suite 200
Santa Ana, CA 92701
714-547-7059
www.rap-architects.com

RTKL Associates Inc.
1250 Connecticut Avenue NW
Washington, DC 20036
202-833-4400
www.rtkl.com

**Shepley Bulfinch Richardson
and Abbott**
40 Broad Street
Boston, MA 02109-4306
617-451-2420
www.sbra.com

Spector Group
3111 New Hyde Park Road
North Hills, NY 11040
516-365-4240
www.spectorgroup.com

Steven Holl Architects
450 West 31 Street 11th Floor
New York, NY 10001
212-629-7262
www.stevenholl.com

Studio 9one2 Architecture
46 11th Street
Hermosa Beach, CA 90254
310-376-9171
www.studio9one2.com

**Tully International Architects
& Engineers**
38616 Stonewall Farm Lane
Middleburg, VA 20117
540-687-6555 or 877-dantully
www.tullyinternational.com

Weiss/Manfredi Architects
130 West 29th Street 12th Floor
New York, NY 10001
212-431-8255

William Morgan Architects
220 East Forsyth Street
Jacksonville, FL 32202-3359
904-356-4195
www.williammorganarchitects.com

INDEX

ABOUT THE AUTHOR

Loretta Hall holds a degree in mathematics from the University of Washington and is a member of Phi Beta Kappa. Formerly a high school teacher, she is now a freelance writer and technical writing instructor. Partly a generalist, she has written two books and numerous magazine articles on topics including history, multiculturalism, and tourism. Also a specialist, she has written articles for magazines and reference books about the mid-tech topics of engineering, construction, and manufacturing. Six books to which Hall contributed chapters have been named "outstanding reference sources" by the New York Public Library and/or the Reference and User Services Association (a division of the American Library Association).

Hall is a member of the Construction Writers Association and SouthWest Writers. She lives in Albuquerque, New Mexico, with her husband, Jerome Hall.

ACKNOWLEDGMENTS

I am deeply grateful to the architects, builders, building owners, property managers, and photographers who answered my questions, offered their insights, and provided photos and drawings. Similarly, I am very grateful to my publisher, Steve Mettee, and his staff, who molded my ambitions and turned them into reality.

I would also like to thank Dan Turner for reading a draft manuscript and composing the foreword for this book.

I appreciate my friends and relatives who were kind enough to ask how my work was progressing and gracious enough to listen to detailed answers.

Finally, special thanks go to a few very special people: to Jennifer, Andromeda, and Athena for their patience and understanding; to Bridget and Bernadette for their valuable advice and encouragement; and to Jerry, who supported me in every way imaginable—and then some.